DIGITAL PAINTING
techniques

VOLUME 5

3DTOTAL**PUBLISHING**

DIGITAL PAINTING
techniques

VOLUME 5

Contents

DIGITAL PAINTING TECHNIQUES

3DTOTAL PUBLISHING

Correspondence: publishing@3dtotal.com
Website: www.3dtotalpublishing.com

First published in the United Kingdom, 2013, by 3DTotal Publishing

Softcover ISBN: 978-1-909414-01-3
Printing & Binding
Everbest Printing (China)
www.everbest.com

Project Files

Our kind artists have supplied resources to accompany their tutorials. These resources come in the form of either custom brushes or template base images. So before you read on, please download these files to your desktop.

For all the files that you will need to follow this book, please visit: **www.3dtotalpublishing.com**. Go to the **"Resources"** section and there you will find information about how to download the files.
Find out which tutorials have resources below:

Concepting Using Simple Brushes
Circles | Squares | Triangles

Custom Brushes for Characters
Red Indian | Yeti | Alien

Painting Materials
Urban Environment

Aging Materials
Knight | Vehicles

Deputy Editor: Jessica Serjent-Tipping
Sub-editor: Jo Hargreaves
Design and Creation: Christopher Perrins
Layout: Matthew Lewis and Aryan Pishneshin

Visit www.3dtotalpublishing.com for a complete list of available book titles.

Drop Ship by JP Räsänen

DIGITAL PAINTING
techniques

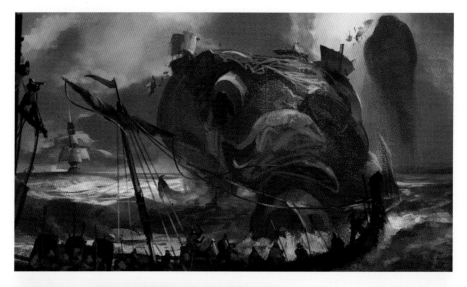

INTRODUCTION

Digital painting flourishes year after year, gaining wider audiences through the production of art for conceptual designs in films and video games. Now in its fifth year, the *Digital Painting Techniques* series continues to bring you a taste of what's on offer in the world of digital painting by presenting the latest techniques and trends, and covering a variety of popular and diverse subjects. These include everything from creature design and character portrayal through to battle scenes and weapon design, as well as concepting using basic shapes, speed painting cinematic mood shots, and painting and aging materials, providing a great starting point for anyone looking to get into the industry or trying to extend their skills.

Digital Painting Techniques: Volume 5 not only provides useful tutorials and advice on these subjects, but is bursting with inspirational material from some of the most talented industry artists of today. For anyone interested in digital art this is a priceless resource!

By Jessica Serjent-Tipping
Deputy Editor | 3DTotal Publishing

Nephilim Rising (Top) | *Delta Epsilon* (Above) © Dr. Chee Ming Wong

FOREWORD

Art is a lifestyle.

Its adventures and meanderings are often both rewarding and lifelong, for those choosing to journey its path.

It has the power to create life, forge new worlds, to inspire each and every one of us in ways profound and experiences unique. In short, art represents the creative potential of gods and in your hands lies a unique collection of digital art and digital art techniques from your fellow artists.

In a way, the current generation of artists is blessed with the variety of media available with which to further both their insight and art education. There are videos, art books and online tutoring courses, but there is something to be said about working from basic principles amongst the tempting array of filters, artistic samples and photographic resources. For a solid grounding in artistic principles will allow you, the artist, to be the platform on which you apply your creative ideas, without the impediment of technical limitations, which can ultimately be trained – it's all about mileage and attention to various details.

You could say that the more technical skills are akin to baking (follow the instructions and

pay attention to the minutiae, and more often than not, a reasonable outcome is pleasantly achieved). Cooking, now cooking is more akin to taking all that technical knowhow and flying by the seat of your pants. It's exploring wide empty spaces on the digital canvas and using all your cumulated artistic instinct to channel, to work, to pixel-push and coax a painting into life that represents your best, latest life's work.

Such is the joy of painting!

The beautiful, wonderful aspect that makes each individual artist unique is that, ultimately, you and I are all different. This is the best news of all.

Each and everyone one of us will be that infinitesimally different, and we should enjoy and celebrate our individuality, not try to clone one another. And sometimes, we are an extremely competitive, unrealistically self-driven and ultimately an altruistic-loving lot when brought together in good company.

Often, it is not uncommon for artists to enter into some tormented Faustian pact whereby we are inspired (gutted that someone else made an amazing painting, that they put it out there first, and that they did it so well, better than you anyway) by another's art piece (how dare they!); be filled with some sense of artistic self-loathing and self-flagellation (should I stay or should I go, oh woe is me, I must crush the opposition,

crush!); and somehow reach deep within our creative process to spur ourselves on to greater heights.

So yes, even if every artist were to be equipped with the same arsenal of painting techniques and equipment, the caliber of artistic output would still vary. Our ideas, inspirations, mileage and technical understanding of the various media all mix and stew together to make up our individual "art life experiences".

So, come partake in this gathering of artworks and shared insight. For within, artists from all walks of life, that span across the vast spectrum of the entertainment industry, design and fine arts, have come together to share their individual processes and workflows that, in some small way, may help better our own unique challenges and approaches to visual troubleshooting – whether it be an existing painting, or in planning the next visual key shot. This collection has something for both the working professional, aspiring enthusiast or most importantly, for the individual, choosing to embark on the unique pathway of digital art.

Ars longa, vita brevis.
Art is long, life is short.

By Dr. Chee Ming Wong
Creative Director | Opus
Artz Ltd, London UK

CHAPTER 01 | SUBJECTS

Deciding on a subject for your painting can take time and can often be tricky, although some might say it's actually the easiest part, as once you have your chosen subject you have to take on the more difficult task of painting it, and turning it into a visually mind-blowing concept. In this section our artists are on hand to help you adapt your work process and create stunning images of your own, by sharing and demonstrating a vast number of useful tips and techniques in topics such as creatures, characters, scenes and weapon design.

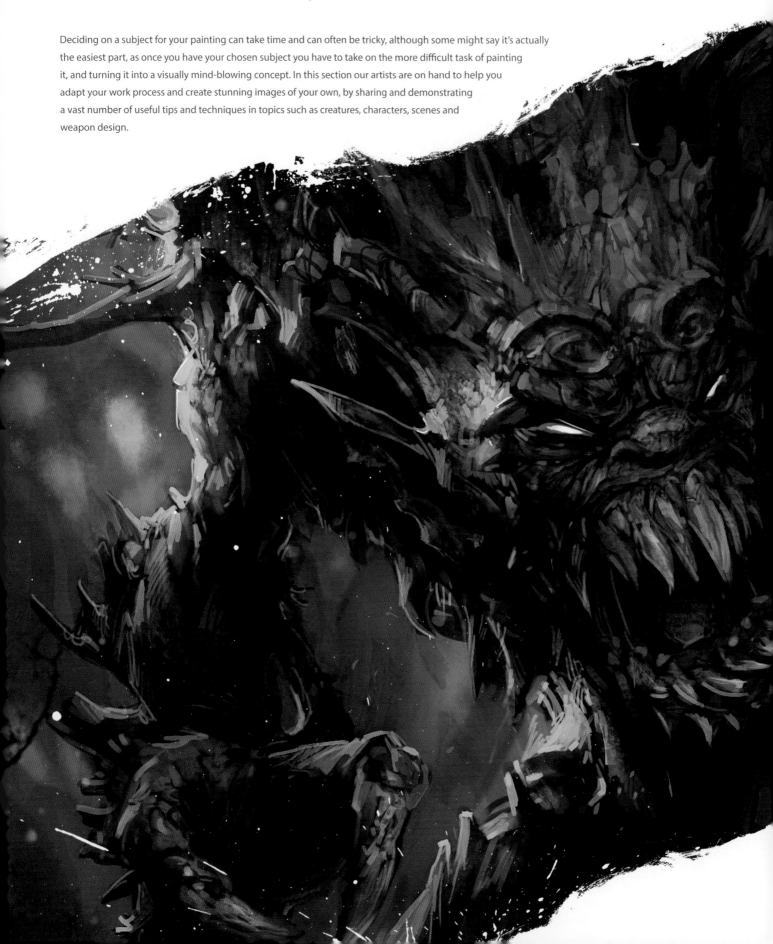

Chapter Index

* Please note, that the Creatures from Mythology Jiang Shi and Leshy tutorials by Simon Dominic have been created using Painter.

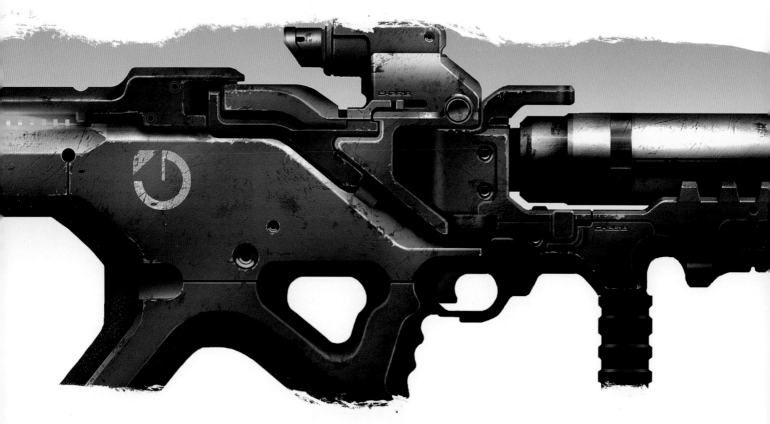

WEAPON DESIGN | SHOULDER MOUNTED WEAPON
By Brian Sum

Introduction

I've chosen to do a shoulder mounted weapon for this tutorial, since I've never done one before and I think it will be a fun challenge. I going to keep with tradition and design one that could exist in the *Mass Effect* universe. I don't have a specific design in mind at this point, but I have a general idea of how I want to approach this weapon. I want to give it a heavy mass, similar to a traditional rocket launcher, but at the same time I want to push for a much more unique silhouette. I want the gun to have some elements that are familiar in traditional weapons, while also adding a fictional element that isn't too "wacky" looking.

> **I'M ALWAYS CONSCIOUS OF WHAT DESIGNS ARE OUT THERE, TO MAKE SURE I DON'T DO SOMETHING SIMILAR**

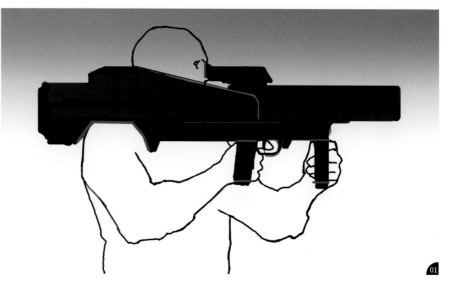

01

Getting Started

I always start by looking at as much reference material about the subject matter as I can. In this I look at a lot of rocket launchers, as well as fictional weapons, to see what's been done already. I'm conscious of what designs are out there, to make sure I don't do something similar.

I start by laying a base figure down to establish where the hand and shoulder placement should be (**Fig.01**).

Once this is established I start laying down shapes with a default round brush at 100% Opacity. I paint a few variations in grayscale

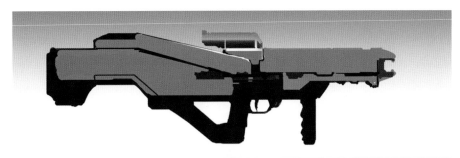

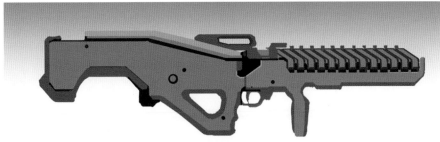

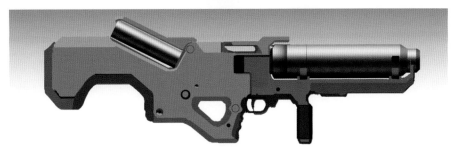

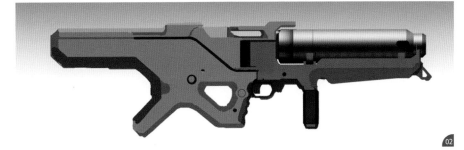

with 2-3 tones. I'm not really thinking about color yet. I'm mainly concerned with the shape of the design and the relationship between the different tones. It's really a balancing act.

I toy with the idea of possibly making it a railgun of some sort and also with how possible ammo clips could slot in. In the end I decide to go with the bottom right version in **Fig.02**, which has a more traditional cylindrical barrel. I like the silhouette and I think it still has that rocket launcher feel.

Adding Detail

At this point I'm somewhat happy with the direction it's going. I gradually start adding in details. I paint in general areas of highlights and shading by isolating areas with the Polygonal Lasso tool and painting with the Airbrush tool. This gives me nice clean edges. To get a metallic effect, I'll usually use an airbrush with the brush blend mode set to Color Dodge. I also paint in a scope and general bolt details, which I think are just as important to the overall composition of the design (**Fig.03**). Again, it's a balancing act.

> *Quick Tip:* Adding an element in one area could suddenly change the design and composition of the entire piece. A general rule that I usually keep in mind is to avoid spreading elements out evenly. This tends to create a flat and boring design. I'm conscious of keeping areas of negative space that compliment the areas of detail.

02

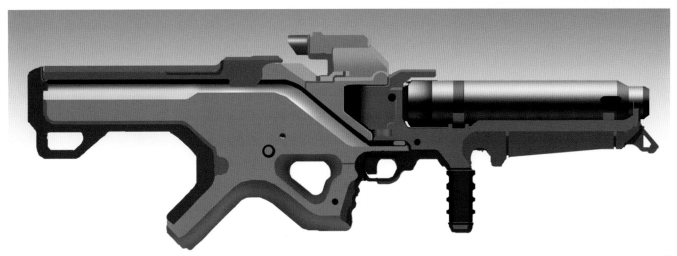

03

I establish guides to make sure my lines are consistently parallel (**Fig.04**). If I were to design a gun that was a little more alien then I would probably try a theme with less parallel lines.

Color and Texture

I lay down a base color and at this point I'm starting to feel that it is heading in the right direction (**Fig.05**). I decide to stick with two colors: a main dominant color and a neutral gray. I'm careful not to choose two dominant colors that would compete with each other, so using a neutral tone is a nice compliment to the main color.

I also start laying down some textures to add detail. I have a scratch/rust texture and a brushed metal texture for the overall surface, and a leather/plastic texture for the handle areas. I play around with the blend modes to see which one fits the best.

Even though the design isn't finished yet, I find putting down base textures helps me to see the end result a lot faster (**Fig.06**).

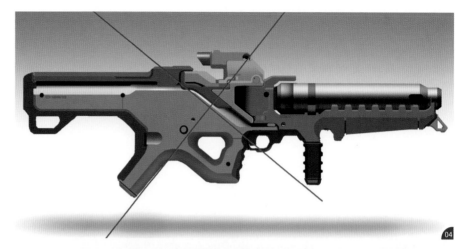

04

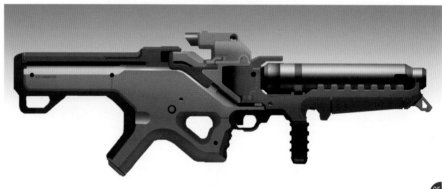

05

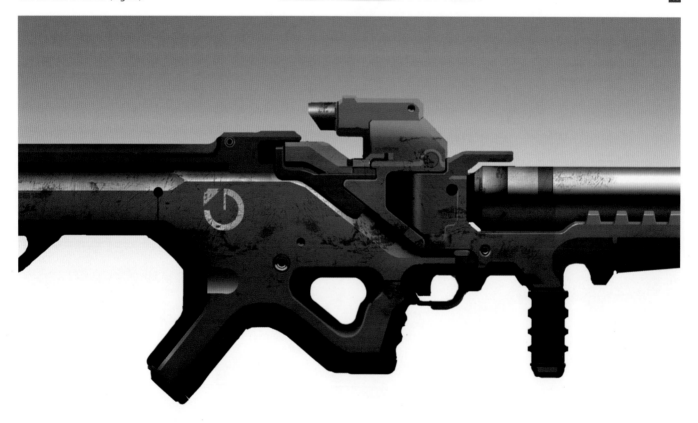

06

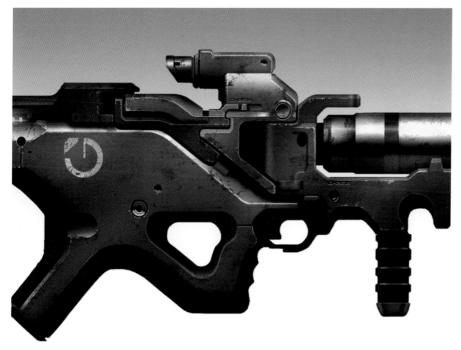

THE CHALLENGE IS KNOWING WHEN TO STOP!

I also add more detailed bolts, a graphic logo and random numbered decals in areas where it feels appropriate. I keep these in separate layers, so that I'm free to adjust the placements where necessary.

I use the Brightness/Contrast adjustment layer with a mask to add shading to the weapon. You can stack multiple layers for added flexibility and control (**Fig.07**).

Final Detail

It's now a matter of looking at all the areas to see where to put the details. I think it's really the details that sell the "coolness" of the weapon. I paint in a scratch pass to give it that extra level of wear and tear. Adding in a light strip in the back gives it that sci-fi feel (**Fig.08**).

Now it's just a matter of going through each area, and adding in highlights and shading to make the image pop. The image is pretty much there at this point; I could go on forever with the details when I reach this stage, but the challenge is knowing when to stop!

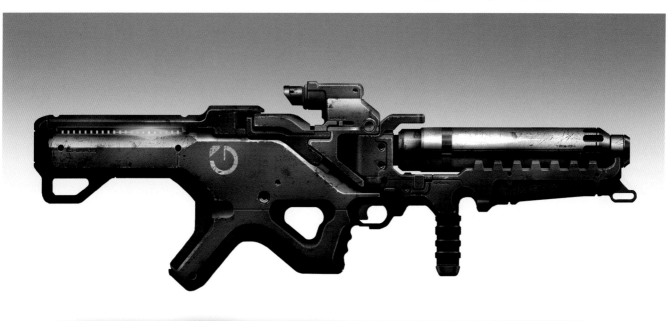

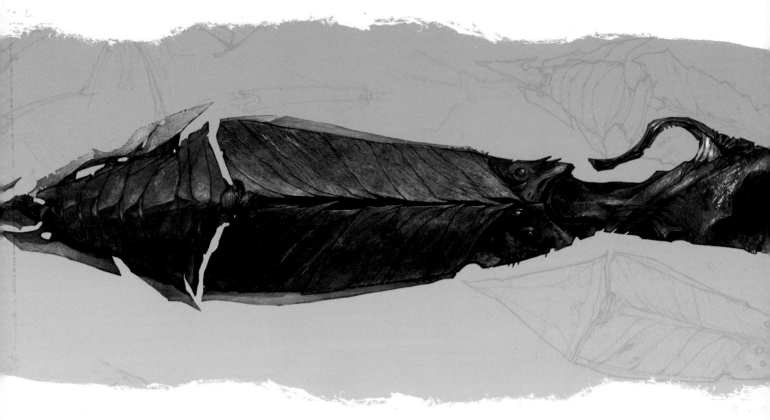

WEAPON DESIGN | THROWING BLADES
By Vadim Sverdlov (Tipa_Graphic)

Introduction
Hello, my name is Vadim Sverdlov (also known as Tipa_Graphic) and I'm an illustrator and concept artist. In this tutorial I'm going to tell you how I paint and develop concepts from scratch, through to the final result.

My brief for this tutorial is to make four throwing blade concepts.

Research
First of all, once I receive a brief to make a piece of concept art, I start researching to get as much information as I can. I am looking for everything that may help; how it looks now, how it looked in the past, how it looked in its most recent development, how it works, from which materials the object is made, etc.

Even if I think that I know a lot about the object, I still spend time doing lots of research, until I fully understand its purpose and how it works. This is especially true when the object is related

to weapons or is some kind of technical item. The weapon has to work; it has a purpose and it has to be fully functional.

After searching for information about throwing blades, I also look for some types of fighting knives. Both have much in common, but the usages are different. However, sometimes simple knives are made of interesting materials and have various design solutions.

First Ideas
Once I have gathered all the required information, I make some guidelines, so that the final result will actually be the one requested by the client (for example, if the object is a handgun, then it has to be short, it must have a handle and a hole, which the bullet will be fired from. If it's a car, it must have wheels).

In this case, unlike a simple knife which is used for cutting and is held by hand, the throwing blade is used against people in order to kill them

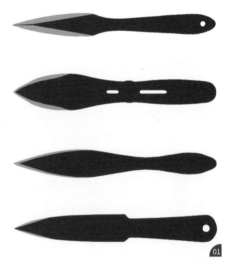

or make some serious injuries. It has to be thrown from some distance, and penetrate the human's body with the sharp side in order to cut or break some bones.

I have chosen a few existing examples (**Fig.01**), and tried to find common ways to achieve its goal.

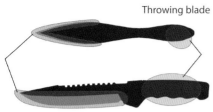

Throwing blade

Combat knife

02

As you can see in **Fig.02**, unlike a simple knife, the throwing blade hits the target with its edge. The bulk of the knife is concentrated on the sharp edge, and the handle is pretty small, so that only a few fingers can fit. This is in order to increase the probability of an accurate hit.

I have decided to make four different concepts. This way I can show you various designs and materials. Only after I choose exactly what I am going to draw, do I start drawing sketches and ideas. If I am not near my computer, I draw on paper in my sketchbook (**Fig.03**).

> **" DRAW EVEN IF YOU WILL NEVER USE IT, BECAUSE OFTEN GOOD IDEAS COME WHEN YOU SEE SEVERAL VARIANTS IN FRONT OF YOU "**

I can do it on my way to work, or in a pub – sometimes great ideas can be born after a glass of beer. I'm not trying to draw accurately as I'm only drawing the ideas, looking for shapes and sketching my thoughts, in order to use this stuff later. However, when I'm near my computer, I make thumbnails (**Fig.04**).

Draw even if you will never use it, because often good ideas come when you see several variants in front of you. You start thinking about combinations of different parts, designs and concepts. Sometimes it's possible to create a great concept right from the first sketch, but if you do then you are really cool.

If no ideas are coming out, then put everything to one side, close your eyes and try to relax;

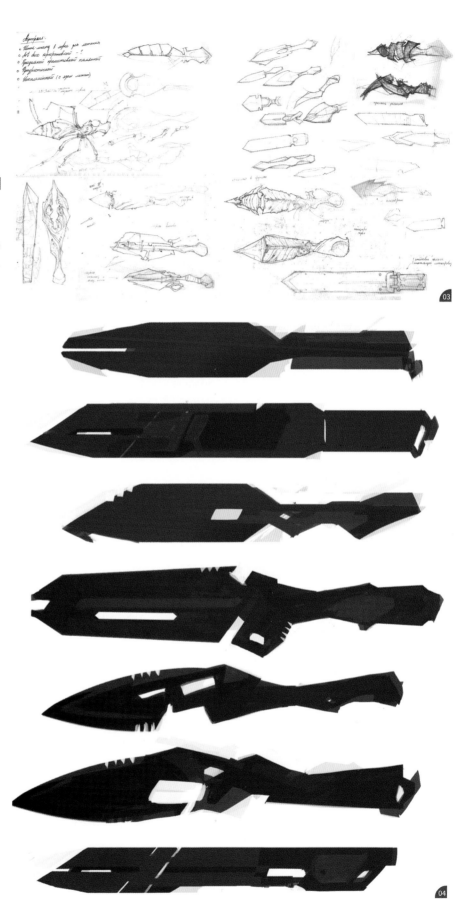

03

04

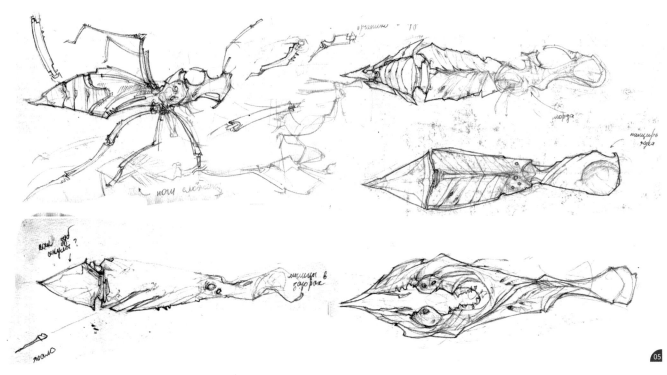

your brain will take a small break and then it will supply you with a bunch of ideas. Sometimes I'm trying not to just create concepts, but also give them some functionality. I'm trying to write down all that comes into my head. For example, there are hundreds of various fighting knives, and the Russian Special Forces have a knife which can fire a bullet. This solution makes it differ from other knives of this type.

First, will be a throwing blade for aliens; they might use them too, right?! This way it's possible to use some new textures and ideas. Within this concept I can combine a blade with something living, like some poisonous thorns, so that the enemy will be paralyzed or dead for definite. Or maybe the blade would be driven further into the body, making it harder to remove it (**Fig.05**).

Later I choose two variants which I like the most, and start to develop them (**Fig.06**).

The Concept

I start with a layer with lines, which are drawn using Multiply (the white color becomes transparent and the black lines remain), and under it I start to fill the painting with gray colors (**Fig.07**), I give it volume, looking for shape, direction and light.

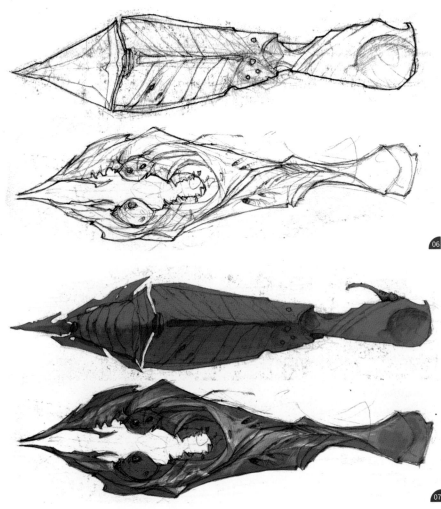

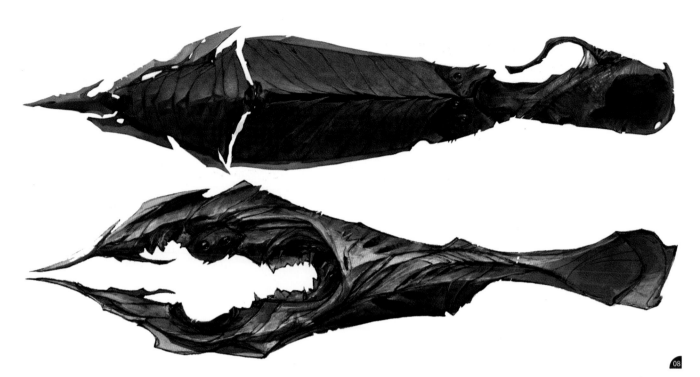

During the first steps it's sometimes easier for me to draw in grayscale, because it's too early to think about colors and textures when there is no particular shape. Don't be afraid of remaking, erasing or repainting again and again; it's only the searching stage, which will later lead us to a better result.

Even at this point it's possible to imagine how the blade concept will look (**Fig.08**). It looks fine, and I could even show it to a client or boss at this stage. However, if you look more closely, you can see many things that can be improved. Please don't forget that many clients can't imagine the final result until they see it with colors and textures. If this object is to be modeled in 3D later on, a concept closest to the final result will be very helpful.

Developing the Idea

Now I'm going to take one design, and develop it. If the throwing blade was combined with something alive, then I think it would perhaps be an insect of some sort. In order to capture the textures in a realistic way, I look at many pictures of beetles, scorpions and body tissues (**Fig.09**).

I've decided that on the top, it will be covered with a shell like a beetle, but there will also be some soft tissue and thorns.

There are several ways to start painting a grayscale concept. For basic colors I often open a

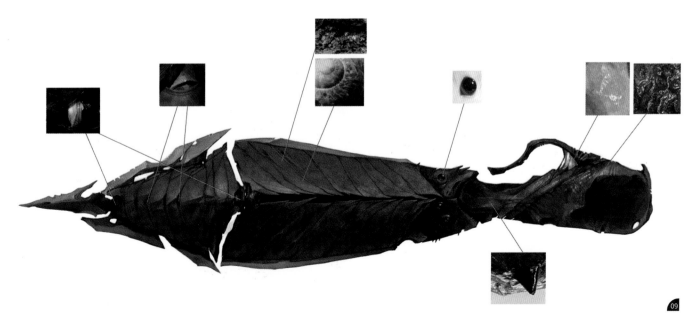

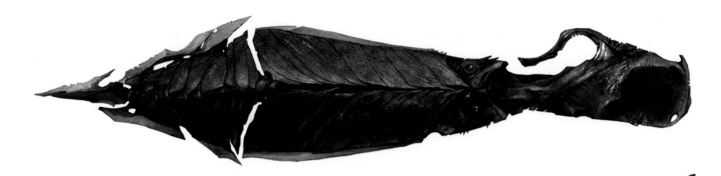

10

layer above another layer, while I put the concept in an Overlay layer and start painting. A few trials are needed in order to understand how it works.

I also put many of the textures in an Overlay layer above my painting. If it makes your painting too dark or too light, you can edit your texture using Levels, so it will fit your painting without destroying it.

Quick Tip: If I need to add some scratches (something white), I put it in a Screen layer. This is the best way to create some mucous surfaces or scratches.

Sometimes, you can just cut a part from a photograph, paste it onto your design and then draw above it. As you can see, there are many ways of doing such things, and you can use what's best for you, as long as it leads to the desired result.

Consequently, I've created a very cute throwing blade. Hooray! Now I can set it as my background, and send it to the client (**Fig.10**).

Second Concept

The next concept I'm going to make is a military blade. I would not say that it is particularly futuristic (maybe placed somewhere five years from now).

I've decided to pick a design from the sketches I made before and finish it. There can be a lot of variations, but I'm going to take one with a simple form. It's not out of laziness; it's because I know that everything that sticks out, and has potential to tangle with the rifle or the vest, will do so, and will be very uncomfortable.

Defining the Material

As you can see in **Fig.11**, the designs are different, but the initial steps and workflow are very similar. As I have already traced, added texture and fine details, the design is looking quite good, but even a new weapon coming straight from the factory will soon be covered with scratches and the paint will wash out on protrusions and edges.

If you are doing a handle, think about what material it needs to be made from, because it should sit firmly in your hand. The blade I've made from a dark iron. In the army they try to paint over or mute the shiny parts so they won't shine or sparkle from the ambient light, giving away their position to the enemy.

After adding some scratches, metal and rubber textures, the throwing knife now looks much more believable and much more like something that would belong to a person who has really been using it. If you look closely, you will notice that there is a button on the blade. This will detach it from the handle, allowing you to replace it with another blade, perhaps more suitable for the intended purpose. Modularity and the possibility of replacing the parts are always good functions. The only thing remaining with this concept is to send it to the client for approval.

Third Concept

Another concept I'm going to look at is a grimy, ragged and crooked blade, ideally suited for a

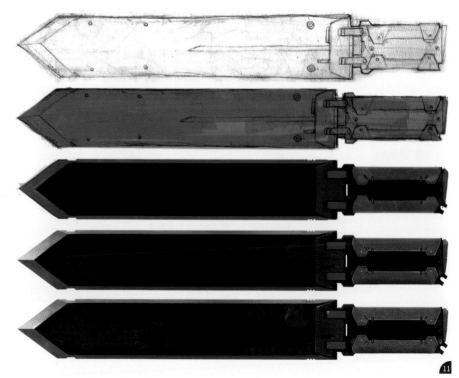

11

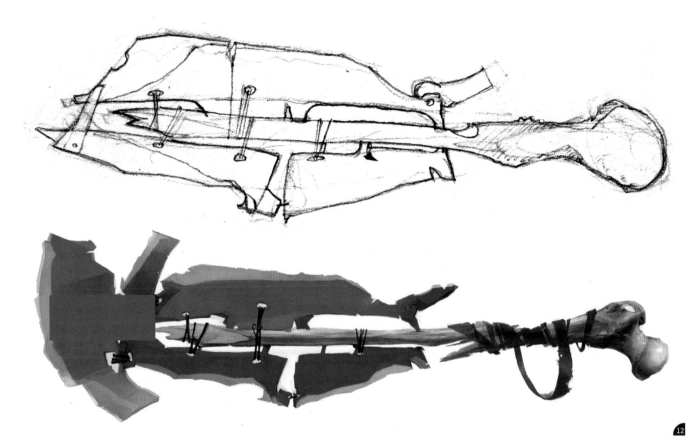

possible post-apocalyptic cannibal tribe. These forms are easier for me to do with calligraphy brushes, so that's what I'll be using.

Functionality

In this kind of world, all the resources that are to hand would be used to create weapons. I think that a human bone would make an excellent handle, as cannibals would have these readily to hand. The blades would be made of iron, which they would have foraged (**Fig.12**).

If you get speared by one, and you don't die instantly from the hit, you'd probably die from the infection. As you can see in **Fig.13**, keeping their weapons clean is not a priority to our cannibals; I've added a lot of scratches, rusted iron and dried blood.

Final Concept

My inspiration and idea for the last concept comes from the Russian paratroopers. Who said that a throwing blade should be small? It's a

piece of iron that is thrown at a target. There can be small knives, and there can be something as big as a machete.

In general, try not to limit yourself or the final outcomes possibilities. Think outside the box. Who said that the grass must be green?

The Russian paratroopers use a small shovel, which is not only for digging, but also for throwing at a target. If you get hit with a great

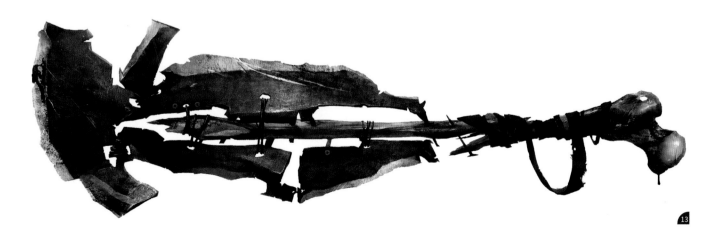

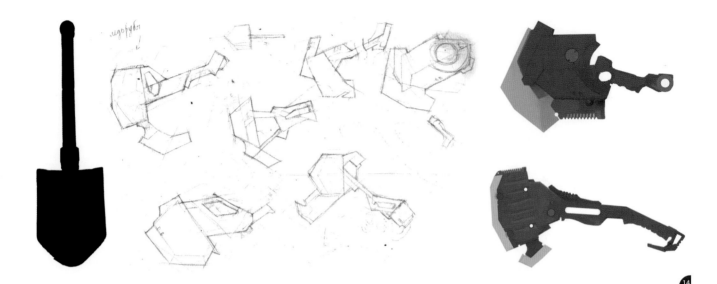

mass of iron, it will not only pierce your body, but will also break your bones on the way. It's almost an axe, but with the cutting edge positioned differently.

I take the silhouette of a shovel and draw some sketches in order to understand where it can be improved, and where and how it should be gripped, so it'd be comfortable (**Fig.14**).

I check out a few axe examples of tomahawks and ice picks, etc. For me, a curved handle is more convenient when you need to hold the axe for a long time, so I decide to use it in my concept. As you can see, the design development steps are the same as before.

> **Quick Tip:** Think about your concept as a product that you would like to implement and sell. Not only should it be functional, but it should also be comfortable.

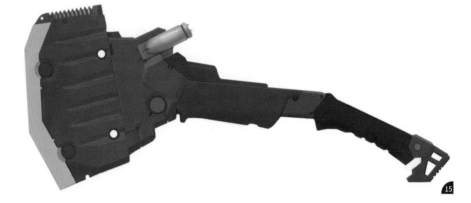

If there is a handle, it should have a comfortable grip. For example, an M16 handle has suffered many changes in recent years in terms of comfort ability. From a simple piece of plastic, it has become a useful accessory, with ergonomic spaces for your fingers, while also doubling as storage space for small spare parts.

It won't improve your marksmanship, but it'll make sure your weapons are more aesthetically pleasing. Design should be beautiful and

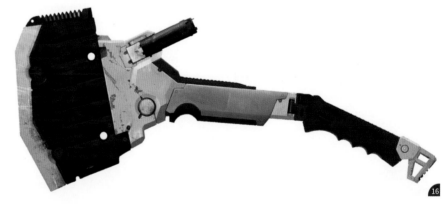

comfortable, without any unnecessary excess. In my design, I've tried to make the handle more comfortable and if you need it, there is also a place for gripping with a second hand (**Fig.15**).

Color and Texture

All that remains is to add color and texture, and my weapon is ready (**Fig.16**). In order for the weapon not to be too long, and for it to able

to be attached to the army vest, I've added the ability to fold the handle in two by pressing the button, as many rifles feature a folding butt.

Conclusion

That's it. I hope that what I have shown and described will help you in your work and creation of new concepts. Do not stop generating new and interesting things – do what you love.

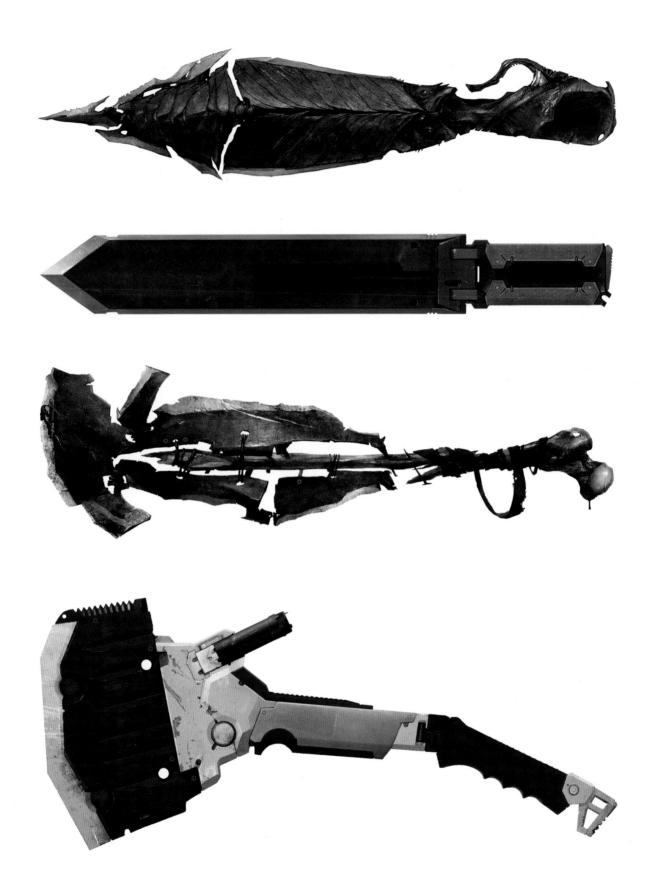

WEAPON DESIGN | HARPOON
By Daniel Baker

Introduction
While working as a senior concept artist at Ninja Theory, I'm often asked to design weapons – everything from swords to submachine guns – so when 3DTotal asked me to do a tutorial for a science fiction harpoon, I leapt at the chance.

Initial Ideas
For this project I'll be starting off with simple black and white silhouette work, mainly because it's fast, fun and the results are easy to interpret and modify according to feedback etc.

I think it will be cool to see maybe a mix of design approaches; maybe harpoons for two opposing forces in a future alien war, where large, shelled creatures need to be mounted and ridden into war.

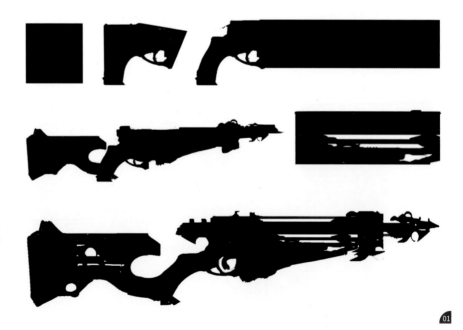

So early on in the design process you will see some very familiar shapes for the human weapons, then some more bizarre, otherworldly approaches for the alien versions.

I usually begin a weapon starting from the grip or stock, and work outwards. I'm not sure why, but it seems to work for me. I do this by creating basic squares and rectangles with the Marquee tool,

then using the Eraser tool with a solid-edged brush selected to start cutting into the shapes, at the same time adding parts to build up a very basic silhouette (**Fig.01**).

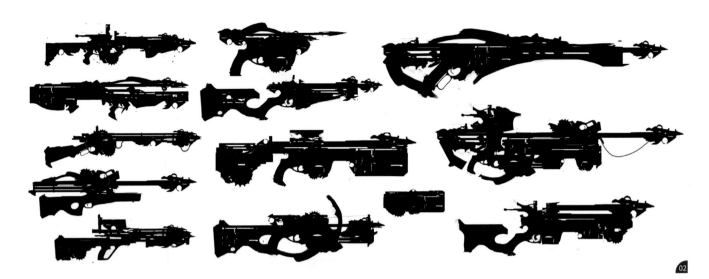

02

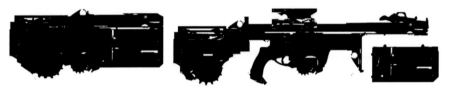

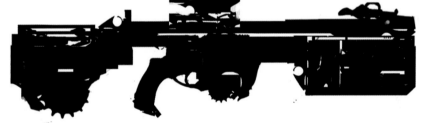

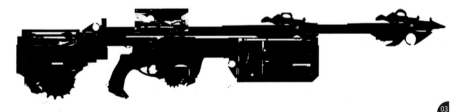

03

If you look at **Fig.02**, with all the different silhouettes collected together, you will probably notice that I've taken some of my favorite aspects from one weapon and used it on another.

To me this makes a lot of sense. Stealing a piece from one harpoon, flipping it upside down or rotating it and putting it in a totally different area, can really help to achieve shapes and structures that you might not have thought of before.

Like most concept artist, I'm a huge *Star Wars* fan and some of my favorite weapons come from the series. I think the reason for this is because many of them are based on real weapons from our world.

With that in mind, don't be scared to get some references together of weapons you have seen that have strong shapes. You can then use as much or as little as you want in your own silhouette sheets.

Choosing a Design
So after looking at the pages of collected silhouettes, I've decided on the design in **Fig.03**.

It's definitely one of the more human-looking objects, but I like the idea of a weapon that can be made more compact and in this compact mode look quite non-threatening. I think it would open up lots of great possibilities for a great reveal when somebody takes it off their back and opens it up!

Okay at this point I've noticed I've made a rather silly mistake: you can see that the power supply is at the front of the weapon, with the line reel built into the stock. It's my job as a concept artist to really rationalize a design, and this is clearly not a rational design – in fact it makes little to no sense at all!

So although not quite as aesthetically pleasing, I've swapped the layout around. The heavy power source now acts as a stock, with the line reel at the front. The line can be connected to the harpoon without getting in the way (**Fig.04**).

Line Work

With that little snag sorted, I can move on to adding some really quick line work. I do this by duplicating the original silhouette and bringing the Opacity down to 50% or so. Then, in a new layer, I add some really quick line work. You could even do a few versions of this and see which works best for you (**Fig.05**).

Values

Once I have decided on the best line work it's time to add some really quick values.

I make a new layer again, put the Opacity down to 50%, set the layer in Multiply mode, and start painting in the darker areas with a hard-edged brush. Once I have this, I make a new layer, put it in Overlay mode, and start adding in light areas with a white brush.

Adding Textures

At this point I have a really basic, but clear-looking concept. The next stage is to add photo textures to bring in a real sense of reality (**Fig.06 – 07**).

I want quite a retro feel to the finish and detailing on the harpoon, so it has a sort of alternative history feel, so I'm going to go for WW2 weaponry – in particular, the Thompson machine gun, which has some really nice detailing.

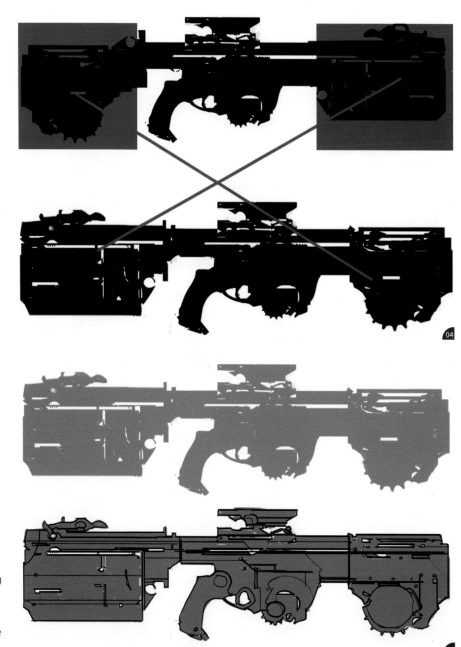

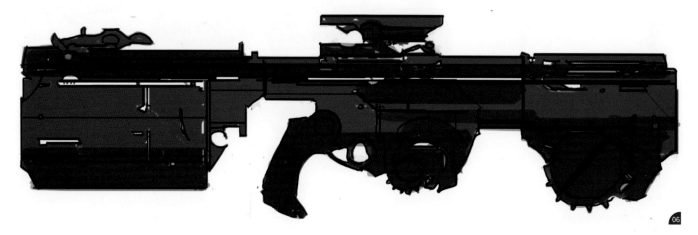

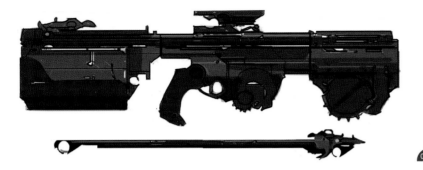

So here, I've literally just cut and pasted the parts from the weapon I like and placed them on to my concept. You will notice at this point that I'm not sticking too closely to the line work. I find that at this stage the process becomes more liquid as you start to see more appropriate shapes coming out of the photo reference.

Also at this point, the silhouette is starting to look a bit heavy. After all, these warriors would need to be able to carry these things over long distances, so I start to cut some shapes in the mid-sections to lose a bit of weight and give the whole thing a much lighter feel (**Fig.08**).

Final Touches

That's the design phase pretty much finished, so with all that out of the way, I add a few extra lines here and there for definition. Then I create a new Color Burn layer, with some more earthy tones to try and get that "used" feel. Finally I add the unused silhouettes as a Multiply layer, just to show the evolution (**Fig.09**).

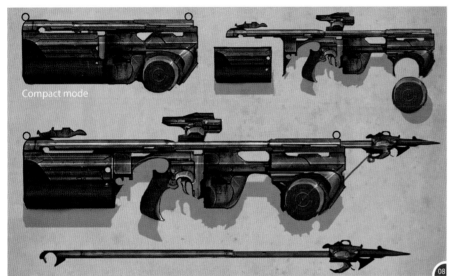

Compact mode

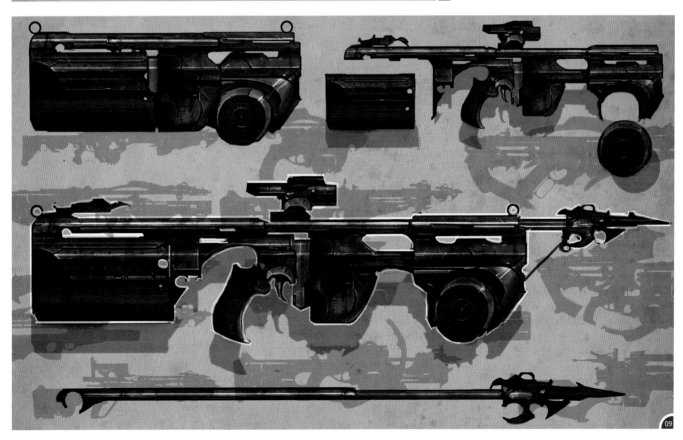

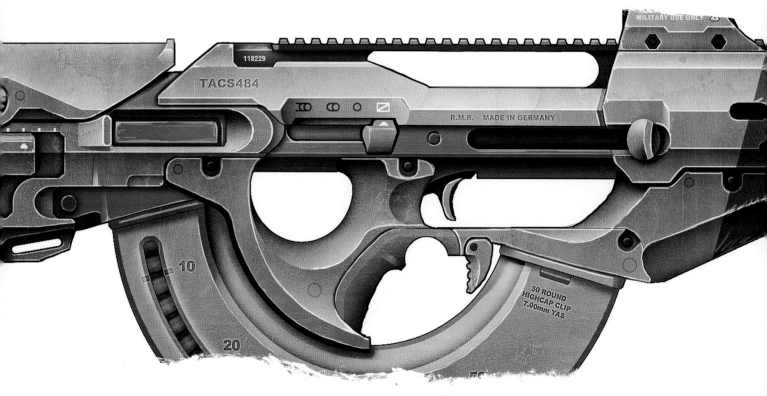

WEAPON DESIGN | ASSAULT RIFLES
By Kris Thaler

Introduction

Hey guys, in this tutorial I am going to show you one possible workflow that can be used to create an assault rifle.

Getting Started

The first step, as always, is to get your ideas together in some rough sketches, to get hold of some ideas and visualize them (**Fig.01**).

After you've picked your favorite – in my case the third one – the next step is to draw a refined outline with straight edges. In order to do this, create an empty canvas. For this tutorial I'm using a medium resolution of 3000 x 1500 px; all machines should be able to handle this.

Create a new layer, choose a soft standard brush with 3 px diameter and start drawing your outline (**Fig.02**). You can copy in your preferred sketch and blow it up so it fills the canvas, and paint over it so you have a base for your more detailed line drawing.

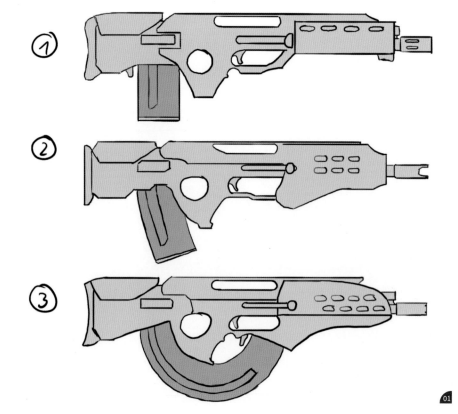

01

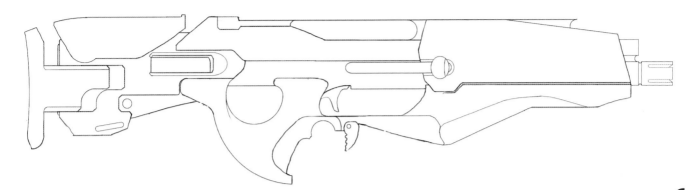

The next step is to give the line drawing a solid background color to add general contrast and differentiate the rifle from the background. Select the negative spaces around the outlines of the gun with the Magic Wand tool and inverting the selection (**Fig.03**). Fill the inverted selection with a 50% gray on a layer below the outline.

Defining the Materials

Now you need to define the different materials of the assault rifle. Create a new layer for each material and name them accordingly. Select the different areas with the Polygon Lasso tool and fill them with the color of the respective material (**Fig.04**). I've used a gray for metal parts, another gray for the rubber back of the stock, a light brown for the plastic parts and a slightly more desaturated brown for the clip's plastic.

As you see, I've decided to lengthen the muzzle break a bit and add some kind of aiming hardware to the top rail; in this case a laser sight optic. Without the optic it looked too new and right out of the factory; with the optic mounted it feels more like it's ready to use. At this point you

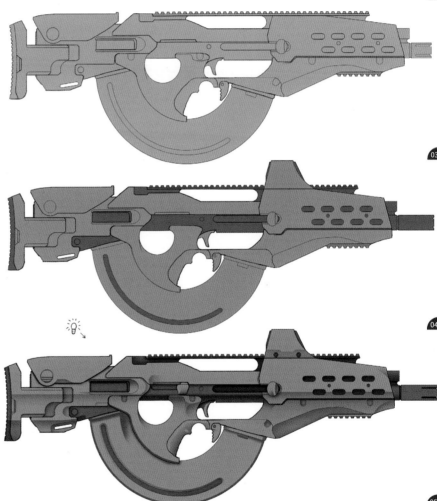

can still make a lot of changes, but you should be finished with additions to your design after it.

Lighting

It's time to achieve some depth in the drawing. I normally use a light source that is situated above the design and to the right; I've painted in a little light bulb to visualize its position, as you can see in **Fig.05**. Feel free to use other light source

positions; this is just the one I found to be the most neutral one for me.

Now paint in all the shadows that would be cast by the light source into a new layer, where the Opacity is set to 40%. Select the areas with the Polygon Lasso tool and use a black color with a soft brush on the plastic material (**Fig.06**), and a more hard-edged brush on the metal parts.

Use the same technique to render the lights. Create a new layer, set it to Overlay layer mode, with the Opacity set to 50%, and paint in the light reflections with a white color (**Fig.07**).

Defining the Edges and Adding Detail

Now the edges need some more definition. Create a new layer set to Overlay and paint in the edges with a 3 px diameter soft white brush. This step is important to get a certain amount of layering in the drawing. Paint over elevated edges, but leave lower edges as they are (**Fig.08**).

Use the same layer to draw scratches on the metal surfaces, which occur on moving elements like the shell ejector and other parts.

After defining the edges, it's time to add some detail on the plastic. Create a new layer and use the Text tool to write whatever you want to have on your assault rifle. A nice choice is always the serial number and the manufacturer; I also add an ammo counter and clip description text. Set the text color to a 50% gray and the layer mode to Overlay. Set two layer effects for it; first, an outer glow with a white color, 50% Opacity on Overlay, and second, an inner glow with a black color and 40% Opacity. Adjust the sizes until have the depth effect you want for it (**Fig.09**).

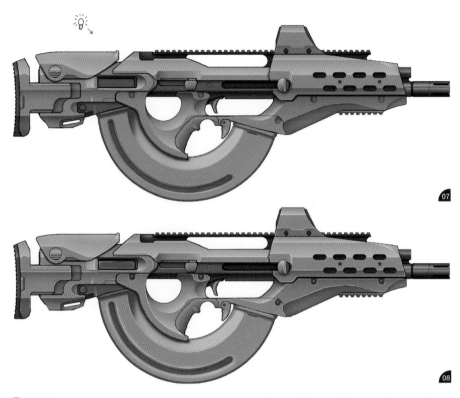

07

08

Textures

The surfaces feel a bit to clean at the moment; let's fix that by adding a surface texture. Go to **www.cgtextures.com** and search it for scratch maps. Pick one that fits your plastic look and slap it in a new layer. Give it a mask by clicking with a pressed Ctrl key on your light brown plastic layer

to get its selection, and then press the Create Mask button. Set the layer to Overlay, desaturate it by pressing Ctrl + U and slide the Saturisation slider to 0. Now set its Opacity to around 30% – you can play with it until it feels right (**Fig.10**).

The same goes for the metal parts of the assault rifle. Search **www.cgtextures.com** for a nice metal surface texture and repeat the previous steps, this time just for the metal elements.

I add more details like safety switch symbols, more text on the laser sight optic, an additional serial number on the rail system and a stock adjustment indicator. Set the layer you paint them in to Overlay to blend it in (**Fig.11**).

To give the weapon a more used look, I add some dark spots on it. To do this, simply create a new layer, select the weapon and using a big soft brush with black selected, add black on random locations all over the assault rifle. Be sure not to overdo it, as it looks more natural to only have some of these spots.

As you can see on the same picture I've added some plastic casting spots. In order to do this, repeat the same steps used for the engraved text,

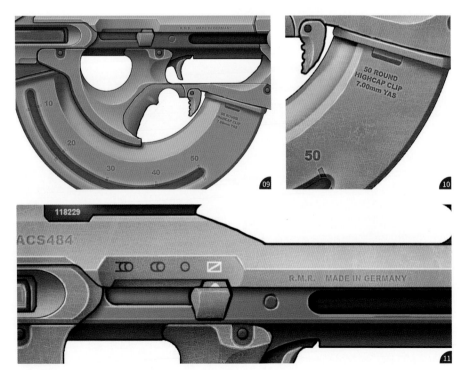

09

10

11

but this time set the layer's Opacity to 50% so the casting spots will look more subtle. Instead of the Text tool, simply use a hard-edged basic brush and paint random dots on the plastic parts of the assault rifle.

Finishing Touches

Now we are almost finished. We only need some bullets in the clip, some decoration and little final touches.

Go to www.resourcecolony.com and download the cartridges featured there for free. Arrange them so they would fit in the clip and give them a mask with only the ammo window selected (**Fig.12**). Give the layer an inner glow effect with a black color at 40% Opacity, to simulate a shadow inside the clip.

Let's add a color for decoration, to give the assault rifle some more character. Add two red stripes on the front of the rifle on a new layer.

Set the layer to Multiply and give it 50% Opacity. Erase out some scratch marks along the edges of the rifle to enhance the used look.

To avoid a look that is too cartoony, set your outline layer's Opacity to 50%.

For additional contrast select your assault rifle, copy the whole thing in a new layer above all the others and run the High Pass filter over it. Desaturate it and set its layer mode to Overlay.

Now play with the opacity until you think the contrast looks nice; I've used it on 20% Opacity. As a final step select your rifle, create a new layer beneath the other layers and run Edit > Stroke with a 3 px outline to give the whole assault rifle a solid contrast.

Afterwards I add some examples of things you can attach to your existing design, by using the same technique used for the main body.

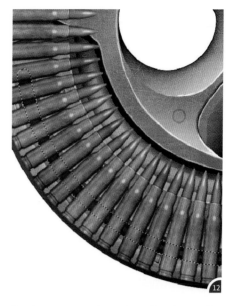

Simply create a new layer above the others and start painting in the additional attachments. As we designed an assault rifle, things you can add are front grips, sights and optics, lamps and lasers, grenade launchers and so on (**Fig.13**).

You can even alter the whole design into a sniper rifle by adding a much longer barrel, a sniper scope and a bipod.

What always look nice are functionality descriptions, so I add the reload mechanism for the grenade launcher as an example.

And we are done. If your first attempt doesn't look like what you had in mind, do not give up, but try again. I hope you learned something!

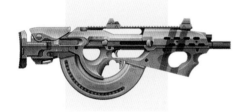

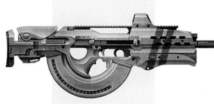

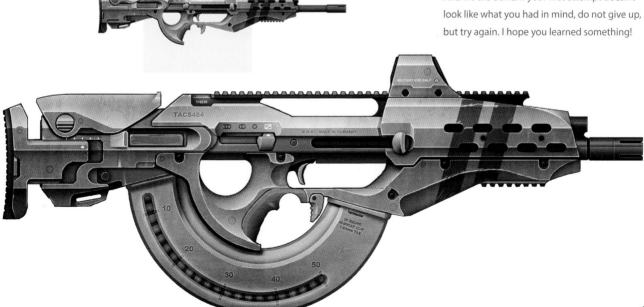

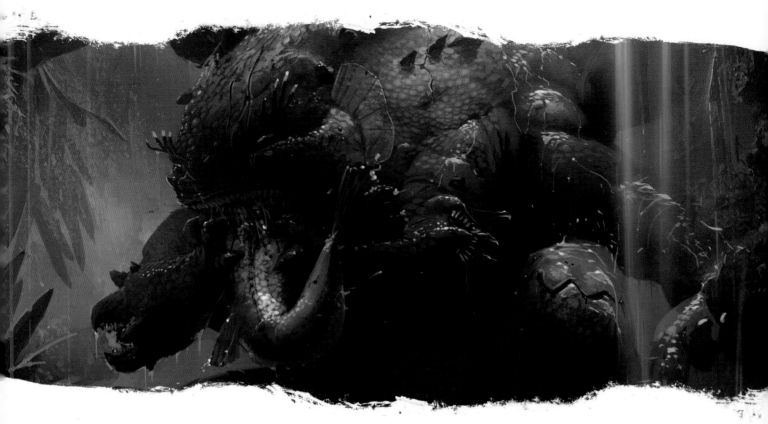

CREATURES FROM MYTHOLOGY | CIPACTLI

By Ignacio Bazán Lazcano

Introduction

From the beginning, the idea of creating a mythological monster interested me. The only instruction I had was that I couldn't see a reference image.

In Aztec mythology, Cipactli is a creature that is part fish and part crocodile, with several mouths. A monster with a voracious hunger, it inhabits forests and marshy places.

I was ill in bed for three weeks, so I had plenty of time to think about this brief as I was able to do little else! Nevertheless, this unusual situation served me well.

During my "spare time", while watching a documentary about wild animals on TV, I got a wonderful idea. I thought, why not draw the creature as if it were really alive? Why not pretend that I am a nature photographer, who accidentally discovers this being in the wild forest?

The idea was to try drawing this picture as if it were a photo I had taken while hiding, so that the beast wouldn't be able to see me. To achieve a realistic effect I had to do some research online, looking for pictures of animals in the jungle/forest, in order to get the right colors to use for the creature's surroundings and environment, as well as an appropriate atmosphere.

Approach

This time, I will try to show you how to achieve a realistic effect in a drawing, by using textures. The texture of most of my digital paintings is similar to that of oil paintings; they are more pictorial and less realistic. This time I will focus more on textures and less on color.

Many times I have seen some artist's work, where they have inserted photographs together with their drawings, trying to give some realism to the final finish. Usually these drawings don't look good – they look sloppy, and more like a badly retouched photo than a super-realistic drawing.

The problem is how to integrate both drawings and photographs, and when to use textures. Textures are used when:

- We need to achieve something realistic
- For fast visualization, look and feel

Reference

Color pick

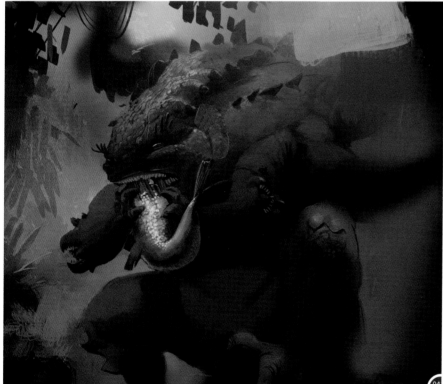

• To give more detail to parts of a drawing
• As inspiration. Many times photos suggest form or assist in composition.

The problem with using photographs is when we abuse them. Textures are there to help enhance an artist's image and creativity, and shouldn't be relied upon to get a good picture.

Photos and Color
The first thing I do is to work on the line drawing. I make several sketches of the creature and finally I keep the improved one (**Fig.01**).

The second step is color. I usually define the floor's base color, starting with the drawing's idea. As Cipactli is going to be in the jungle, the base color will be green (**Fig.02**).

To choose final colors I use several photos that belong to my personal collection. One of the great advantages of digital painting is that we can take the color palette from another image, without having to form it (**Fig.03**).

With this method of application, color can achieve a realistic atmosphere even before the texture is applied (**Fig.04**).

Type of Textures
Once I have defined the drawing palette and have all the elements well-lit, I can move on to the texturing stage.

We can add texture or detail to a drawing in the following different ways:

• Creating brushes
• Using pictures
• Painting repeated shapes

Creating Brushes
We can create brushes from photos, and use those brushes to produce realistic textures and details. This technique is very easy; we just need a good photo, and a clear area of it. What I've done for my image is to find a photo of a lizard and select the scales with a magic wand. Then I've created a new brush and finally edited it using F5 (**Fig.05**).

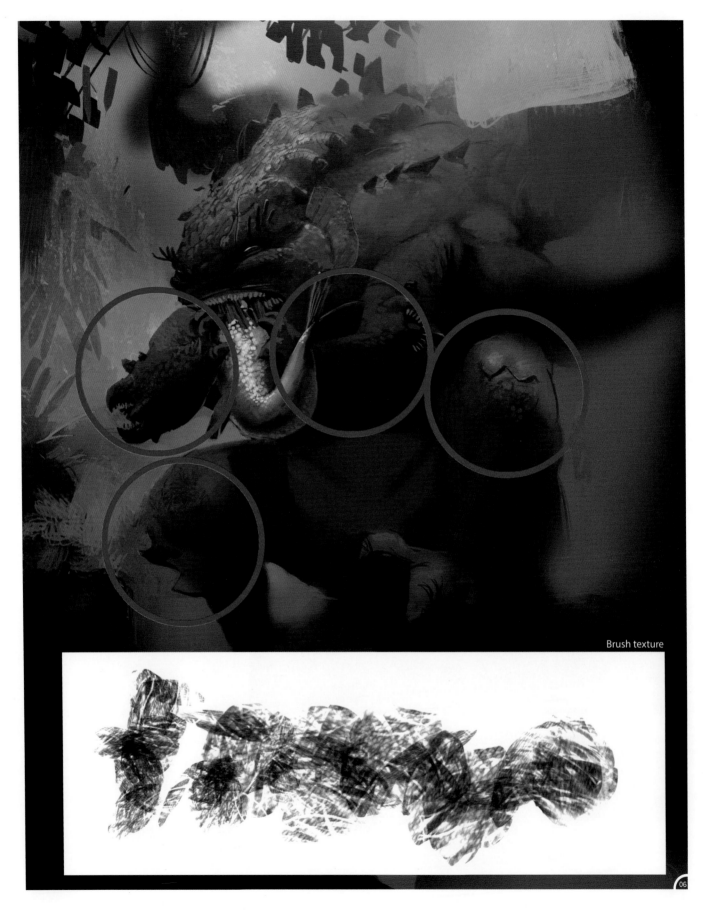

Brush texture

06

With this new brush, I can quickly detail key parts of my drawing (**Fig.06**).

This method is very similar to the one I use to create a brush; the difference is that I cut out this texture and paste it directly onto the drawing (**Fig.07**).

To adapt texture to the picture we can use several tools:

- **Ctrl + T + Curve:** Used to change the image size and make the texture match the form of the target area (**Fig.08**).

- **Ctrl + L:** Used to control light or darkness levels of the picture. It will help us to combine the texture contrast with our drawing.

- **Ctrl + B:** Allows you to match texture color with that of your drawing.

Whenever we use this method we will then use a brush and the Eraser tool to match the texture with the drawing (**Fig.09**).

Using any brush from our brushes portfolio, we can generate textures through repetition. This is hand-made repeated spots or stripes, or attractive shapes. In this case I'm not using any specific tool from Photoshop, just my own hand movement (**Fig.10**).

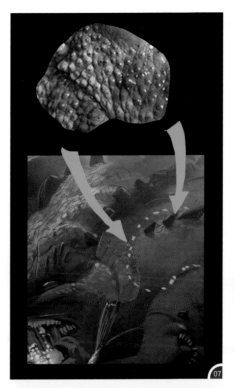

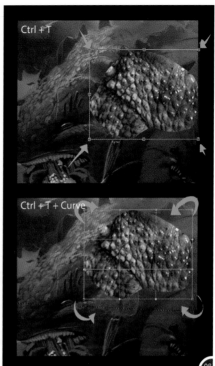

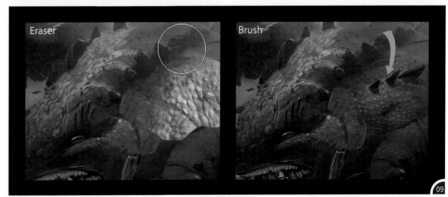

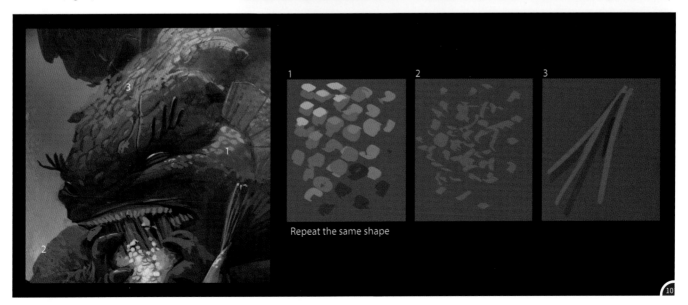

Repeat the same shape

Plants

To obtain an even more realistic environment, I place objects out of focus in the foreground. This makes it look more like a photograph.

I create the leaves in my drawing by using the Lasso tool. I first make a new layer and then, using the Lasso tool, draw the shape of a leaf. With this area still selected, I take a different brush that has some interesting textures and I paint inside this selection. The result is a perfect leaf.

Finally, on this layer, I use the Blur filter, which puts the leaf out of focus in relation to the background image, thus generating much more distance and depth in the image (**Fig.11**).

Water

I draw a pair of vertical stripes in a blue-gray color on a new layer, and then use the Motion Blur filter, to get an effect that will result in a beautiful and realistic waterfall. Then all that's left is to give it final details with the brush (**Fig.12**).

Conclusion

Digital painting today allows us to work quickly and in an economical way. We can achieve high levels of realism in a short period of time. It can also allow us to adapt to any editorial or visual format and make changes almost in real-time. However, it is necessary to know how to use these tools with judgment and not abuse them. We must also understand and take advantage of new technologies, without relying on them.

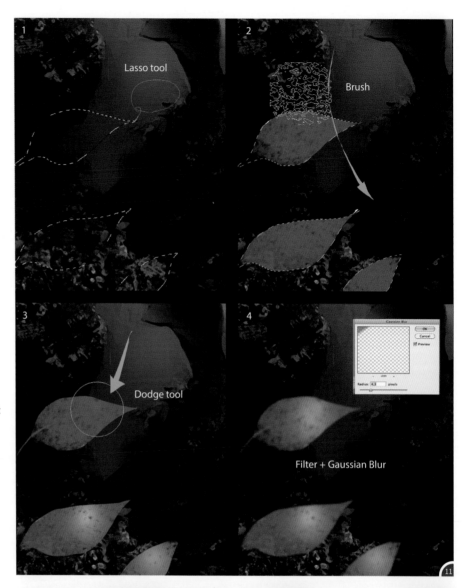

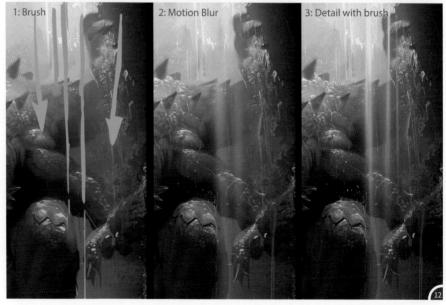

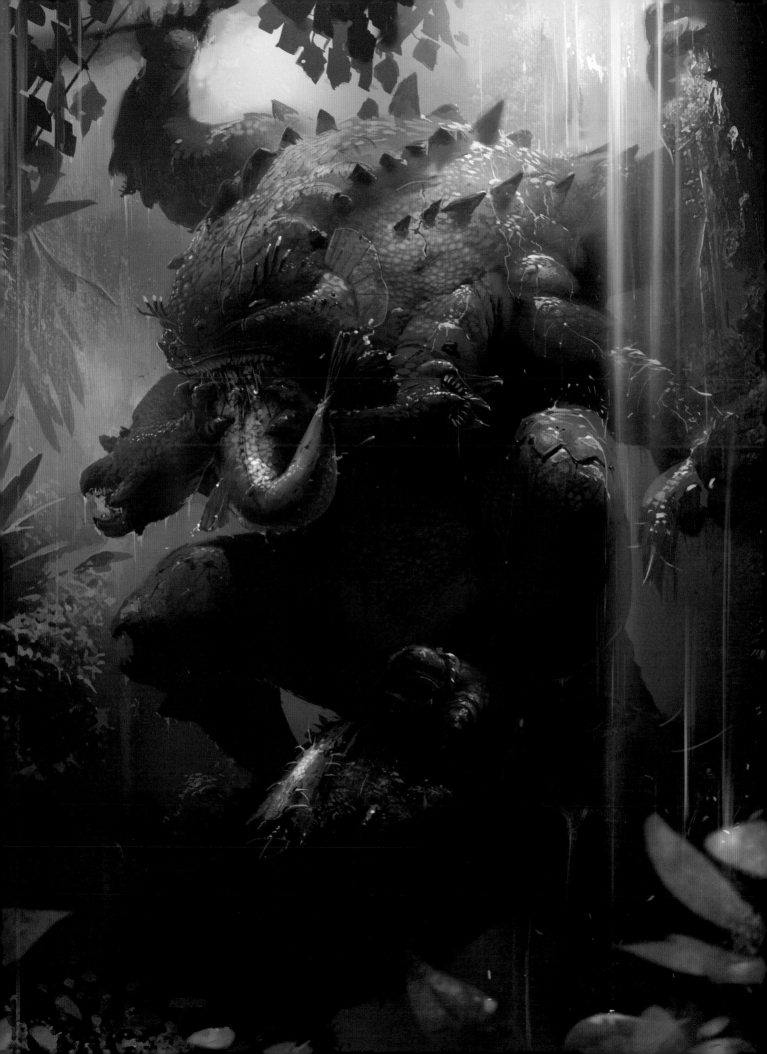

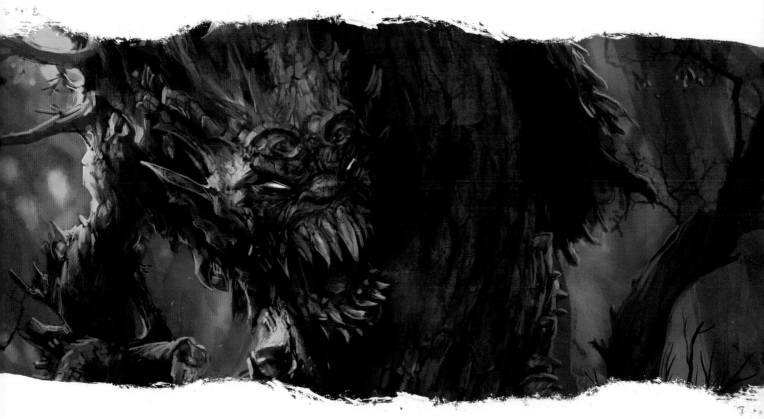

CREATURES FROM MYTHOLOGY | HIDEBEHIND

By Carlos Cabrera

Introduction

Our subject matter in this tutorial is a Hidebehind, which is a nocturnal creature that lives in dark forests. The first thought that comes to my mind is the Ents from *The Lord of the Rings*. The Hidebehind is a creature that hunts lost lumberjacks in creepy forests, but Ents are peaceful creatures. So we're going to take the basic idea of an Ent-like creature and add extra features to transform it into a creepy, nocturnal predator.

Making a Start

To start, create a very rough sketch of the monster in your head. As the aim is to paint an immersing and dynamic illustration, you have to think about the camera angle and focal point. In this case it will be the lumberjack and the second focal point will be the monster with the dark forest as the background.

The first thing we have to do is to think about the color palette. Start by thinking about the

cold and warm colors to simplify the process. In this case, in my image, I've decided on a pale turquoise for the background and a rich green for the monster to keep the colors cool. You may be thinking, why green? The reason I'm using green is because we want the painting to move from cold to warm colors, and green contains yellow, which makes it slightly warmer than turquoise.

OK, so we know about the colors in the background and on the creature, but what about the lumberjack? The obvious choice is warmer colors like the nice orange in fire. This warm area will pop-out of the image and create the focal point we are looking for.

Perspective

So with this in mind we can continue with our sketch. The first thing we need to establish is the perspective and some sort of idea about composition (**Fig.01**). I'm using a triangular composition to emphasize our two big focal areas. One triangle contains the monster and the

forest in the background. The second triangle, which is the same as the other but inverted, contains the creature's head and the lumberjack. Once these two triangles are in place, it creates some further triangles and I decide to place the entire body of the lumberjack in this triangle. It is

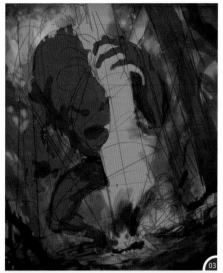

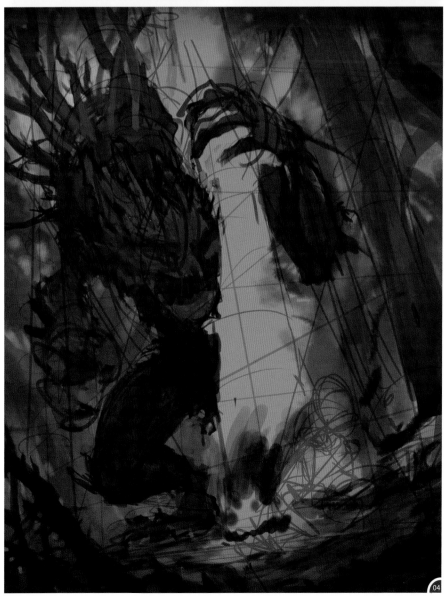

important for you to think about how you would like to view the image when you are setting up the composition of the scene.

Blocking in Color

When the frame is in place it is time to start adding some colors. To start with we can keep it simple by adding the cold and warm areas. As the background is all turquoise, it can be bucket filled. You can see how I have also added the warm color to my painting (**Fig.02**). To start with you simply want to add the ambient color of the warm area, rather than detailing anything.

Adding Volume

When you're at this point, it's time to add some volume to the creature and colors to the floor. Do you remember the ghost with the white mask in *Spirited Away*? In one part of the movie he starts to eat people and convert himself into an abomination with a long neck, heavy legs and big arms. Well that's exactly what I have in mind, as you can see in **Fig.03**. We don't need to add detail here, just big strokes to show how the overall shape works in the scene.

> **Quick Tip:** When using big strokes to establish the overall shape, remember that foreground objects like branches or foliage will be darker or black. The mid-ground objects will be less black and the background will not be black at all. By following this you will achieve a sense of depth.

Developing the Character

At this point we need to continue working on the monster. I think a good idea will be to add branches to his back, which will act a bit like natural camouflage, so he can get close to his prey without being detected. With a round brush, start to add some shadows to his legs and dark spots where the eyes and mouth will be, remembering to keep the features in the triangles that we created earlier (**Fig.04**).

As you can see, you don't need to worry about how it looks. This stage has to be very artistic and fast. Try not to think too much and just try to achieve the feel you want for your image. Concentrate on how the lines flow and the

rhythm of the overall image. If you fill your head with different techniques and worry too much about specific features, that worry will be translated to the image and the viewer will see it without really knowing what is wrong with the illustration. I'm not a great artist and I still have a lot to learn, but I try to enjoy every illustration and translate that emotion to the viewer. Remember to take your time to think through every step before you start and then just let the strokes flow.

In **Fig.05**, you can see a more advanced step. To get to this point you need to keep working bit by bit on your creature. I've developed its head and neck, and given volume to the tree. Although the color in the background looks lighter, it is in fact the same color as it was before. It looks lighter because the creature has more volume and is darker than it was before.

> ❝ I ALSO ADDED SOME MUSHROOMS TO THE TREE TO BREAK THE MONOCHROMATIC LOOK OF THE TRUNK ❞

Some branches carefully placed here and there accentuate the triangular composition that we

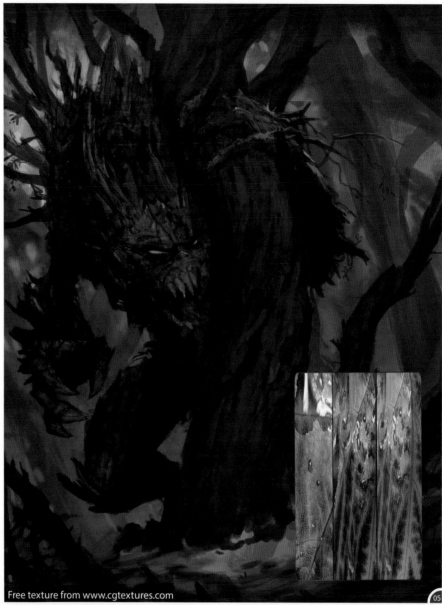

Free texture from www.cgtextures.com

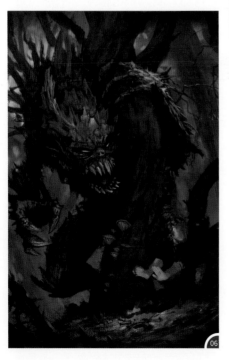

started with. Once you have finished adding the volume to your monster you can start using free textures to add more detail and realism to the creature. Pick a nice wood texture and add it to a new layer set to Overlay mode with a low level of opacity. In Fig.05 you can see where some texture has been added to the creature's leg.

The Lumberjack

Now we have the overall mood created, we can add the lumberjack. We want to use big paint strokes again at this point and avoid getting too wrapped up in the detail. I've also added some mushrooms to the tree to break the monochromatic look of the trunk. I drew these

in reds and oranges as I thought they would look great next to the campfire later (**Fig.06**). Here you can see how the lumberjack has a clear silhouette made from color with almost no detail at all on him yet.

To accentuate the cold background, I've painted the lumberjack sitting next to a fire. This kind of thing adds story and interest to the image, as the viewer will be able to see that it is a cold, nighttime scene.

Adding Interest

At this point it is a case of continuing to work on the character and adding more detail. It is

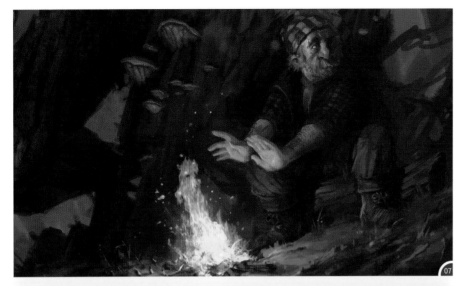

important to continue developing the image as a whole so you can also work on the branches that were being burnt on the fire. You can also add some photo elements like the photo I've used for the fire. I've added the photo and adjusted it to Screen layer mode.

> **Quick Tip:** It is handy to remember that whenever you are adding fire, explosions, blast or areas of light to your image, it should be done in Screen mode. Textures like rock, wood, etc are best applied on Overlay or Multiply.

You can also use Color Dodge to add light, but you would need to do it at a quite low opacity. Don't try to paint all the light on a character or in the background with Color Dodge, as it will look awful and very digital! Try to paint it in Normal mode and use these kinds of tricks in the final stages. In **Fig.07** you can see how a simple image of fire in Screen mode, and an orangey color set to Overlay, give our lumberjack a nice, finished campfire.

We are almost finished at this point. The detail on the image looks good and if we were to add any more detail, the image would start to look over-saturated. At this point, it's good to change some of the stuff than may have been bothering you from the beginning. For example, I'm not happy with the creature's face or hands in my image – they look cool, but not scary enough! – so I update them. The hand doesn't look as if it is resting on the tree either, so I change that too (**Fig.08**).

The nose looks a little strange as well, so I change it for a more human-looking nose. If you think about it, he has got hands, legs and a face, so it makes sense to give him a human-looking nose.

On the forehead, I put some strange symbols to add some mystery. Now it looks more creature-like and less like a tree!

Lighting
This final stage is very important! The painting is looking good so far, but there is something missing. Maybe it's detail, or maybe we need

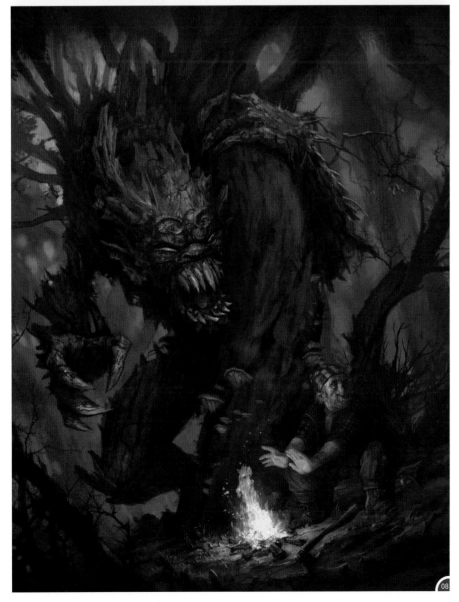

more characters in the scene? It is very easy to think that the problem at this point is detail, but it's not – it's the light! We need a secondary light, which is a light that comes from the environment or something in it. So far all we really have is the ambient light, which is a turquoise color, and some glow from the fire.

At this point you need to pick the brightest color from the background, add a little white to it and add some light to the tree and mushrooms (**Fig.09 – 10**). Don't be afraid to cover some of your detail with this color; your image will need this kind of light. You can see how quickly it has improved my painting. It really makes the monster pop out of the background! The same sort of lighting can be added to the lumberjack as well to separate him from the background.

This is starting to look good, but there is still more to be done. The same effect would be caused by the campfire. So at this point we need to do the same as we did with the other light: pick a lighter version of the color of the fire and add it to all the surrounding elements, like the tree, mushrooms and the creature. This stage is extremely important to do. If you forget to add this kind of "cinematic" light to your scene, the illustration is going to look unfinished.

Finishing Touches

You may decide at this point that you want to add more textures to the scene (**Fig.11**). Here you can see the texture I've used to add a little more detail to the trunk. I've also added some sparks coming from the fire.

> **Quick Tip:** The important thing to remember is this order of doing things: composition, color, volume, detail and secondary light. If you follow these steps carefully, your paintings will start to look better and your process will become faster.

Thanks again for reading one of my tutorials. I encourage you to follow these simple steps and paint at least one monster to test these fun Photoshop techniques. Over and out!

Free texture from www.cgtextures.com

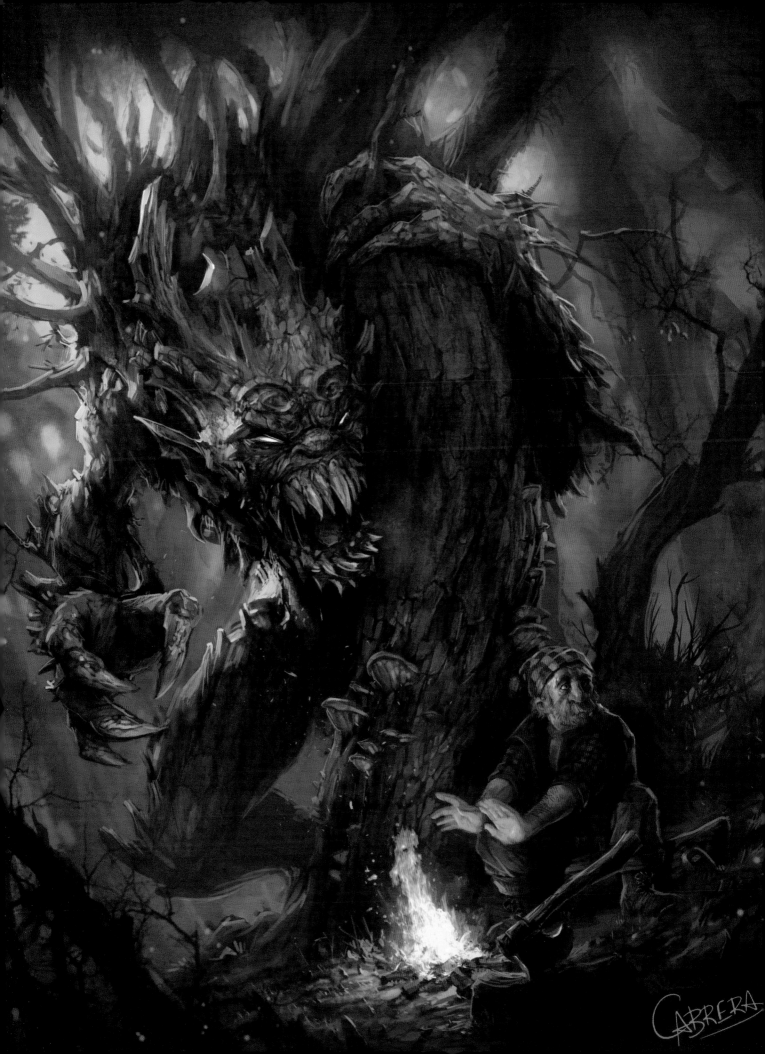

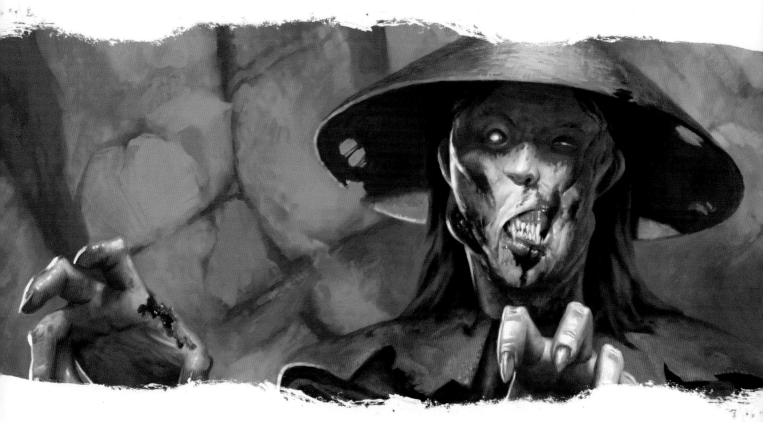

CREATURES FROM MYTHOLOGY | JIANG SHI

By Simon Dominic

Introduction

A Jiang Shi is a type of vampire zombie from Chinese folklore. According to legend, the Jiang Shi rests in a coffin during the day, or hides in a cave, and then comes out at night to terrorize the local community and seek all types of warm-blooded prey. When it catches its quarry it absorbs their life essence, or *qi*. In typical

zombie fashion it holds its arms outstretched when it's hunting, although it's also rumored to hop everywhere, which is not typical zombie – or vampire – behavior.

Defining the Artists' Oils Brush

I use two basic brushes for most of my paintings. The most important one to me is the Artists' Oils brush, which I use in combination with paper grain to produce an authentic oil painting effect. The most important thing is to link the Opacity with an Expression setting of Pressure. I set the value of the Opacity to 100%. For Grain I use a mid-range value as this maximizes grain appearance with Artists' Oils (for some reason the effect decreases again as you increase from 50 to 100%).

For the Artists' Oils specific settings, I set Amount to 100% and have high Viscosity and low Blend. Bristling and Clumpiness I set fairly high and Trail-off very low at 4%. I work with Wetness at 100%.

For this and all my brushes, I tweak the brush-specific brush calibration settings in the Brush Calibration panel so that I get a full range of pressure settings, from feather-light blending to hard lines (**Fig.01**).

The Circular Brush

My second basic brush is the circular brush, which is simply a grainy soft cover brush with 100% Opacity linked to Pressure. I set the Grain value very high as grain works as expected for this brush variant. I link both Resaturation and Bleed to Pressure and set them medium-low. This allows for blending at low pressures and solid paint when the pen is pressed harder. Again, I spend a little time tweaking the brush calibration settings to make sure the brush performs optimally. Dryout I set very high to prevent my strokes from running out of paint (**Fig.02**).

Painting Concepts

I roughly sketch a couple of color concepts using the Artists' Oils brush. One character I have in

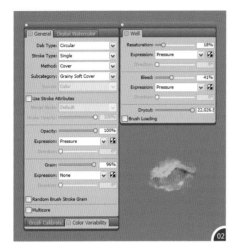

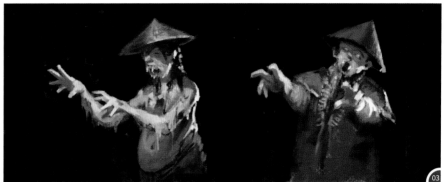

semi-profile and the other is reaching towards the viewer. At this stage I'm not bothered about detail, just overall composition. I decide that I like the latter pose best as it provides the best involvement for the viewer (**Fig.03**).

Choosing the Face and Head

My character concepts are quite small, so I decide to do some separate concepts for the face. I spend about 10 minutes on each with the intention of picking the most appealing and using it as a base for my final character. I decide to go with option B in the end. I found A too miserable, C was too devious, D looked more mentally challenged than vampire and E was too reptilian. I included F because he makes me laugh (**Fig.04**).

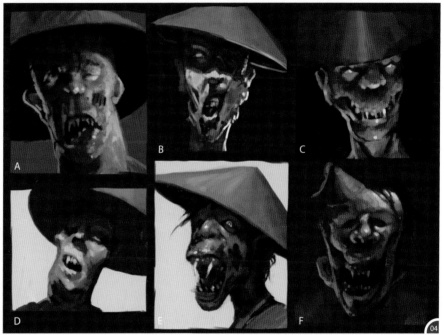

Beginning the Painting

Before I start, I collect some references. I also find a couple of photos of traditional Chinese clothing and an excellent Chinese hat. In order to get a reference for the hands, I take a photo of myself in a similar pose to that of my concept character and then use Smart Blur to remove all the distracting detail. I create a canvas of 700 x 967 pixels and, loosely referencing my collected images, sketch the initial outline of the Jiang Shi using a dark Artists' Oils brush. It has next to no detail at this stage and represents just the basic pose (**Fig.05**).

Rough Color

The next stage is to add rough color using the Artists' Oils brush. For my concepts I used a limited range Color Set palette composed

of orangey reds, but for the actual painting I'm going to pick colors as necessary from the Temporal Color Palette, which I have assigned to the \ key for ease of use.

> **I MAKE THE SHADOWS MORE DESATURATED THAN THE DIRECTLY LIT AREAS, TO ACCOUNT FOR LIGHT REFLECTED FROM THE GRAY-BLUE WALLS OF THE CAVE**

I choose a hue contrast between my character and the background, which is a rocky cave wall. This makes him stand out and hopefully appear to be reaching for the viewer. Again, details

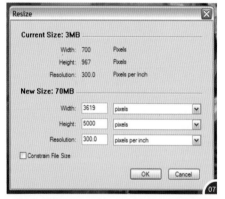

aren't important right now, but in addition to the composition I'm now looking at defining my character's form via light and shadow. In this case his hat is particularly integral to producing that effect, as the shadow it casts over his eyes and forehead gives solidity and form to the focus of the piece – the face. It also portrays a more sinister ambience rather than having the whole head lit uniformly.

I make the shadows more desaturated than the directly lit areas, to account for light reflected from the gray-blue walls of the cave. This has the added advantage of providing some linkage between the character and the background. Contrast is good, but if it's overplayed the result can end up looking pasted and flat (**Fig.06**).

Resizing the Image

I'm going to work fairly large in order to be able to easily add fine detail, so I resize the image from 700 x 967 pixels to 3619 x 5000 pixels. It's very important to keep the aspect ratio (X vs. Y) the same to avoid stretching and distortion. When resizing upwards it also blurs your brush strokes, but that's fine because I haven't yet added any detail and any blurring will be painted over later in the process (**Fig.07**).

Making a Start on Detail

If you've read any of my other tutorials you'll know that I don't have any sort of strategy for which parts of the painting to detail first. Sometimes I'll begin with the background, other times with the focus and often I'll just jump

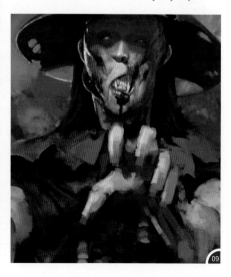

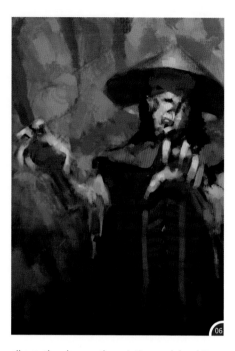

all over the place on the painting, and do a bit here and a bit there until it's all done. For no particular reason, I'm starting on this piece with the face. The rough brush strokes I've added have already taken the face in a pleasing direction. I accentuate the mottling on the cheeks and around the mouth, and tweak the blobby nose to make it lopsided and distorted. As for the mouth itself, in the rough brush strokes I can see a crooked toothy grimace onto which I further define fangs, exposed gums and taut skin (**Fig.08**).

Zombie Clothing

Once I've got the face looking broadly as I want it, I zoom out to about 33% and have a play around with the zombie's garments. I have a small black and white photo of a guy in traditional Chinese robes, so I use this to inspire some ideas about what the Jiang Shi is wearing. The photo is too small and blurred to make out any details, but that's OK because I'm painting the Jiang Shi's clothing as very ragged and disordered, as you'd expect from a vampire zombie. Because of this I can get away without making the clothing functional and instead build it from folds, creases and swathes of ragged material (**Fig.09**).

Little Touches

I add a bit of embroidery to certain parts of the creature's robes, and a few other intricacies too. I

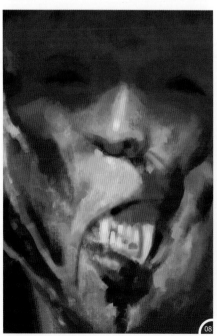

make sure I keep these areas localized otherwise the clothing would appear too fussy (**Fig.10**).

Painting the Arms and Hands

When painting the hands and arms, I keep my reference photo handy so that I can keep checking my painting against the pose.

> **Quick Tip:** One important point to bear in mind is the direction of the light source and where your painting elements are situated in the space. Combining this information will give you the position of your highlights and shadows.

It's not necessary to try and paint shadows with ray-tracing accuracy, but they need to be roughly in the right place for the painting to read right. Using the Artists' Oils brush I refine the hands and arms, using saturated oranges and yellows for directly lit areas and desaturated oranges for shadows (which look blue when viewed against the saturated colors). Because the Jiang Shi is undead I add some areas of decomposing flesh to the arms. Of course, you can get plenty of references from Google, but personally I prefer to paint it from my imagination (**Fig.11**)!

Smoothing the Skin

To add fine details, I zoom in to 100% and use my circular brush. Using a hard pressure on this brush produces dense lines, whilst a lighter pressure blends existing paint. I also use a third brush for blending only, which is a copy of

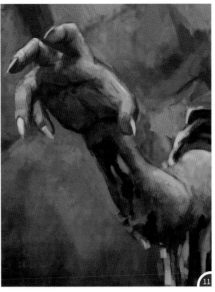

my circular brush, but with no saturation. This allows for a smoother blend and should be used sparingly to avoid an excessively digital, fuzzy look (**Fig.12**).

Spicing Things Up

It's a good idea to make sure all your main elements are present as early as possible, but small changes can be made any time. In this instance I decide that because this guy's hand is looking a bit smooth and ladylike it could do with some roughening up. I take a chunk out of the fleshy part near his thumbs, being mindful to add a variety of reds and a couple of tiny white highlights to make the wound authentic-looking. I also add a few more wrinkles to the skin using the circular brush (**Fig.13**).

Rim Lighting

To add impact I indulge in a bit of fancy lighting by imagining a bright, localized light source to the left of the image. This provides some stark rim lighting that helps define the form of our Jiang Shi. I use this technique sparingly because it can easily make objects appear flat (**Fig.14**).

Artistic License

Strictly speaking, the lighting on both hands should be identical. However, because the creature's right hand (on the left as we see it) is pointed towards the edge of the painting and his left hand is nearer the focus (the head), I accentuate the lighting on the left hand and decrease it on the right. This has the twin effect of drawing the viewer's eye to the focus, whilst

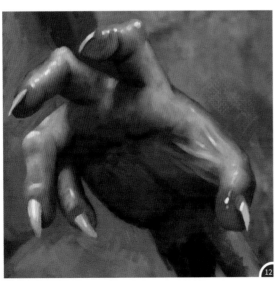

not leading the viewer's eye out of the image via a bright element close to the border (**Fig.15**).

Using an Overlay Layer

The focus of this piece is the head area of the creature and, to some extent, its upper torso and left hand (on our right). I decide to boost the saturation and value of the Jiang Shi's head and for variation, I use an Overlay layer. I create a layer using the Layers panel and set it to Overlay. Then I set the saturation to 50% and with a high value, saturated orange, I make light strokes across the sunlit areas of the face and head. I'm careful not to include the shadow because I want the shadow to remain dim and under-saturated. When I'm done, I drop the layer to the canvas and continue as normal (**Fig.16**).

Final Clothing Detail

At 100% zoom I tidy up the Jiang Shi's clothing. As I mentioned previously, it's not particularly functional and it wouldn't win any fashion design prizes, but overall I think it works as intended. I add a couple of buttons in amongst the tattered strands of material and beef up the embroidery a little so that it catches the light on the uppermost sides of creases (**Fig.17**).

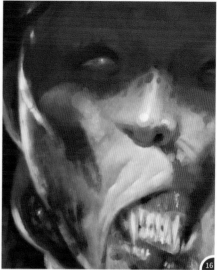

The Background

So far I've done very little to the background since my original small color sketch. Because I intend this to be a portrait painting, the background need be nothing more than a suggestion of environment. Legend has it that the Jiang Shi often spends his nights in a cave, so I've gone with a generic rock texture. I keep the fine detail to a minimum and use hopefully just enough to convey the location impression I'm after, whilst not overpowering our main subject (**Fig.18**).

The Straw Hat

The Jiang Shi's hat in this instance is made from a straw weave. Happily I don't need to paint a thousand strands of straw in order to make that clear. Instead, I suggest the texture by lightly sketching a number of long, horizontal and shorter, vertical lines. I paint the horizontal lines

so that they follow the lateral ellipse of the hat shape, and the vertical lines so they converge at the apex. I am always aware of where my light source is coming from, so I adjust the value of the paint color accordingly (**Fig.19**).

Applying Finishing Touches

A quick appraisal tells me that it's almost finished so I leave it for a few days and come back to look at it with a fresh perspective. I enhance some of the detail, mostly around the arms and upper clothing, and also adjust the color balance a little in order to bring out the contrasts (**Fig.20**).

The last thing left to do is to resize the image down to its specified dimensions and save it as a 300ppi TIF.

That wraps up this tutorial and I hope you enjoyed it.

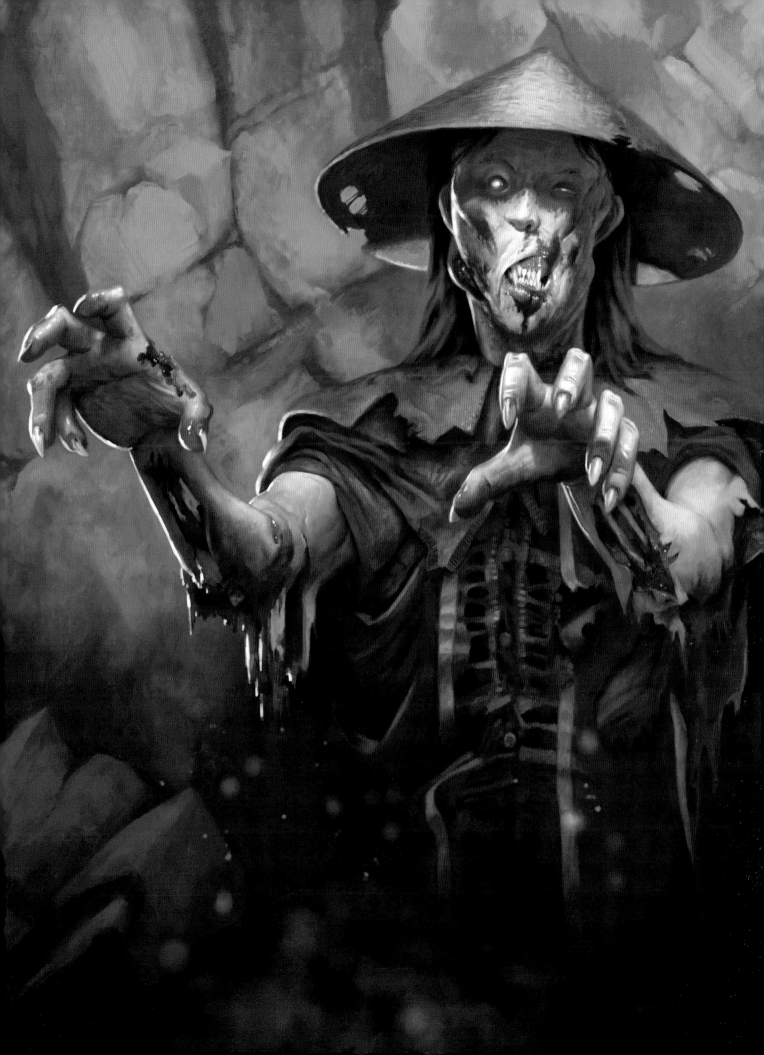

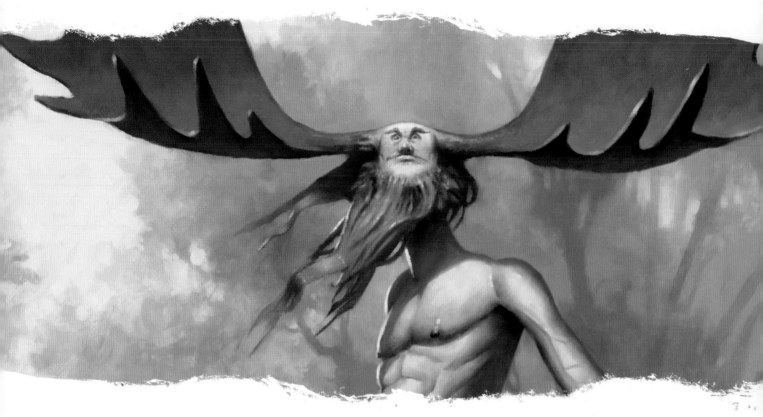

CREATURES FROM MYTHOLOGY | LESHY

By Simon Dominic

Introduction

The Leshy is a forest-dwelling creature from mythology that is able to change size from the smallest blade of grass to the tallest tree. He appears in the form of a pale-skinned man with green eyes and a beard made from grass and vines, and is sometimes rumored to have a tail, hooves and horns. The Leshy is the friend of other forest denizens and is often depicted in the company of bears or gray wolves. Because his official title is Lord of the Forest he carries a wooden club, presumably in case anyone disputes it.

I'll be using Painter 12 to illustrate the Leshy in his native habitat. I did wonder whether to show the Leshy in miniature form, but I think that would make him too ineffective-looking, so instead I'm opting for full-on giant mode.

Concept Sketch

I quickly sketch several representations of the Leshy, with his grassy beard, hooves and club.

Earlier I browsed some horned animals on the web and considered what different types of horn would look like. Goat and oxen horns would make him appear too demonic and bull horns too mundane, so I go with moose antlers, which fit in well with the woodland environment. To simulate a pencil I use a circular brush set to

Grainy Soft Cover, with pressure-dependent Opacity set to 100% and 95% Grain. The grain setting allows me to give that characteristic charcoal roughness when I boost the contrast of the paper settings. I also sketch in some bright highlights to help give the concepts dimension and form (**Fig.01**).

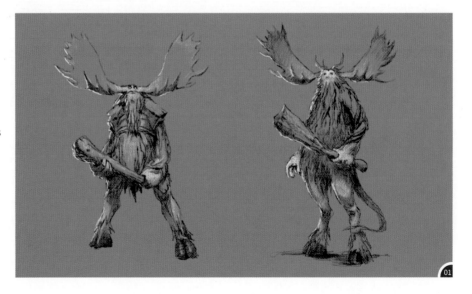

> **❝ I decide that despite my initial sketch appearing okay, the Leshy strikes me as too human looking, more like an old bloke with a green beard than a mystical Lord of the Forest ❞**

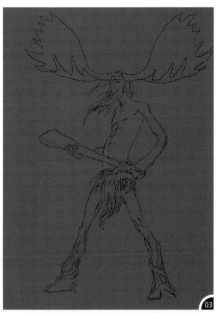

Color Concept

I then paint another concept of my chosen character, this time in color. I paint it small and quickly, taking about 10 minutes. The idea with the color concept is that it gives me an impression of how the finished image might look in terms of color and composition. I decide that despite my initial sketch appearing okay, the Leshy strikes me as too human-looking, more like an old bloke with a green beard than a mystical Lord of the Forest. For that reason I go back to my sketching and create another concept, this time depicting the Leshy as thinner and less human in appearance (**Fig.02**).

Outline Sketch

I collect a few reference photos to help me with key areas such as the Leshy's pose and the forest floor. Next I create a 1448 x 2000 pixel canvas in a low value color. I don't like starting with a pure white canvas as I find it a bit dazzling and also it prevents me from adding highlights in the sketch stage.

On this new canvas I create a layer onto which I sketch my new, slim-line Leshy, referring to my character reference to get a general idea of the torso anatomy and the hand positions when gripping the wooden club (**Fig.03**).

Filling out the Sketch

Once I complete the outline sketch in black pencil, I add areas of shadow. I don't press too hard as I want the texture of the paper to show through. The final sketch stage is to create another layer above the sketch layer. This is my highlight layer. I switch to white and sketch over the areas that are affected by my primary

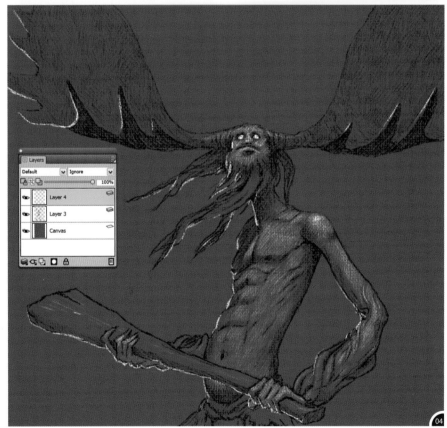

light source, the sun, which will be above the character and slightly to its right (the left as we see it here) (**Fig.04**).

Creating a Palette

After taking some time to browse my reference photos, I now create a color palette. I display

my Mixer palette, clear it and dab onto it a new selection of colors based on the most prevalent colors in my reference photos. I have decided my scene will be damp and misty, so I keep most of my colors in the mid to low saturation range, whilst ensuring they cover a full range of values (light to dark).

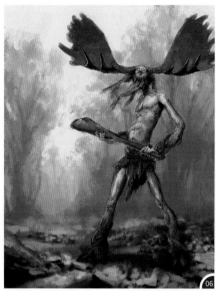

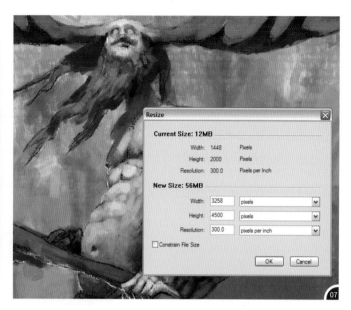

When I've got the basic colors down, I use the New Color Set From Mixer Pad option in the Mixer panel menu. This gives me a number of swatches in my Color Set Library panel, some of which I delete to keep the size manageable. I won't be sticking strictly to these colors, but they do give me a good base on which to start (**Fig.05**).

Blocking in Colors

Still working at a relatively small level (2000 pixels high) I apply color directly to the canvas beneath my two sketch layers. So now I have the canvas, which is blank; layer 1, which contains the color; layer 2, which has the black pencil lines on it and layer 3, which has the white pencil highlights in it.

I make the decision to have my Leshy standing in a woodland clearing, so that he doesn't get lost amongst the trees (or get his antlers caught; I guess that's why he finds it useful to change size). As he is very tall in his current incarnation, I paint the horizon line close to the bottom of the canvas. This gives the impression that he is towering above us. As a general rule, characters that are the same height as the viewer will have their eyes in line with the horizon no matter how far in the distance they appear, assuming a flat surface.

In the foreground I slop some bright and dark colors to represent rocks. The middle distance

is dominated by grass and bracken, with the odd clump of weeds and a mass of brambles thrown in for good measure. The nature of the vegetation may well change further down the line, but right now my priority is covering the canvas with paint to give me a representative base from which to go forward.

The forest itself is represented by the looming shapes of trees, painted using desaturated greens and browns to suggest distant objects on a misty day. The trees are too far away to explicitly detail all but the largest boughs and branches, so I use blobs of a lighter value to represent the networks of smaller twigs. In order to avoid the forest looking like a solid mass I dapple the edges of the tree forms with dabs of sky color, which gives the effect of individual clumps of branches through which patches of sky can be seen (**Fig.06**).

Resize Up

Once the color is blocked in I resize the image upwards whilst retaining the aspect ratio, so 1448 x 2000 pixels become 3528 x 4500 pixels. This is larger than my final image will be because I like to work at this size in order to easily paint fine detail. Zooming in to 100% now reveals a mess of textures and paint blobs. This is good; if it wasn't a mess I'd start to worry.

The textured, random nature of these brush strokes and blobs is very useful when painting

vegetation and other non-ordered subjects. The human brain is not particularly good at inventing believable organic shapes from scratch, but it is very good at finding patterns in randomness or semi-randomness. The messy brush strokes provide good stimulus from which embryonic clumps of grass, rocks and branches can emerge (**Fig.07**).

Painting the Forest

Using an Artists' Oils brush with 50% Grain, I add detail to the background forest. I use value as a method of communicating depth, with trees nearer the viewer being of lower value than those further away. I keep my strokes relatively loose so that they don't overwhelm my main character with detail. Also, I make sure my brush stokes aren't too sharp, for the same reason (**Fig.08**).

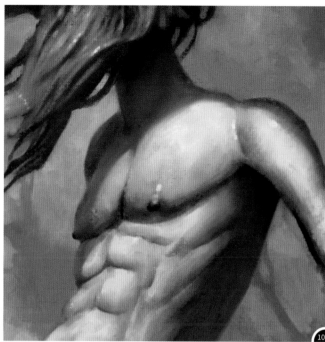

Suggesting Branches

Against the outer edges of the paint blobs representing the branches, I etch lines of sky color. This gives the impression of branches being present without my having to laboriously paint every one of them. I allow some of the original texture to remain in the main body of the tree, smoothing it over very lightly with a blending brush so that no pixelation remains from the original up-sizing (**Fig.09**).

Creature Detail

I now move on to the creature itself. I tend to add detail to a blocked-in color image using a three-stage process. First, I use the Artists' Oils brush to further define the forms. The grain in the brush gives a nice textured effect and the pressure-dependent opacity ensures that a soft touch will blend the strokes (I always advise that in the General panel you set your Opacity to Pressure).

Quick Tip: A good tip when using Grain with Artists Oils is to set the Grain at around 50% because, oddly enough, increasing it beyond this value starts to decrease the effect.

For the next stage, which is the very fine detail, I'll use my circular pencil brush with added Bleed and low Resaturation. I only use this in the areas

that need extra detail so I don't go over the whole thing again. Lastly, I use a blending brush to subtly merge similarly colored areas of paints in areas that need it. I'm very careful not to blend too much and to leave sharp boundaries where necessary (**Fig.10**).

Leshy Limbs

The arms and legs of my Leshy are composed partially of mossy roots that merge into the flesh of the forearms and shins. I paint these vegetation areas with darker greens, browns and reds. In order to give the impression of dark coloration rather than shadow, I include some specular highlights – little dots of bright paint reflecting the main light source (**Fig.11**).

Painting Antlers

I loosely reference the shape of a pair of antlers from a photo of a moose, simplifying and modifying them a little. The lighting in the photo does not match that of my image so I need to understand the shape of the antlers. The lower portion curves towards us and back up to point at the sky. The central and rear portion curves more gradually upwards, passing through the vertical and, right at the tip, curving back just a little towards us. When we combine this with the position of our light source it gives a deep shadow underneath the lower points contrasting

with the bright surface above. The shadow increases with height as the antler becomes more oblique to the light. Along the edges of the antlers I add thin lines of highlight and shadow to show thickness; otherwise they would look like they're made of paper (**Fig.12**).

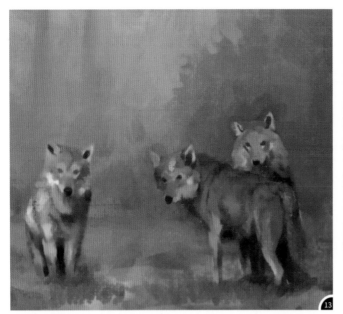

Just Add Wolves

According to the myth, the Leshy was often in the company of bears or gray wolves. I go for wolves and after I find a couple of reference images I paint three of the animals into the background using the small circular brush. I avoid using dark colors because the wolves are in the middle distance and therefore affected by the misty atmosphere. Because they are so far away we can't make out the grain of their fur so I use a mottling, blended effect to portray their coats (**Fig.13**).

Mossy Rocks

In a damp environment like this rocks are likely to have moss on them.

Quick Tip: One useful tip for painting moss is to initially paint it using very dark colors, then partially cover them with brighter greens.

This helps give the impression that the moss has some thickness and is not just green paint smeared over the rock. For the rocks themselves I use a combination of the Artists' Oils brush and circular brush again, the latter used primarily for detail. I set the color variability on the circular brush using the Color Variability panel. I set Hue, Value and Saturation to 18%, 1% and 1% respectively. This has the effect of a pronounced mottling of the hue (the color), and a slight variation of value (light and dark) and saturation on each brush dab (**Fig.14**).

Vegetation

The painting of vegetation can be approached in many different ways. This time I use the basic textures and colors already down on the canvas to sketch a dark, random mass of shapes representing grass, brambles and leaves. There are already a variety of shapes and patterns present from my initial coloring and these help with the impression of tangled foliage. With my blender brush I smooth this paint so that it appears out of focus. This is the background for my actual vegetation, which I paint on top using mainly brighter colors and sharper strokes. I use some reference for the different types of plant, e.g brambles, but I take care not to add too much detail to any particular area.

Appropriate Detail

As the vegetation gets further away the detail decreases until it fades into ill-defined areas of color. When combined with the color fading this gives a good impression of depth and it ensures that our main character stands out against the background (**Fig.15**).

Finishing Off

As is customary, I leave my image for a day or two then come back to it to see if anything else needs doing. I apply a bit more detail to the Leshy's face and blend some background areas that I had missed before. Last of all I save a copy of my image in TIF format at the specified size of 2480 x 3425 pixels. I ensure Resolution is set to 300ppi so that the image can be printed if required. That concludes the tutorial and I hope you've enjoyed reading it.

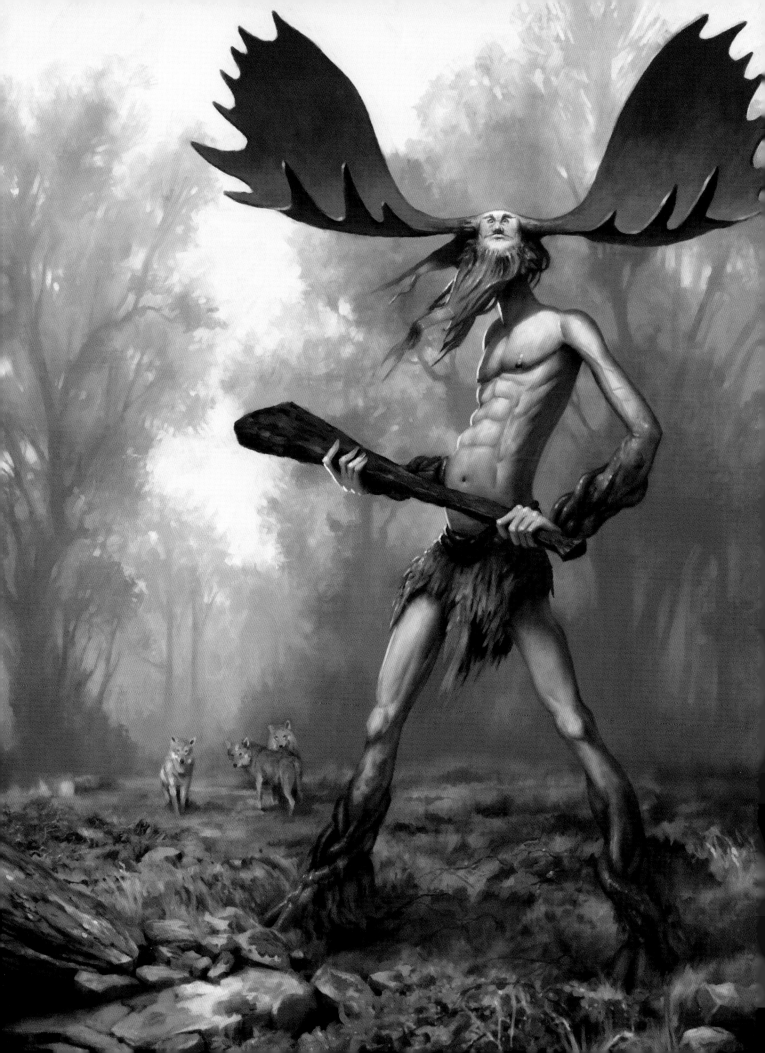

CHARACTER PORTRAYAL | CHILD
By Jason Wei Che Juan

Introduction

A good initial sketch will make a more successful finished piece, and save time for corrections later. The initial sketches can help us figure out composition, value, proportions and even facial expression. I believe it sets an important foundation when creating a nice portrait.

First Sketches

Initially I usually focus on the structure of the face and the facial expression. Here are a couple of initial sketches; the first one was from my imagination (**Fig.01**). The second and third was from my own photo references.

There are several key differences between the structure of an adult's face and a child's face. When a baby has just been born, their facial features are not as strong as an adult's. The eyes, nose, and mouth are very smooth and round, and the cheeks are much plumper. As for the proportions and the relation between the features, they are much closer on a child

than they are on an adult. For example, a child's forehead is large, and their noses are small and very close to the eyes, which in turn are very big in relation to the size of the head (**Fig.02**).

Another key difference is that children's heads are bigger in comparison to their bodies than those of adults. You will see in **Fig.03** that their shoulders are smaller when they are younger

and they get wider as they get older. The picture only shows the difference between a young child and a young teenager, but you can see that as they get older their shoulders will grow faster than their heads, their facial features will become more angular and linear, and will slowly get bigger, and their forehead will no longer be as large in relation to their features.

I started with three initial sketches of the child's face and since the third option was the most interesting one, it is the one I decided to develop into a finished portrait painting.

Color

Once the value and the proportions were in place, the color could be applied (**Fig.04**). I used the HSB (Hue, Saturation, and Brightness) color system to fill in the color. I tend to apply the value range between 30-70%, and the saturation is usually lower than it should be. I like to use Overlay layers in the same way as you would if you were glazing traditional media, which means I can add more and more color on top until I am satisfied with the result. It is important to keep the value the same throughout the painting; if you don't, the image will look inconsistent (**Fig.05**).

I then went on to add shadow to the face. I started by adding a dark value and shading the face as if it were a sphere, since that is the most similar shape to a head (**Fig.06 – 07**).

In general I like to use the same brushes from the beginning to end, but sometimes I use airbrushes on a larger area. I always try to keep a little bit of texture on the canvas, even in a very smooth area like the child's skin (**Fig.08**).

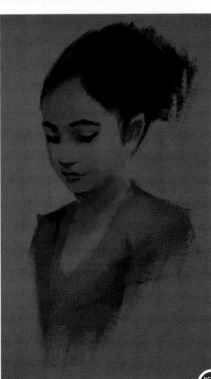

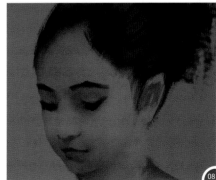

Fig.09 shows the different stages of development of the mouth. As you can see, when shading you can occasionally lose the proportions that were in the initial sketch. This is why it is important to try to keep to the areas that you want to shade, as you don't want to lose the shape that you liked when you started the painting.

Shading

There are several techniques that you can use in Photoshop when shading. The techniques I use are to use clipping masks, Soft Light and Overlay mode. Clipping masks help us keep the edge quality, regardless of the brushes we use and the strokes we paint. Soft Light and Overlay layers help us to add the value gradually without losing the existing layers of the painting. There isn't a great amount of difference between painting a child's face and an adult's, apart from the fact that a child has slightly smoother skin, and this should be considered. A child wouldn't have wrinkles or folds of skin like an adult might.

Adding Detail

Once you have added shadow to your painting, the next step is to refine it and add more details (**Fig.10**). Adding details doesn't mean painting in more features or adding hair lines; it is about defining and demonstrating the actual shape of the nose, mouth, eyes and cheeks more precisely.

Adding more color to the face is also important. I added more colors to the ears and nose as they are more reddish. I did the same with the eyes as they can be quite red, especially on children. They usually have red cheeks too. When you add color it is more like changing the hue and saturation rather than changing the value. At this stage the face should be solid, which means the rest are just icing on the cake.

Finishing Touches

Fig.11 shows an oil painting I did a couple of years ago. There are benefits to all the different media you can create art with, and the cool thing about Photoshop is that you can take any picture and merge it into your current painting.

I flipped this painting and rotated it 90 degrees to use it for the background (**Fig.12**). As you can see, the portrait became more interesting, and started to feel more vivid and fun to look at.

> **Quick Tip:** Once you have created a lot of paintings (regardless of the media) you can combine them into future paintings to make something new and interesting.

Fig.13 shows step-by-step how I painted the jewels that I added to the painting.

The last thing I did to the painting was balance all the elements, including color, value and detail.

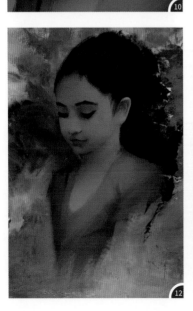

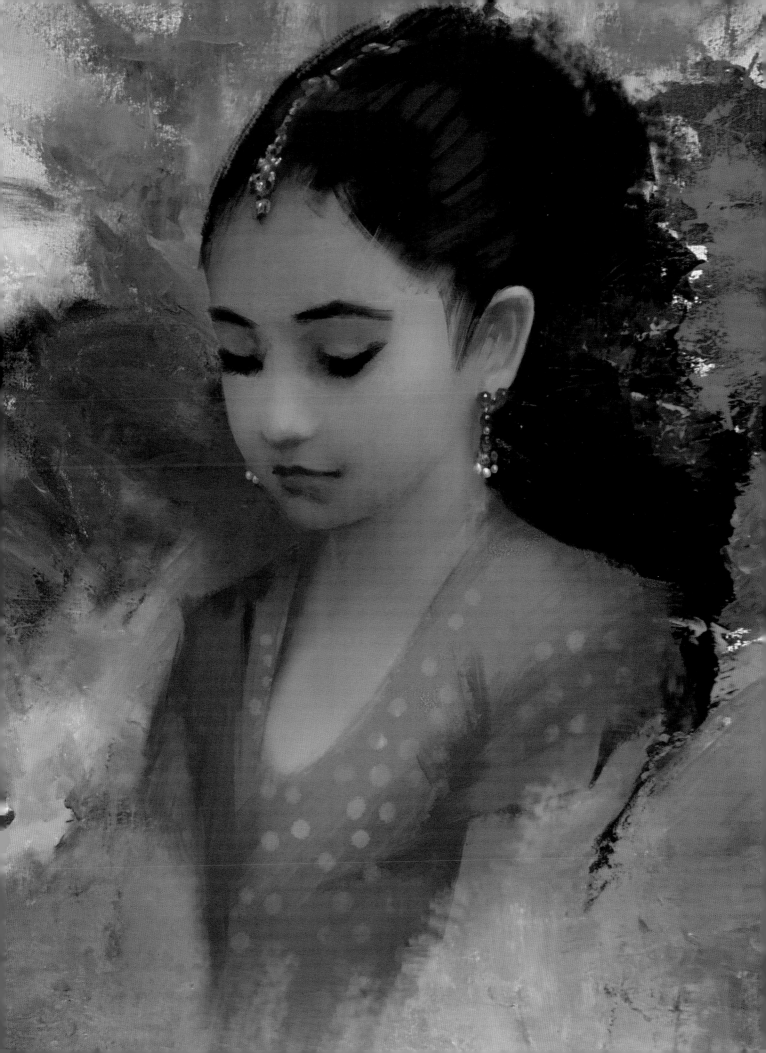

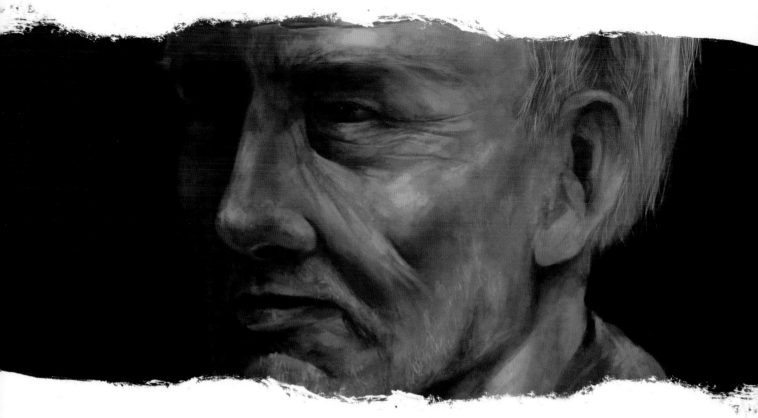

CHARACTER PORTRAYAL | OLD MAN
By Richard Tilbury

Introduction

I chose the subject of an old person for this tutorial as, in many ways; they have the most interesting faces. Their faces often show the history of their lives and are full of character compared to a younger person. When you look at older people there are certain aspects that help define their age, most notably the increased number of wrinkles and the loss of the skin's elasticity, which is particularly noticeable around the eyes. Other obvious signs are also a thinning and graying of the hair. Of course, every individual is different with some appearing more gaunt as they age and developing more pronounced bone structure, whilst others may perhaps have more folds across their face and less in the way of finer wrinkles.

One thing that is often noticeable is that older people seem to have bigger ears. This is due to the fact that these never completely stop growing and is why ear lobes appear larger in the older generation. Aging is caused both by a natural degenerative process and external factors ,such as exposure to the sun or smoking. However, for the purposes of this tutorial we will assume our character has aged naturally and not been affected too much by sun damage.

Blocking In

I often like to paint my characters on a different layer to the background as this gives me the opportunity to experiment with the color scheme throughout the process without affecting the main subject. The first step is to establish the rough composition and block in the shape of the character. I created a background layer using a neutral gray and then blocked in the portrait on a new layer above this.

Fig.01 shows the first stage, which was done digitally in Photoshop. The tonal range can be seen in the upper left corner, showing the darkest through to the lightest values with the mid value being used to block in the main shape. I decided initially that the light source should

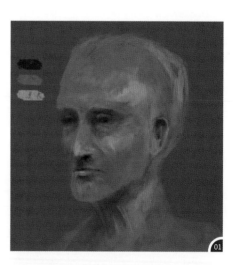

come from the right-hand side and so focused the highlights accordingly.

I used a textured chalk brush during this stage and in fact, throughout the entire painting process – this can be seen in **Fig.02**. I always make sure that the Opacity is set to Pen Pressure as it affords the most control when using a graphics tablet.

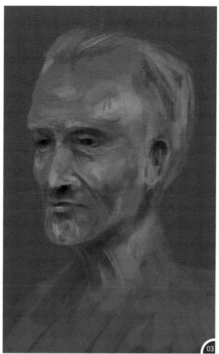

Using the same brush, I continued to build up the face. At this stage I was unsure about exactly where the main wrinkles would lie, so added some random highlights and shadows across the face in order to experiment a little, and get a better understanding of what he would look like. I also started to create the volume of the hair (**Fig.03**).

I continued to build the detail into the face using the same chalk brush, as well as adding in the clothing (**Fig.04**). The thing to remember with any portrait – especially with an older person who has more wrinkles and variety across the skin – is that you should never lose sight of the overall volume and light source. You can see in this image that the main shadows are under the chin and nose, as well as the eye sockets, cheek bones and below the bottom lip. In contrast, the highlights are placed on those planes that are nearest, such as the right side of the forehead, cheek and nose.

> **Quick Tip:** If you establish these volumes early on you can then use them as a tonal guide when adding in detail later on.

Adding Color

The portrait at this stage was well underway, despite being a little crude and so it felt like a good time to introduce some color. Sometimes I use color from the start, and at other times I work in black and white as I did here and then add the color on a separate layer. In this instance I created a new layer set to Overlay and then began to paint in a general skin tone (**Fig.05**). You can see the color set to Normal blending mode on the left and the resultant effect when set to Overlay on the right.

The advantage of using this technique is that you can quickly and easily experiment with the color scheme independently. Because the blending mode is set to Overlay it means that the color maintains the tonal range of the underlying layer and therefore enables you to change the color palette with a lot more ease. Usually once I am happy with how everything looks I flatten the layers, but during this early phase it can prove quite useful.

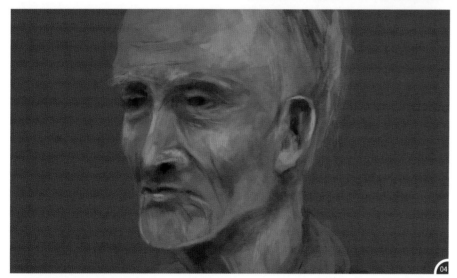

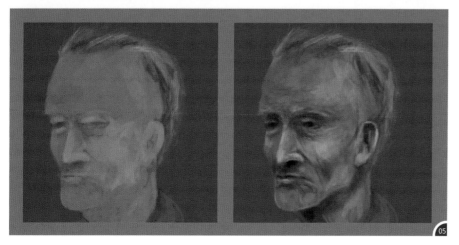

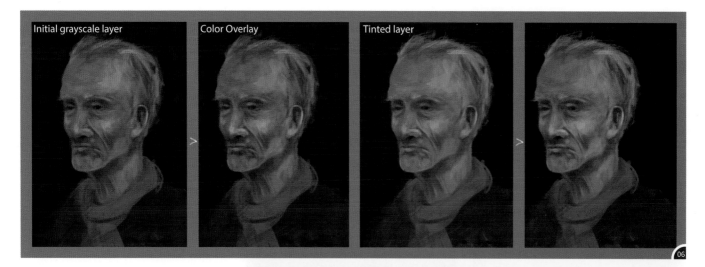

Initial grayscale layer | Color Overlay | Tinted layer

After trying some variations by way of Image > Adjustments > Color Balance, I decided to experiment by duplicating the grayscale layer and tinting it towards a warmer hue to see the effect. This seemed to add more life to the skin tones, which I preferred, and so I left this layer intact. The initial layer with the color overlay can be seen in the left two images in **Fig.06** and can be compared to the tinted layer on the right.

I was quite happy with the color scheme at this stage and so started to refine the details. For the purposes of this tutorial I kept these on a separate layer set to Normal blending mode. **Fig.07** shows the layer at the top of the palette (called "refinements") and the resultant effect in the right-hand image.

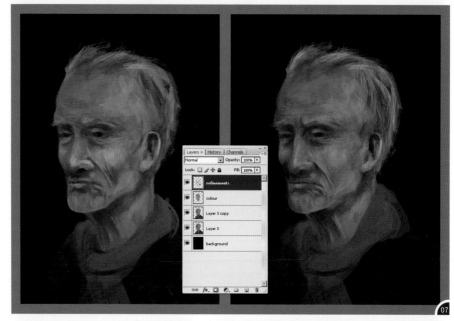

These refinements blend the various parts of the face and smooth out the tonal range, as well as add some definition.

Fig.08 shows a further stage where I have added in some more color variation to the skin and painted in some cooler values around the chin to suggest stubble. I have also accentuated some of the highlights around the nose, cheek and forehead.

At this point I thought that the head was looking a little elongated and gaunt, so I decided to use the Warp tool to change the proportions. First of all I flattened every layer except the background and then went to Edit > Transform > Warp (**Fig.09**).

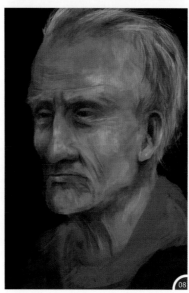

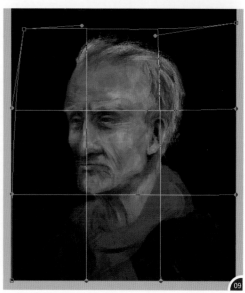

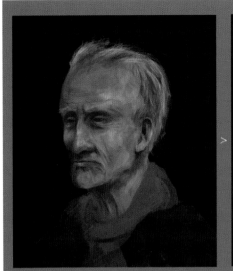 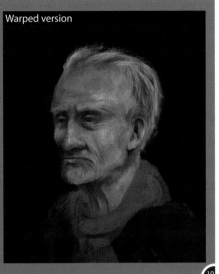

Warped version

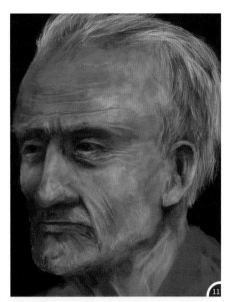

I compressed the head slightly, then copied and pasted the eyes onto a new layer and made them slightly larger using Edit > Transform > Scale. I then used a soft-edged eraser to blend them in with the head and flattened the two layers (**Fig.10**).

With the shape of the head looking a little less gaunt now and the skin tones at a reasonable stage, it was time to work on the hair a little more. When it comes to painting hair I find that the best way is to use a very small brush (1-3 pixels wide) and simply paint in the individual hairs using repeated strokes.

I decided to add a new layer for the hair detail, as well as the stubble, in order that it could be changed or edited with the eraser. **Fig.11** shows this layer at the top of the Layers palette.

Final Stages

The portrait at this point was reaching the final stages, but as the subject orientated around age I thought it would be interesting to give it a quality similar to an old photograph by way of a vignette and some weathering around the edges (**Fig.12**). I used a textured brush to create a border using a pale brown, which I then made semi-transparent by turning the Opacity down to around 60%. You can see what this layer looks like on a white background (1). I then added a vignette layer (2) which was set to Screen blending mode at around 50% Opacity. When the

two layers are combined they look similar to the main image on the left.

I wanted to increase the contrast between the light and dark areas across the face, and liked the notion of the left side of the head almost blending into the background. The fact that part of the face could be shown to disappear into shadow seemed to suggest a transient state, which suited the subject. To do this I went to Layer > New Adjustment Layer > Levels (**Fig.13**). I altered the Output Levels by moving the white slider towards the center (red arrow), thus darkening the entire character.

Adjustment layers automatically incorporate a mask, which appears as a thumbnail in the Layers palette (outlined in red in **Fig.14**). The mask is initially filled with white and shows the adjustment layer, but by painting with black in the actual mask you are able to reveal the layer below – in this case the lighter version. The left image shows the mask from within the Channels palette (red area) and the final effect on the right. The red area reveals the original layer (shown in black in the small mask thumbnail) whilst the white area shows the Levels adjustment.

You can paint into the mask using black and white, and therefore alter it at any point without

Overlay at 47% Opacity

Multiply at 70% Opacity

affecting the original layer. This enables a non-destructive form of editing, which is very flexible.

I added one further adjustment layer, which was Color Balance. **Fig.15** shows the settings that were used and how they appeared in the Layers palette on the right-hand side. I used this layer to add a warmer tint to the overall picture by increasing the red and yellow values. Here is a current version of the portrait with the border, vignette and both the adjustment layers (**Fig.16**).

The image was almost complete, but the color still seemed a little subdued, so as opposed to creating extra adjustment layers I opted to use a gradient on a separate layer to add a color wash.

To increase the light intensity I used a pale orange and dragged a Foreground To Transparent gradient from the right side of the

head across to the far left (red arrow – upper image – **Fig.17**). I then set the blending mode to Overlay at 47% Opacity.

To darken the shadows I followed the same technique, but this time chose dark red and dragged the same gradient from the left side of the head to roughly the middle of the right eye (red arrow – lower image – Fig.17). I then set the blending mode to Multiply at 70% Opacity. Using an eraser, I then deleted parts of both gradients to focus the washes more accurately.

You will notice that I also added a Color Balance adjustment layer, which is restricted to the outer edges via the black ellipse in the mask. This simply added a warmer tint to the vignette.

With these final three layers the image could be flattened and then called complete (**Fig.18**).

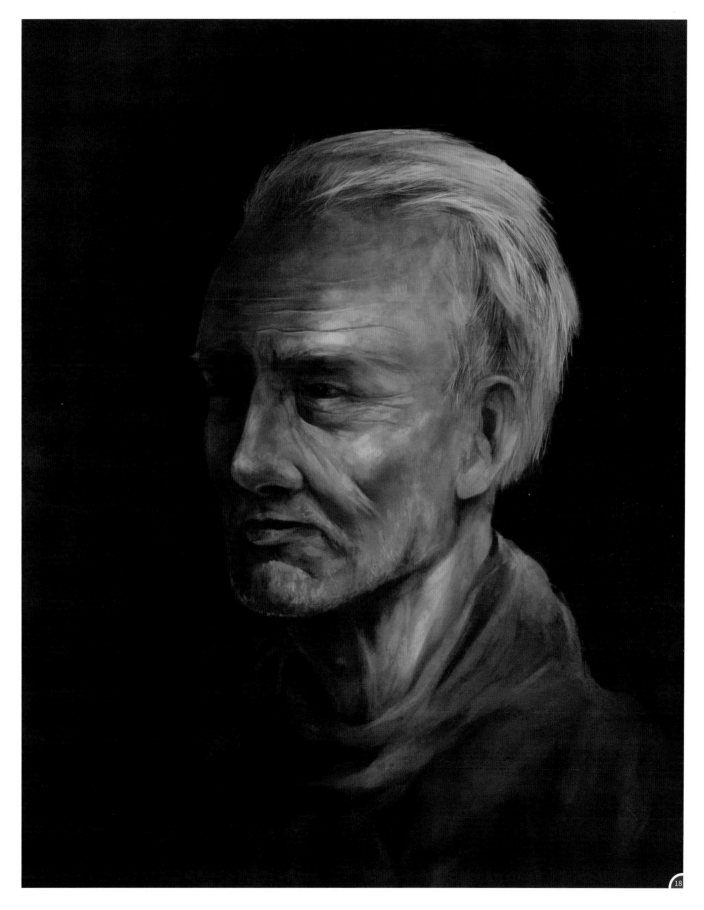

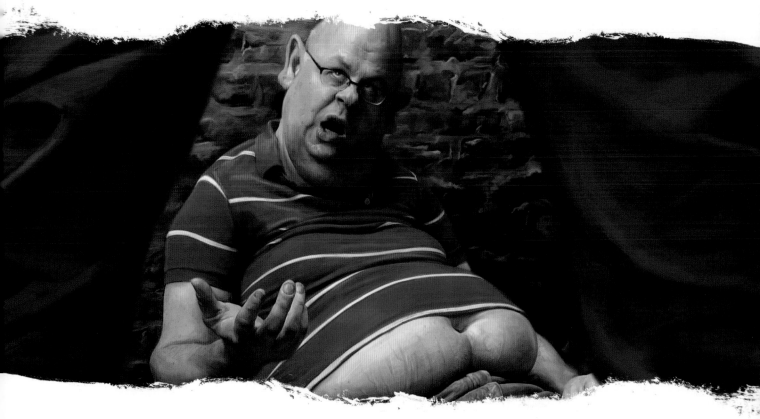

CHARACTER PORTRAYAL | OBESE
By Jason Seiler

Introduction

I've done a few tutorials now for 3DTotal and most have been portraits. This time around, I was asked to share how I would approach painting a person who is obese and what steps I would take. I decided that rather than doing another portrait, I would instead create a character caught within a moment of time.

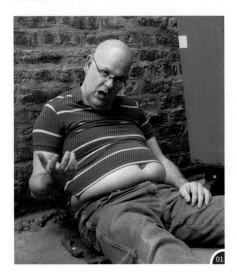

Before I explain my idea for this piece, I would like to first share my thoughts on drawing and painting a person who is obese. To me, painting is painting, no matter what your subject matter is. It doesn't matter if you are painting a thin person or a heavy person; I would approach both in the same way and I feel it would be no different than if I were painting an animal or a vehicle. With all painting, I focus mostly on my values and then, after that, color, harmony, edges and so on. In the end, none of these matter at all if there isn't a solid idea and drawing to build on.

So, the key to "painting an obese person" boils down to your observational skills as an artist. You need to be able to see shapes and understand enough about human anatomy to be able to push, pull and essentially create a believable obese character.

References and Sketches

The first step for me was coming up with the idea. I knew right away that I wanted to paint something dark and humorous. I wanted to create a character and then put that character into an interesting situation. I wanted the final image to look as if I had paused a scene in a movie. I wanted the viewer to look at the image and not know exactly what was going on or who the characters were. For me, not knowing is what this illustration was all about.

To help this idea along, I decided that I would force my viewers to look through the legs of my second character, in order to see my main character. This helped to add suspense, curiosity and humor to the image.

Once I had my idea, I asked a couple friends of mine to model and pose for me. After taking several pictures, I was then able to start my sketch (**Fig.01 – 03**).

Character is very important to me, and I wanted this piece to have a lot of character. I added this by pushing and controlling the expression on his

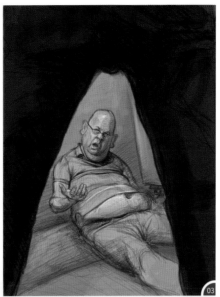

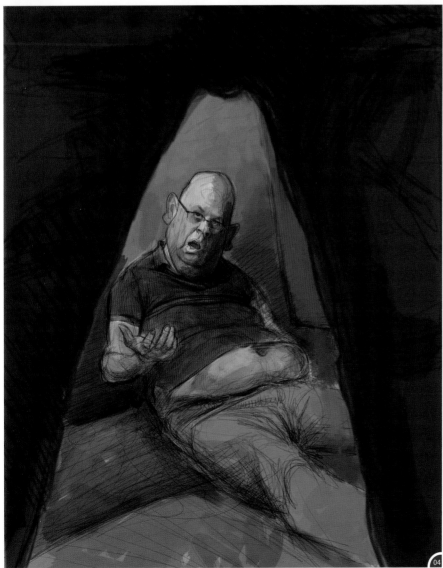

face. In addition to this, I also used his hands and body to express and create personality.

Before I did any drawing at all, I already had a clear image in mind of what I wanted to create. Because of this, the sketch came together fast. There were only a few things that I needed to get down before moving on to the painting. First, I had to pull off the composition that I was imagining in my head, and then I needed to nail down the expression and gesture. When drawing the body, I just kept in mind that I wanted it to "feel" heavy and sluggish.

Knowing that this was a tutorial on creating an obese character, I simply used my imagination to add additional weight to my character's face and body. To do this, it takes an understanding of the human skull and bones. It's important to never forget the framework or foundation within the body. Once I had captured all of the main aspects that I considered important, I was ready to paint.

Starting the Painting

I used Photoshop CS5, and painted in CMYK mode at 300 dpi resolution. For the majority of this painting I used brush #24, which is a standard Photoshop brush, and worked with the Opacity set to 88% and the Flow set to 100%. Before I start any painting, I usually have a look or feeling in mind as far as the colors go. For this painting, I wanted it to be dark and perhaps moody, and thought that the soft flesh on my character would contrast well against a dark and grimy brick wall.

When sketching my idea out, I made sure to do the sketch on a separate layer. When it came time to paint, the first thing I did was create a layer under my sketch so that I could quickly block in color without losing my sketch (**Fig.04**). You can see in my first few block-ins that there is a blue shape to the left of my character (our right). That was going to be the edge of a garbage bin, but I eventually decided that it wasn't important and that it was taking away from the character rather than supporting him, so I got rid of it.

It didn't take long before I began to paint on top of my sketch. I never fall in love with my sketches.

Instead I use them only as a guide to build my painting on top of. So, you can see in **Fig.05** that I started to block in color on top of my sketch.

I always want my digital paintings to look and feel like traditional paintings. When painting traditionally, you can't zoom way in to paint additional details. You can only get so close to your canvas. And besides, a painting – for the most part – is meant to be viewed from a few feet back and the same goes for illustration work that I do for magazines. The viewer looking at one of my paintings in a magazine cannot zoom in to see any details, they can only see what they're holding right there in their hands. So, when I paint digitally, I paint from a distance and I always start by using larger brushes. This helps me block in the painting as a whole. As the painting begins to develop I will zoom in and refine my details using smaller brushes. What matters to me is how the painting looks as a whole. From a distance my final painting has a realistic look to it, but when you zoom in close, you can see how loose I kept it. It's a painting, so I paint it as I would do traditionally.

The beginning stage of any painting can be both exciting and overwhelming. To keep things simple, I never worry about details; instead, I squint my eyes and block in large shapes of color and value, and I do this until the whole piece is blocked in. Once this is done, my values are, for the most part, set and so is my color. I will make adjustments here and there, but now all I have to do is refine my painting.

In **Fig.06** you can see that I continued with my block-in. You will notice that I filled in the pants of my secondary character and I did this for two reasons. First, the darker they are, the closer they will feel to the viewer, and they will help frame and compose my image as well. Second, I like to paint dark to light, so I will later paint into the darker value and color that I first lay down, with a lighter value and color.

I didn't want the jeans of the second character to be too detailed; in fact, I wanted them to be slightly out of focus, again, drawing more attention to my main character. When blocking in

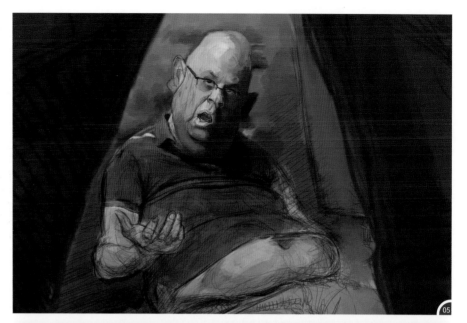

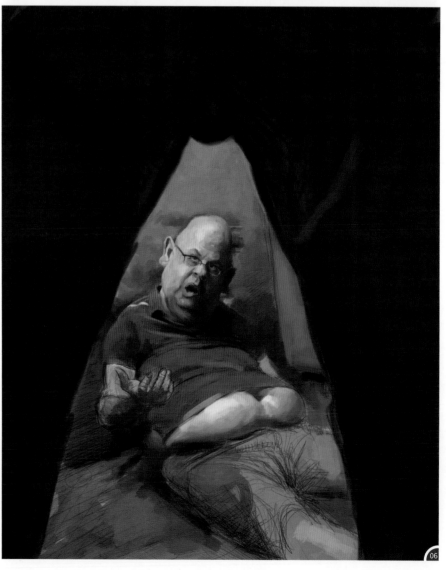

> **IF THE HANDS AREN'T DRAWN AND PAINTED WELL, THEN IT DOESN'T MATTER HOW GREAT THE FACE OR THE REST OF THE IMAGE IS – THE WHOLE PIECE WILL SUCK**

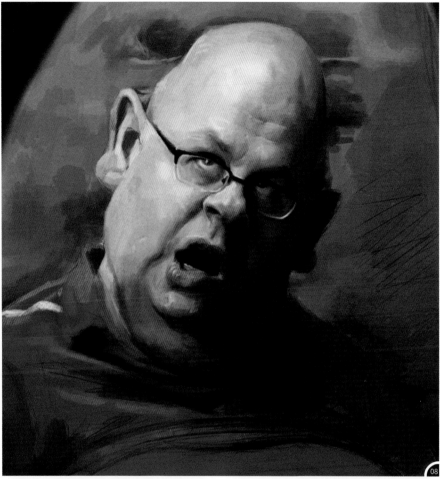

the shapes on the jeans, I decided that I wanted to keep them darker in color and value. My lightest values should be on my main character. So, I mixed a blue-like color, blended it with my black, and simply drew in the folds of the clothing, leaving the dark under-painting only where I wanted it (**Fig.07**).

> **Quick Tip:** It is important when blocking in to not stay in one area for too long. Try to work on the whole painting at once.

Blocking In

Eventually I came to a point in my block-in where I decided I wanted to bring my character's face to more of a finish, so that way I would know what areas I needed to hold back on and what other areas I should detail further (**Fig.08**). You will notice that the blue garbage can is still in the painting. What you are seeing here is the struggle I went through during the creation of this piece,

such as asking myself if I should leave the can or get rid of it. I never stop asking myself questions; always trying to improve on my original idea. Don't be afraid to start areas over and don't be afraid to completely get rid of something if it's not working, especially if it is not improving the quality of your painting.

To me, hands are just as important as the face. If the hands aren't drawn and painted well, then it

doesn't matter how great the face or the rest of the image is – the whole piece will suck. For this piece the hands were an important part of my story. They needed to show a lot of expression and character, so I spent quite a while painting the hands, especially the right one (**Fig.09 – 10**).

I continued with my block-in and slowly began to define form and shape, now blocking in the jeans on my character. As I blocked in my character's

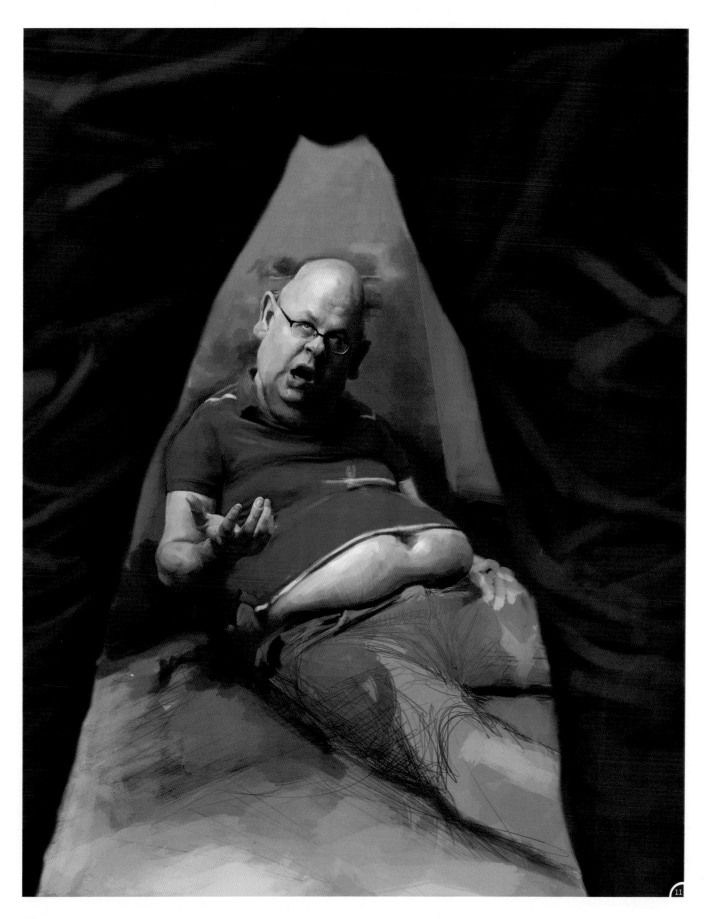

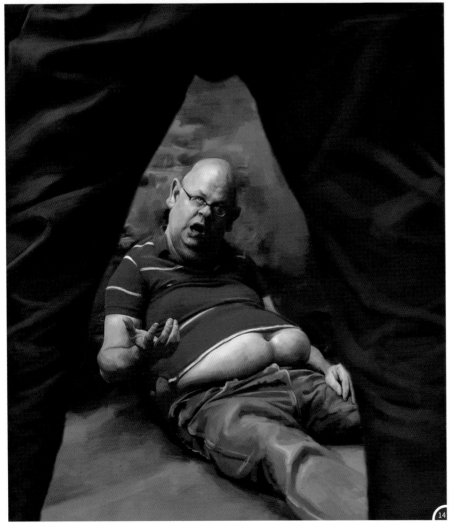

blue jeans, I was also looking at his gut and keeping in mind that the shapes needed to be pushed and formed to feel real. There needed to be a sense of weight, flesh and the material of the jeans (**Fig.11 – 12**).

In **Fig.13** you will see that I started to define the left hand, as well as the overall shape of my character's belly. I also began to paint in stripes on his shirt, but soon realized that I was breaking one of my own rules: save the details for the end. I ended up painting over the stripes and re-working them later on.

Fig.14 shows a real turning point for me. I had taken a couple of days off from working on the painting to work on other jobs that I had. And when I came back to work on it, I was coming back to it with fresh eyes. Immediately, I began to paint away the garbage can – it was distracting and not important to my story at all. Also, the size of my character's head was a little too large and was taking away from the character that I was trying to create, so I adjusted the head size.

The other thing that you may notice is the change in my overall color scheme and mood. I felt my painting was too cool, so I warmed it up by painting a green-ish yellow color into everything. I did this by creating a new layer, setting it to Color and then painting where it was needed.

In **Fig.15** you will see that I made yet another adjustment, again to enhance the character. I felt that the hand would express more of what I wanted if it were larger. If I'd done this painting traditionally, this would have been a huge hassle. This is one of the perks of working digitally – it gives you the freedom to continually develop and improve your original idea. When working traditionally, it's important to plan more and spend more time on your original sketch.

Besides the hand I also continued to develop the belly shape, as well as a subtle blocking in of the bricks behind my character.

Finishing Touches

I worked on the design of the brick shapes, but also continued with the shape and form of my character. I decided quite early on that I wanted stretch marks on my character's stomach (**Fig.16**).

While working on finishing touches in the painting, I noticed a tangent that really bothered me and had to go right away. The stripe on his shirt wasn't actually touching his fingers but it was too close and distracted the eye. So, I simply painted it out and re-painted it higher upon the shirt (**Fig.17**).

To finish the painting, I slowly worked my way to using smaller brushes in order to add the subtle details that I felt were needed. The stomach plays a big part in the story of this character, so I spent a little more time refining the shape and adding details such as stomach hair, moles and freckles, as well as a few more stretch marks.

The bricks were a little more challenging, but I kept my focus on shape, value and color, again not zooming in too far. When looking up close, you can see how loose they really are (**Fig.18**).

There really isn't anything all that different when it comes to painting a thin person verses painting an obese person; it's up to you as the artist to be able to observe and study the unique qualities that make us human.

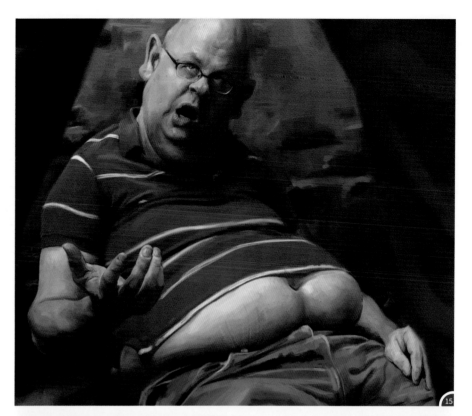

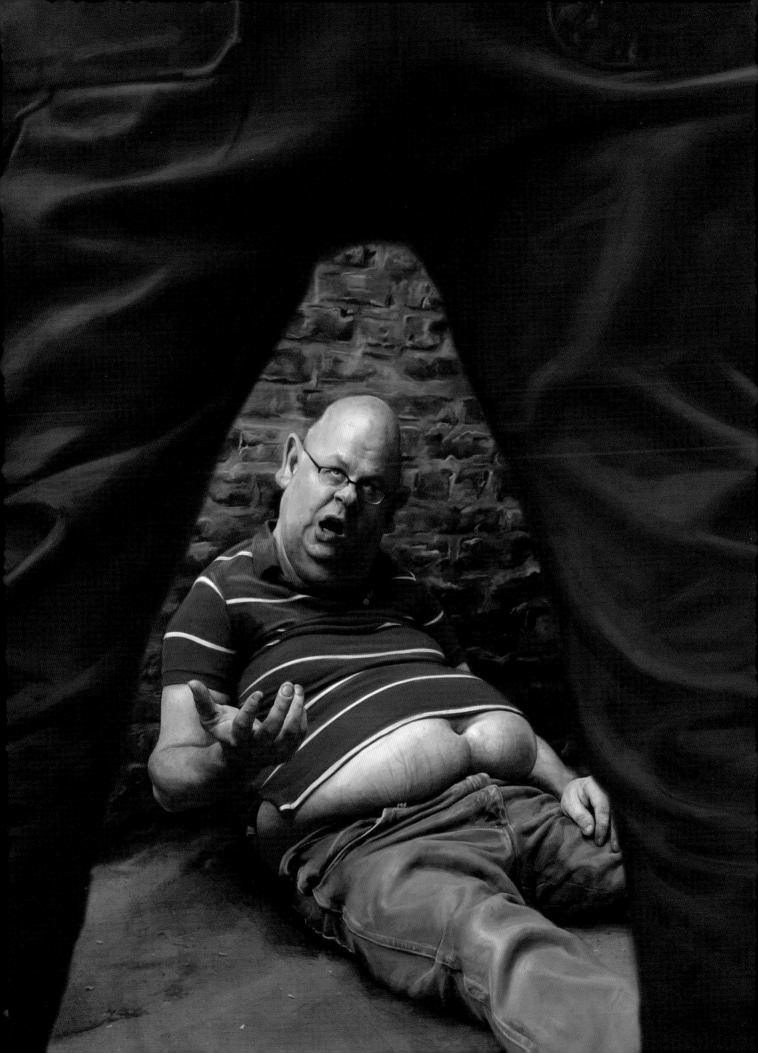

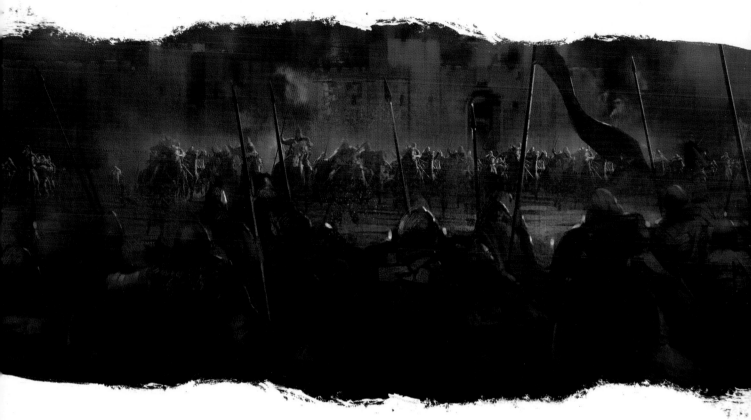

BATTLE SCENES| MEDIEVAL
By Donglu Yu

Introduction

Drawing battling armies might seem like a complex and a tough job that demands a lot of time and energy, however, there are a few tricks that can simplify the whole process.

In the following tutorial I am going to share some of these tricks with you, while I discuss how I researched and sketched out a battle scene image, as well as offering a few tips on finalizing the image.

Sketching the Soldiers

First I sketched out a small group of five to six soldiers with different poses and a range of contrast (**Fig.01 – 03**). It is better to have the groups drawn at slightly different angles, but also coherent in terms of design and sizes if they are put together.

Horses are quite hard to draw, so in order to save some time, I focused on the horses' upper body parts. The legs were partly hidden by the dirt

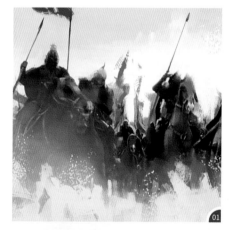

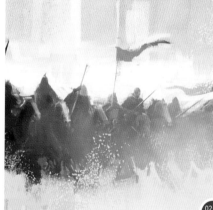

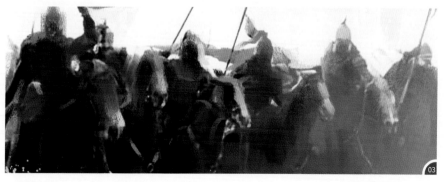

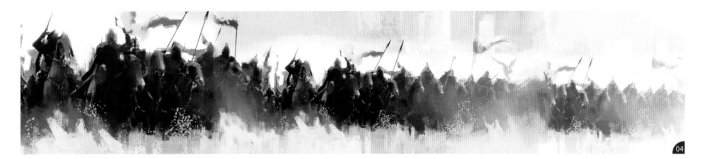

and splashes, so I didn't have to worry too much about them.

As for the soldiers, since this was a medieval scene, it was important to draw certain iconic elements, such as the medieval helmet, spears, flags and metal armor. You don't need too many details to describe your scene to viewers as long as you use highly recognizable shapes like this.

Then here came the fun part. I took the three groups of soldiers, duplicated each of them and blended everything together to form an army (**Fig.04**). I tried to make smart use of the Free Transform tool and painted some fog in to suggest the atmospheric perspective for the soldiers that are further away.

This part took about an hour and half to two hours. Those sketches were not only helpful for the final image, they also gave me the opportunity to warm up and become more familiar with the feel of the medieval period setting and the battle scene.

Sketching the Castle
I knew that I didn't have to spend too much time researching the castle, because I only used it as a backdrop for my scene. However, just for the fun and to warm up, I did three sketches of medieval castles (**Fig.05 – 07**). They all shared strong shapes and were made of heavy stone bricks.

Even though the castles were only in black and white, I was already thinking about my lighting in the final image while sketching them. All the castles were against a lighter sky, which made their iconic shape easily readable. I tried different angles and close-ups of certain areas to see how they were built and the textures on the materials.

Composition
After doing these studies, I felt pretty confident about starting to paint the battle image. Before starting anything, I needed to find a strong composition. This is the foundation of any image; without it, no matter how many hours you spend drawing the details, the image won't stand out.

The most common battle scene is usually of two armies, one running from the left of the canvas and the other from the right. This time, I wanted to try something different. I wanted to have an army in the foreground, running towards the troops coming from the castle (**Fig.08**).

It didn't take too much energy to achieve this composition, because of the studies that I'd done previously. Since there were many more elements on the final composition than the previous individual sketches, I put less detail into the individual components, and focused more on the mood and feel of the battle scene.

I also added some smoke and burning going on inside the castle, to make the whole scene more dramatic and chaotic.

Strong Silhouettes

One thing that really helped to make the composition work were the silhouettes of the foreground army. Not only did they add motion in the scene, but they also played an important role in directing the viewers' eyes right into the center of the image. This point is made clear in **Fig.09**. This image only has two values, black and white, however it conveys tons of information to the viewer simply because of its silhouettes. It shows helmets, flags and spears; it can't be anything else other than an army.

I still enjoy doing similar silhouette studies on my other projects; it helps to keep improving the readability of my paintings enormously.

Painting Smoke

Each person has a favorite way to start the color process; they all work, as long as you are comfortable with the process. I want to focus on how to push the quality of a digital painting and the color nuances, instead of explaining the basics.

In order to save time, I often use photo references and blend them with brush strokes. This is a quick and effective way to achieve a realistic palette. All the areas in red rectangles are areas where photo references have been integrated (**Fig.10**). Below the image is the cloud brush that I used to paint-over and erase the photos.

When using this kind of techniques, it is important to pick a customized brush that shares similar shapes with the smoke, as it facilitates the integration and blending greatly. Feel free to erase certain areas along the way with Opacity turned on; it will accentuate the semi-transparent property on certain areas of the smoke to give it a realistic feeling. When everything is blended, you can paint-over with a lightly textured brush, so the photo will have a hand-painted effect.

Painting Splashes

Since Photoshop brushes are always one of the most loved and discussed topics among digital painters, I wanted to make sure I had some to

talk about myself, so I used two splash brushes on the running horses and the fierce armies. The first was for smaller splatters with tiny dots; the second was for bigger splashes (**Fig.11**). These kind of brushes are also very good for snow, any other dirt effect or blood stains.

When you make customized brushes, they can also be useful on other projects to save time and energy. It is important to keep in mind that they are not only to draw with, but also to erase with.

> **Quick Tip:** Drawing and erasing with the same brush can create a more casual and random effect. Don't forget to have the tablet pen sensitivity turned on; since the brush stroke is a repetition of the initial brush form, sometimes it generates a repetitive pattern in the stroke that you want to avoid.

Highlights

As I continued my painting, I carried the color palette determined by my background castle to

the mid-ground and foreground armies. Even though it looked like that there were lots of things going on the canvas and it was becoming quite a complex painting, it had a very simple recipe behind it. Everything was based on a initial silhouette pass, with material and texture information then added, and finally touched up with some crisp highlights.

As I have already talked about silhouettes and the integration of reference materials, I want to emphasize the importance of highlights. Crisp highlights on edges give information about the direction of the light source, define the shape of objects and characters further, and clearly separate foreground elements from mid-ground or background elements (**Fig.12**).

The last point was especially significant in this scene, because it is always difficult to make a battle scene chaotic, yet easy to read. With the proper use of those crisp highlights, I was able to give a finished quality to the painting.

ArtRage

As I am a fan of ArtRage because of its ability to mimic the traditional effect, I always like to export my paintings to ArtRage, in order to give them a few subtle strokes with the Oil Painting brushes (**Fig.13**). If you do this, make them subtle and use them on mid-value areas where there is no shadow and aren't too many highlights, because mid-value areas are the ones that would most likely pick up light and reflect details.

Finalizing

Since this was a battle scene, there was an easy way to add motion to it: Radial Blur. This can be accessed under the Filter tab in Photoshop (Filter > Blur > Radial Blur). I gave it an amount of about

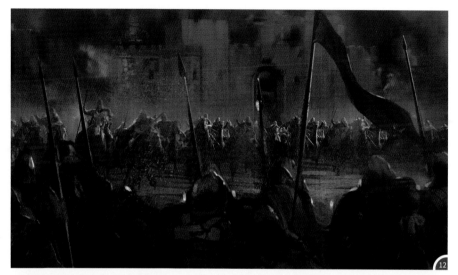

16, selected the Blur Method > Zoom, dragged the Blur Center to where I needed it and clicked OK (**Fig.14**). As you can see, it gives the effect that the viewer is holding a hand-held camera and running with the fierce army towards the battle.

I hope that a battle scene is, now, a much easier subject for you to paint. The secret is not to paint every single soldier; only paint essentials that will

give the impression that there are huge armies out there. After all, viewers won't count how many soldiers you actually have in your painting; they are much more focused on the overall feel of the battlefield. Even if the process of artistic creation is mostly based on inspiration and feeling, there is still a logical recipe behind it that can make the actual execution much easier than you have initially imagined!

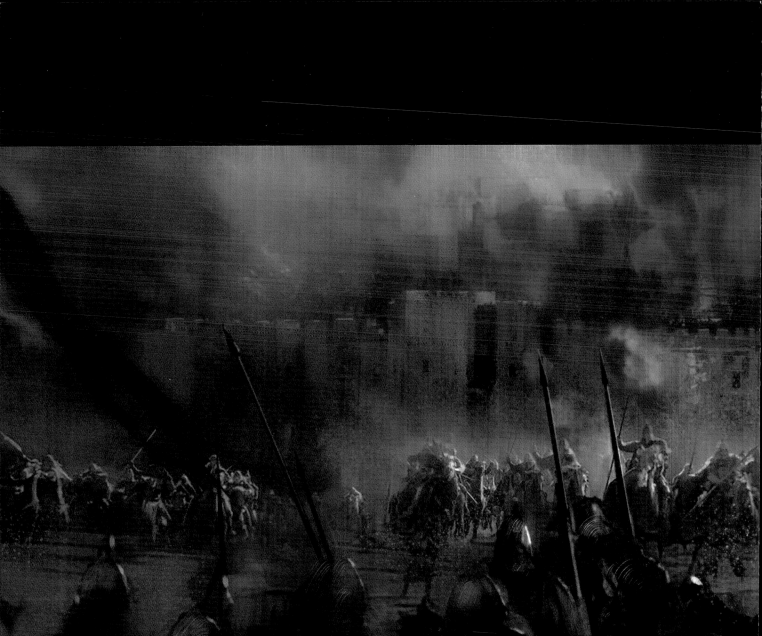

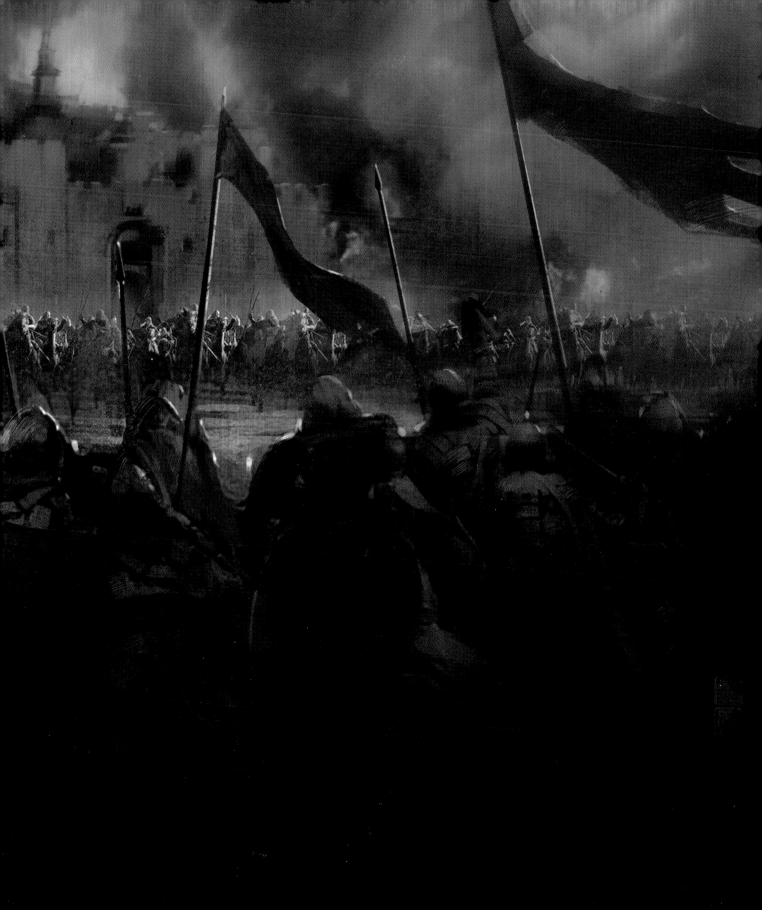

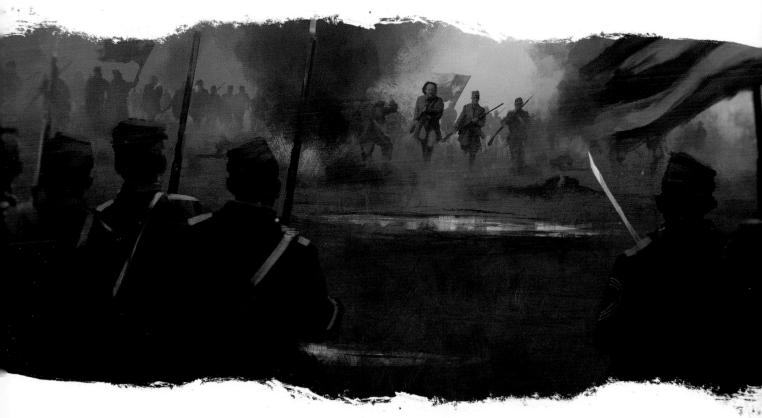

BATTLE SCENES| AMERICAN CIVIL WAR
By Markus Lovadina

Introduction

For this tutorial I was set the task of creating a battle scene from the American Civil War. It's a tricky thing to come up with a battle scene, at least for me, because most of my landscapes are fairly "empty" and show just one character to give a sense of scale. It means doing a lot of research, especially when it comes to a real historical view.

Studies and Research

As mentioned above, when painting a real historical event you really have to do a lot of research. No matter if you do it online or just the good old way – reading a book. Try to get as much information as possible regarding that time, the clothes that were worn, the weapons and every other detail that relates to that specific time. Or watch a movie. Actually there are a bunch available relating to this theme.

Getting Ready

After spending a couple of hours reading books and looking at images on the web, I was in

the mood. The first thing that popped into my mind was that this image was screaming out for a "cinematographic" approach. With all the information in mind and absolutely motivated, I fired up Photoshop and prepared to let my imagination flow.

Background

For most of my images I start to paint in the background, just with pretty rough strokes. I also try to set the color theme at the beginning of every image. I do know that the colors will change during the entire painting process, but

it's good to have a color theme in mind when the first brush stroke hits the canvas. For this image I had something moody and foggy in mind, as I knew this would be a battlefield where a lot of things would be happening, for example, cannonballs hitting the ground, explosions, smoke and gunfire (**Fig.01**).

The colors also needed to suggest an early hour of the morning. Using two different brushes (a slightly square one with textures and a more sparkly one for adding additional textures) I painted in the background. By keeping things loose at the beginning of a painting, I'm able to define the horizon and it allows me, at the same time, to keep my composition open.

Developing the Background Further

Still keeping things pretty loose, I developed the background a tad further. The loose details were made by the same brush I used for the blocking in. I really enjoy this time as you're able to develop the image further and can start to think

about composition, additional elements and what could be done with customized brushes.

For now, the main focus was still the mood and atmosphere. At a certain point, I decided to paint in some fences and ancient canons (**Fig.02**).

Happy with the look and the direction the image was taking, it was time for the characters.

> **THE MORE DETAIL YOU SHOW ON A CHARACTER, THEN THE CLOSER HE'LL BE TO THE CAMERA**

Customized Brush for Characters

Since I knew that there would be tons of characters in this image, I decided to take the "customized brush" route for it. I created a new document and started to paint in rough human shapes – all with different poses, behavior and amounts of detail. Based on references, I used a more grayish color for the characters. The color decision was also based on the look of the Confederate States Army, in order to keep things more historically correct.

The characters differ in terms of detail (**Fig.03**). The one on the left is a foreground character, while the others are used for background purposes. The more detail you show on a character, then the closer he'll be to the camera.

Happy with the look and the knowledge that the characters could be changed to suit my needs during the painting process, I merged the layers.

By using the Hue/Saturation adjustment, I changed the characters to gray values (**Fig.04**). If you'd like to create your own brushes, you have to keep these values in mind: black = opaque and white = transparent. I then added some value corrections to the characters and made a brush out of them.

Painting the Characters

By using the newly made brush, I painted in the first row of characters. The brush was set to Opacity and Scattering. The ones further in the background were simply kept in a grayish tone. I got the color by using the Color Picker. The Color Picker is one of my most used tools in Photoshop as it allows you to pick a color and change it on the canvas.

It's a good idea to keep your work on separate layers, no matter if it's a brush or images you'd like to reuse. If you'd like to change it to gray values, duplicate the layer and change the color values on that particular layer.

By using a scatter brush I made some time ago, I painted in the first fire effects. Those effects were painted on a separate layer and set to Soft Light. The layer was duplicated again and I set the Opacity to about 10% (**Fig.05**).

Details and Color Adjustment

As you see in **Fig.06**, I painted in more characters the same way I did in Fig.05. The only thing you should always keep in mind is to add additional details here and there to various characters or erase certain areas. This adds a good amount of variety to the characters and their appearance.

On top of that, I added a standard bearer, which is a simple way of letting the viewer know who's who in an image or battle scene. For the flag I did a bit of research and added the ones that looked best to me. To be honest, there is no guarantee that those are the ones that would have really

been used, but they looked good. I also added a horseman to the right side of the image.

Happy so far with the actual look, I decided to change the color to a more bluish tone. While the first color theme could be seen as a day or noon scene, the actual color theme has more of an

early morning mood. The colors were changed by using the Color Balance adjustment. I use this effect as often as I can, as it allows me to change not only the entire look of the image, but it also gives me the opportunity to change certain values, e.g highlights, mid-tones or just the shadows, if necessary (**Fig.07**).

Pushing Details Further

As you can seen in **Fig.08**, I added some more characters and details to the background. I normally paint a lot of landscapes and due to that I have a good collection of tree brushes. The trees in the background were not really necessary, but those trees added something to the storytelling of the image. Instead of having just a plain battleground, the trees suggest that this battlefield could be a sort of field or it could be close to a town or village.

By using the same sparkled brush I mentioned at the beginning, I added some more details to the ground. In my opinion you don't have to paint in every single grass blade; it's enough to give the viewer a painted impression of grass and their imagination will do the rest. Most additions to the story or the image are made by the viewer themselves.

Foreground Characters

It was now time to paint in the foreground. What's a battle without the opposing side? At this point I had already defined the rushing army as the Confederate States Army. Now I had to bring in the United States Army, or a glance of them at least.

The foreground characters were made in a similar way to the first characters, by painting in

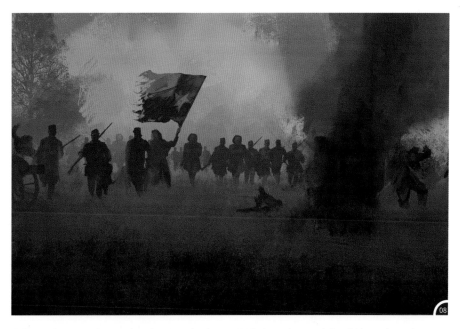

different shapes and poses, but this time I had to keep in mind that the characters had to show more defensive behavior.

Based on the research I made at the beginning of this painting, I still had in mind how the US army needed to look. It was also time to make a final decision on how the entire image should appear to the viewer. There are a couple of highly detailed painting styles, but I'm completely used to a less detailed style. For me this sort of style allows people to bring in their own imagination and to add in their own details.

With the style now defined, I kept things less detailed and just painted in necessary details, such as the belt, caps, blankets, and so on. On the right side of the image I painted a fence to add more depth to the image. The fence was made simply with the Selection tool. I drew the shape of a fence on a separate layer and used my all-time favorite brush for filling in the main color. Then I created a new layer and painted in the highlights and the shadows (**Fig.09**). If necessary, I could also have created another layer, painted in more detailed highlights and played around with the layer settings (Add, Hard and Soft Light).

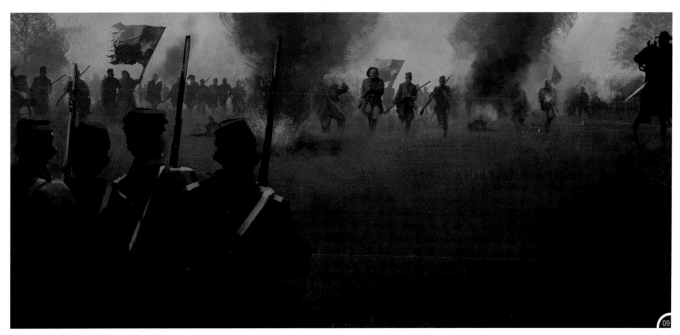

I really wasn't pleased with the fence, so I duplicated the characters on the left-hand side, flipped them and added different details or got rid of elements that suggested they were copied and pasted (**Fig.10**).

Further Details and Structure

It was time to paint in the final details and take care of any mistakes that were made. To support the feeling of different armies, I added the US flag to the upper right corner. The flag was simply painted by using a round standard brush for the initial blocking in and later, using a structured dotted brush, I gave the flag a more painted feel.

On top of that I decided to give the mid-ground more structure. This was achieved by using a customized shape. The shape was created by reusing one of my older paintings. I opened the painting, made a black and white image out of it, selected the black areas and created a clipping path out of the selection. With the selected clipping path, I went to the top menu bar, Edit > Define Pattern. With this, the shape was made on a separate layer and I could use it as often as I liked, without any resolution restrictions.

I erased the areas that were overlapping and not needed, then adjusted the opacity until I was happy. The next step was to add some additional color values to the image (**Fig.11**).

I created a couple of new layers (to be precise, three) and made a layer group out of those layers. All layers were set to Soft Light. Layer one got a simple orange ramp, I gave a more reddish tone to layer two, and layer three was deleted and replaced by the Color Balance. To that layer group I added a layer mask and by using a soft ramp again, I got rid of the areas that I didn't wanted to be colored or tinted (**Fig.12**)

Final Touches

Happy with the actual look, I took a break and did something else, something that had nothing to do with painting. Try reading a book, browsing the web or just having a nice chat with some of your mates. Try to give your eyes a break from your actual painting or job. This will give you a fresh view on your painting.

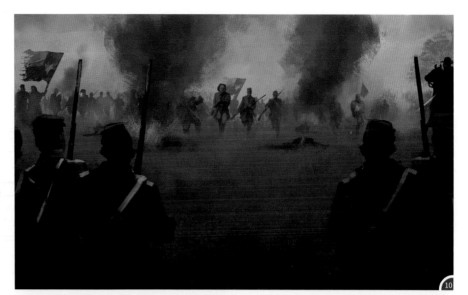

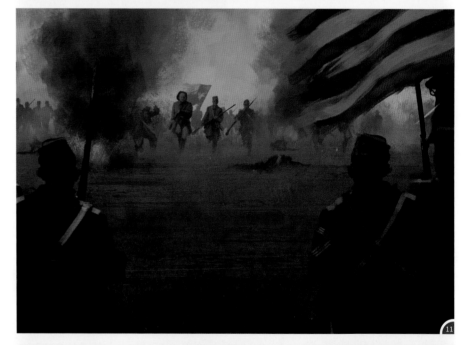

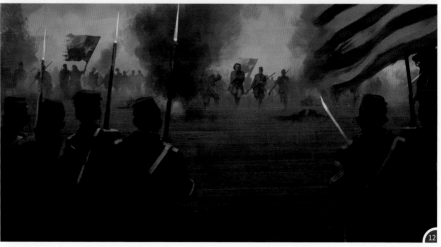

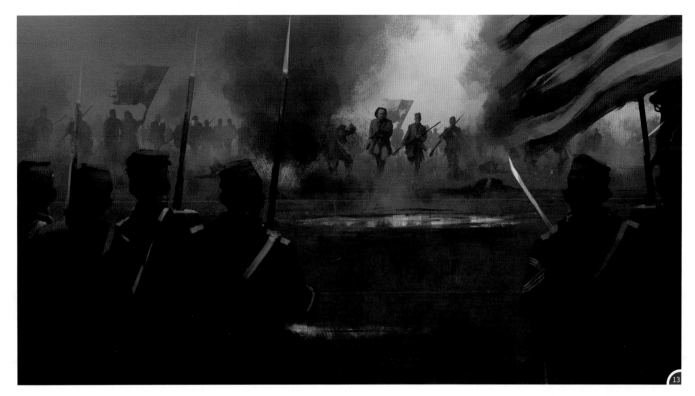

After the break, I realized that the ground still looked too even. To break up this even area, I created a new layer and drew in the shape of a puddle with the Lasso tool. I blocked in a color base by using the same brush as I used for most of the image. After that, I created a new layer on top of the color base and set it to Overlay. Another layer was created to paint in the darker areas of the puddle and to suggest reflection.

Happy with the look, I duplicated the layer, flipped it and made a second puddle. For a better foggy and moody feeling, a soft radial ramp with a neutral gray was added on a new layer (**Fig.13**).

With the image close to being finished, I decided to reduce the big black frames a bit and to tilt the camera a tad.

Quick Tip: Changing the angle of your image can be a good and simple way of getting a more dynamic feeling into your paintings.

As a final step, I merged all the layers together, then added an Iris Blur filter to the outer edges of the image and a Sharpening filter to the entire painting as well (**Fig.14**).

Conclusion

When working on a battle scene it's always a good approach to do as much research as possible. Not only will it give you a better understanding of how each faction looks, it will also guide you towards the right mood. You'll get a feel for the environment and the behavior of each faction.

On top of that, always keep in mind what kind of story you'd like to tell and how the viewer should experience it. I'm really a big fan of movies and plays, therefore my decision was an easy one

(cinematic). Also try to give enough information and details to the viewer, but only enough to let their imagination flow. The ability to tell your own story through your images is the best thing that could happen to an artist, at least in my humble opinion.

I hope this tutorial has been of help to you and has also given you a small insight into how I work. It's not the way someone else will work, but maybe there will be one or two ideas that you could use when it comes to creating your own artwork.

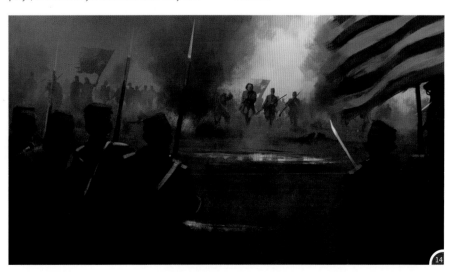

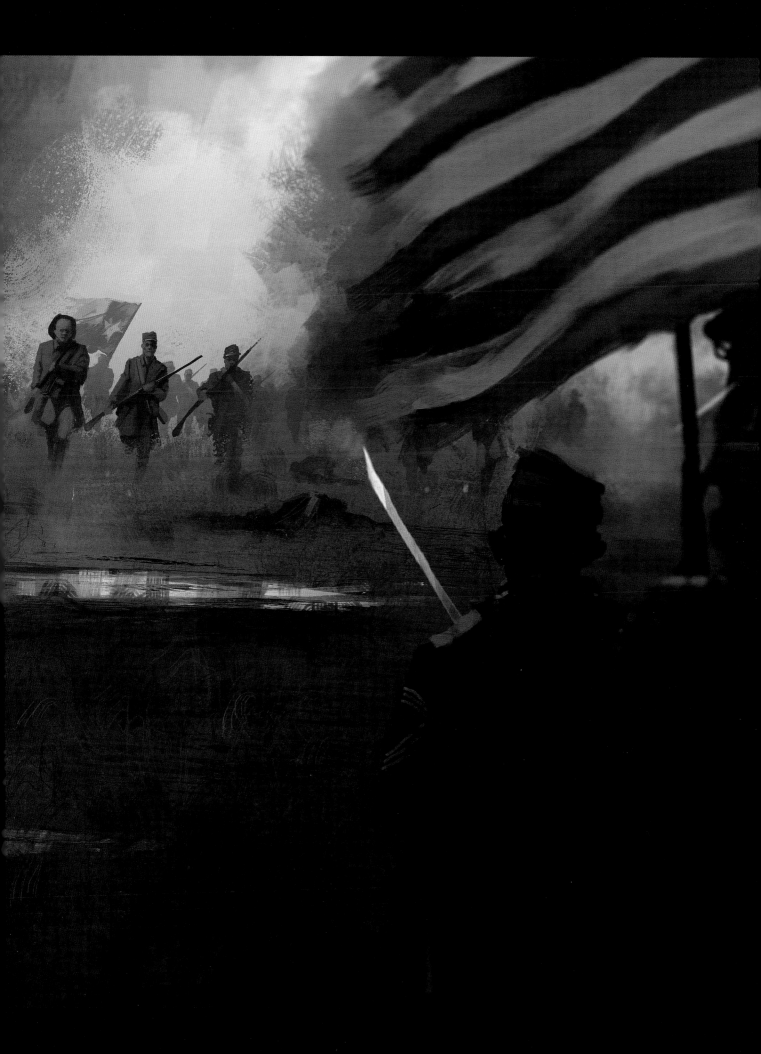

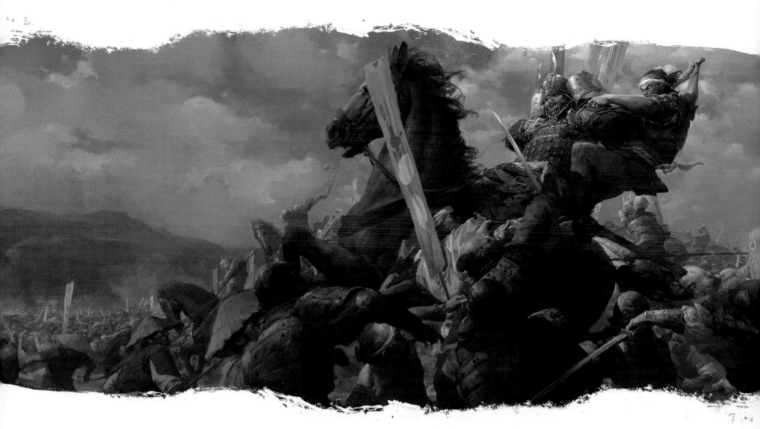

BATTLE SCENES| SAMURAI
By Fenghua Zhong

Introduction

In this tutorial, I will demonstrate how to paint a battle scene. I usually visualize the story of the painting first to establish the scene and the composition. This piece is set in a feudal shōgun period in Japan, where the over-powerful lords are determined to become the new shōgun.

Getting Started

To start off, I establish the horizon line determined from the proportions between the sky, the earth and the camera angle, which in this case is an eye-level shot. Normally in nature, the sky is a lot brighter than the earth, but I do not want to use a very bright color for the sky at this stage, as this will make the painting unstable and make it a lot harder to add brighter colors, such as the light source or the clouds (**Fig.01**).

Blocking In

Next, I put down large blocks of paint to find the basic values and rough in the main elements. At this stage, I check that the difference between

the values are clearly noticeable, while hinting at the composition of the painting. In this piece, I have used a triangular composition, giving the focal point a sense of power (**Fig.02**).

After I am satisfied with the rough composition, I paint more changes in values; adding more

colors for different elements of the image and finding smaller surfaces within larger surfaces, such as the samurai on top of the brown horse. I usually like to make the focal point distinct from rest of elements in the piece, where at this point, I am starting to consider painting in more hue and saturation differences at the focal point.

During this process, I do not need to be meticulous and precise on the exact shapes of the various elements of the painting, or even the natural color of the object, as long as there are more varieties in the color palette. The variety of color also makes the piece more mesmerizing to look at than a simpler color palette would. Eventually, all of these blocks of color will become figures or other objects in the piece (**Fig.03**).

> **" I CHECK THE BODY LANGUAGE OF VARIOUS CHARACTERS IN THE PIECE, MAKING SURE THAT THEY HAVE DIFFERENT AND INTERESTING POSES "**

Focal Point

At this stage, I check the body language of various characters in the piece, making sure that they have different and interesting poses, whist

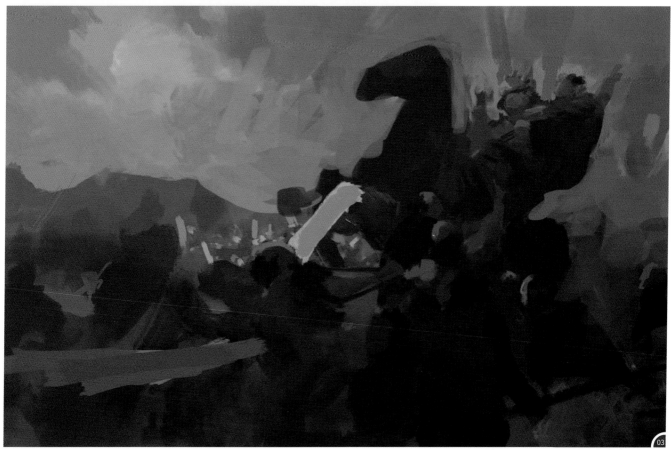

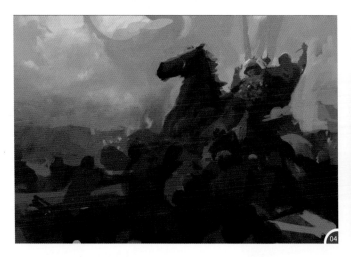

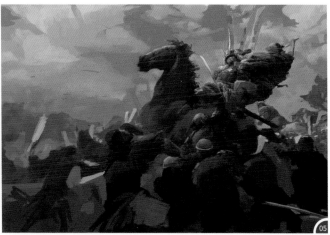

taking into account the direction in which the characters are facing. Despite the characters having different poses, there is an emotional connection between them. For example, I have the samurai officer on the brown horse as the focal point. The emotional connection is the opposing side's soldiers targeting the samurai officer's head, whist there maybe some soldiers on the samurai officer's side wanting to protect him. There is a distinct flow towards the focal point, such as the flow of direction of the enemy soldiers gunning for the samurai officer's head, creating a connection between the characters in the piece, whilst directing the eye of the viewer (**Fig.04 – 05**).

After setting the main frame of the painting, I can now zoom into different parts, focusing in on the details, and finding the change in values and colors in smaller areas. Also at this point, I can use brighter colors to lighten the center of the piece, the samurai officer and the immediate subjects around him – such as the cloud and the other soldiers – making identifying the center of the piece easier (**Fig.06**).

Now I start to figure out the depth of the painting, making sure the objects that are further away are less saturated and darker in value because of the atmospheric pressure, as

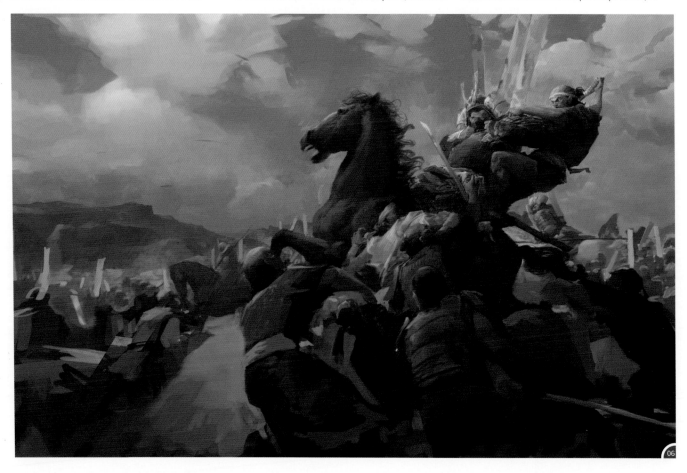

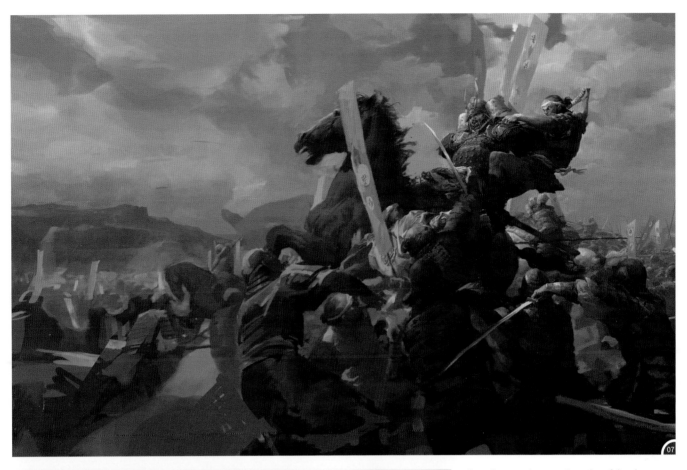

the colors are closer to the color of the sky, so the colors are in effect become cooler as a result. I also use smaller flecks of paint to hint at the details of subjects far away (**Fig.07**).

Final Details

For the final touches, I add in more details to the center of the piece and the foreground elements, to sell the mood and push the depth of the painting.

Quick Tip: Raising the levels of saturation in the foreground objects and brightening the values of the objects around them can create greater depth in an image.

At this point I also look at areas with faults, and try to improve them (**Fig.08**).

Overall, I am pretty satisfied with the final outcome of the piece. There could be some improvement on the execution of some parts, but the mood is close to what I initially had in mind.

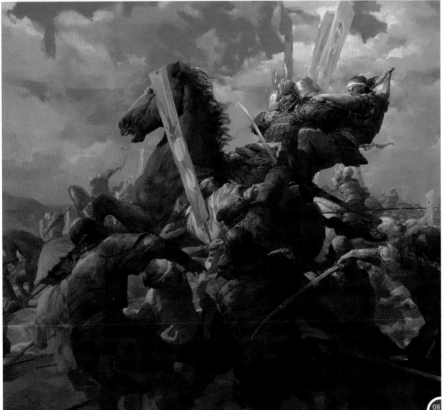

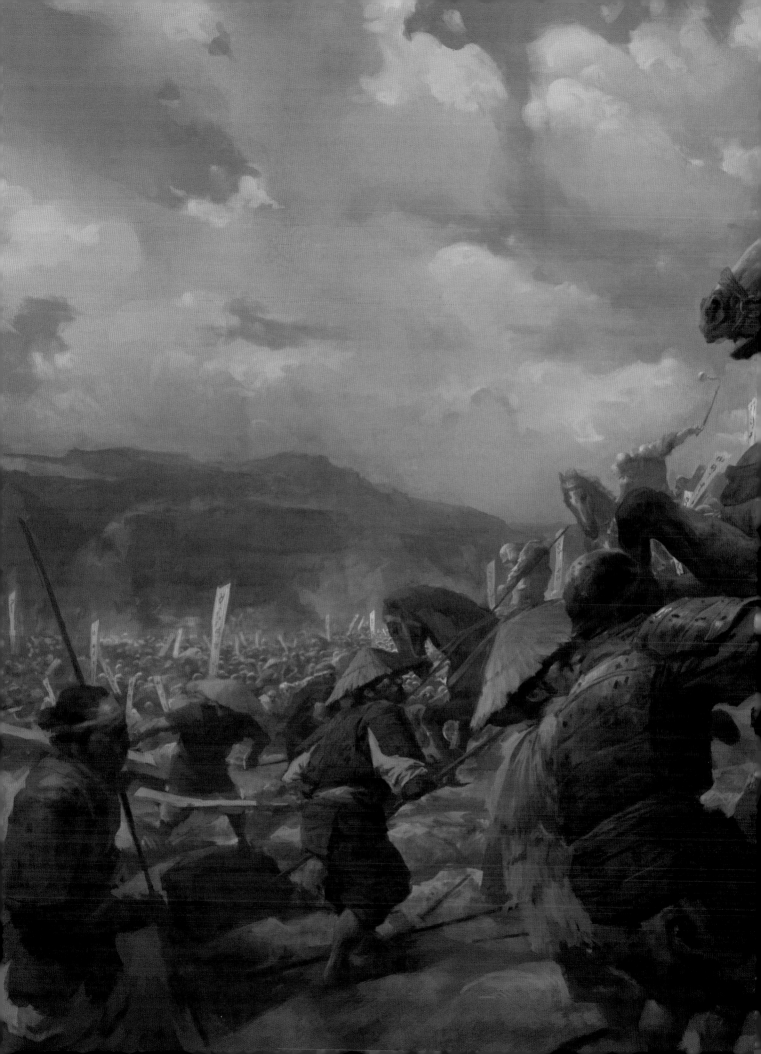

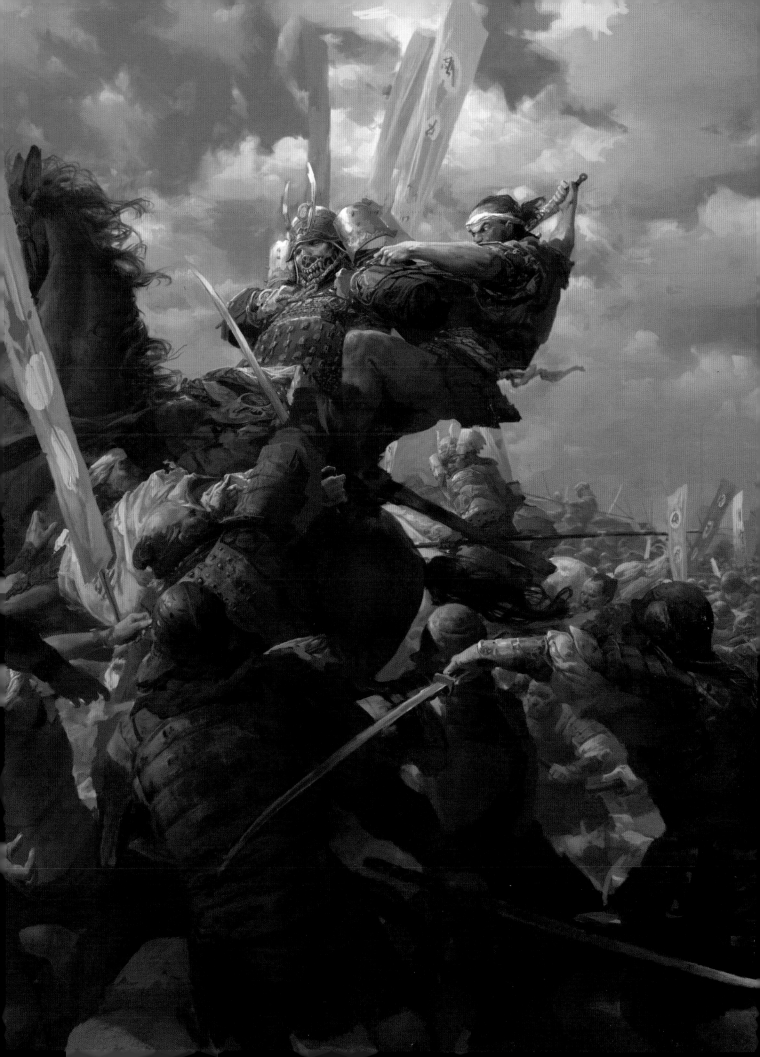

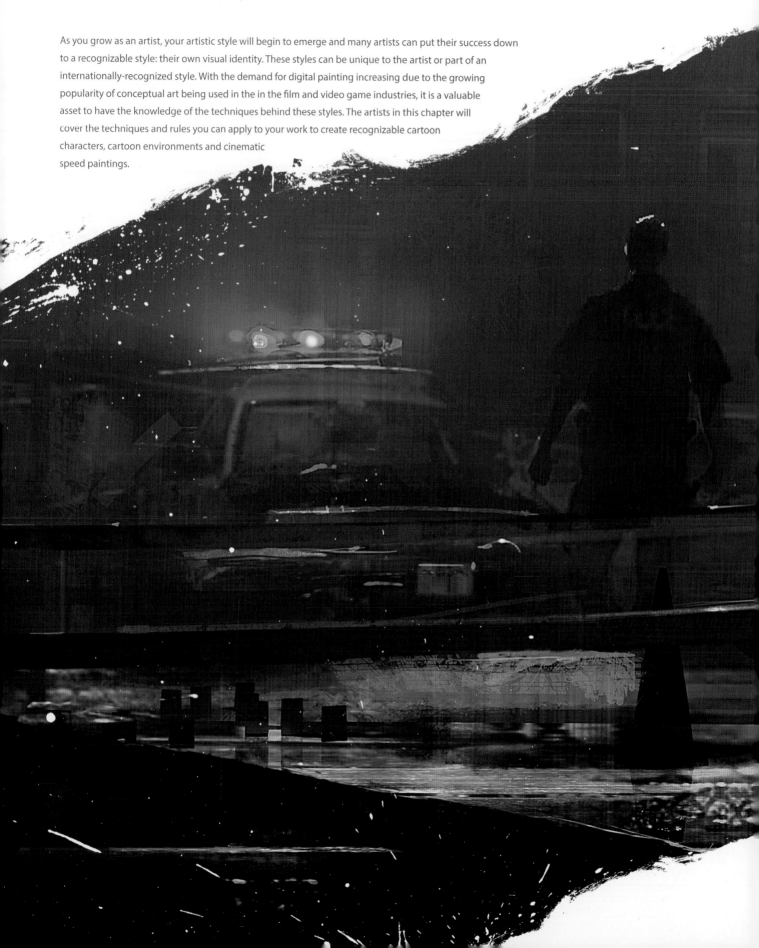

CHAPTER 02 | STYLES

As you grow as an artist, your artistic style will begin to emerge and many artists can put their success down to a recognizable style: their own visual identity. These styles can be unique to the artist or part of an internationally-recognized style. With the demand for digital painting increasing due to the growing popularity of conceptual art being used in the in the film and video game industries, it is a valuable asset to have the knowledge of the techniques behind these styles. The artists in this chapter will cover the techniques and rules you can apply to your work to create recognizable cartoon characters, cartoon environments and cinematic speed paintings.

Chapter Index

CARTOON CHARACTERS | '70S PORN STAR

By Max Kostenko

Initial Ideas

The very first step in creating a character for me is to find material on the internet. Since I got the theme of a '70s porn star, I put this into Google. Initially, I singled out a few things that symbolize a porn star of the 1970s to me:

- Porn: a naked or half-naked man
- The star: a man with a majestic, perhaps haughty look, with film awards
- '70s: a moustache and hair, which were popular in those years

Based on these ideas, I saved a few favorite photos. A sitting posture seemed to be very suitable to me, and therefore I imagined the future character sitting in a chair with a haughty air. Also, I liked the idea of him having a moustache, big hair and tights.

Several years ago, when I first started working as an illustrator, I paid little time and attention to searching for photographs for the project,

although it is a very important part. Now I can confidently say that the more detailed an idea you have about the design of the image before you start working, then the easier the process will be.

I have often lacked the patience to think about the image at the sketching stage. I wanted to quickly move on to coloring and focusing on the details so much that I missed the overall composition. So now I spend a lot of time on reference sketches.

Getting Started

For this project, I'm starting to work with a rough outline of the silhouette, for which I usually use a brush with a large radius. I call this stage "playing with your imagination," because in the subconscious the mind draws the missing parts and as a result, interesting images can be born. I'm not specifically trying to draw a head and shoulders; I just relax and paint, and in the process some suitable options emerge.

Incidentally, the picture size is around 3000 pixels and 300 dpi, which is an average size I feel comfortable enough to work with for a detailed drawing (**Fig.01**).

Next, I lower the opacity of the first layer to a translucent silhouette and create a new layer, where I am trying to find a successful line (**Fig.02**).

Refining the Sketch

Then I create a new layer and render a more accurate silhouette. Now that I am satisfied with the contours of the body and head, I think about working in more detail. I repeat the first and second stage until I reach the desired result (**Fig.03**).

❝ NOW THAT I AM SATISFIED WITH THE CONTOURS OF THE BODY AND HEAD, I THINK ABOUT WORKING IN MORE DETAIL ❞

Again, in a new layer, I try to find interesting facial lines. It seems to me that the actor has a very suitable refined chin and nose (**Fig.04**).

At this point, I like the outcome of the sketches I've done, and I decide that it's time to make a more elaborate and detailed sketch.

Now I'm on the right track. The features and expression are the look I am after (**Fig.05**).

Color, Light and Volume

I pour a uniform color over the sofa and the silhouette of the character in different layers, so that later it will be easier to edit the location of

the character, if needed. Generally, when it comes to commercial work, it is better to use layers as this can save time when updating. But when I paint for myself, I often use only one layer as it is more picturesque and less computerized (**Fig.06**).

The next step is finding the right lighting and volume. I decide to make a soft light on the right, so I darken the left side and the right lightens up. At this point, I work in one color, since no color is easier to precisely focus the volume on. For shading, I use a Multiply layer and clipping mask, then I choose a color slightly darker than the area in which I will paint (**Fig.07**).

Quick Tip: Adding a pinkish color on the cheeks, nose, knees and ears always gives a more lively type of skin.

Now the whole body looks too dark, so I decide to lighten the layer with the character in.

Sometimes I use the Auto Contrast feature to brighten any part of the picture, as it can help a lot and Photoshop will suggest which part of the picture to make lighter or darker. But it's important not to over-use this feature; it is best to use it as a small hint in some cases. For example, if you are working on an image for a long time and feel that something is wrong in it but can't understand what, often the problem is that the character doesn't have enough contrast to make them stand out from the background, causing them to blend in. In order for the picture to look good, each item must be clearly legible in the composition.

In my case, Photoshop has proposed that the body is lightened, but now the skin is very white and looks like plastic. So with a soft brush, I add a solid color, which gives a more realistic view of the skin (**Fig.08**).

The next day I look at the picture with my wife and together we realize that the picture doesn't have enough bright spots. So I decide to make the sofa brighter and paint it red. Actually, I often leave work for a few days and later, with fresh eyes, I am to be able to assess all the flaws (**Fig.09**).

Next I start to work on the face, to make it look more alive. So that it looks nicer, I add different shades to the skin color taken from the background color and the sofa color. On the cheeks, lips and ears I use the red from the sofa, on the chin I use green from the plants and on the eyelids I use a little bit of purple from the background. The main thing to remember is to do this very carefully and not to overdo it. I use the brush with 10-20% Opacity. I also add the red from the sofa on his neck and back (**Fig.10**).

Next, I decide to add a leotard and work through the hair. I usually start with a dark brown color and a broad brush, then gradually decrease the radius of the brush and add a more reddish and yellowish color. I used to reduce to the smallest brush size, but in reality hair curls and bunches up to each other, so each individual hair isn't visible. Realistically every hair that is drawn is not necessarily rendered. It is enough to draw the end of several individual hairs on the edge of his hair, bearing in mind the edges aren't always clear and may appear blurry, giving a fluffy effect (**Fig.11**).

I reduce the brightness of the hair because it looks too red. When drawing the leotard/clothes it is important to add the fabric folds and seams, because without them clothes will look like plastic. I usually look at photos as a reference for better results (**Fig.12**).

I make a new layer and in this layer I create a clipping mask. With a soft brush I darken and lighten a different area. Most importantly, I try not to forget what coverage I chose initially. I have the right light and shadow on the side of his legs, and I add a gray reflex from the background (**Fig.13**).

Final Details

The last step is to add details: the soft pillows and film awards, etc. I make the fluffy pillows with

the Smudge tool, in the same way that I use it for shading. I draw every hair on the legs and arms manually. Typically, I work on the hands last; this time I take a picture of his hand and redraw it in accordance with the lighting throughout the picture.

Finally, when I am happy everything is finished, I combine all the layers and render everything again to make a more traditional look, leaving some of the strokes and roughness in (**Fig.14**).

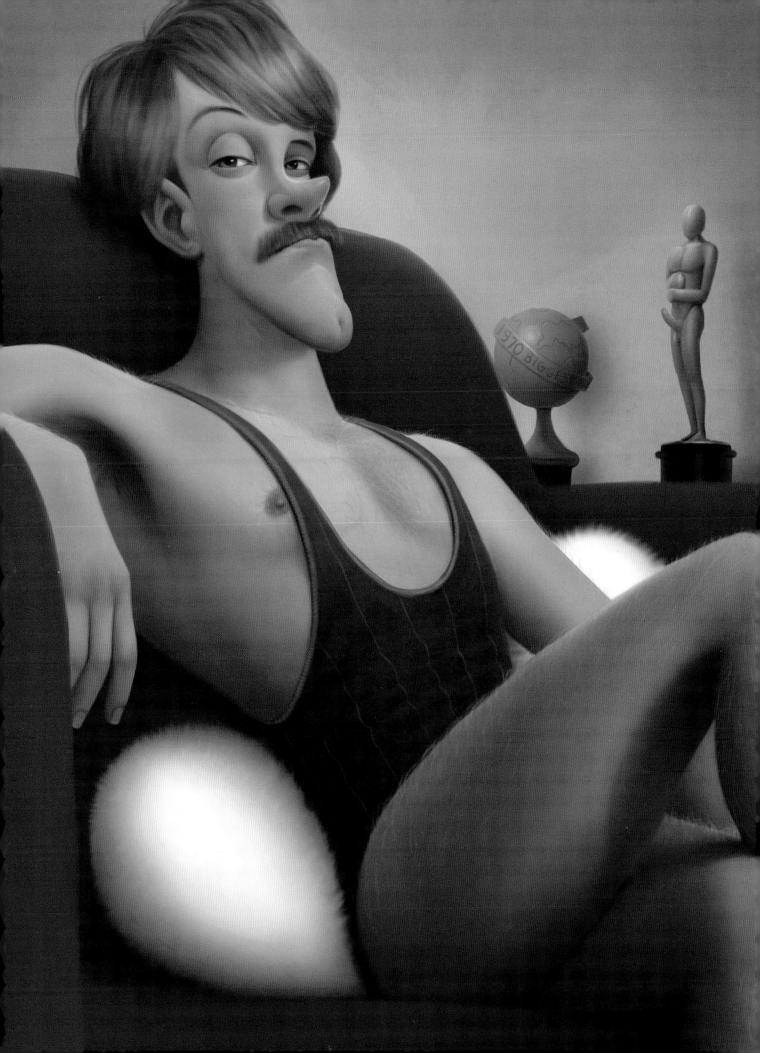

CARTOON CHARACTERS | PIRATE

By Brett Bean

Introduction

First, before I do anything else, I warm up. I just begin drawing random shapes and ideas on paper, and I tell my brain I'm allowed to play. I don't get stuck in a "finish it quick" mode. This is usually how I approach the start of any design. I will sip my coffee and just doodle until my brain wakes up and starts thinking about the "problem", which today is a pirate.

First Ideas

Next, depending on time constraints, I decide whether to use real materials or go straight to digital. Since I rarely have the time, I opt to do all my sketching in the real world. That's how we all started in school or as kids, and that's always the most intuitive and fun process for me.

It is way too easy to erase, go over, change and manipulate on the computer at the start of the design phase. Having the ability to do both is imperative as a character designer. Computer freezes and deadlines? Draw it out. Only have a

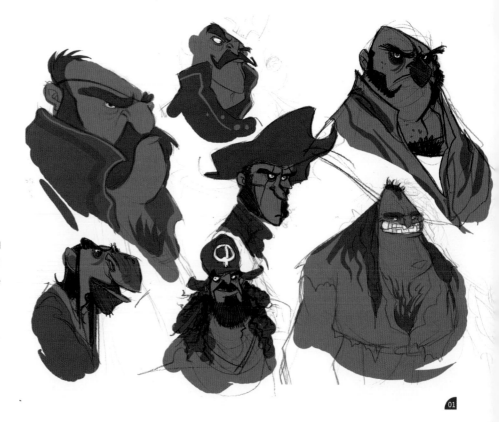

01

white board and the executive has given you five minutes to wow him with the next big idea for the company? Block it out. Stuck with the pencil? Go straight to Photoshop and just make shapes and carve things away.

Having more tools and ways to use them will make you a greater asset to any team or project, and the more you use them, the more comfortable it becomes and that's what leads to making your work look effortless. But it's not just about practicing; it's also about understanding and utilizing the strengths and weaknesses of all the mediums you can.

After sketching for a bit, and not exactly being sure of what I want, I start to just mess around with shapes and faces. What personality do I want to get at? How much realism vs. stylization do I want to have? I think about all this as I just explore shapes (**Fig.01**).

> ❝ I HOPE TO EXPLORE A
> STRONG FEMALE, WHILE
> DOING REAL WOMEN
> OUT THERE JUSTICE ❞

After a bit I start creating a story. Maybe he just shot his parrot after it pooped on him, or maybe it's a child who's acting like a pirate with a cardboard cutout leg and a beard and mustache made from crayon markings. Since I don't have a boss for the illustration I'm allowed to just

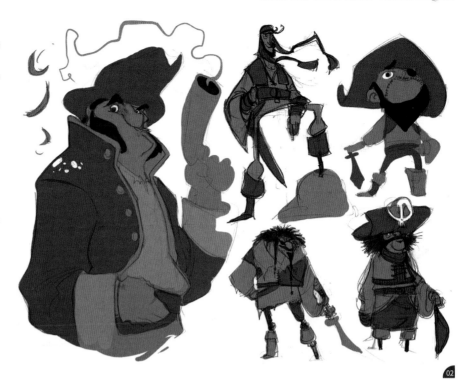

play. This can cause panic at times when you're confronted with a blank page and too many possibilities, so attitude is the key (**Fig.02**).

Moving on to the females, I go for strong but not overly sexualized. There are too many artists and too much art devoted to scantily-clad women, so I hope to explore a strong female, while doing real women justice.

Here I am playing with styles; big to little shapes playing off each other. The middle image is probably the closest to my natural sensibilities and style. I specifically know I will not choose this

one for the tutorial, as it's too comfortable a fit and I will not learn anything in the process. This was a key idea when I agreed to do this tutorial – that I would try to make something different from my usual style (**Fig.03**).

These are more shapes, postures and extreme silhouettes. I like the last image too, but she is very static and I don't feel like I want to take her any further (**Fig.04**).

I scan in the images and put them on a Multiply layer, create a Normal layer under that one and use a hard brush with two or three tones to

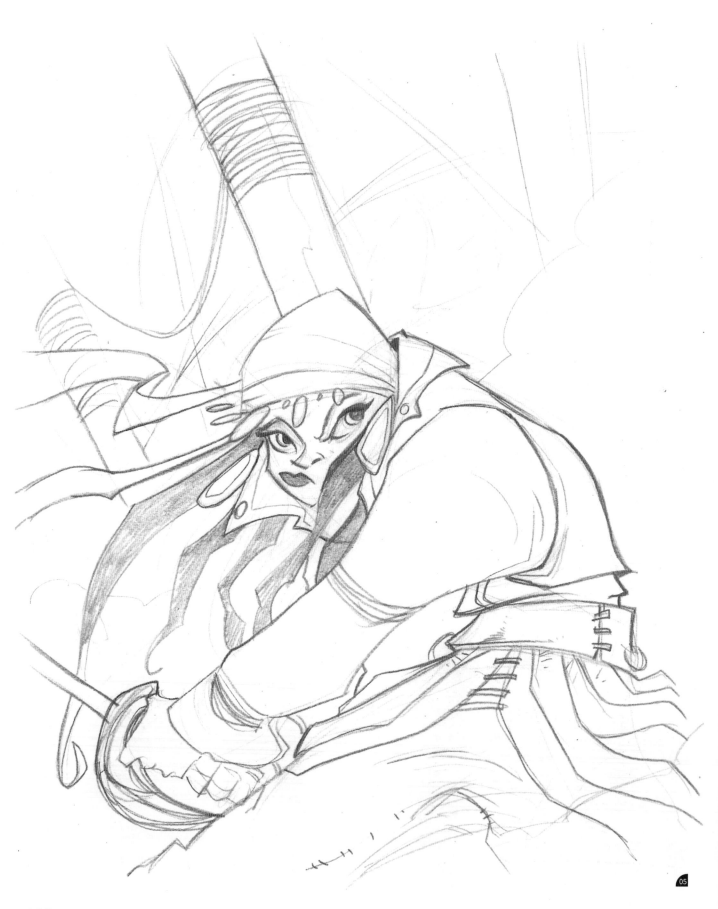

create a basic value study. After I use a mid-color brush (I never use grayscale; so boring to my eyes) and then use the Lock Transparent Pixels option on the layer. This way I can use a lighter color and a darker color, and play with the tones without having to worry about going outside of my silhouettes. I find it easier to play and explore if I have less to worry about.

Most of this is a nice transitional phase for me, as I decide what image will be the one I use, and it gets me thinking about the costume and other information I will use in the coming stages.

Blocking In Colors

I've chosen my design. It's got some action and isn't static like many of the other images. She's tough, but not overly dolled up and so I make this a Multiply layer in Photoshop as my top layer. I will eventually draw on top of the line work, but keep all my basic colors and tone underneath it (**Fig.05**).

I start blocking all my shapes into large color chunks. I have a few different approaches and I decide on this one for the reason that most of my information has been planned out ahead of time. If I'd started to paint without any under drawing, my approach would have been different (**Fig.06**).

I break up most of the colors and components into separate layers. Whenever I work for clients I do this as it is very easy to change a color if they don't like it, rather than having to repaint a big portion of the image. After all my layers are separated I create layers for textures.

> **Quick Tip:** When you hold the Alt button and put your cursor in between two layers, it masks itself to that layer.

Again, this saves me from going outside the lines and I no longer have to concern myself with that problem.

So now I just grab some weird texture brushes and go with it. This is controlled chaos. I absolutely don't believe in letting brushes (that are usually not even my brushes) change and manipulate my designs. In my opinion, good

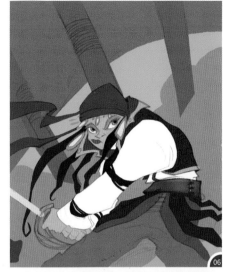

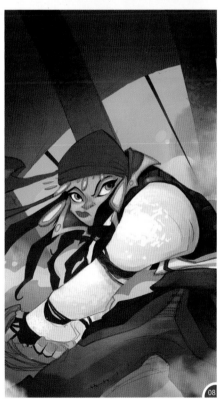

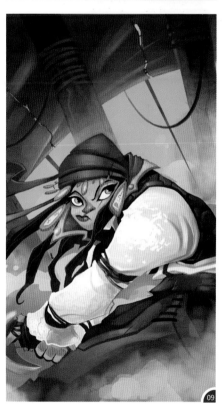

designs are thought out, not willy-nilly. I do understand that others don't share my belief though, but because those brushes are working inside my decisions, then I can play with those brushes and they will work for me and not against the choices I have established.

Lighting and Atmosphere

This is when all the basic colors have been decided. I start creating some atmosphere to show myself what I am hoping to accomplish. I

work on lighting and where to draw the eye. So I make two layers, one on Overlay where I push and pull colors (never grays) and another above my line art on Normal.

After I establish some lighting that works for me, I go to that top layer and I start to just paint over the line art I don't want to see. In the end I will leave markings in, as that's the style I want for this painting compared to others. It's all a choice; I could be wrong, but I made it (**Fig.07 – 09**).

The eyes have started to bug me. I go through three or four versions, re-doing the eyes. Along with all the other problems like lighting and atmosphere, I just keep fidgeting with the eyes. I also add a textured image on Overlay (**Fig.10**).

Now all the designs are "correct". Okay, so basically nothing is ever completely correct in our field as it's all about personal taste, but I am no longer bothered with what's happening on my screen. This is usually how I design. Fix stuff until that tiny voice goes, "okay, that's cool now". So now I move on to the lighting and how I want the eyes to move around (**Fig.11**).

I add a Color Balance adjustment layer to push back on some of my shadows.

Final Details

Here I add a border above all the other layers and because I view pirates as a bit dirtier and haphazard, I want to make it scratchy and a bit aggressive. I also add a Color Dodge to beef up the highlights and eyes, to manipulate where I want the audience to look first (**Fig.12**).

Now I make some last finishing touches, like tweaking the eyes, and adding a touch more smoke and a signature.

As I try to never paint the same way twice it lends itself to being a new experience all the time, which keeps me happy, but can also be a double-edged sword when you forget how you did something well and need to repeat it. More often than not some form of it will manifest as you paint, learn and grow as an artist. Again, depending on my subject matter, my client, and the time allowed, I will change my approach from design to design. Having different ways to solve the problem of design and painting can only make you a stronger visionary.

I hope something from this tutorial gives you an "aha!" moment, an understanding of how another artist's brain works, or maybe some workflow ideas as you go on and create your own pieces. Good luck and I'll see you online.

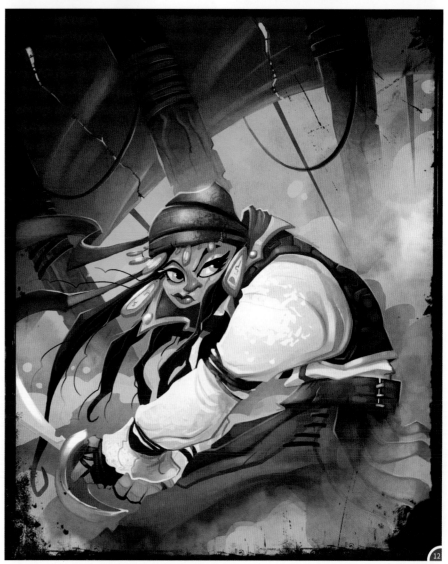

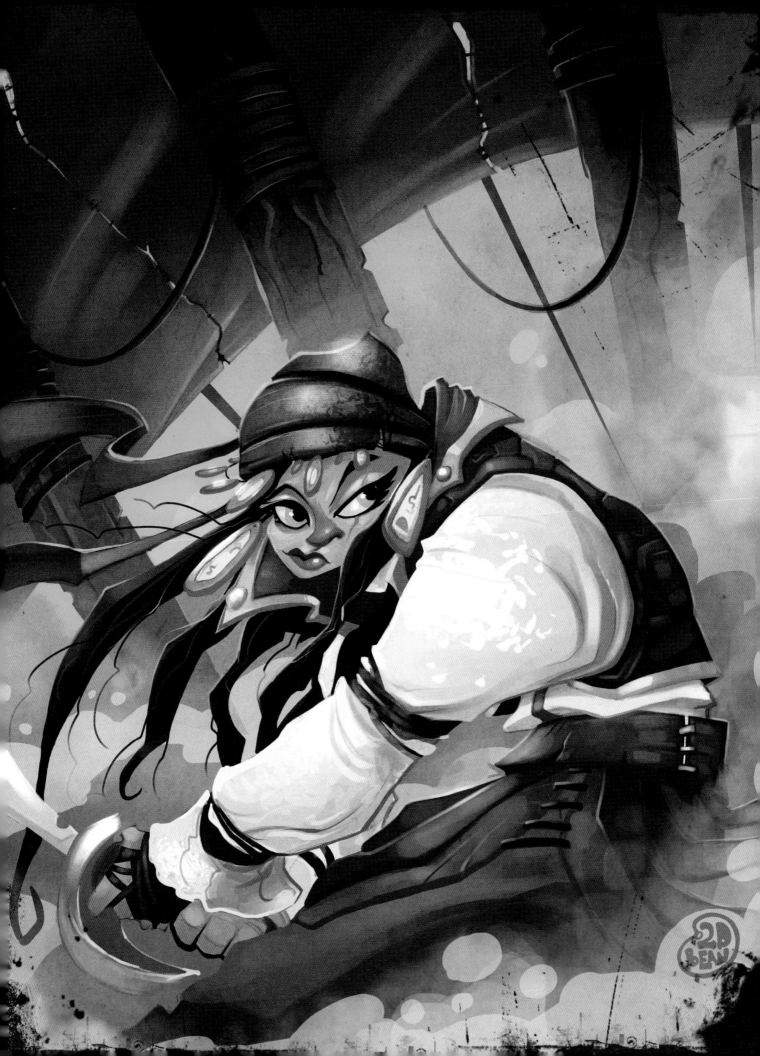

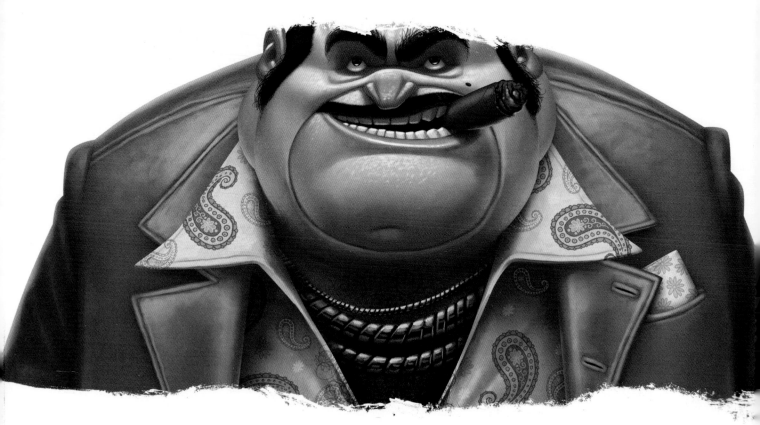

CARTOON CHARACTERS | LOAN SHARK
By Denis Zilber

Introduction

Hi guys! Today I'll be showing you how I designed a loan shark. It's quite an exciting character to design, with a lot of cultural references. Loan sharks are widely used in movies and literature, and are definitely one of the most interesting character types I've had a chance to work on.

Reference

Before actually starting to design my loan shark, I have to decide what he should look like. What are his main attributes and characteristics? I imagine this guy to be around 50 – 60 years old, bulky, stocky, maybe fat, maybe bald, or with brown or black hair. He is a respectable man, well, at least in his neighborhood. He is rich and as a sign of his social status he wears a lot of gold: a gold watch and heavy golden rings.

Basically his social status and respectability are the only things he cares about, because they provide a solid basis for his business. His everyday activities lie within that gray area

01

between criminal and legal, which allows him to hang out with a bunch of bad guys and at the same time stay out of prison. He is not a mobster (although maybe he's a former one), but he knows what life on the streets is like.

I imagine him wearing an old-fashioned blazer or leather jacket. He might even just wear a shirt with suspenders, something from the early '70s or '80s when he was young. A yellow or red colorful silk shirt, with a funny flower or paisley pattern on it, with bright jeans, snake leather red boots or shoes, and a huge sparkling belt buckle with a big dollar sign decorated with rhinestones. He is a kind of a macho man; he is very hairy, with a hairy chest and hairy arms, and a big black mole on his cheek, which makes him unpleasant to look at.

> **WHEN I SKETCH A TEST OF THE FACE, I COME UP WITH THE IDEA OF A THIN, LITTLE MUSTACHE THAT WOULD MAKE HIM LOOK LIKE SOME COMIC BANANA REPUBLIC DICTATOR, WHICH IS ALWAYS FUNNY**

After I have decided how I want my character to look, I search for photo references on the internet. I imagine him as Tony Soprano, dressed like Nicolas Cage from *Snake Eyes*. *Goodfellas* is another great movie for research for this reason.

First Sketches

Once I have gathered all the reference material I need for my work, I start doodling. I sketch a couple of tests of different shapes, trying to stick to a square shape in order to make my character heavy and fat. When I sketch a test of the face, I come up with the idea of a thin, little mustache that would make him look like some comic banana republic dictator, which is always funny (**Fig.01**).

Jokes aside, at this point I start building up the character with a rough sketch first, then

another pass and then another, more refined and detailed version. By the time I have reached the third design, I've made his eyebrows bigger and bushier, and changed his nose from a bulbous one to a hawk-like one. I feel these details will make him look more dangerous and less silly. Another detail that I decide that he has to have is a cigar and it has to be Cuban (**Fig.02**).

I move on to another pass, this time from a side view. I complete a couple of full-body sketches

from the side, just to see how this character might look in his full scale. At this stage I reach a turning point in my design process. I realize that my design is not good. Well, maybe my loan shark does have a certain amount of character, but he's turned out too realistic, too complicated, less simplified and stylized than I think he should be. I feel like I need a funnier character, someone more suitable for an animated movie, someone more exaggerated and grotesque. I decide to start over (**Fig.03**).

Refining the Sketch

In **Fig.04** you can see the new design that I come up with. As you can see it is a completely new style, with new proportions and less realism and he looks more grotesque too. I have left the main attributes of his personality, his outfit and his body type, but just changed my overall approach by making him in more of a cartoon style and less of a caricature.

> **" HIS PALMS ARE SOFT BECAUSE HE HAS NEVER DONE A HARD DAY'S WORK IN HIS LIFE; THE HEAVIEST THING HE HAS EVER LIFTED IS A ROLL OF BANK NOTES "**

I sketch another pass of the side view. It's important to keep the same proportions when you switch to the side view. In most cases I have to tweak my front view as well, because not everything that looks OK in the front view looks the same when you place it within a 3D space. That's why I think it's really crucial to imagine your character as a 3D object at the very beginning of your design process; otherwise you may end up with something that will be really hard to animate later (**Fig.05**).

In **Fig.06** you can see a few hand poses that I have sketched. I wanted him to have fat fingers and small nails. His palms are soft because he has never done a hard day's work in his life; the heaviest thing he has ever lifted is a roll of bank notes. He talks a lot with his hands, using very expressive hand gestures, mostly with two or three fingers and usually while holding his beloved Cuban cigar.

I continue to sketch a series of facial expressions. Our guy has a fat and fleshy face, so when his facial muscles move or when he moves his jaw down or to the side, the whole of his face changes shape. The most important feature of the face for expressing emotions are the eyebrows, so I had to make them as big and flexible as physically possible. In real life, and especially in animation, when eyebrows move so

do all the upper parts of the face: the forehead, eyelids and nose. When working on facial expressions, it's a good idea to keep those things in mind (**Fig.07**).

Painting

At this point it's time to start painting our character, so I put my sketch on the top layer, with 10 – 20% Opacity and Multiply blending mode; this is so I can clearly see what is happening beneath. Then I create different shapes with the Photoshop Pen tool, separate them into different layers and lock their transparency. I color these shapes with basic colors, with each color block in a separate layer. This makes my life easier when painting, as by working with an object in a separate layer you can always undo decisions that don't work without ruining the whole image.

Apart from painting, I make one design on the spot, well, two actually. First I decide to give up on the idea of him being bald, and instead give him a nice, greased, black, mobster-style haircut. It makes him look stronger and more masculine; less like an accountant and more like a guy you wouldn't want to mess with. The second decision is to change his bright blazer to a leather jacket, which makes him look a bit less classy and more of a low-level thug. The leather jacket, in my humble opinion, looks much cooler than any blazer. I have one myself and Tony Soprano, by the way, had one too; you don't need any more reasons than that (**Fig.08**)!

Color and Light

I reach the stage where I begin blocking in basic colors and volumes, as sort of under-painting that I will later refine pass by pass. On the subject of basics, I usually tend to start to color an image with an ambient occlusion. This means that firstly I decide what the lighting conditions are within the scene and what the diffused lighting is. The color of that diffused lighting will strongly affect every object (especially the shadows) in my scene, making colors shift toward warm or cold sections of the spectrum.

In this particular case, my character is placed within a neutral white environment, so there

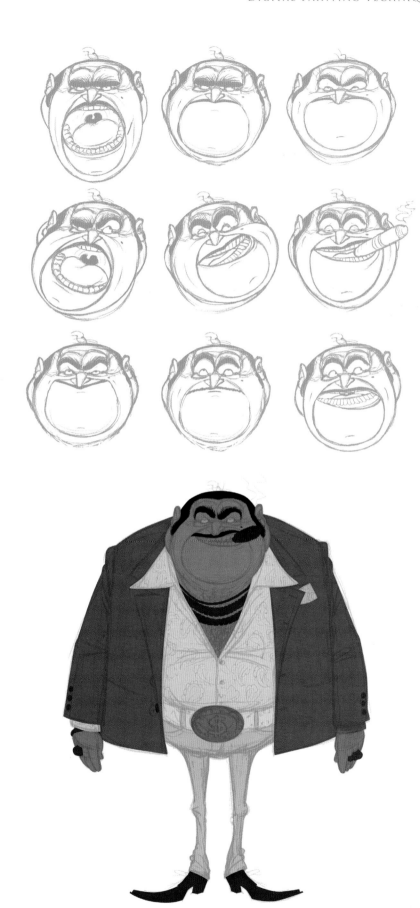

is no color shift. But when it comes to adding highlights, reflections and polishing later on, I'll have to add some subtly white reflections on the edges of highly reflective objects, such as hair, metal, leather and human skin.

For now the only thing I do is paint soft shadows on the Ambient Occlusion layer, in areas where diffused light doesn't reach. I also make the surface that we see from bigger angles slightly darker. Although our main lighting is diffused, (e.g coming from all around), as long as there is some kind of floor in the scene, even a white one, the amount of light coming from above will be significantly bigger than that reflected by the floor. So, basically all surfaces facing downwards will be darker than those facing up (**Fig.09**).

Finishing Touches

At this point I am almost done. The two most important elements to this character are his face, of course, and his leather jacket, so I paint them first. They both have to be rendered perfectly – the face for obvious reasons and the jacket because if it isn't it may look like plastic. Leather has its own unique texture, which reflects light differently in different areas, dependant on how greasy or shabby these parts are. In many cases manufacturers also add some texture variations to leather, so we should take all these details into consideration when painting leather.

In addition to the white diffused light, I decide to add another light source: some kind of warm, soft spotlight right above our guy's head. This will make the skin tones warmer and will also make the shadows darker (in physics terms it's not true of course, it's only an illusion created by the higher contrast between shadows and light).

I complete a final pass and a side view of the character is added. I do a lot at this stage. I paint a nice paisley pattern on his shirt, finish his white jeans using a rough fabric texture, and paint his shoes using a real snakeskin texture. I also paint his hands, golden rings and his belt buckle. I tweak the tone of his skin, making him slightly redder; I also add some additional highlights and made the shadows darker in some places (**Fig.10**).

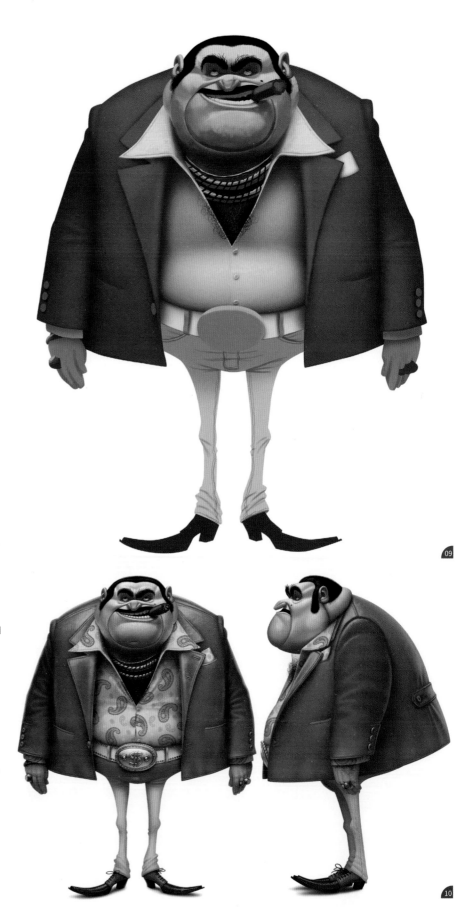

110

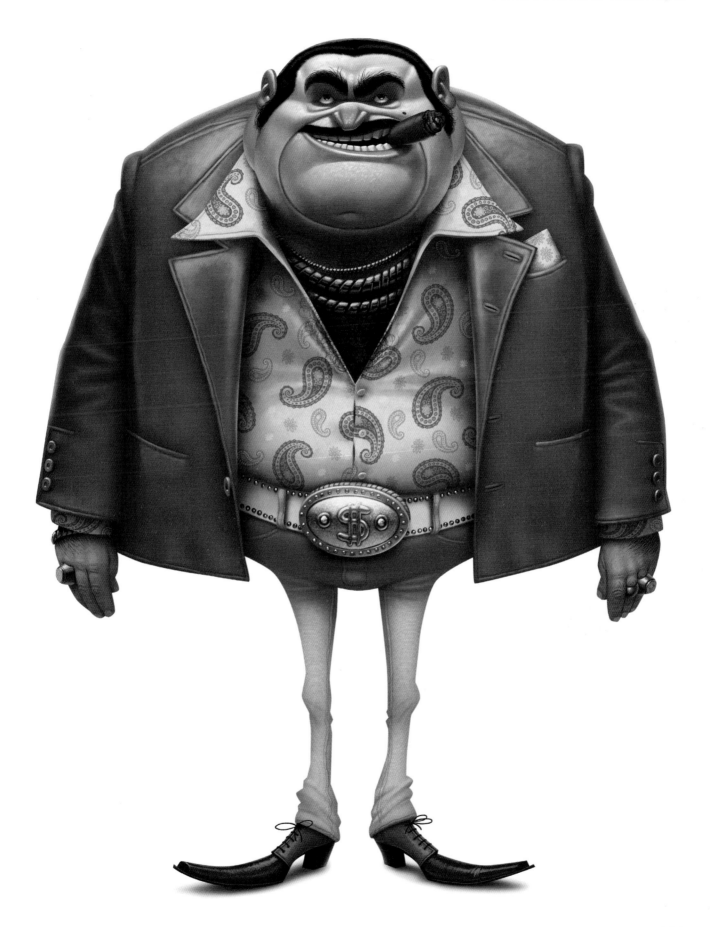

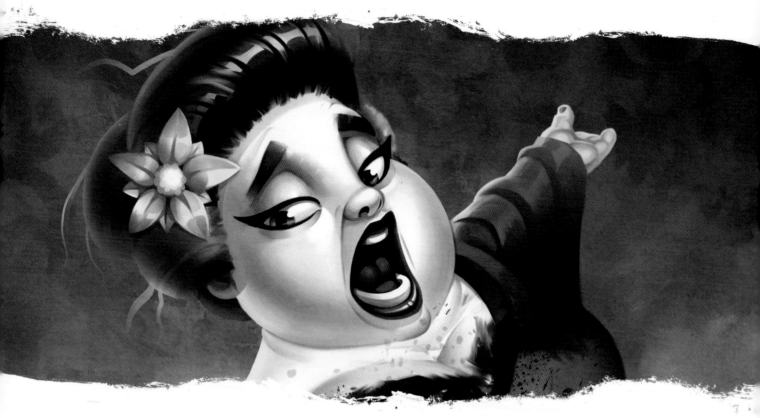

CARTOON CHARACTERS | OPERA SINGER
By Johannes Helgeson

Introduction

I wish to implore all readers of this tutorial to question what I write and to realize that I, in no way whatsoever, hold all the answers. I have been wrong many, many times in the past, and making mistakes is an inherent part of my artistic growth. The process outlined in this tutorial is merely one of many, and I emphasize that I think everyone needs to find their own way of working. That said, I hope I can highlight some techniques or mindsets that might be of use, and give something back to the digital art community, which has been of such great importance to me.

Story and Purpose

The first step is to read and understand the brief. What does the client want? What brief have I been given? In this case, my task was to design and paint a cartoon opera singer, and outline my process for artists at a beginner to medium level.

I decided to start with figuring out the story that the opera singer would be telling/singing to her audience. This dictates everything from the design of her clothes and her gestures, to her shape language, expression and colors. The story is my red thread; without this, my design will be empty and meaningless – a technical exercise at best. My goal is to entertain my viewers, much in the same way as the opera singer I have depicted.

> ❝ AN OPERA SINGER IS LAMENTING (THROUGH SONG) THE HIGH COST OF LOYALTY. I CRAFTED THE EVENTS OF THE STORY AROUND THIS STATEMENT ❞

A story is a sequence of events leading to a conclusion. The conclusion is the story's point; the message you aim to communicate. I don't think a story is good without it. I wanted this to be an honest statement deriving from my own experiences in life, so I spent several days thinking about what I actually wanted to say. In the end I decided to try communicating the idea that loyalty has a high price.

My ambition was to depict the moment when the character shares this message with the audience. An opera singer is lamenting (through song) the high cost of loyalty. I crafted the events of the story around this statement. I decided upon drawing a geisha in ancient Japan; it was something I had never drawn before and I like to challenge myself. The story's events, briefly described, go something like this:

"A geisha, who is the proprietor of an entertainment establishment, realizes one of her maiko (an apprentice geisha) is being subjected to severe physical abuse (her life is in peril), by one of her most prominent clients, the son of the region's daimyo (a feudal lord with immense political and military power, subordinate only to the shōgun). She decides to protect her maiko,

by rushing to her aid and stabbing the daimyo's son in the throat with her hairpin. She knows that by doing so, she has doomed herself and all of her workers; the daimyo's revenge will be relentless. She sings out loud her lamentations, as she thinks about what to do next."

Next up, I had to do some research. What does a geisha look like? What was ancient Japan like? I looked at some of my favorite Akira Kurosawa movies, like *The Seven Samurai* and *Ran*, as well as *Memoirs of a Geisha* by director Rob Marshall. I read about the era in general and geisha culture on Wikipedia, trying to understand more of the world I was trying to depict. I spent about two days doing this, gathering reference images as I went. Hopefully I could fool everyone into believing that I had some sort of knowledge about this subject matter!

Character Thumbnail Sketches

Finally I felt ready to draw. The purpose of these sketches, made in Photoshop, was to figure out the silhouette, shapes, colors and overall features of the design as quickly as possible. I was not working on the pose or the expression, or doing any type of rendering. I was not being high-brow in the least; I was just having fun and staying relaxed. As dictated by the story, on one hand my character is an opera singer, and on the other hand she's a maternal geisha.

The singer aspect was difficult to communicate without the use of a pose, but I decided to make

her bosom large, adding some weight and making her short. This is a cliché used for female opera singers, but it served its purpose well I think. The whole big voice/small frame is a nice visual contrast. Her big lips would also insinuate the singing nature.

For kimonos (the dress of a geisha), purple is a color used in autumn and winter, and since this geisha is in the autumn of her years, it had a reasonable color symbolism. I made her shapes primarily round and convex, a trope often used for kind characters. The orange/gold was nice to communicate wisdom, and the white would have really highlighted the blood, but in the end, purple felt best, so that's what I went with. The torn sleeve tells the story of a battle recently fought. I like to make the background gray, as this color or lack thereof, is unlikely to mess with my perception of the colors of my design. 90% of what I did here ended up in the trash can, so adding finish was pointless (**Fig.01**).

Line Art Drawing

Having the design pretty much figured out, I could start to focus on the storytelling aspects of the pose. I thought about verbs and adverbs, not

nouns – singing mournfully, leaning dramatically, etc. I was very much concerned with the major directional flow of the pose, trying to make sure all the prominent lines flowed in the same direction. I stood up and struck the pose myself, feeling where the weight and tension went. I didn't wish to obscure important parts of the design either. A clear and readable silhouette is of paramount importance.

Putting a square on the ground plane helped me to place my character in 3D space and not forget about the perspective. I drew four failed versions, with my 0.7 colored lead mechanical pencils on regular copy paper, until I arrived at a drawing I liked. I think drawing is very difficult, and one of the major differences in myself now and seven years ago when I started drawing is that I'm much more stubborn now; I don't stop trying as easily. Creating thumbnails and drawing took about a day (**Fig.02**).

Masking the Positive Shape

Having scanned the drawing into Photoshop, I used the Polygonal Lasso tool to mask out the drawing from the waste space on the paper. I find this is the quickest way for me to do it. I

put the drawing on top in Multiply Blend mode and simply filled in the Polygonal Lasso tool selection with a red color on the layer beneath. By Ctrl + clicking on that layer, I got a convenient selection. With that selection intact, I clicked on the line art layer, then inverted the selection (Ctrl + I) and pressed Delete. Voila, the negative, wasted space was gone (**Fig.03**).

Local Colors

Again using the Polygonal Lasso tool, I blocked in the local colors using the Fill and Paint Bucket tools. The local color is the "true" color of an object, uninfluenced by reflected light, shadows or the main light; it's 100% self-lit. I put this layer beneath the line art layer (still in Multiply) in Normal mode, and above the mask layer from the previous step. I hit Alt and clicked between this layer and the mask; this limited the contents of this layer to the positive space of the underlying layer (**Fig.04**).

Lighting Guide

I thought about what sort of lighting I wanted the scene to have. In order to try to be consistent, I quickly painted a "reference lighting ball". This is similar to what I did in university when we had to incorporate 3D animation into real life footage. In order to make the 3D model fit in the scene, it had to be lit according to the light of the camera footage, and so we made sure to shoot some scenes with a white plaster cast ball in frame as reference. I kept this in a separate layer, and referred to it often during the painting (**Fig.05**).

Shadow Blocking

Using two different Multiply layers, one for the shadows which are cast and formed, and one for the ambient occlusion, I mapped out with the shadow pattern. I tried to be consistent with the lighting guide I established previously. I was being rough on purpose, knowing that I would polish this later. Ambient occlusion happens where the ambient light is being occluded/blocked, for instance in crevices, and where different surfaces touch upon each other (**Fig.06**).

Combine and Flatten

Besides flattening the layers that I had up to this point, I also added some secondary light sources

as Screen layers. In addition, I made a rough block-in of the main light with a warm orange color in an Overlay layer. In this lighting setup, surfaces reached by the main light source are tinted towards warmer hues, and the surfaces hidden in shadow are shaded towards colder hues. The image looked kind of indistinct, but it gave me a decent base that I could start rendering from.

My next move was to flatten the layers again and start painting, trying to clarify the forms and getting rid of the line art (**Fig.07**).

> **" FOR ME, A DRAWING ISN'T SET IN STONE WHEN THE LINE ART IS DONE; I KEEP CHANGING AND FIXING THE DRAWING AS I'M PAINTING "**

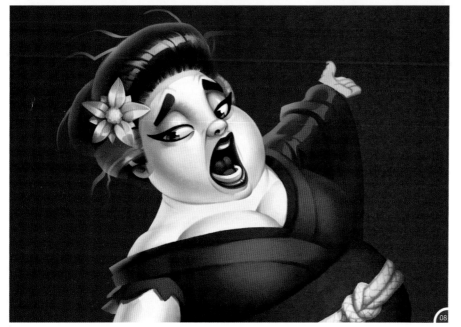

Rendering the Head

I started by rendering the head. It's the most fun part for me, and once it's done, I kind of have a reference point for the rest. I rendered mostly using the standard round brush with Opacity set to Pen Pressure, and did some softening with the default airbrush. For the hair I used the Smudge tool with a custom painterly brush in an attempt to suggest it was hair without painting the individual strands (**Fig.08**).

More Rendering

I simply kept on painting, using the same technique that I had used for the face. I wasn't afraid to push and pull stuff around either; for instance, I changed the arm furthest away, which was too long. For me, a drawing isn't set in stone when the line art is done; I like to keep changing and fixing the drawing as I'm painting. At this stage I almost always feel like throwing the painting away, because it looks like a mess. I've worked on building patience over the years, and I can sort of push through these moments now, hoping that the final piece will look okay. With every finished piece I have ever made, at one point or another, I have always felt like scrapping it (**Fig.09**).

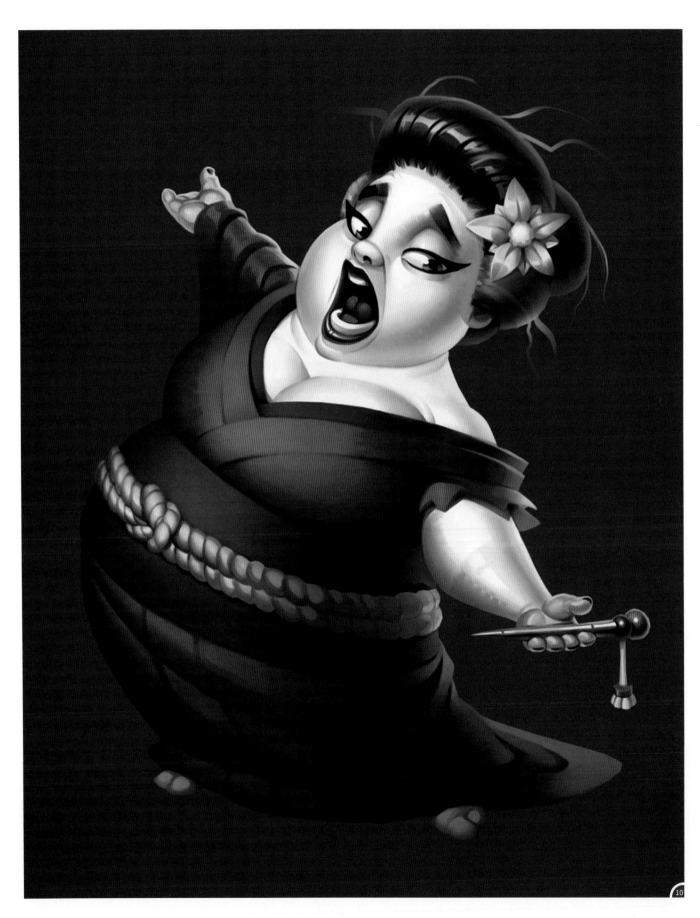

Even More Rendering

It's great to flip your image to get a fresh perspective and see it in a new light. I think it's easy to become blind to errors after a while, and changing the perspective can often reveal embarrassing flaws. I've made Flip Canvas Horizontally into a keyboard shortcut (**Fig.10**).

Changing Stuff and Rendering More

I decided to make her kimono longer, thereby removing the feet. I felt the white socks created too much of a contrast near the bottom of her, and that's not where I wanted the viewer's focus to be. Also, the longer kimono put further emphasis on her shortness (**Fig.11**).

Atmospheric Perspective and Selective Desaturation

In an attempt to further emphasize the face and hand with the hairpin, I slightly desaturated everything else. The eye tends to focus at the points where there's most contrast (in value as well as hue, chroma and shape), and being aware of this can help direct the attention of the viewer. Keeping a uniform saturation and chroma throughout the design can be disastrous. In a Screen layer I made the parts farther away from the camera fade into the atmospheric fog of the scene, further creating an illusion of depth (**Fig.12**).

Blood!

On a separate layer set to Multiply, I started painting blood (**Fig.13**). I painted this using a

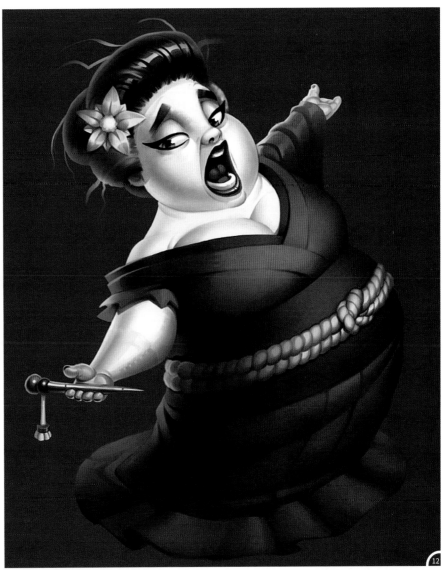

custom splatter brush, as well as by using the Smudge tool set to Finger Painting. I intentionally overdid it, thinking of it as part of her opera costume. In addition, there's a bit of shock value to it, as images in a cartoon style and blood aren't usually displayed together. This is not an opera for kids.

Dragon

On a layer set to Screen, I painted a dragon-type creature. In order to have it blend with the folds of the fabric I created a layer mask and, with a soft airbrush, I knocked it down in the shadows. Not only does this motif symbolize the horror to come in the story, but the tail sort of wraps around her similar to what a boa constrictor snake would do: a symbol of her situation. Also, dragons are cool (**Fig.14**).

Background

Using a wide assortment of custom brushes, along with the Smudge tool and some textures that I took from **www.cgtextures.com**, I tried to create a smoky and ominous background (**Fig.15**).

Final Steps

Finally I went in with the Blur tool on some edges, which I wished to recede into space, and I added a fabric texture to her kimono. On top of everything, in an Overlay layer, I put a subtle paper texture. I think the smooth rendering style that I predominantly used requires some variation so it doesn't become boring (**Fig.16**).

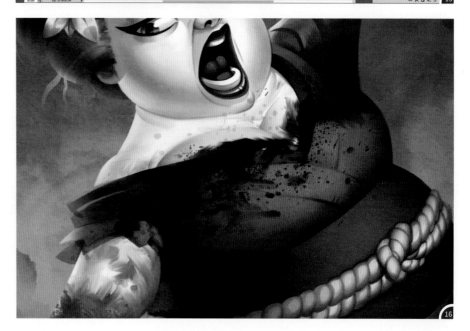

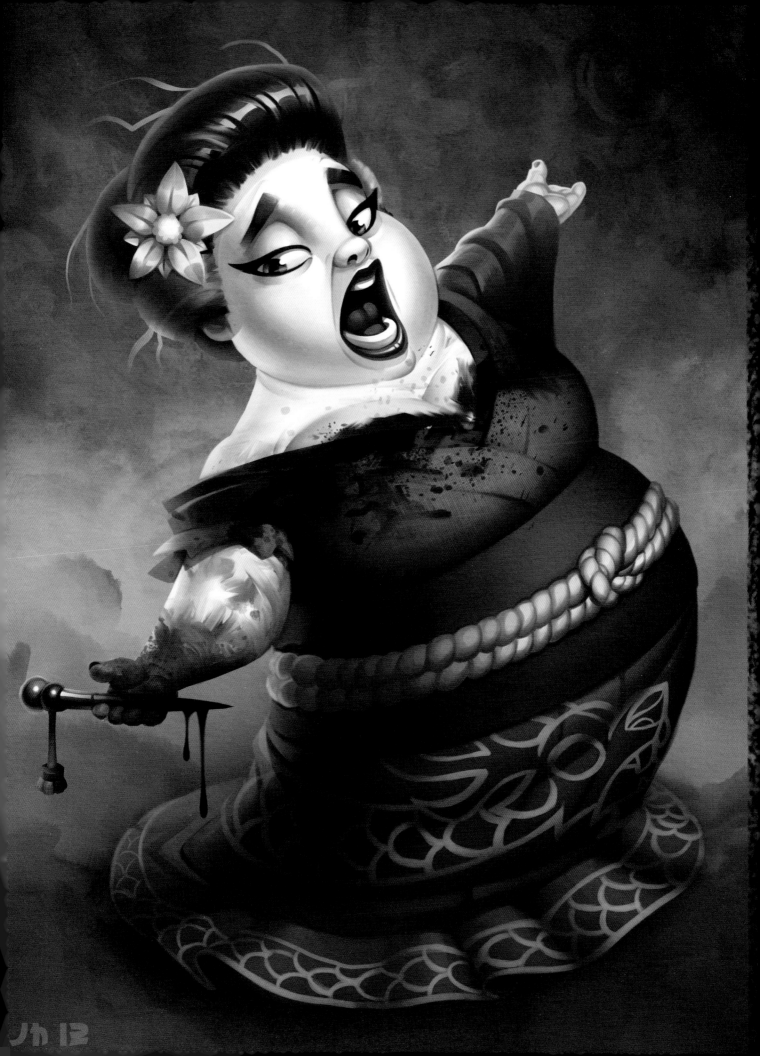

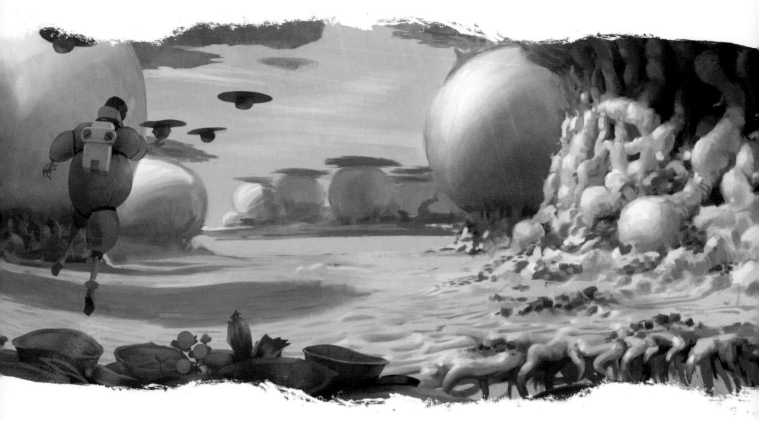

CARTOON ENVIRONMENTS | ALIEN WORLD

By Simon Kopp

Introduction

In this tutorial I will show my process of tackling a painting from start to finish! My goal is to create an alien-type landscape; therefore I will have to make up something completely new.

Existing Examples

First of all I look up the works of other artists. What did they do and what already exists? This step doesn't need to be taken unconditionally, since this may hinder your own creativity immensely. It can block your senses for your own ideas, but I've found it can be very helpful to get a slight overview about what has already been done. If there is nothing in my own reference collections, I search the web. For example, CGHub, DeviantArt and even Google are great sources for every kind of alien world. You will then have to decide if you like what you see or what you could possibly do better.

This is when I get my first ideas. I look for things I didn't see or things that could be combined in

a new and unique way. Then I write them down! Written words can be inspiring and can help to bring that initial idea back into your mind at a future work stage.

It is also important to know what you have on your planet. Which kinds of plants and animals are there? Get yourself some photo books of wildlife and forests from every region of the world. It is really important to know what is already here!

Get the Idea

In the next step I sharpen my own idea of what should be implemented into the picture. I continue writing here; brainstorming in a written way is the best way for me to get satisfying ideas, especially when the content of the idea is vague.

Start with a white piece of paper and write down one word. For example, the topic you want to deal with. In my case this would be an alien planet. So I start by writing down "alien". The

first thing that comes to my mind is Area 51, so I write that down too. Next to Area 51 I write down military, aircraft, air, sky, clouds, water, pond, etc. And there I am. The first idea of what I want to do builds up and I decide to make "pond" my main focus.

Next I think about the different parts of a pond. What does a small area of water consist of? What lives in it? I do that in a similar fashion to before, writing down what comes into my mind.

Then I look up some of the new ideas on Google to get some more inspiration. I find water lilies an interesting overall theme and decide to stick with it. They are flat, thin and build a layer on the surface of the water. That sounds pretty interesting to me: a world consisting of layers, a planet growing by the plants living on it, building up structures layer by layer.

To avoid having just horizontal lines in the picture, I decide to counter the thin layering with

thick, fleshy, round shapes; something along the lines of fat carrots or beetroot to show some weight on the thin layers.

Drawing Time

Now I sit down in front of my PC and go through my references. I think about what I could do with the plants. How should they look? How do they interact with the world around them and how do their roots work? As I already have some ideas in my head, I start scribbling.

Always have references to hand so you can look stuff up. You're not supposed to know everything, and don't be shy about getting a thought down quickly if you have a good idea! I had one and I feared forgetting it over night (**Fig.01**).

" JUST BY LOOKING AT OTHER ARTISTS' PAINTINGS AND SEEING HOW THEY MANAGED TO SOLVE PROBLEMS I KNOW I WILL ENCOUNTER DURING THE PAINTING PROCESS, I LEARN A LOT "

As I'm drawing the first, rough ideas for the plants, I also start thinking about the format and perhaps even about a composition for the final image. They are just vague ideas at this stage, but it is better to have them written down than be disappointed later because you didn't sketch them (**Fig.02**).

This is also the time where I think about colors. What color scheme do I want to use, what fits my purpose? This is not thinking in value, but more in local colors. I know I want to go with red colors for the leaves, but I'm going to make more concrete decisions about that when I start painting. I always take a look in my library of paintings where other artists have done a color scheme like that before and how they tackled it. Just by looking at other artists' paintings and seeing how they managed to solve the problems I know I will encounter during the painting process, I learn a lot.

01

02

121

I do two quick paintings to get first ideas for the composition. Later on I decide to go with none of them. But it is never wasted time to find out about what you don't want to do (**Fig.03 – 04**)!

Preparing the Image

As I continue to develop the image, a certain idea crystallizes in my head that I want to pursue further. So I roughly sketch it in Photoshop and it suits my thoughts. I create a new document in a portrait format and build up a perspective grid. That helps me so much while drawing and painting later, and it is necessary to get everything right.

I use the following rules for setting up an image. Make a guideline where you'd like the horizon to be. It can even be outside the image; it doesn't matter. Open the Paths palette and create a new path. Now select the Pen tool (P) and click where the first vanishing point on the horizon is supposed to be. Then click somewhere else.

> **Quick Tip:** Later when drawing or painting, the line can be easily moved by holding Ctrl and clicking on the end of the path. It's important to note that clicking the path will move the whole path; you just want the end to move. If you want to do a fast grid you can right-click your path in the Paths tab and hit Stroke. That will draw the path with your current brush (**Fig.05**).

Next you need to create a new layer. Go to Filter and click Vanishing Point (**Fig.06**). A new window opens. Click every side of your now created rectangle to create a grid. Try to be precise! Once you are done with that, you can click and hold the sides of the blue grid and pull them outwards, so it covers your canvas with squares in perspective. These squares are such a big help as they are reliable size measures for the eye in perspective. Next to Grid size you will find a little menu button, click it and check Render Grids to Photoshop. Click OK and love your grid!

Drawing

Now I take the next step and draw the image to a stage that I can comfortably work with in the painting process. I don't need anything refined

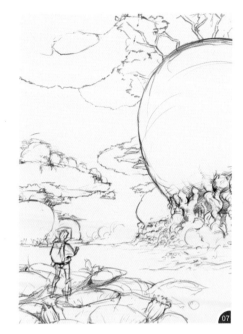
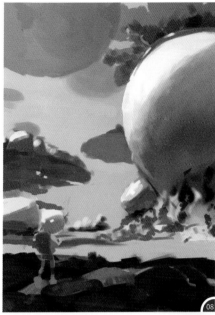
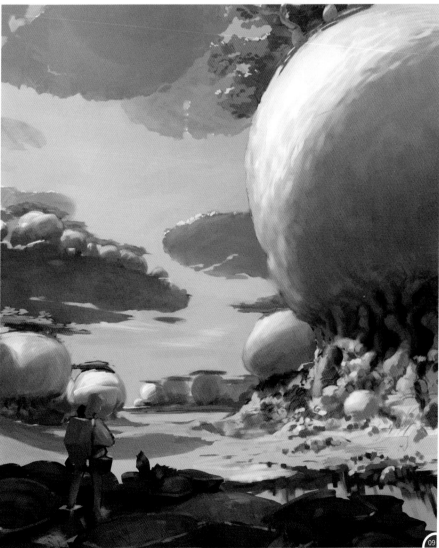

in the drawing as I will change the perspective, sizes and content a lot while painting. I rarely get a drawing on the PC to a finished state, as it is just a means to an end for me (**Fig.07**). This doesn't take as much time as completely abandoning a drawing from my workflow. I would have to tackle too many things at once. Getting values and colors right is hard enough.

> ## YOU CAN OFTEN RECOGNIZE IF A PAINTING WAS PAINTED WITH COLORS FROM THE START, OR IN BLACK AND WHITE FIRST

Color Block-in
A step I like to skip is adding values to thumbnails. As this image is going to be in bright sunlight, I already know what to do and where the light comes from. I'm aware of what will be lit and what will be in the dark.

I rarely do thumbnails anymore because I always go too far with them and I have not found any convincing ways for me to bring color to a tonal painting, as colors change values drastically. You can often recognize if a painting was painted with colors from the start, or in black and white first and just colored afterwards. The second type happens to have two kinds of brush strokes, the value brush strokes and the ones you brought in your colors with, and that always boggles me. It doesn't harmonize as well as just starting with colors right away, because it often just doesn't look consistent. I'm not saying it is a bad way! There are artists out there who rock this way. It just doesn't work for me.

I work in the block-in stage for a while, since I find most of the errors here. Mirroring horizontally helps a lot, but I always tend to forget about this while working. Changing colors and adjusting levels is a great benefit of working digitally, and also a vivid part of the block-in (**Fig.08**).

Finishing the Painting
From here on it is just work! After having the block-in ready it's mostly painting in the details

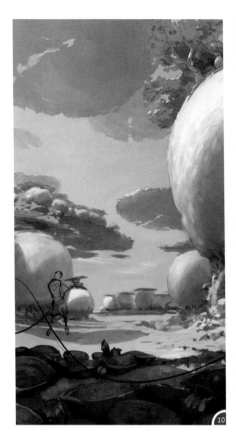

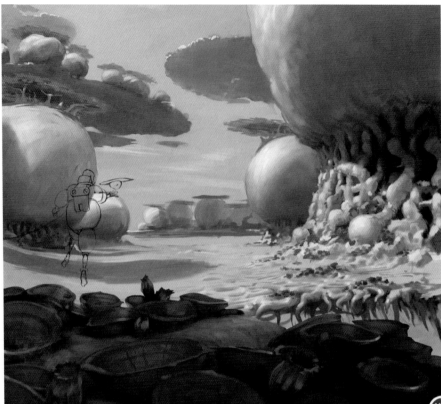

now. I must never lose concentration as there are some mistakes that have definitely crept in that I need to find in the process (**Fig.09**).

There has been some progress at this point and by looking at **Fig.10** you can see some rather big changes. I delete the astronaut and sketch a new one. Having him floating appears to be better and gives a sense of weightlessness to this world. I also adjust the size of two of the trees in the near background and now the detailing starts.

I still dislike the astronaut and sketch a new one (**Fig.11**). He gets a rather tight line drawing as I am not as familiar with humans as with landscapes. The viewer is most familiar with humans therefore everything has to look right.

At this stage I want to add more plants and details to the world. I give myself a pat on the back for having ideas sketched down and add some to the image. I also start to detail the astronaut (**Fig.12**). As I don't like the arrangement of the flying things, I change them around and add some finishing touches to the atmosphere and surroundings. And then I'm done!

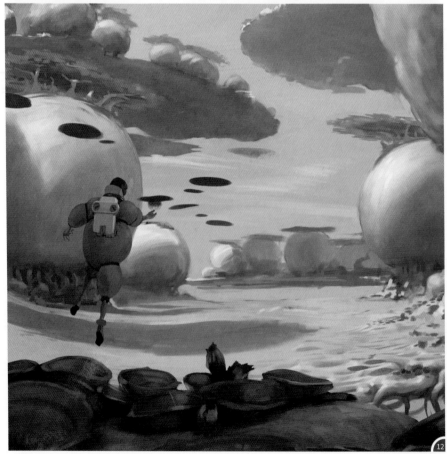

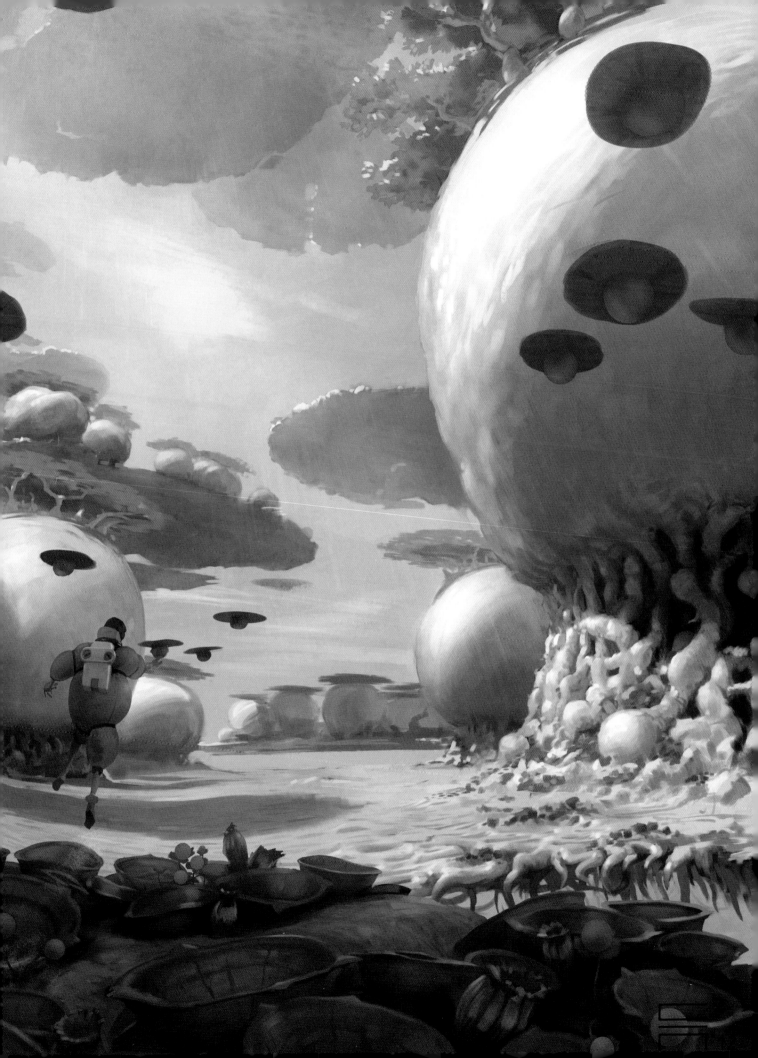

CARTOON ENVIRONMENTS | FOREST VILLAGE

By Ivan Smirnov

Looking for Ideas and Inspiration

I get inspiration for such works from the world around me, which is so varied and rich, as well as from recognized painters who work using both digital and traditional methods. While working on a picture with a lot of elements, I try to move from a general image to details. It lets me make required changes quickly and if I stop working at any moment, it will remain well-balanced.

Creating Mini Sketches

Before starting the main part of an image, I usually spend some time making some mini sketches. It gives me freedom when it comes to choosing the composition. This stage is extremely important for the final result, as it allows me to assess several variants of the possible composition quickly.

While creating the mini sketches, I was trying to achieve the effect of a magic and cozy place in the picture. Finally, I chose an unusual location for the houses. By surrounding them with rocks

I was trying to create a sense of coziness and a feeling that this place is hidden from the outside world (**Fig.01**).

At this stage you should pay particular attention to the values of the future image, dividing it into planes and grounds. First of all, the image of the surrounding area should give viewers a feeling of space and depth. To reach this effect a viewer should understand the placement of the objects within the frame and how far away they are.

A sense of depth can be easily achieved by following some simple rules. Contrast range becomes stronger in the foreground and weaker in the background. It is also important that main silhouettes in every plain should be distinct.

To attract the viewer into the picture you can add some shadowed objects in the foreground. They give the viewer a feeling of close proximity to the scene. In this case, a big tree with roots turned out to be an organic decision. Although it doesn't

mean that the foreground should always be taken by large dark objects. This technique will work with smaller objects as well.

After I chose the sketch to work with, I created a new document with an enlarged resolution so I didn't feel tempted to draw in the details. Then I could start working on them (**Fig.02**).

> **" I USUALLY START ADDING COLORS IN THE EARLY STAGES OF AN IMAGE. IT GIVES BETTER CONTROL OF COLORS WHILE DRAWING THE DETAILS "**

You can see that the enlarged sketch has very few details. Before I worked further on the image, I made a rough design of the houses with pointed towers, and worked on the shapes of trees and rocks (**Fig.03**).

I usually start adding colors in the early stages of an image. It gives me better control over the colors while drawing the details.

I began by applying a Color Balance to the black and white sketch. It gave some general color, which would be mixed further with other layers of paint (**Fig.04**).

Then the picture was divided into general colored spots. Coloring was done using the Hard Light blending mode. My algorithm of coloring is somewhere in between giving details their own color and ignoring the details under the color to create fine colorful spots. For instance, I haven't colored the grass evenly, but given it colors from cold green to warm orange. I've varied the hue and saturation of colors for other parts as well (**Fig.05**).

When I work on a picture, the polishing of its color continues until I finish working on the details. That is why after getting colors from Hard Light, I go on to work on them using Soft Light and Overlay blending modes.

You can intensify sunlight– make lightened parts warmer and brighter – by using these modes. On the contrary, you can add a cold color palette to the shadowed parts of the work.

It should be noted that the color blending modes of modern graphic programs are quite convenient. They let you change a picture in a moment without having to redraw the details overall.

After getting the appropriate tints I kept on adding details, using the derived colors and adding new ones (**Fig.06**). For example, the mushrooms on the tree on the left of the picture were too insignificant at the general coloring stage. But at this stage I worked them out with a suitable color.

I added new tints to the grass and made lots of tiny stones to show a scale in comparison to other objects. I also put some obvious cold tints in the shadowed areas on the tree and orange spots on the lightened parts. I thought about the design of the fairy houses at this stage too; they were given new elements in construction and some new colors (**Fig.07 – 09**).

During the next stage I worked on the details of the whole picture, starting with the background, and finishing with the leaves and bushes in the foreground.

New forms were given to the stones in the background, and light and shade became more complicated due to the separation of tints to warm and cold ones. Small bushes were added in the foreground to diversify the monotony of the stones. I did not make them contrast too much, so that they did not distract attention from the houses.

The construction of the house at the bottom of the rock was too plain and influenced the scale of the picture; therefore, one more floor was added, as well as some elements that helped to convey its size. You can also notice that the picture had gained more contrast by this point; colors appear to be richer and the overall atmosphere has become softer (**Fig.10**).

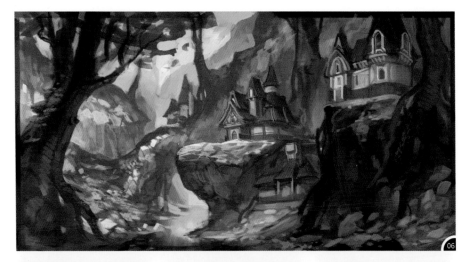

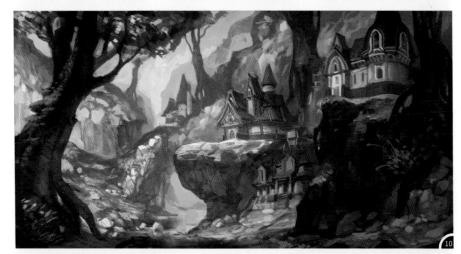

To achieve this effect you should do the following: copy the whole picture to a new layer, put it above in the Soft Light mode, and then use a Gaussian Blur filter. The derived layer would look like **Fig.11** in Normal mode.

Each time you add new details, you should try to make them visible in contrast to the surrounding color. It makes them more noticeable to the viewer. In the following stages the feeling of space between the main objects of the picture became stronger due to my use of haze. In fact, the contrast between them became more distinct (**Fig.12**).

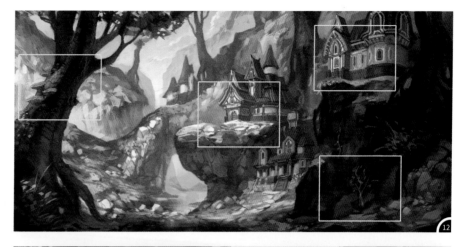

I added some clouds in the background and the sky became brighter at the skyline. Brightened colors appeared on the bank of the river and highlights were added to the water. I continued working on the details of the houses and rocks (**Fig.13**). Actually, when all the planned objects were outlined, the focus was working on details and polishing.

The main time was given to the detailing of the surrounding territory of the houses; at this point I realized that I wasn't satisfied with their size. I also thought that the houses needed to be supported by something else in the picture. So I copied them to another layer and made them a bit smaller. Then I added some fences around them. I also placed a rotunda in front of the one on the rock as I thought it would be nice to spend time there. I added another house with

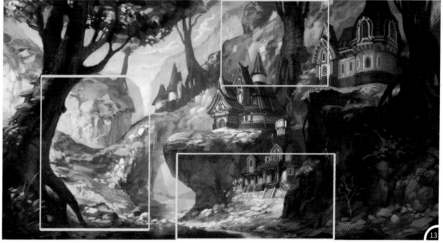

small towers in the background. As it is further away from the viewer, I wanted it to look like mushrooms (**Fig.14 – 15**).

To create a stronger story for the image, I added two characters; they are children hopping on the

stones over the river. Maybe, they are living in one of the houses (**Fig.16**).

It was then time for the final detailing of the houses. I added some beams and complementary colors to the walls to make them look more interesting and also put small windows in to give an impression of the scale. The wall of the house in the foreground is covered with ivy, which gives the effect of unity between the houses and the nature around them. I put some small ropes on the fences to join them. I also enlarged the children a little, because I thought they looked too small before (**Fig.17 – 18**).

In the last stage I made some final strokes and effects. I added reflections of the children in the water. I also lightened the environment by using Soft Light and Linear Dodge (Add) effects, and added sharpness with the help of the Unsharp Mask filter. At this point, the image was complete.

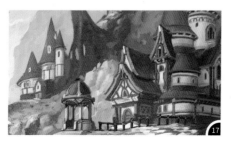

SPEED PAINTING CINEMATIC SCENES | DESERTED GAS STATION
By Shaddy Safadi

The Idea

The brief I got from the folks at 3DTotal said they wanted a speed painting on the subject of a deserted gas station, where something bad has just happened and everyone has had to leave immediately.

My first thought was that I'd do something with giant bugs and people riding them, an idea I've always liked. After a dozen unsuccessful lunchtime doodles in my little lined notepad, that I also keep my groceries and to-do lists in, I realized something I come to realize with every painting. That I suck and will always suck, and every painting up until now has been a fluke, but this time everyone will find out that I'm an incompetent phony.

After a good sob and taking a few days to recover, I re-read the brief and remembered a talk I'd had with Maciej Kuciara (a fellow concept artist of superior awesomeness), who kept telling me that nowadays it's "all about sci-fi, Bro." So

I decided to give sci-fi a try, even though it's stupid and everybody knows waterfalls and epic mountains are where it's at!

It's important to mention that I'm not into concepts just looking visually cool. Just looking cool by itself bores me conceptually. Of course, this industry thrives on and caters to people who love cool-looking images, so concepts must have that element, but I try to include something

in my images that gives a character a visual weakness or awkwardness that will add a touch of humanity.

Anyway it popped into my head that it would be cool to see a robot (sci-fi element) in a deserted gas station (fulfilling the brief) and drinking spilled gas from the ground like a giraffe. A few more doodles in the notebook and I was ready for Photoshop!

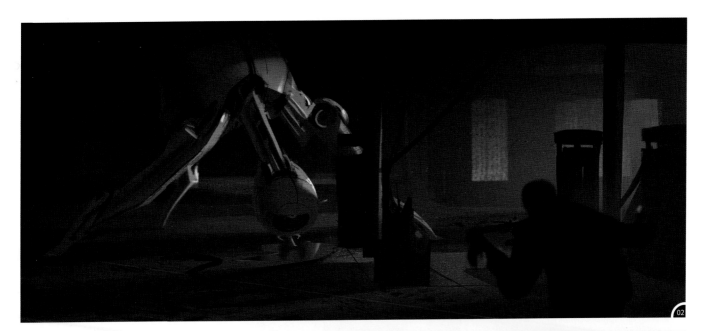

From the start I knew the main visual element was going to be a gangly robot drinking from a puddle of fuel with splayed legs and initially I wanted the robot to have a mysterious cloaked owner. Sometimes I figure out composition as a process of elimination – the robot must go here and not be centered, the legs must go here in order to read as giraffe-like – and so everything else had to work around accentuating that first read of the gas drinking robot (**Fig.01**).

Then it got a bit too *Final Fantasy*, so I went with a scared survivor holding a Molotov cocktail. Boom goes the dynamite! It was almost too much story to tell in one image, but that's my weakness and I'm sticking to it! I sent the composition to Maciej for feedback and he told me off for putting the foreground guy out of focus – apparently you never pull focus on something in the foreground if it's an important part of the narrative. You can if it's unimportant like a tree or debris... that makes sense, me stupid (**Fig.02**).

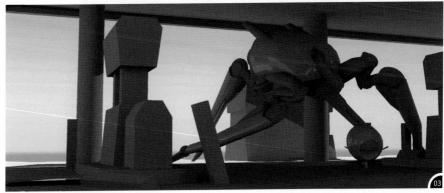

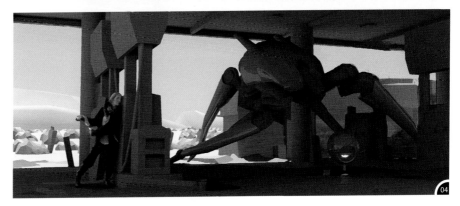

Concept Block Mesh

By now most people know that cheating is the way to go in this next era of concept art and all you need is basic Maya knowledge. Everything here was built with simple cylinders and squares, stretched and rotated into place. Grouping items is important and after I had one leg I could group and duplicate the rest. I made sure to do a hack modeling job; nothing was seamed, everything

intersected, and the model would be impossible to texture and that is good. A quick model is what you need to assess, and quickly change and reassess (**Fig.03**).

Another element that I played with was the camera (**Fig.04**). I played with the focal length and made hundreds of adjustments to find the exact shot I wanted. For rendering I used mental

ray within Maya and clicked on one button, Physical Sun and Sky, in the render settings. This threw a single sun light in the scene, which I could move around and all the ambient and bounce light was calculated automatically!

At this point I painted over in Photoshop to try out value compositions. Every element mattered and I tried to figure everything out as a test – I

didn't want any surprises. Also your quick instinct knows best and often an image can be ruined later with over thinking/adding.

In Fig.04 you'll noticed a figure, which came from photo shoots at various gas stations. I took over a hundred photos at first with my friend Kari, as I liked the idea of the character being a cute girl. We did fifteen minutes of various poses as when you're doing something like this, you can't forget you're still in the concept stage and you must get the person to try things you need. If they look like they are posing, so will the concept! Imagine you're sketching and be commanding. Direct them! I would say things like "You're scared!" and "This thing will kill you!" (**Fig.05**).

In the end I did another shoot with my brother, as Kari was slightly too hot to be a believable survivor. Nobody with skinny legs and large assets would get past day three of the apocalypse! My brother, on the other hand, is cut and already looks like a survivor, plus he was a better actor (**Fig.06 – 07**).

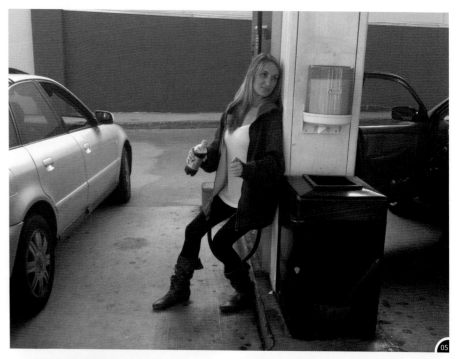

> **❝ IT'S COMPLETELY CRAZY, BUT OFTEN WE ARE TOO LAZY TO GET OUT OF OUR CHAIRS AND WALK DOWN THE STREET TO SEE THINGS FIRSTHAND ❞**

With two thirds of the shameless cheating out of the way, the only part that remained was gaining inspiration from other artists! I always collect a main image that has the style I'm looking for and I keep it in my PSD file above the image, along with other photo references. It's important to keep your own compositions as reference above the image too. Like I mentioned, your over-thinking brain will always try to overcomplicate an image after looking at it for too long, but resist the urge and keep it as you originally sketched it.

On a 40 hour painting I will often spend up to 10 of those hours just searching for photo references. In this case, a modern gas station was easy to go and shoot references of. It's

completely crazy, but often we are too lazy to get out of our chairs and walk down the street to see things firsthand! There were lots of great little details about materials, lighting and reflections that were great to see for myself, plus I could go at different times of day and shoot from angles that matched my lighting situation (**Fig.08 – 09**).

Painting

Finally, after about two days of work, I was ready to start actually painting the image, but even then I still didn't have a great idea about color. Waiting on color only works if you are not doing much with it. In my case I was just trying to make it that time of day. You can see that I

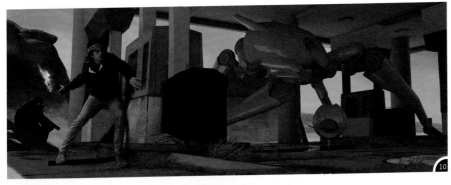

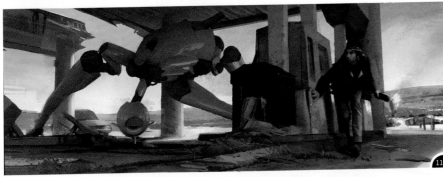

started a paint-over on the 3D block mesh. The huge amount of information that I'd got from the render let me know exactly where the ambient light was coming from and where it was brighter. It was just a matter of using my brushes and the Custom Shape tool to get a variety of wear on the structures. It helped to have reference work up to help me know when to stop doodling (**Fig.10**).

> **I LEARNED FROM A JEAN LEON GEROME SHOW AT THE GETTY THAT EVERY SINGLE THING CAN HELP DESIGN AND LEAD YOUR EYE AROUND THE IMAGE**

This was an awkward step where I prematurely finished the painting in a really quick and dirty way, to get an exact idea of the final color, composition, lighting, etc. I put a filter on the image to blur out the detail, which helped me to quickly and easily see what was being read. I remembered that the image was about a robot drinking like a giraffe while a survivor snuck up with a Molotov cocktail, and if any adjustments needed to be made, like putting a darker hill behind the guy so the fire read or moving debris away from the head so the robot read, then now was the time to make those adjustments. Not to mention that after this point in an image you can rest easy knowing that the image is headed where you want it to – no surprises (**Fig.11**)!

Back to square one now, as this battle wasn't over yet! I tried out a few different arrangements and showed them to my brother, a non-artist, to see what immediately grabbed him. He liked the simpler one on the bottom, saying the rest got too fussy with all the background stuff (**Fig.12**).

Also notice on the bottom image that the mountain got higher on purpose to balance out the empty weight on that side. The bottom image also had a nozzle hose that hung into the frame, which I thought helped lead your eye to the gas and gave it a reason for being there. I learned from a Jean Leon Gerome show at the Getty that every single thing can help design

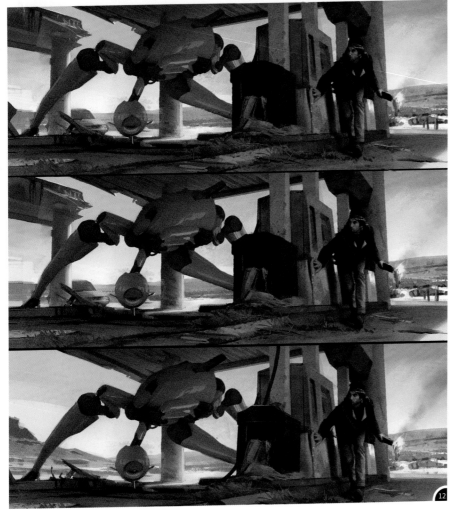

135

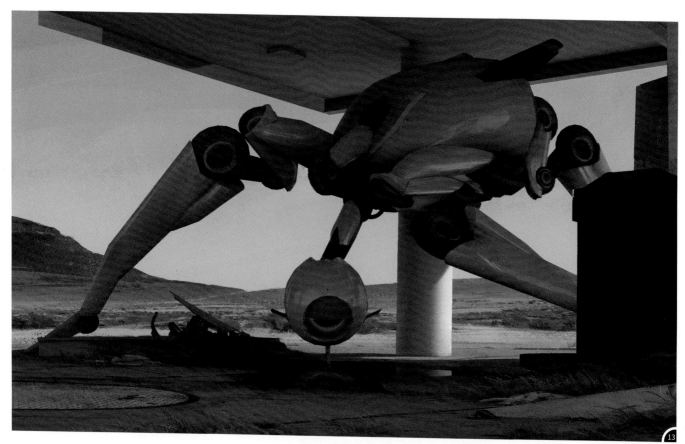

and lead your eye around the image, almost like there's an "art" to it.

So, **Fig.13** was about 20 hours after Fig.12, but notice how the robot was nearly done, and the guy hadn't been started at all. The difference was minimal between them, but that is the power of getting everything perfect before you even start painting, so you can't possibly screw it up.

Notice on the robot, I took care not to ruin the lighting from the render, but rather just added slight texture and wear. I included some photos of gears on an Overlay layer to pop into those circular areas that needed mechanical detail. The robot's eye also got a photo of a jet engine, and the grass and background were custom brush-painted. Take a look at my site **www. shaddyconceptart.com** for my favorite brushes.

Finishing Touches

At this point the image was basically done. Notice the guy is similar to the photo, but repainted so the strokes on him match with the strokes on everything else. It may seem weird to take things that are already a photograph and make them less real, but when you're dealing with three things – photo, 3D and hand-painted – it's a balancing act in getting things to match

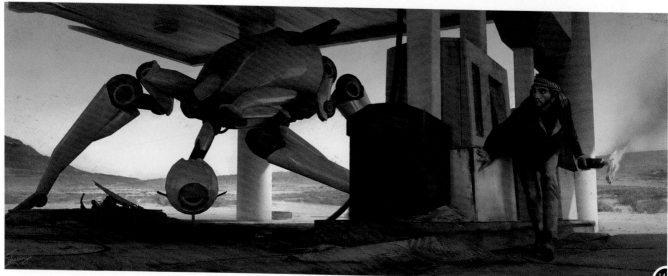

and it doesn't happen by just hoping it gels. Images like this are a fight the whole way, with a psychotic attention to consistency and detail, but at the same time being careful not to overwork it. That's why you need references (**Fig.14**).

I sent it to Maciej for some last-minute feedback and he said exactly this: "Much better than the previous stuff you sent. It looks pretty good already, though there is something lacking in the character's pose. It's like its good and all, but there is something I can't really grasp that makes it look a bit artificial. Not like super-bad or anything, just missing an extra touch in the pose or something that would make it 100% there. Also I don't like the eye of that robot creature. Everything else looks cool, but the eye reminds me of a cheap cartoon network flick. You could come up with something more unique and original." You can see his version in **Fig.15**.

Although his paint-over was awesome and his robot eye was certainly cooler, it lost some of the character of the robot, making him too, well, cool! The added fins were great and the detail notes were spot on. He is a master of consistency in detail and hiding photos. I also looked back at my Jaime Jones artist reference and felt like I needed more movement, so I made the image a little sand stormy, giving me an excuse to have more flying, burry bits! And with those last few changes, the concept was finished (**Fig.16**).

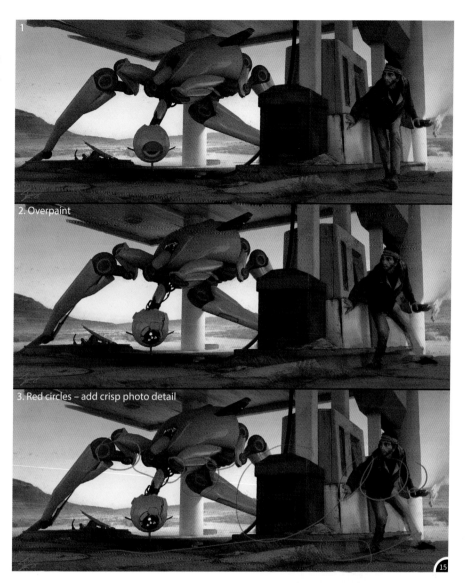

1

2. Overpaint

3. Red circles – add crisp photo detail

15

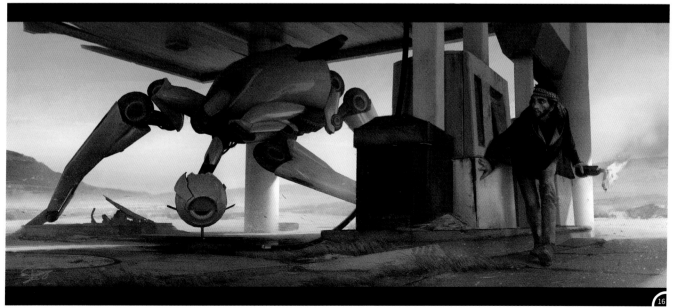

16

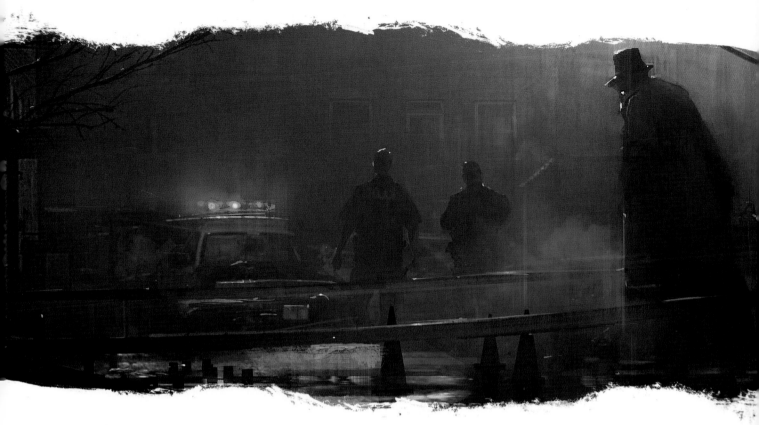

SPEED PAINTING CINEMATIC SCENES | CRIME SCENE
By Donglu Yu

Introduction

In this tutorial, I would like to show you how I brainstorm, research, create and finalize this concept piece, which is based on a given theme.

Mind Mapping and Research

The requirements of the concept are rather simple. The subject is a crime scene late at night, and I have been asked to emphasize the mood of the painting. There is a lot to think about before putting some strokes on the canvas. I collect my thoughts and let the mind-mapping extend as far as it can.

So here is the fun part! I have put down all the key words that come to mind when I think about the subject "crime scene". I divide them into four categories, which are the main components of an image: weather condition (for mostly outdoor scenes), mood, props and characters. Weather condition determines immediately how you will be able to light the scene. Once you have the light source, the mood of the painting can

then be easily decided. Characters and props complement each other; they play big roles in terms of giving the story plot and the set description.

> ❝ I KEEP ASKING MYSELF DIFFERENT QUESTIONS, AND ANSWER THEM AT THE SAME TIME ON THE CANVAS ❞

In this case, I write down police, yellow tape, traffic cones, detective, etc. These objects/characters have strongly recognizable silhouettes, which I can easily use in the foreground of the image. Sometimes, I have been asked how I find ideas for my painting; this mind-map is a very efficient tool to trigger fresh ideas and to link them together in a single image.

Aside from what's on my mind-map, some other factors are also part of the thinking process.

Region and culture, which can heavily impact the visual result of the props and characters I want to describe. The type of crime could also shift the mood of my scene. For example, a tertiary crime scene in downtown Tokyo surely feels different to a secondary crime scene in a small village in Transylvania.

Thumbnails

After mind-mapping, I start to throw out quick thumbnails. The thumbnails are pretty loose art-wise, as well as concept-wise. It's like a different type of mind-map, with a greater visual input. Do I want to put the scene on a highway or perhaps in a populated neighborhood? I keep asking myself different questions, and answer them at the same time on the canvas.

After doing about a dozen, I look at all of them equally and try to find the interest point of each image. Some of them focus more on the setting, while others focus more on the action. And this is where personal choice comes into play (**Fig.01**).

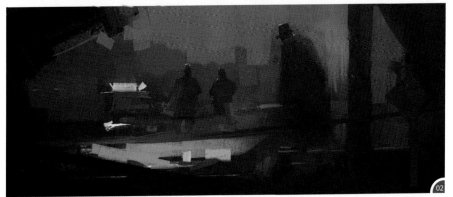

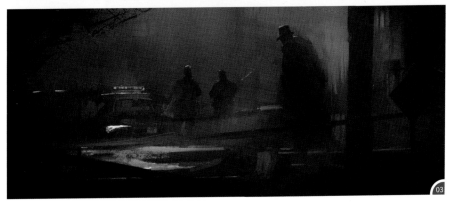

Finally an important thought strikes me; a line that all artists know, yet can be easily forgotten: less is more. That is why I pick the sketch that can be seen in **Fig.02**.

> ❝ OF COURSE, THAT DOESN'T MEAN SHOW THEM AN EMPTY CANVAS AND TELL THEM IT'S A FIELD IN WINTER COVERED BY SNOW ❞

Less is More

There are many interpretations of what "less is more" means. Here is mine for making this concept: don't show too much and don't show the obvious. Fewer elements give the viewer more space for imagination. Of course, that doesn't mean show them an empty canvas and tell them it's a field in winter covered by snow. What I meant by "less" is that if one police car does the work, I don't put two in unless there is a necessary reason for it. Equally, if I don't have to define the degree of the crime, then I don't need to put a corpse on the ground and blood stains all over the place and tell people, "Hey, look! It's a murder scene!"

I really like the thumbnail that I've chosen because it demonstrates the idea of less is more. I can see a car, two policemen in the mid-ground, a detective guy in the foreground, and some tapes. Four elements nail down a scene, and I have room to play with lighting and mood.

Continuing the Thumbnail

I take the chosen thumbnail and start to define the shapes a little more. There are mostly grey values overlapping each other to give some vague ideas of what is happening in the original thumbnail. The goal here is to define all the objects/characters only to the point that their shapes will be easily recognized. Don't start to be too precise with the lines yet, because it will give you a hard time when it comes to putting down colors. You will be afraid to destroy any precise lines that you have spent hours drawing; this will definitely limit your progress and the fun experience of making a concept (**Fig.03**).

139

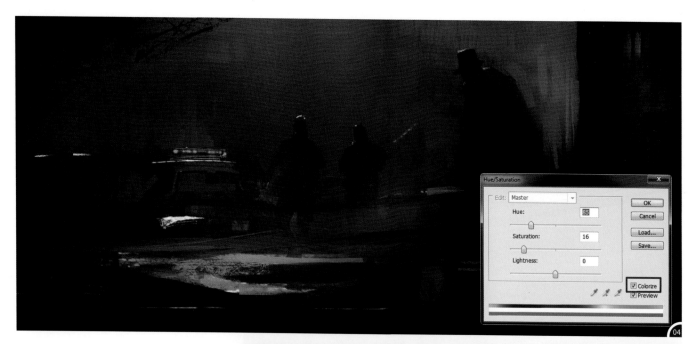

Colors

I merge all the layers, and do a Hue/Saturation adjustment. I tick the Colorize box and give it a hue according to my personal preference. Then I desaturate the color, so I can add more saturated colors later on (**Fig.04**).

Quick Tip: A good way to work on an image is always staying with less contrasting and desaturated tones until the last few steps, as this gives you good control over the image. Otherwise the color palette would soon become a rainbow palette with all the colors in the spectrum.

The painting obviously won't stay monochromatic. I pick similar colors to the original hue that I have just chosen and paint over the objects/characters. Just subtle nuances are fine. How the color is perceived by our eyes depends heavily on its neighborhood colors. The color of the "yellow" tape I've used is actually found in the green family in the Color Pick window, not the yellow family. However in the actual painting, our eyes define it as yellow because it has slightly warmer tones compared to the colored pixels around it (**Fig.05**).

I keep adding the color nuances to the whole painting, while maintaining the loose feeling. It is important to not give much definition yet.

Organizing the Layers

At this point, I start to organize my layers. Surprisingly, I first merge everything together! Keeping every single object on separate layers won't give you much of an option to have fun with the lighting; you end up spending more time choosing the right layer to work with than actually spending time painting. Matte painters have their different ways to work on an image;

they usually keep all the layers separate, so compositing can be done easily after. But I am making a concept piece here and the goal is to achieve the right mood in a short amount of time.

So here is the trick. I merge all the layers, but I create masks for different objects (**Fig.06**). The masks can just be flat colors; I usually use

black with the right selection. It saves your RAM enormously, thus you can speed up the painting process, even on big canvas. Computer lags make artists lose patience and, most importantly, painting momentum, so keep the layers simple and clean, and use the masks – it can save you a lot of time!

I add props using the masks too (**Fig.07**). I paint freely on the merged layers; when I need to paint on a specific objects, I make the selection with the corresponding mask layer, hide the selection and just paint within the selection to have clean silhouettes.

Brushes

At this point, I want to talk about the brushes. The question I have probably been asked the most frequently is: what brushes do you use?

Unfortunately, there are no magic brushes that can do the work for you. Everything depends on having basic knowledge, such as color mixing and lighting. Brushes are merely tools.

I try to stay with the essential brushes. The five brushes that I rely on are a small crisp brush to paint highlights and sharp lines, two texture brushes to give some tonal nuances, a fog brush to emphasis ambiance and a charcoal brush to do all the basic painting works (**Fig.08**).

I do create specific brushes for different projects, such as fantasy, science fiction or nature scenes. They can make the painting process faster, but they can't do a good job without a solid starting point, which can only be achieved with those modest, standard and simple brushes.

Lighting

For this late night scene, I have chosen a backlit situation. This lighting method can accentuate silhouettes and make the whole painting more dramatic. In this scenario, the detective's back shot is emphasized because of the light source behind him – this light source could be from a passing vehicle, from an open window or from the traffic light (as long as the light source is in the right place, it gives me a good explanation for its origin).

Since this is also a rainy night, the wet surfaces have a very reflective property; it gives me a reason to add sharp highlights on some edges (**Fig.09**). Observe the little highlights that I've circled in red; they are delicate, but they help make the shapes pop out in the painting and better define those silhouettes for the viewers.

I've stayed with less contrasting tones up until this point, but now it is time to give it a color

punch to make the scene more special. I add
some vivid purple and red for the siren lights,
using a feathered round brush to paint them in.
Also I enhance those colors with 60% Opacity on
the surrounding surfaces, because those surfaces
reflect the siren lights (**Fig.10**). Suddenly, the
scene comes to life.

Detailing

I continue detailing everything on the painting
to tighten the image. Now I have to make sure I
give all the objects clean outlines; this cleanness
gives the painting a finishing quality. Observe
the tree branches in the upper left corner, the
wires in the upper right corner, the police tape at
the bottom and all the props in the foreground
– they all have clean outlines. Inside the outlines,
I stay loose with textures. Those textures give
the image a more hand-painted feel. I add
small highlights here and there, and erase them

out occasionally to make them look loose and
accidental (**Fig.11**).

Finalizing

To make this rainy scene more believable, I
make a new layer and fill it with black. Then I

go to Filter > Add Noise (**Fig.12**). I enter a Noise
Amount of about 80%, chose Gaussian and tick
Monochromatic to get a layer filled with noise.

Next, I go to Filter > Motion Blur (**Fig.13**). I enter
-90 degrees for the Angle and a Distance of about

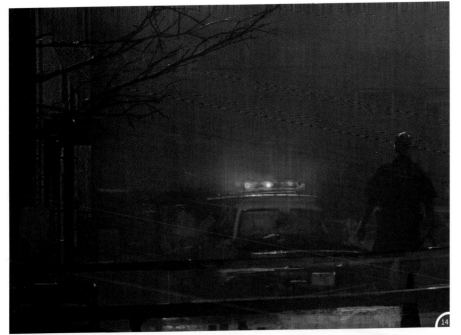

100 pixels, then I overlay this layer at about 60% Opacity (**Fig.14**).

Fig.15 shows a comparison of the before and after; observe how this special layer has tightened everything together in the painting. Moreover, I've used the fog brush to paint a subtle fog behind the detective; it makes the character more mysterious and adds some subtle ambiance to the scene.

In the very last step, I apply four adjustment layers to make the overall feel more consistent and coherent with the late night mood (**Fig.16**). Adjustment layers are very flexible and can give a painting different visual options without destroying the original painting underneath, which can be useful if you're working with an art director and need to be able to try out different things.

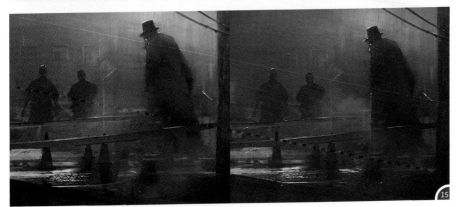

Now the painting is complete, it's time to put on the signature! Look back at the brainstorming map that I did at the beginning and the final result – is it a satisfying experience? Conceptualizing is not only a way to get interesting visual results, but also a training process to cement the virtual image in your brain onto the canvas. The more often you do this kind of training with your brain, the easier it gets to make concepts.

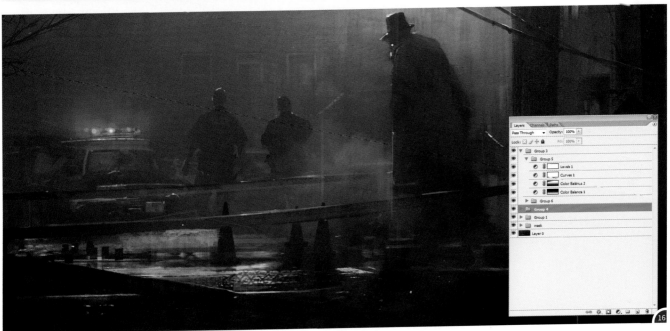

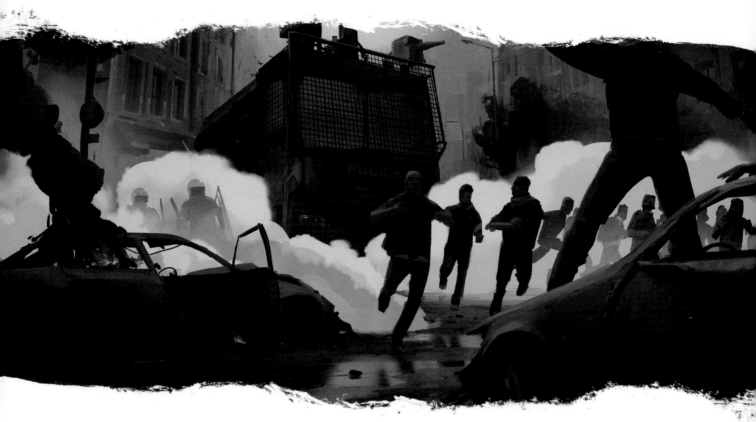

SPEED PAINTING CINEMATIC SCENES | STREET RIOT
By Michal Lisowski

Introduction

I always find painting for animation or cinematic projects fascinating. I think that any visual artist that can enter into another dimension will relate to this part of the industry. You painted something, and now everything you painted is moving. In this case the tutorial was a hypothetical situation, but I tried to treat it as a real cinematic production process. I was asked to do a speed painting of a street riot scene. My directions were action, mood and dynamic. The main goal was to capture the vital, critical moment. I also wanted to put the viewer in the center of the action.

With my experience of working in the industry, I can say that the role of a moodboard is not only to show a specific camera shot, but also to show the specific color and mood of the scene. It will be a guide for a 3D graphic team, whose task it will be to execute this mood in the animation. Sometimes the moodboard is painted based on the storyboard. An art director or one of the

leading artists chooses some key frames that should be painted to complete the vision of the final product, and every artist working on this project should know how the scene they are working on should look. I have also worked on projects, where the moodboard was already created with unlit gray frames in 3D software, and then your job is to add color and light effects.

As I mentioned before, for this tutorial I was tasked with creating a cinematic scene of a street riot. The frame needed to be designed in a way that put the viewer in the center of the action. I was also asked to offer an convey and moody atmosphere for the whole scene. The riot shouldn't look like a war or some kind of military conflict; rather it should be some kind of disgusted crowd of locals in the act of frenzied

destruction or a disappointed gang of football hooligan's war against police. Now I was briefed and ready to work.

When choosing my working technique, I had to keep in mind that I needed to paint the image relatively fast, because usually in this kind of project more than one image is needed, and the deadline is usually quite short. I chose the technique that would give me the ability to quickly put down and process readable paint. I worked out the style of painting based on the hard brushes and operated with simple shapes. Sometimes I also found the Lasso tool very useful. I will try to give tips on the whole of my painting process in this tutorial.

Let's Roll

I usually start my work with a very raw sketch, but it's more about capturing an idea than a good concept sketch. Sometimes it is just a few simple strokes that help me to catch an idea (**Fig.01**). The goal in this case was a dynamic street riot scene and I had a few ideas about how to enrich the narration. I wanted to paint a police anti-riot vehicle emerging from the smoke, looming over the rioters – a kind of David and Goliath story. The rioters are escaping in every direction, which gives the impression of panic and disorder. All these elements were crucial for my scene; however it was likely that I would add other elements along the way, like a crowd, buildings, vehicles, etc, but it wasn't important at this time.

In the next stage I tried to determine the color scheme for the whole scene. With a very simple, square-shaped brush I painted the silhouettes of the rioters and the vehicles. I used the Lasso tool for the biggest objects (**Fig.02**). I looked for some interesting colors and the result was a scheme based on the saturated variations of blues, violets, and greens, and a bright milky yellow for the smoke, to create contrast. The whole frame is cut vertically with this color. It gave me an interesting contrast to the objects in the foreground. I tried not to lose this effect in further steps. I knew that if I chose a good color palette at this stage, then there would be no frustration later. This is a real milestone in every one of my paintings.

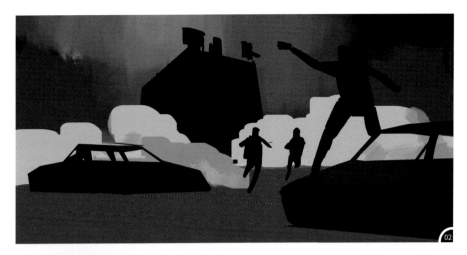

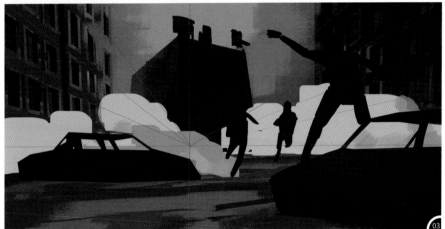

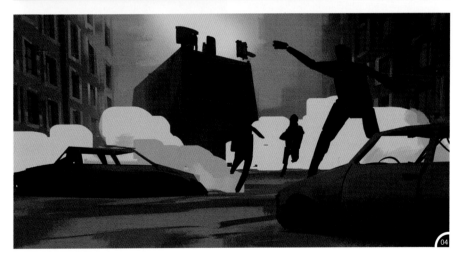

The next step was to enrich the environment with the objects that helped me to tell more of the story. To maintain a correct perspective, I marked the horizon and the intersecting lines. Now I could paint the building elevations on both sides of the street (**Fig.03**). I still used hard brushes and the Lasso tool. It was nice to pick the color from the sky and use it for the

windows with a lower opacity value. I also tried to enrich the color palette, but making sure that everything was unified as the image evolved.

I started to add light to the cars in the foreground to build their shapes. I also brightened the background with Soft Light, which gave me the deeper mood of the cloudy day (**Fig.04**).

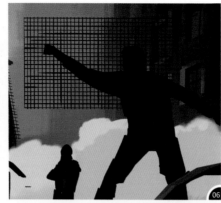

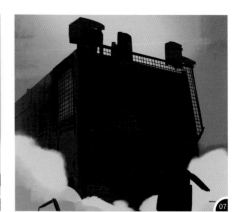

Bearing in mind that I had more time for painting, I could afford to paint more details in, like clouds of smoke or after-burn details (**Fig.05**).

To add an anti-riot shield on the police vehicle, firstly I painted it flat, without perspective (**Fig.06**), then used the Distort tool to match it to the front of the truck. I did the same for the side window (**Fig.07**). Doing it this way was beneficial as it allowed me to speed up the process and it created a good effect.

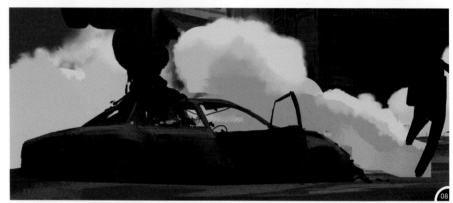

I thought that with the scene depicting a riot, a bit of fire would be a good addition. I put the fire in the car on the left, which added some drama to the scene (**Fig.08**). Next I painted lamps, trees and the texture of the asphalt on the street. I knew that it would have been quicker to find a cool asphalt texture and bring it to my picture, but I really enjoy studying new structures and materials, and trying to paint them with brushes or define my own brushes to give me interesting effects. In short – I don't have a problem seeing photos in other artist's art, but in my case, I don't have fun with that technique.

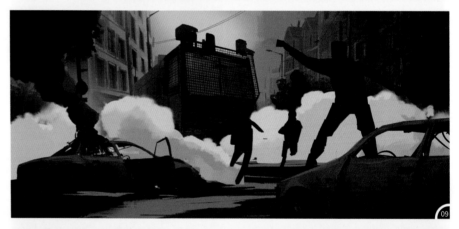

I used the same technique that I used for the shields on the police truck. Firstly I painted a flat texture with the random round brush configured with high values of Spacing, Size Jitter, Scatter and Count. Then after that I used the Distort tool to fit it to the surface of the street. Previously marked perspective guide lines were useful at this moment (**Fig.09**).

At this stage I also fixed the perspective in the background, which improved the dynamics of the shoot (**Fig.10**). It was worth it, because now,

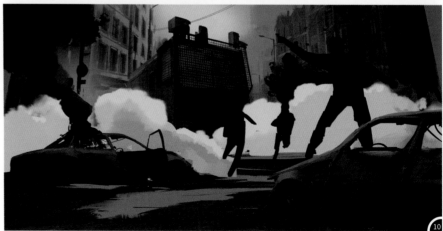

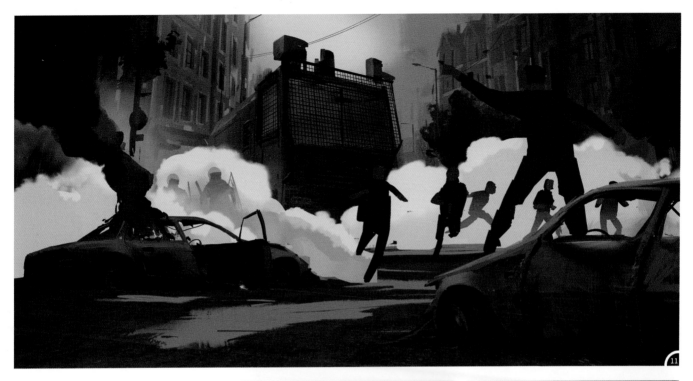

when I analyzed all the steps of this artwork, I could see that it didn't look as good as before.

Three guys and a police truck were not enough to call it a street riot, so I added rioters running through the smoke. I also painted policemen emerging from the bright clouds (**Fig.11**).

All the time I tried to keep adding details over the whole canvas, like the scratches on the cars, more running silhouettes in the mid-ground, as well as improving the existing parts (**Fig.12**).

I thought that it would be interesting to add reflections in the puddle. I copied elements just next to the puddle, flipped them vertically and used the Smudge tool and eraser to create a mirror effect (**Fig.13**). Also adding bricks and stones on the street gave me a rewarding effect.

At this moment I thought the whole scene was okay and decided not to add any more elements. I didn't want to cover up my work with unnecessary elements that could break down the composition. The time of adjustments and corrections had come. One of the biggest changes was to repaint the guy standing on the car in the foreground. I also added another figure on his right-hand side.

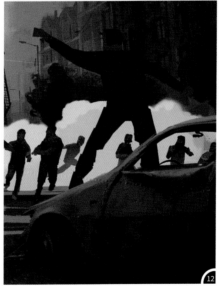

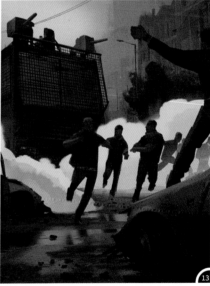

Now that the main character had the flare in his hand it meant that the riot had really begun!

At this stage I also wanted to check the legibility of the planes and the depth of the scene. I wanted to be sure that the values of the background elements weren't too intense. Sometimes it's easier to check this by desaturating the whole picture, re-sizing to a thumbnail size or looking at the image through squinted eyes. I tend to use the last method most.

Summary

Everything is readable to me, from every element of the narration to the overall mood. Also the background story matches the initial brief. Of course, everything could be more polished and done better, but I prefer to paint scenes loosely like this. This style is relatively fast and gives me a chance to develop cool pictures in a short time period. Everything happens with the use of a very limited set of brushes and only the Smudge and Lasso tool.

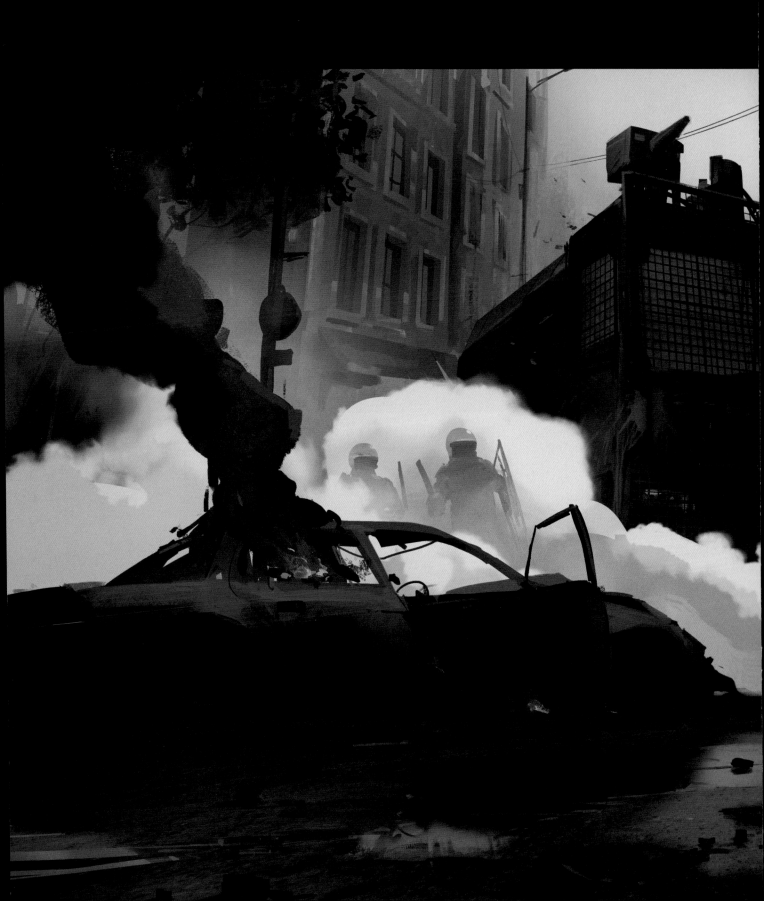

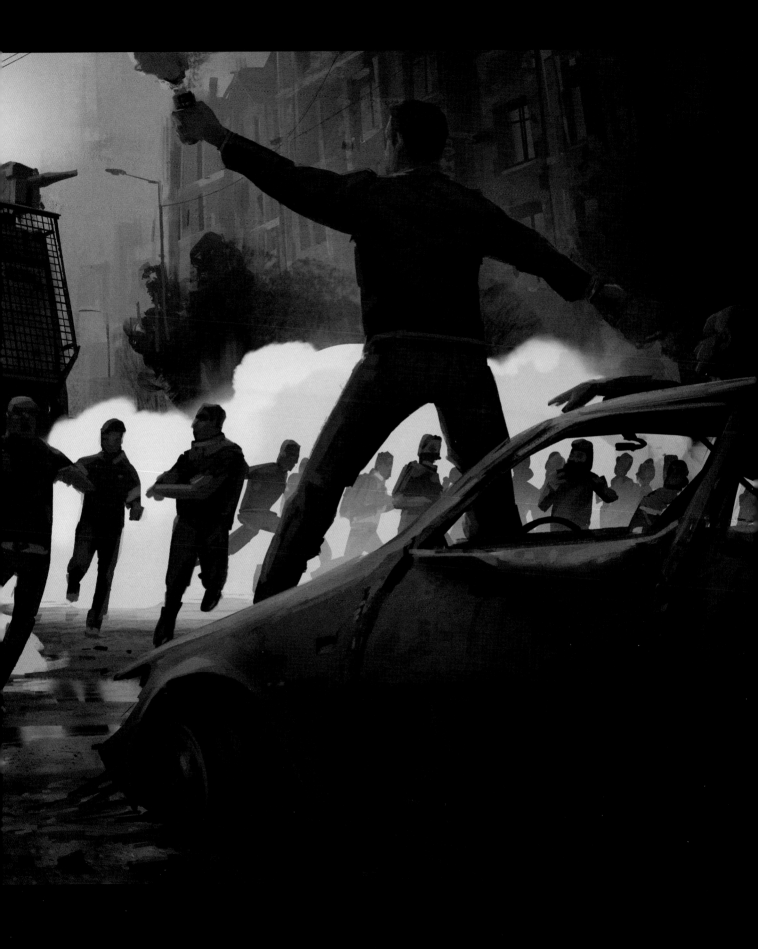

CHAPTER 03 | TECHNIQUES

The type of image you are working on will determine what techniques you will be using; this is why the knowledge of a variety of methods and work processes is invaluable to professional and aspiring artists. In this chapter the artists will be looking at the use of custom brushes, using Google SketchUp as a base, concepting using simple shapes, painting and aging materials. This, along with the variety of valuable tips and approaches provided throughout the book, will help you to improve your skills and techniques, and become faster and more productive in this amazing medium.

Project Files
Several artist have supplied resources to accompany their tutorials. These resources can be downloaded from: **http://www.3dtotalpublishing.com/ resources.html**.

Below you can find which tutorials have resources:

Concepting Using Simple Brushes
Circles | Squares | Triangles

Custom Brushes for Characters
Red Indian | Yeti | Alien

Painting Materials
Urban Environment

Aging Materials
Knight | Vehicles

Chapter Index

SketchUp Vehicles | All-Terrain
By Levi Hopkins

Introduction

Google SketchUp is a great way for artists to create 3D block-ins for their concepts. By blocking in vehicles in 3D you can solve a lot of problems in real-time that may not have been discovered until later down the pipeline in a production environment. If you have a strong knowledge of 3D you may be able to tackle assignments that may have been out of your comfort zone to block-in traditionally. However, there is no replacement for a traditional foundation in art, and 3D should just be an additional tool to compliment a strong foundation.

Gathering References

Gathering references is very important to any concept assignment. Whenever I'm assigned a specific project, I spend time in the beginning gathering references to help me understand the mechanics of what I'm about to tackle. Likewise, references help spur the imagination and reveal ideas that you may not have thought of in

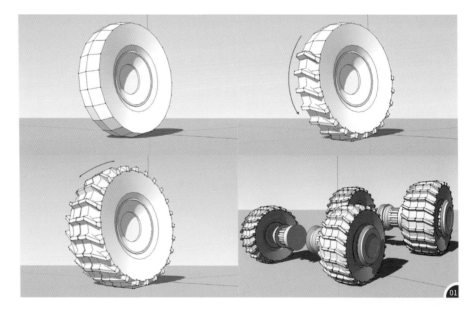

the first place. I will use references for design inspiration, mood, palettes and a variety of other things.

My approach to 3D block-ins is the same as when creating concept paintings. I like to keep things very loose, open-ended, with the ability to change the design at any time if I'm not happy with the outcome. I'm constantly reminding myself that a 3D block-in is just that, a block-in, and can be altered later in the painting process. It's very important to keep yourself loose when

using 3D in a concept. Just like digital painting, if you restrict yourself then the final outcome can lose a lot of energy or will stop you experiencing happy accidents, which are really important in art.

Getting Started

The assignment for this tutorial is pretty open-ended, other than needing to create a personnel carrier, all-terrain vehicle. The first step I take when doing a land-based vehicle is to block-in the wheels, treads, mech-legs or whatever else provides the locomotion of the vehicle. By blocking in the wheels I can quickly work on the basic proportions of the overall design. I start the wheel with a quick Circle tool and then begin to use the Push/Pull tool to make extrusions. By scaling these extrusions I'm able to create a more rounded tire shape.

After the basic tire shape is blocked in, I begin working on the tread (**Fig.01**). Since this vehicle must work on all terrains I've decided to make a very thick tread to help with traction. To create the tread I make a basic rectangle shape and then push/pull it into a more angled shape. Next, I use the Rotate tool on the tread with the pivot point being located at the center of the tire.

> **Quick Tip:** By placing your pivot at the center of the tire you can then make copies of the tread every 15 degrees until you've wrapped around to the original.

Once the tire tread is complete I make a copy of the half of the wheel I've created, and flip it on two of the axis to make a full tire. The final step is

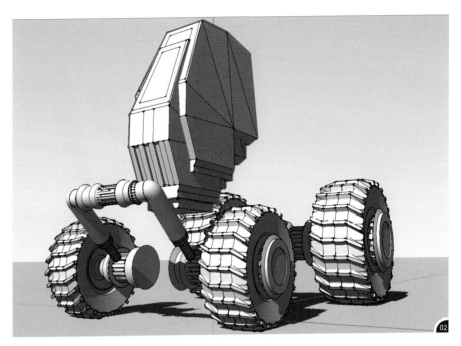

to make three more copies of the tire and place them in a position that would work for a land-based vehicle.

Vehicle Design

The exploration phase of a 3D block-in tends to be the most exciting and rewarding part. Once the wheels have been established you can start working on the overall design of the vehicle. I begin exploring by creating a basic rectangular shape that I then use the Push/Pull tool to make a bit more complex (**Fig.02**). I then use the Move tool on some of the edges to create more dynamic angles.

Once I've established this first shape, I like to incorporate a principle that is very similar to using custom brushes or custom shapes in

Photoshop. By creating this one shape I am then able to create a variety of others by simply scaling, rotating or intersecting multiples of the base shape (**Fig.03**). I will use this method constantly in a 3D block-in to help spur my imagination and speed up the process. By using this method you can quickly block in advanced vehicles or architecture, and with a few accent pieces it can become unrecognizable that you're just reusing one shape.

When I have a good set of pieces to work with, I start blocking them in over the wheel base (**Fig.04**). This is an exploratory phase that involves a lot of trial-and-error, and potentially creates an opportunity for happy accidents. Even after I have this step blocked in, I will still continue to tweak things until the end of the 3D phase.

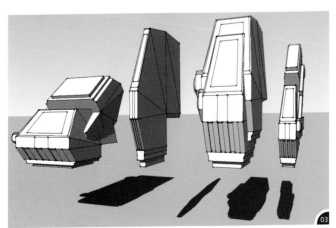

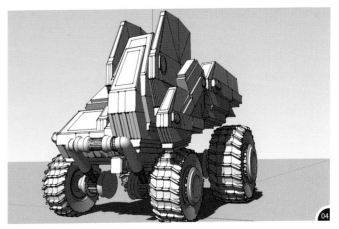

Now I add some accent pieces to push the character and purpose of the vehicle. I really like to play with light sources in my concept pieces, so for this vehicle I'm designing it under the premise that it works mostly in an environment with minimal natural light. By thinking through a small backstory, you can push some character into even a simple vehicle concept. I decide to add a bunch of spotlights, headlights or any other light source that could be created by the vehicle. The lights will add some complexity to the concept, painting and storytelling aspect of the design (**Fig.05**).

> " **IF I MADE A CHANGE LIKE THIS IN ONE OF MY DIGITAL PAINTINGS, IT WOULD TAKE A LOT MORE EFFORT TO PUSH THE PERSPECTIVE BACK INTO THE CORRECT ALIGNMENT** "

Finishing the Block-in

To finalize the block-in phase, I do a few simple tricks to help push out the rigid look that a lot of 3D can have. I basically take any major pieces of the vehicle, and tilt or tweak them so their alignment is no longer exactly 90 degrees. I take every spotlight and move them slightly to get rid of the factory feel. I also add one more set of back wheels and then rotate the front wheels as if the vehicle may be on the move. These are all quick techniques and adjustments that help push the design of the vehicle (**Fig.06**).

The final step in this block-in looks like a radical change, but in the end it's a simple tweak. I basically take the main structure of the vehicle and just flip it vertically (**Fig.07**). Changes like this are possible because of the 3D block-in phase. If I made a change like this in one of my digital paintings, it would take a lot more effort to push the perspective back into the correct alignment. Now it's time to paint.

Painting

To start the paint-over of my 3D block-in, I first need to decide what angle I'd like the vehicle at.

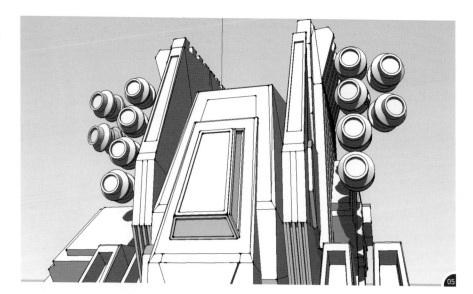

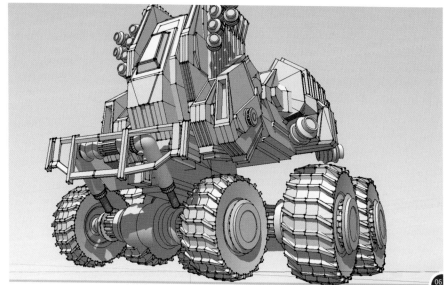

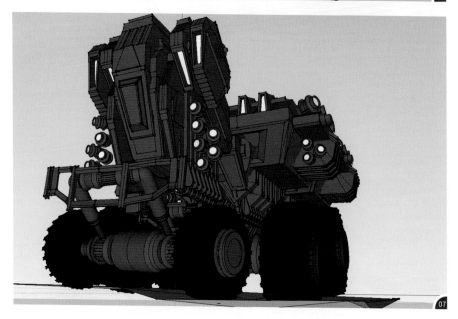

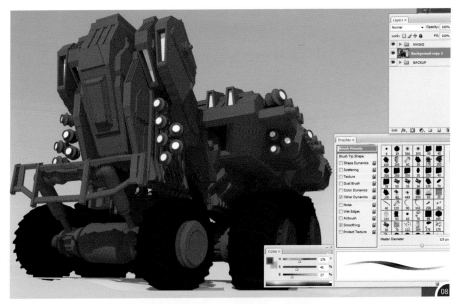

The nice thing about 3D is the ability to quickly maneuver the camera around and feel out what angle will work best in a painting. Once I've established the angle I do a quick render (**Fig.08**) and overlay the wireframe over the vehicle to help guide my perspective in the painting.

The next step is to create a bunch of layers that I will use as masks for my painting. I do this in SketchUp by hiding all the pieces of the vehicle apart from one, and rendering that isolated piece out. By doing this I can create layers in Photoshop that I can Ctrl + click on to get a quick selection. It's important in concept paintings to be able to have some nice, clean edges when needed – especially with vehicles and architecture.

> **THE NICE THING ABOUT PHOTOSHOP IS THAT THERE ARE A MULTITUDE OF WAYS TO CHANGE OR ADJUST COLORS, EVEN NEAR THE END OF A PAINTING**

Rendering

Now that I've laid the base groundwork for a painting, I can move on to rendering the vehicle. My first step is to start laying down the values, colors and hints of texture that I think will look good on the vehicle. This is a phase that I may continue to adjust throughout the painting process. I lay down color with a simple Multiply layer over the 3D block-in (**Fig.09**).

The next step is to start dropping in some paint in the background, along with brush strokes for texture. I'll often overlay old paintings I've done to help speed up the brushwork in this phase. By selecting all the masks I created earlier, I'm able to easily paint behind the vehicle (**Fig.10**).

As far as colors go, in my painting process they are constantly changing as the painting evolves. The nice thing about Photoshop is that there are a multitude of ways to change or adjust colors, even near the end of a painting. At this stage I know that I need my brightest values to be the assortment of spotlights and headlights

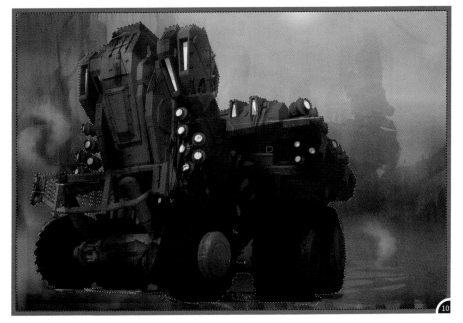

on the vehicle, so I tone down the brightness of the background with the Hue/Saturation panel (**Fig.11**).

After establishing the value structure between the lights, vehicle and background, I move on to more rendering-type tasks. I decide to tackle the light beams by creating a selection that resembles the shape the light will take from the source (**Fig.12**). I then fill in these selections with the use of gradients or a soft-edged brush, and then erase some of the light so it fades off into the distance.

Next, I tackle the grill on the vehicle. I do this by focusing in on an empty area on my canvas and then, with a textured flat brush, I paint down a simple bar that I then copy and paste to create duplicates (**Fig.13**).

I then move the layer to the correct position on the vehicle, free transform it into perspective and erase out any parts that should fall behind the main structure of the grill (**Fig.14**).

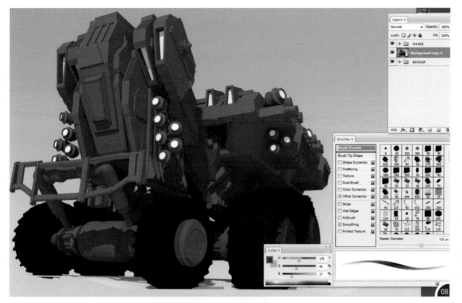

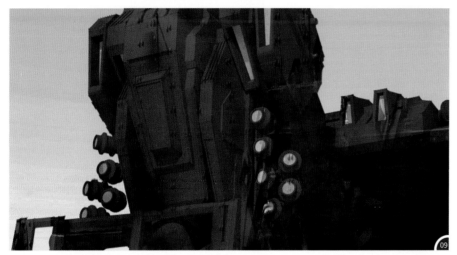

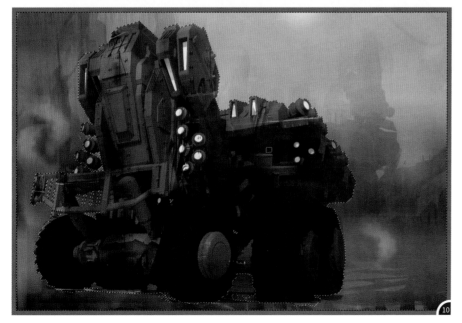

The nice thing about 3D is the ability to quickly maneuver the camera around and feel out what angle will work best in a painting. Once I've established the angle I do a quick render (**Fig.08**) and overlay the wireframe over the vehicle to help guide my perspective in the painting.

The next step is to create a bunch of layers that I will use as masks for my painting. I do this in SketchUp by hiding all the pieces of the vehicle apart from one, and rendering that isolated piece out. By doing this I can create layers in Photoshop that I can Ctrl + click on to get a quick selection. It's important in concept paintings to be able to have some nice, clean edges when needed – especially with vehicles and architecture.

> ❝ THE NICE THING
> ABOUT PHOTOSHOP
> IS THAT THERE ARE A
> MULTITUDE OF WAYS
> TO CHANGE OR ADJUST
> COLORS, EVEN NEAR THE
> END OF A PAINTING ❞

Rendering

Now that I've laid the base groundwork for a painting, I can move on to rendering the vehicle. My first step is to start laying down the values, colors and hints of texture that I think will look good on the vehicle. This is a phase that I may continue to adjust throughout the painting process. I lay down color with a simple Multiply layer over the 3D block-in (**Fig.09**).

The next step is to start dropping in some paint in the background, along with brush strokes for texture. I'll often overlay old paintings I've done to help speed up the brushwork in this phase. By selecting all the masks I created earlier, I'm able to easily paint behind the vehicle (**Fig.10**).

As far as colors go, in my painting process they are constantly changing as the painting evolves. The nice thing about Photoshop is that there are a multitude of ways to change or adjust colors, even near the end of a painting. At this stage I know that I need my brightest values to be the assortment of spotlights and headlights

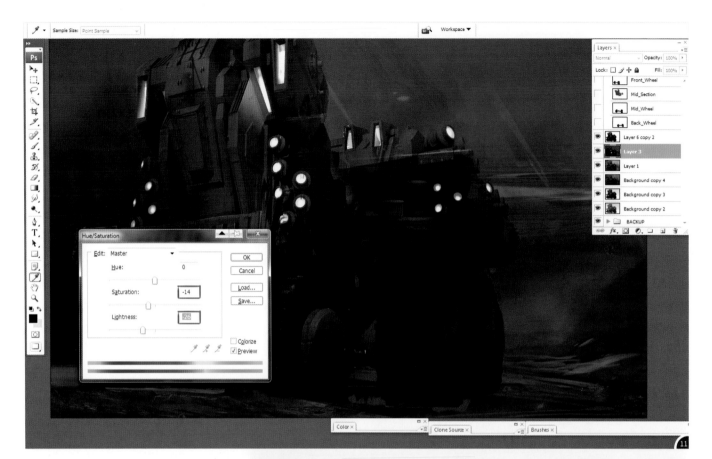

on the vehicle, so I tone down the brightness of the background with the Hue/Saturation panel (**Fig.11**).

After establishing the value structure between the lights, vehicle and background, I move on to more rendering-type tasks. I decide to tackle the light beams by creating a selection that resembles the shape the light will take from the source (**Fig.12**). I then fill in these selections with the use of gradients or a soft-edged brush, and then erase some of the light so it fades off into the distance.

Next, I tackle the grill on the vehicle. I do this by focusing in on an empty area on my canvas and then, with a textured flat brush, I paint down a simple bar that I then copy and paste to create duplicates (**Fig.13**).

I then move the layer to the correct position on the vehicle, free transform it into perspective and erase out any parts that should fall behind the main structure of the grill (**Fig.14**).

Once I've zoomed in on the grill area, I realize it's probably time to start putting down hints of highlights from all the lights on the vehicle. I do this by taking a simple soft-edged brush with the color sampled directly from the lights. I just do some quick strokes of paint to create the illusion that light is actually hitting some of the metal parts of the vehicle (**Fig.15**).

Next, I notice that some of the back wheels on the far side of the vehicle are still at the same value as the wheels closest to the viewer. To establish some depth in the piece, I need to push the value of the back wheels out. I do this by selecting the front wheel layer mask I created earlier, inverting the selection and then pushing back the wheels in the distance with the correct value (**Fig.16**).

Finishing Details

Now with some basic rendering I've reached the point where I want to start putting some finishing touches on the overall piece. One trick I like to do is to flatten the entire image, make a duplicate layer and run the Photoshop Motion Blur filter on the duplicated layer. I then erase out a lot of the blurred image with a textured flat brush. I erase more in some areas than others, creating a contrast in edge quality throughout the piece. Some edges in the piece will be super-sharp and clear, while others will blur almost into the background. This bit of motion blur helps integrate the vehicle with its background.

At this point I'd consider the image pretty much done. One thing a concept artist needs to learn is when to stop on any given piece and consider it done. This is probably the most difficult task for me as a concept artist. I really wish I could just render away for eternity on all my pieces.

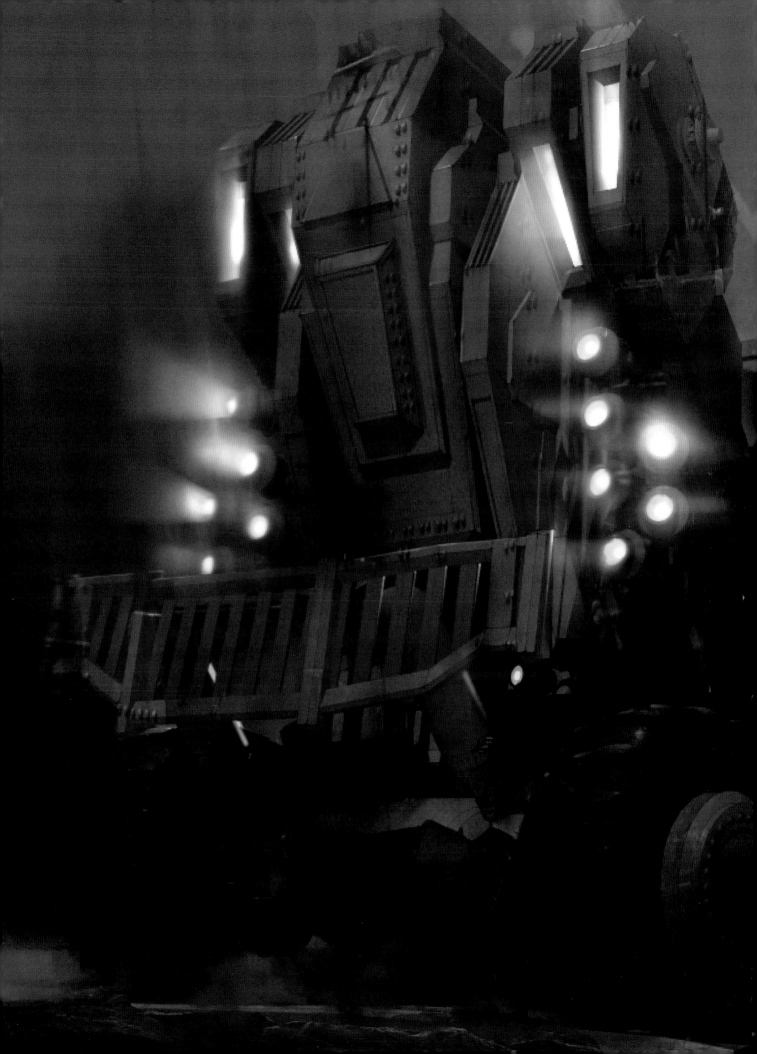

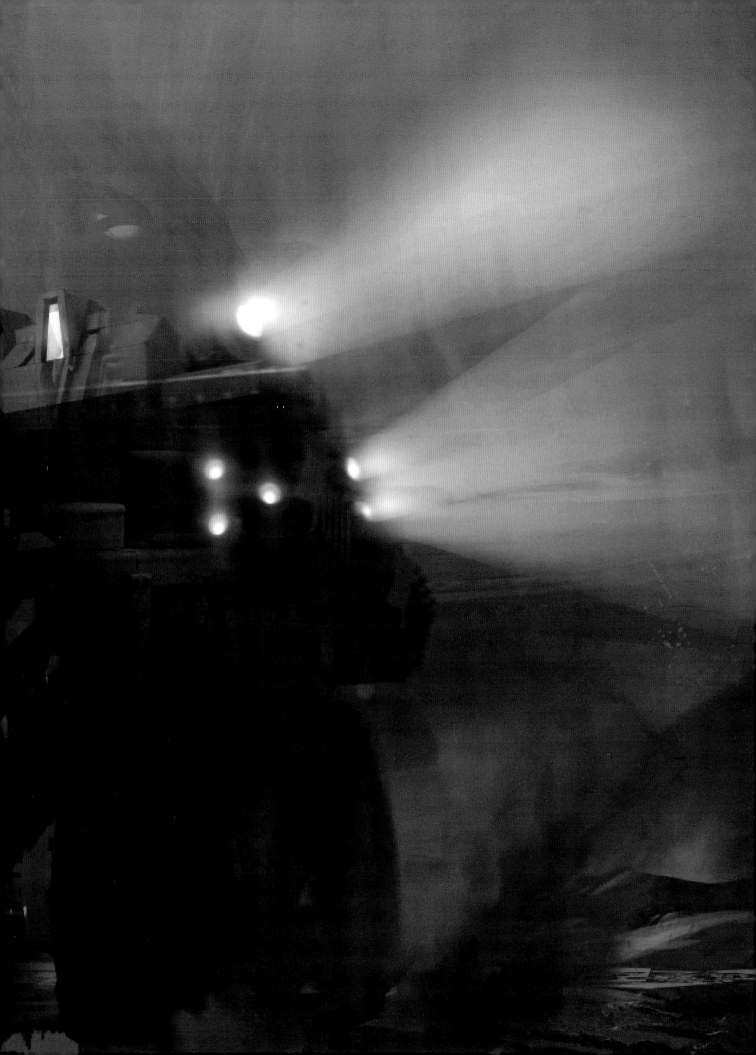

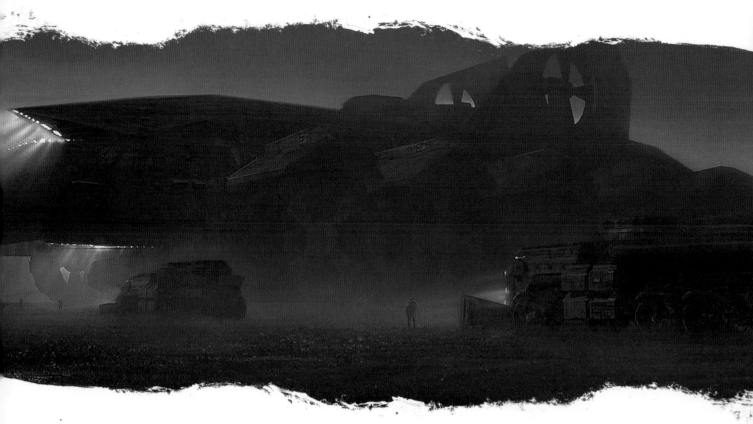

SKETCHUP VEHICLES | DROP SHIP
By JP Räsänen

Introduction

As you know, there are plenty of tutorials available these days that teach us about painting techniques in Photoshop and modeling, texturing and rendering techniques in a variety of software. The different pieces of software are like different tools in your toolbox. The better you handle them, the easier and maybe even faster you can develop your images. Instead of just talking about how to use these tools, I'd like to take this opportunity to share my thoughts and techniques about how I usually approach these design topics, and how I try to develop my way of thinking.

> " I LIKE TO THINK OF A MOOD BOARD AS AN EMBODIMENT OF IDEAS, THOUGHTS, GOALS AND FEATURES THAT I WANT TO ACHIEVE IN MY DESIGN "

When I have a subject for an illustration, I usually think about how to achieve my goal in the best possible way. This basically means that I try to decide how the subject should be represented and what the point of the image is.

When I think about this particular subject, a drop ship, I have to decide what is necessary in the design, and I do this using mood boards. They can be as simple as just a bunch of ideas in my mind or they can be a couple of reference

images. It really depends on the subject and whether I am designing something for myself, someone else, or a larger group of people. I like to think of a mood board as an embodiment of ideas, thoughts, goals and features that I want to achieve in my design.

I usually have the final composition in my mind when I start to develop an image. At first I concentrate on the things that I think are the most important. In this particular case I am thinking about the fact that a drop ship needs to have a drawbridge, a doorway, or some kind of ramp that can be used to load and unload vehicles and other things. The ramp is like the center of everything. It's a starting point for a design. I also have to concentrate on things like, how would I like to show the drop ship? What kind of camera angle should I use? What about the cropping of the image? What other elements do I want to add in? And so on.

I could adjust the camera to be inside the drop ship, to show how the ramp works and how vehicles use it to get in and out. I could also select another camera angle to show how big

the vehicle is or how it operates in air or on land. These are the decisions that define what kind of impression I want to create.

Here I am trying to tell as much as I can in a single image, so I end up using a camera angle that shows a few harvesters coming back to the drop ship, along with a couple of men and a few more drop ships in the air. I also want to add glowing plants in the field to support the story about harvesters coming back to the ship with silos full of grain. These elements help achieve the wanted perspective, scale and depth.

Modeling

I usually start by figuring out how big the vehicle is going to be. In this case I choose to model the tires first because they are the closest big entity and can be compared to human scale. Also they are easy to adjust (**Fig.01**).

After choosing the scale I start blocking out the spokes, which I also design to act like rotor blades. The blades are one of the key features of the drop ship so I want to make sure that the form is simple enough to be recognized (**Fig.02**).

After I have the basic shapes of the tires defined, I copy them a few times and make the first block of the body of the vehicle. Then I figure out how many of these tires I need to have. The key point here is to create a basic setup that I think will be believable. It means that I'm constantly trying to think of things like how big the wheels have to be to carry the body weight, what kind of wheels are needed, how they look and so on. I also try to think about aspects like where the center of the mass is to make sure the vehicle looks balanced. I end up copying the tires five times on both sides of the body (**Fig.03**).

To get the final form of the drop ship, I start from a basic rectangular shape and use the Push/Pull tool to create the wanted shape. Because I have designed the vehicle to operate both on land and in the air, I try to achieve forms that will serve both of these purposes. Therefore I add a pair of small rotors to the rear of the vehicle (**Fig.04 – 06).**

After the body shape and the wheels are ready, I design a mudguard that has a dual role in the design, because it functions as an engine or a

transmission mechanism for the blades and the wheels. I want it to be tilt-able so the wheels/ engines can be tilted like landing gear on a plane. The form is made by defining a basic slice plane. After I have the desired shape, I use the Push/Pull tool to get the final forms (**Fig.07 – 08**).

> **❝ IF I KNOW I'M GOING TO ILLUSTRATE A VEHICLE IN MOTION, I DON'T WANT TO PUT TOO MUCH EFFORT INTO DETAILS BECAUSE THEY CANNOT BE SEEN IN MOTION ❞**

When the shape of the mudguard is ready, I copy the shape. Copying can be done by pressing the Ctrl key while dragging the object in the desired direction. Then you just place the copied object where you want it to be (**Fig.09**).

Quick Tip: Another useful trick in SketchUp is to use the Scale tool for mirroring objects. First select the Scale tool and then select the element or the shape you want to mirror. When you have done this you have to select the direction (red, green and blue) you want to scale to (**Fig.10**). When scaling is active, press 1 and then hit the Enter key to get an exact mirrored object.

After mirroring and copying the mudguards for each tire, I finalize the model by adding some details to the front side of the vehicle. I add a few silos at the top of the vehicle and model the ramp underneath the vehicle (**Fig.11**).

At this point of an image I'm pretty sure of what kind of camera angle I'm going to use, so I know how much detail I'm going to need and where I need to put it. Details can be added gradually if needed. For example, if I know I'm going to illustrate a vehicle in motion, I don't want to put too much effort into details because they cannot be seen in motion. Instead, if I want to concentrate on the vehicle itself, I might need to model more detail. The level of detail really depends on the purpose of the design.

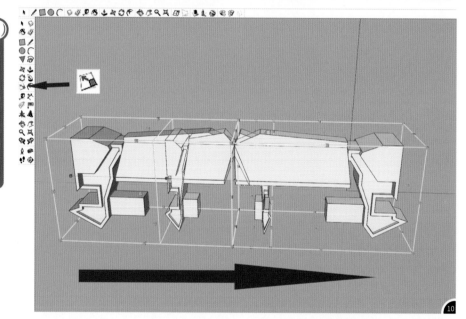

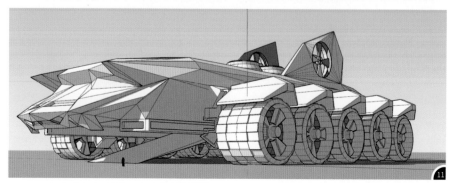

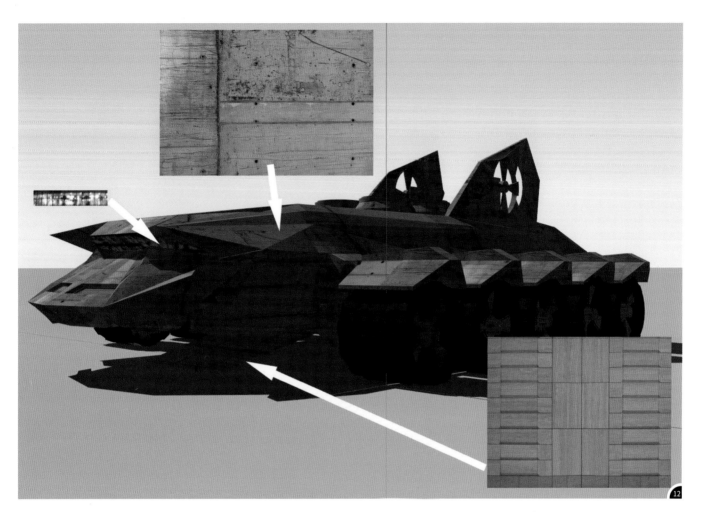

The final step for the vehicle is a very basic texturing job. When I do these kinds of over-paint images, I usually try to get some basic colors and values by using certain textures. Even if I create something metallic, I might select some sort of concrete textures that contain nice tones, colors and details. The basic texturing helps me to get a simple base where I can start the over-paint process (**Fig.12**).

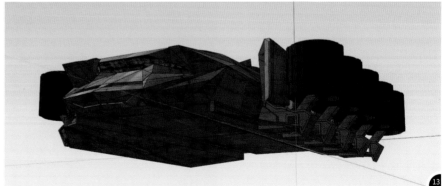

Fig.13 shows the vehicle in the air and shows the functionality of the wheels/rotor blades while it is off the ground. As you can see, I have also closed the ramp.

After finishing the main mode, I develop a harvester unit, which has a dual role in the design and overall composition (**Fig.14**). I use the same wheels from the drop ship. The harvesters and details in them help to unify the image's elements. I can also use them as a perspective tool to adjust the overall scale.

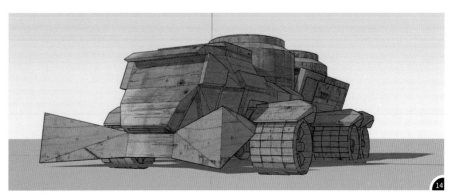

After testing a couple of camera angles and positions, I end up using the angle shown in **Fig.15** because it supports my goal to create the impression of a massive drop ship. As I mentioned before, I want this illustration to tell a story about harvesters that are coming back to the drop ship with silos full of grain, so I also add a couple more vehicles in the air to add story and perspective to the image.

Painting

When I have rendered the required layers, I usually do some adjustments on them and select a photo that can be used as a background. I also like to select at least one photo that I can use as a starting point for the overall lighting (**Fig.16**).

When I know what kind of lighting conditions I want to achieve, I can use the Brightness and Contrast tools to adjust the rendered layers to the same lighting conditions. For this image, I decide to create a sunset scene so I'm interested in photos that show different objects under sunset conditions. They are all useful because I can use them as a reference as to how to integrate rendered objects into the scene. At this point I'm interested in the overall mood and feel, not so much about texturing or details.

After getting the overall mood right, I decide to expand the image to the left and add some sort of blocking element, which helps to move the viewer's eye towards the main vehicle and its ramp. The headlights and the lights underneath the ship have a similar role. They have also been designed to catch the viewer's eye as the brightest spot in the image. Now it's time to set up some basic textures by overlaying them over the objects (**Fig.17**).

When the composition feels right, I decide to change the overall color tones to something more like a nightly blue. This is a simple trick that can be done by adding a blue layer in Overlay mode on top of the image. I usually like to use gradients or even gradients from photos instead of solid, even colors (**Fig.18**).

After the texturing and painting has been done, it is time to add more depth to the image. I

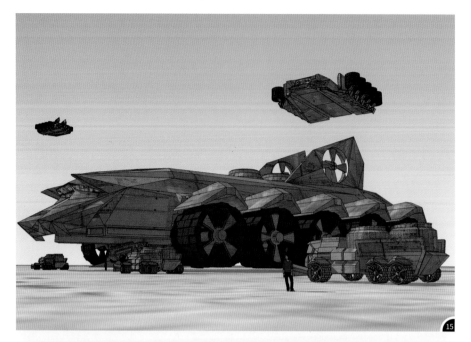

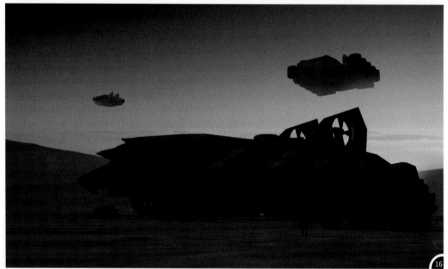

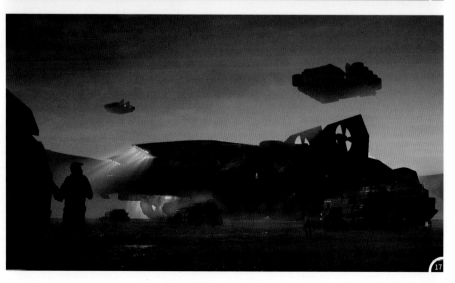

constantly try to think about the overall mood, feel, scene, location, time and other things that can provide any kind of help to achieve the final look and feel of an image. One of these things is haze or fog, which can be used to separate elements from each other and therefore get more depth into the image. I try to create spaces between different elements. This is a fundamental part of any form of art. Haze or fog helps to create spaces, but it also flattens the contrast. **Fig.19** represents the value changes from front to back.

Fig.20 represents another way of changing the tones between different surfaces or objects. This is like mimicking an Ambient Occlusion map by using different color tones on the bottom of the object than on the top of the object. It's like rendering the light so that there is less light on the bottom of the object and more on the top.

Finishing Touches

At this point of the process I am very close to getting into the finishing touches and the overall fine-tuning. I basically make sure that everything looks right and I usually do things like tweak textures, clear edges, make hue and saturation changes, and brightness and contrast changes. I try to highlight things that I feel are important

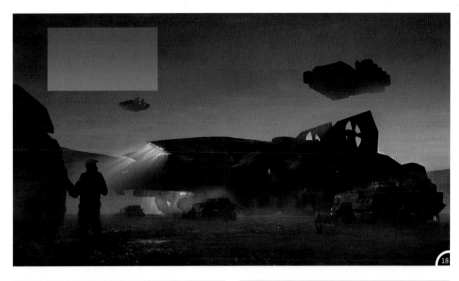

from a storytelling point of view and try to fade out things that steal the attention away from the key areas.

For example, if you look at **Fig.21** you can see that I haven't painted any light on the vehicles

in the air (green circles). I wanted to keep them clean and simple so that they wouldn't steal the attention too much. As you can see on the left in the image, the human looking at the ramp is also leading the viewer's eye in the wanted direction and the three harvesters have the same purpose.

SKETCHUP VEHICLES | SUBMARINE
By Carlos Cabrera

Introduction

In this tutorial you will learn how to create a futuristic submarine from scratch. We will begin with a 3D base made in Google SketchUp, then add textures and tweak it in Photoshop to create an illustration. I use these techniques on a daily basis, whether it is for an illustration or for game companies. Google SketchUp is a neat tool that can really speed up your workflow.

Before we start doing anything we need to find some reference images of what we want to paint. This is a very important and crucial process for any illustration, since we don't want to lose the focus of our main subject once the creative process begins. In this case we need to search for submarine pictures, particularly ones with blue tones on them like you would see in movies or military archives.

Once we have enough references it's time to draw some thumbnails. What we are looking for is a futuristic design for our submarine (**Fig.01**).

SketchUp 3D Base

I think that F is the design that comes closest to the futuristic look we're trying to produce. The next step is to open Google SketchUp, select the Line tool from the toolbar and draw a shape

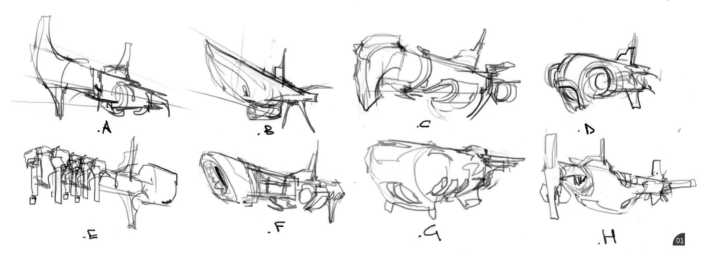

similar to the one in **Fig.02**. This will become the tail for our submarine later. Start modeling the submarine sections. At this point the order you create parts in is not crucial, as when you are done you can easily group everything together.

What we are doing at this point is basically drawing the submarine from a top perspective in SketchUp. Modeling both sides is not needed, since when you have half of the object you can flip it to save time and guarantee that it is perfectly symmetrical. Now we can use the Push/Pull tool to extrude the object (**Fig.03**). Select the face on the end and use the Scale tool to shrink it, which will create a sort of bevel effect.

Once you have this shape, repeat the previous step several times until you create a curve. You can then finish this section by continuing to add parts to it (**Fig.04 – 05**).

Now that we have half an object finished, select all the objects and group them (right-click > Group). Once this is done you can just copy the grouped object, paste it anywhere else on the canvas (make sure it's not on top of your object) and make a mirror to obtain the second half of the submarine's tail. The process is easy enough.

Right-click over the object and select the Flip Along option. Select the axis you want to flip; in my case, the red axis. Now you should have both objects aligned next to each other (**Fig.06**).

Select the Move tool from your main toolbar and select any corner of the cloned object. Once you have one picked, slowly drag your mouse to snap that corner to the original (**Fig.07**).

And that is it for the tail. All you need to do now is repeat the process for the hull. Remember we are only drawing half of the object as we will clone the other half later.

When happy with the shape, use the Push/Pull and Scale tools. This time, shrink the top face of the object. The main difference with this part is that we are going to use Scale on both faces. Use this on both the top and the bottom faces to achieve a cylindrical shape (**Fig.08 – 10**).

Select both of the front faces of the tube and extrude again to create the two bridges that connect the hull with the submarine front. Now we just have to model the front using the reference thumbnail we drew (**Fig.11 – 12**).

Group, duplicate and join everything the same way as you did with the tail (**Fig.13**).

With a simple cylinder and the bevel technique we can now create propellers and position them on both sides of the submarine (**Fig.14**).

Now we only have to model the bridge, following the same steps as we used to model our tail and propellers. Shape, push, scale, group and clone – easy as pie (**Fig.15**).

We have now finished modeling all the important parts of the submarine. Next we need to do combine each object, make it a group and deform it with the Scale tool if the final shape doesn't seem quite right (**Fig.16 – 17**).

Now that we have finished the modeling stage we need to go to File > Export > 2D Graphic and export the image to Adobe Photoshop. If you like, you can use a rendering plug-in like Podium or V-Ray to create a more realistic image.

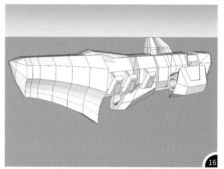

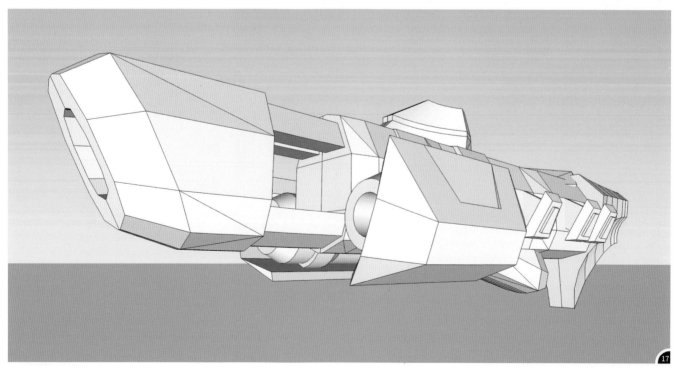

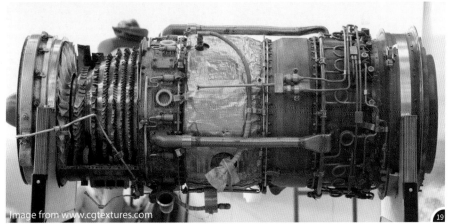

Image from www.cgtextures.com

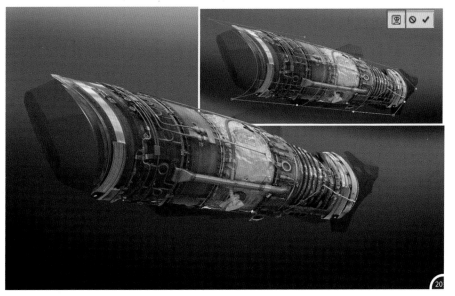

Photoshop Textures

For this stage we can use some textures. I've taken mine from **CGTextures.com**. We use these to add more detail to our futuristic submarine with a couple of simple techniques that anyone can learn in a few minutes.

Firstly we need to paint over all the visible faces of our submarine and leave it clean. We also need to create a mask of the entire submarine to help us later when we need to paint the background. Having all these elements ready means we can start using the color and atmosphere references we gathered at the beginning. The first step will be to paint a dark blue gradient (almost black) to light blue over our background (**Fig.19**).

To texture the submarine's hull I chose an interesting texture that belonged to an old plane turbine. Cut out the shape you want and get rid of the part you don't need. Don't worry too much about it being perfect at this stage (**Fig.20**).

It will probably be the case that the turbine texture is not in the same perspective as the submarine. To fix this, use the Transform tool (Ctrl + T) along with the Wrap function. Deform the texture to come up with a cylindrical shape (**Fig.21**). This is a technique I use to avoid having to look for a picture with perfect perspective.

Now that we have our texture in the right perspective, change the blending mode to Overlay so that it blends with our submarine. If part of your texture ends up covering the background, use the previously created mask to erase it and avoid fighting with the Photoshop Lasso tool. You results will vary, but it should end up looking something like **Fig.22**.

With the same technique, add detail to the submarine propellers and the front of the ship. You can see my progress in **Fig.23 – 27**.

If any of the textures don't look nice set to Overlay, try other blending options or even adjust the colors to match the image. Anything goes! In **Fig.28** you can see how the image looks with the newly applied textures.

New Shapes and Final Details

With your favorite brush, add detail to the shape of your futuristic submarine. Keep in mind where the light comes from. In this case it comes from above and is a light blue color. Start adding details by adding small strokes, as you can see in **Fig.29**. Add an army-green gradient from top to bottom. This will make the submarine shape pop from the background.

The next step is to create the lights with some simple white lines. Once you have done this, apply a light blue outer glow to them to create the volumetric effect that people love so much.

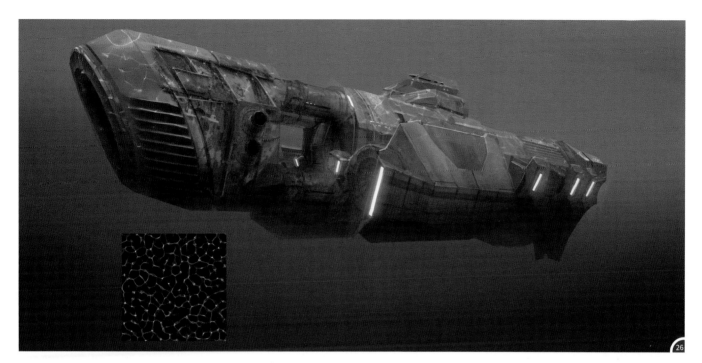

Search the internet for a caustic texture to apply to the whole submarine using the same Transform/Wrap technique we used earlier (**Fig.30**). The texture will need to be set to Color Dodge blending mode, which gives the illusion of having the water reflected over the submarine.

We're almost there now; we just have to do some minor tweaks here and there. The submarine shape is right, but there's another way to give it a futuristic appearance. This is the fun part of the whole process, because this is when we add details to really sell the image (**Fig.31**). A communist star is perfect to give our submarine history. You could also add other small details like the bubbles on the propellers and the text on the side.

The background looks a tad dull so how about adding a mine or two to enrich the illustration and make it more fun and interesting to the viewer. To do this, select part of the background and quickly add detail. Do this on a different layer to be able to clone it later and create a minefield.

Once you have your ocean full of mines, select the mines closer to the camera and use a Blur filter to add fake depth of field. You can also add a lens flare simulating the sun in Screen mode.

I hope you have enjoyed working on this as much as I have. Have fun creating your own futuristic vehicles!

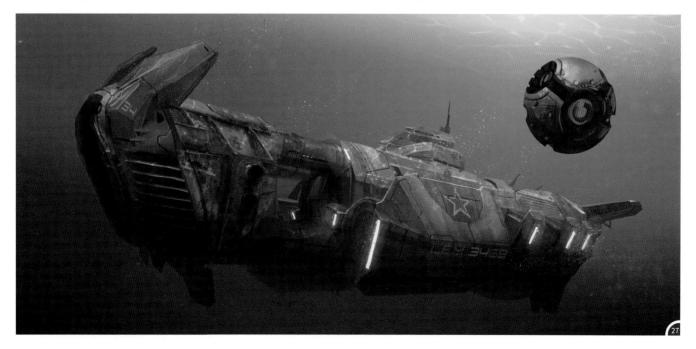

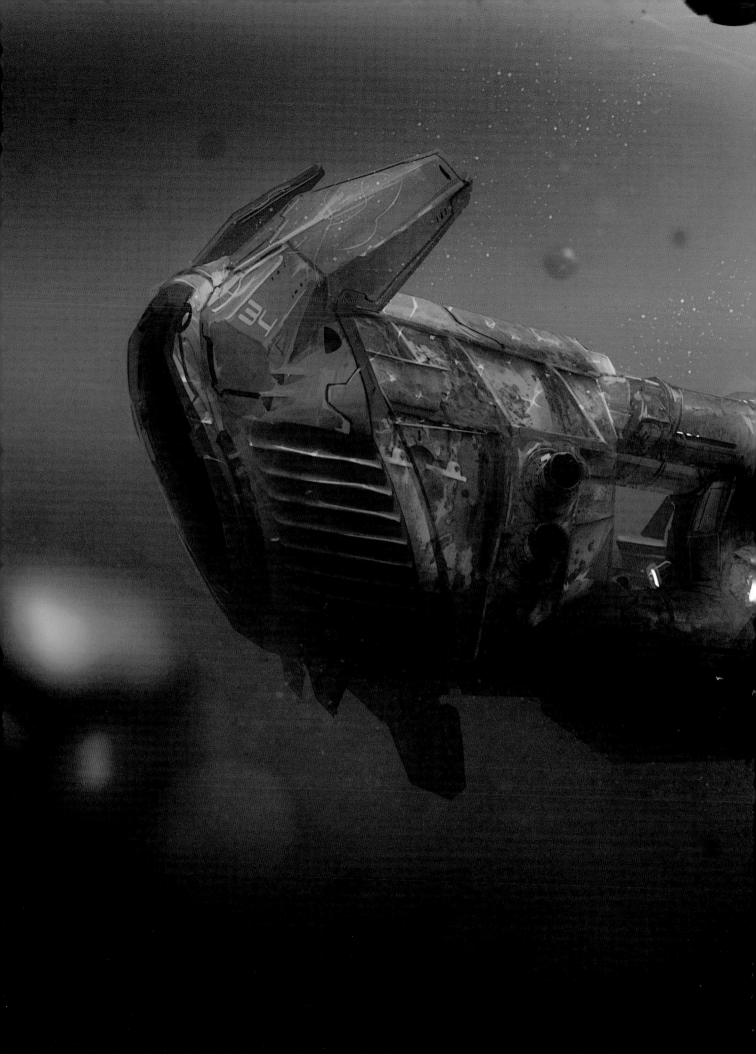

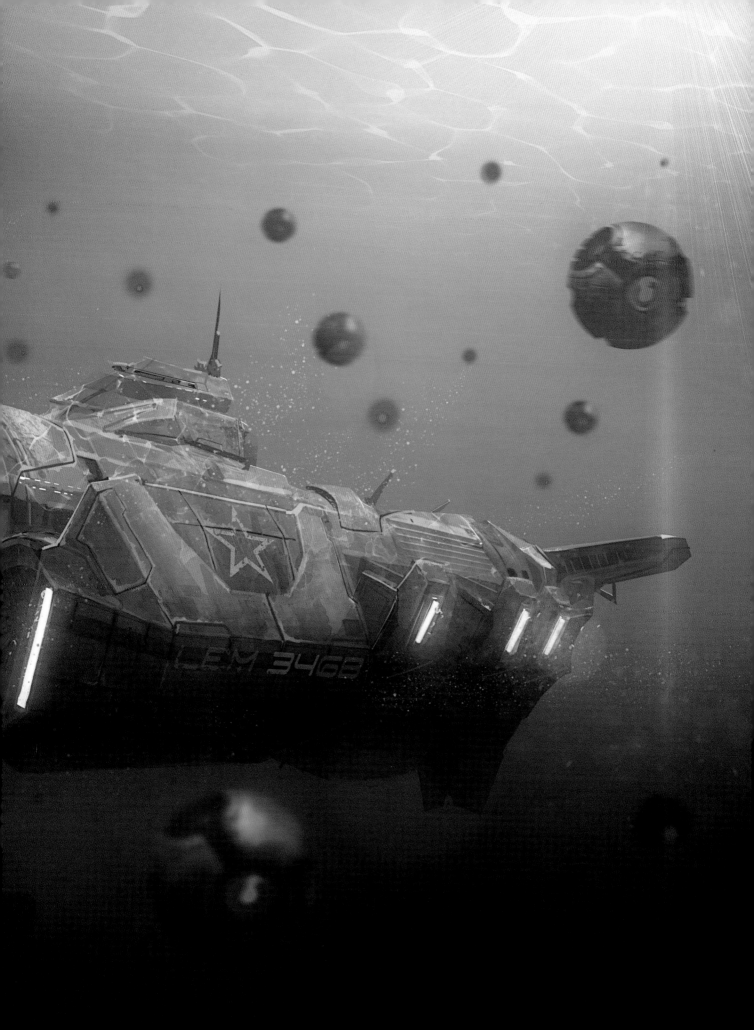

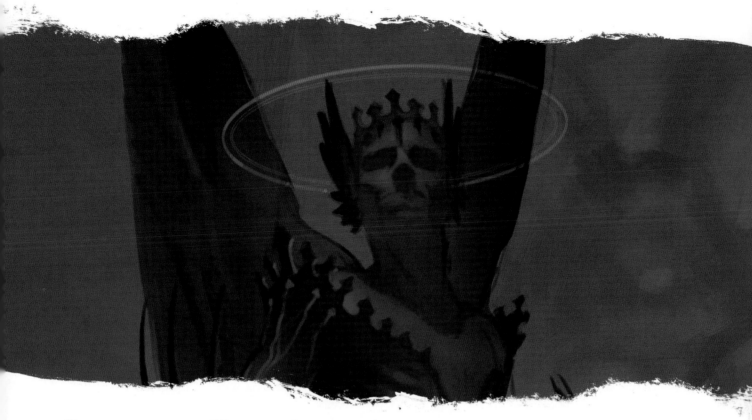

CONCEPTING USING SIMPLE BRUSHES | CIRCLE
By Clint Cearley

Introduction
This tutorial covers the creation of a basic round brush with 100% Opacity and size control suited for making sharp, quick thumbnail sketches.

Open Photoshop
Any version of Photoshop from the last decade should be able to follow this tutorial.

Create New File
Create a new file by following this path: File > New or Ctrl/Cmd + N. The pixel size you make this file will define the size of the brush shape and should be set at the maximum size you intend to use the brush. In the case of it being used to create thumbnails, the brush won't need to be large, but even so it's best to set it a little higher than what you think. This file is made at an even 500 x 500 px, since the circle brush will have the same width and height (**Fig.01**).

Understanding Brush Creation
In a moment we will tell Photoshop to create

a brush from this file, but it's important to understand what it's looking for in order to do that. All Photoshop cares about is light and dark, so it's best to use only black and white, not color. While you can choose Transparent as the background during the file creation, it doesn't matter as white is treated as transparent for the brush creation process; anything darker than white will be part of the brush and white will be transparent (**Fig.02**).

The Brush Shape
You can get fancy with custom brushes, but we'll stay simple right now and create a circle brush. Selecting and holding down on the Rectangular Marquee tool in the Tool palette will bring up the option to select the other Marquee tools, which can be used to select a large circle.

Pressing D will default the foreground and background colors to black and white

respectively. A quick Alt + Delete shortcut fills the selection with the foreground color of black. At this stage we are only setting the shape of the brush, not its behavioral parameters (**Fig.03**).

Defining the Brush

Creating or defining a brush is very simple, just go to Edit > Define Brush Preset. This will bring up a dialog box showing the brush thumbnail and give you a chance to name the brush. Personally, I view my brushes by their brush stroke example and not by their name, so I don't bother renaming them (**Fig.04**). Right-clicking on the canvas shows that the brush has now been added to the brush library.

Changing Library View

Your brush list may look different from the one pictured, but it can easily be changed by clicking the small triangle in the upper right corner. These options control the addition and removal of individual brushes and brush sets, available

brush sets, and brush list view options (the third section). Choose Stroke Thumbnail to display the brushes, the same as the example in **Fig.05**.

Preparing to Set Parameters

With the shape defined, the brush parameters need to be set. To do that create a new, larger canvas to test the brush in. Selecting the brush from the list, make a few strokes to see how it behaves. With no custom parameters set the brush will be large and clunky with no response to stylus pressure (**Fig.06**).

To set the parameters we'll need the Brush window, which is found under Window > Brush or F5. To minimize the Brush window just double-click the dark top bar of the window pane and double-click to reopen.

The Brush Window

If you are unfamiliar with the Brush window and its settings, it can be a little confusing, so let's go through an overview of its options before the customizing begins.

The window is basically broken into four sections: left, top right, bottom right and base. The options on the left list focus on various responses to pressure and directional input, and will replace the right side with more detailed options when selected. The top right simply shows us which brush is currently selected. The bottom right controls let us set the default brush size, its rotation, hardness and spacing (the non pressure-sensitive controls). The base is a brush stroke example that will automatically adjust to reflect any changes made (**Fig.07**).

Although this tutorial will not be making use of all the options on the left-hand side list, I will,

however, give you a quick summary of the top options so that you can be more familiar with your tools.

- **Shape Dynamics** controls the size, angle and roundness in response to pressure or pen tilt. This is one of the most important and most-used control sections.
- **Scattering** lets you make the brush behave more like a shotgun than a pistol, by creating a spray of random paint. Instead of the usual "one pen stroke for one paint stroke", Scattering can create many.
- **Texture** allows you to texture your strokes based on images in your texture library.
- **Dual Brush** essentially lets you cross two brushes into one, but can be tricky to set up and is not commonly used as it can give unexpected results when painting.
- **Color Dynamics** can add variations to your paint color during brush strokes.
- **Transfer** controls the opacity sensitivity of your brush and is also one of most used options.

Setting Parameters

Starting with the non pressure-sensitive options in the bottom right, the size of 497 is too large to be a useful default, so set it to 30.

As the shape is a circle, the Rotation setting does not matter, but it can be controlled by inputting numbers into the rotation bar or clicking and rotating the arrow on the circle image.

The Spacing scale determines how much distance to allow between each time it paints the brush shape within the brush stroke. The smaller the number the smoother the stroke, so in this case it should be set to 1 (**Fig.08**).

This brush needs to be size-sensitive so check Shape Dynamics in the left list and move the Size Jitter scale to 100%, with the Control set to Pen Pressure. This tells the computer that the brush tip size should scale directly proportionate to the stylus pressure. How much it is allowed to scale is determined by the Minimum Diameter setting below it. Set at 0%, the brush is allowed to scale down to nothing, whereas at 50% the brush tip can never be smaller than 50% of the current brush size selected. 0% is the default and what is needed in this case, so you can leave it, and the lower options, unchanged (**Fig.09**).

For normal digital painting I would normally turn on Transfer for Opacity Sensitivity and possibly Texture for Variance, but for this thumbnail process we just want clean black lines, so leave them as they are (**Fig.10**).

Saving the Brush

Be sure to save the brush after setting the parameters. This can be done by clicking the dropdown arrow in the upper right of the Brush window and selecting New Brush Preset, or by selecting the same from the dropdown list of the brush list box (right-click on the canvas) (**Fig.11**).

The Thumbnails

There are many approaches to creating thumbnail sketches and the solid round brush we just created lends itself to making quick thumbnail sketches, which will be fleshed out later.

As the characters we're creating are not for anything specific, they can be treated as a mind-mapping session. Where one would normally picture a character clearly in their mind before drawing, the focus instead is simply on creating an interesting pose or shape. While creating poses and shapes, the mind immediately begins to try and find a character in the mess. That inclination is what you follow, so the character develops as you draw. At this point, go for variety. Man, woman, robot and warrior; try lots of subjects (**Fig.12**).

The poses should be loose and not over-thought. Keep things simple at this stage; use straight

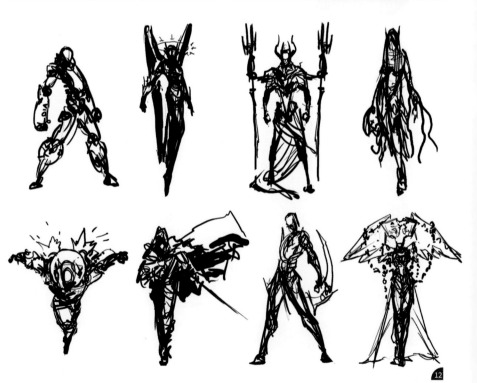

black for color and make sure that you go easy on the eraser.

It is important not to get side-tracked with details. You only want to establish enough so you can return to the character and know what you had in mind. My example characters are slightly more developed than I normally would do, so you would be able to make sense of the scribbles.

New File

While a finished concept can be envisioned based on any of the sketches, I've chosen the angelic figure as an example to work with. I copy the figure and paste it into a new 3000 px file, then scale it to the proper size (**Fig.13**).

> **TAKING THE TIME TO ACQUIRE A FEW HELPFUL REFERENCES CAN ADD AUTHENTICITY, AND STREAMLINE TRIAL AND ERROR**

Quick References

A concept aims to be a proof of direction and so doesn't require a high level of finish, but taking the time to acquire a few helpful references can add authenticity, and streamline trial and error.

Mac's built-in webcam and Photo Booth program can be used to snap head and body references, while a flashlight is all that is needed for the simple lighting setup. With Photo Booth open, I drag the photos straight from the photo strip into the open Photoshop file, which places the image in a new layer (**Fig.14**).

Refining the Figure

The original sketch layer's opacity is turned down and a new Normal layer created over it. On this layer, I refine the pose with the aid of the references. The new pose meshes the proportions and pose of the original sketch with lighting and anatomical queues from the photos.

In terms of the body photo, it was only by exhaling air and sucking in my stomach that I could achieve the emaciated look seen in **Fig.15**.

Details

With the figure complete, I create a new layer is on which the spikes, head wings and back wings are sketched. The spike pattern is a simple curve and point pattern that is quick to sketch in, but a more interesting and detailed pattern would be developed for a polished piece.

I use a separate layer for the halo as the size may need to be adjusted later. The Figure, Details and Halo layers are placed in a layer folder whose blending mode is set to Multiply, so it will show over the bottom layers (**Fig.16**).

Basic Tones

With a large soft brush, I paint the background in simple tones for now (**Fig.17**).

I select the figure using the freehand Lasso tool (the white is a visual aid only to show the area selected). This area is then copied from the background and pasted into a new layer. I create another Normal layer over this one and the layer mask is turned on by right-clicking on the layer name and selecting Apply Layer Mask. This means that only what is painted inside the shape of the layer below it will be visible, which in this case is the shape of the figure. Now, I do not have to be concerned with painting outside any of the edges, as it is impossible to do so (**Fig.18**).

With a large soft brush, I paint in the major tones. A simple color scheme of red and charcoal is chosen, as it gives color, good contrast and is recognizable even at a small size.

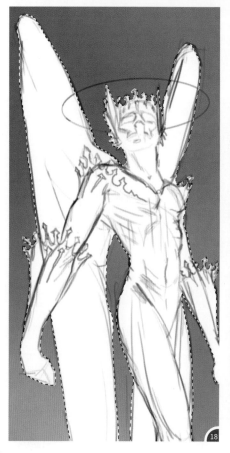

Refining Paint

Building off the basic red/charcoal and light/
dark contrasts, I continue painting with a smaller
round brush. The Halo layer is copied and shifted
to red, and has its blending mode set to Linear
Dodge to give a luminescent quality (**Fig.19**).

Setup

I create a new layer over the background, onto
which a cloudscape is broadly painted. A Normal
layer is then created over the Multiply Drawing
layer, where details and edge work is refined
(**Fig.20**).

Concept

The arm and shoulder spikes are too uniform in
size, so I gently elongate several of the center
arm spikes to break the pattern. The glowing red
veining of the forearm is continued on the upper
arm for added visual interest (**Fig.21**).

The piece is now complete. It's not a polished
final image, but is solid enough to present to a
client to get their approval before continuing.

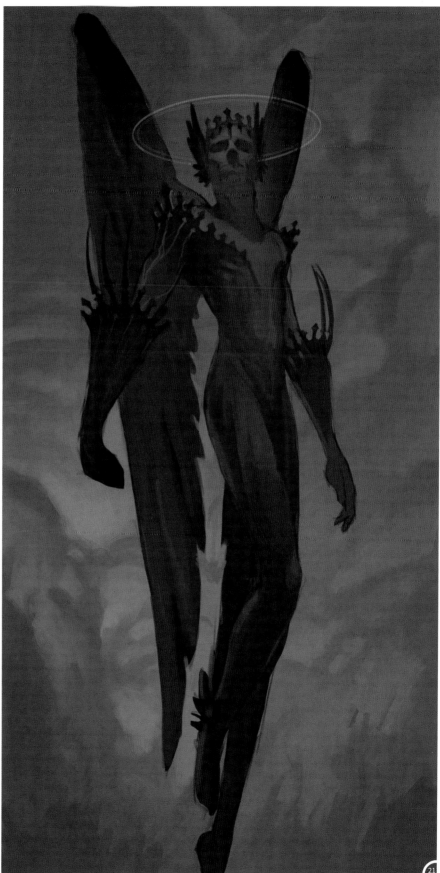

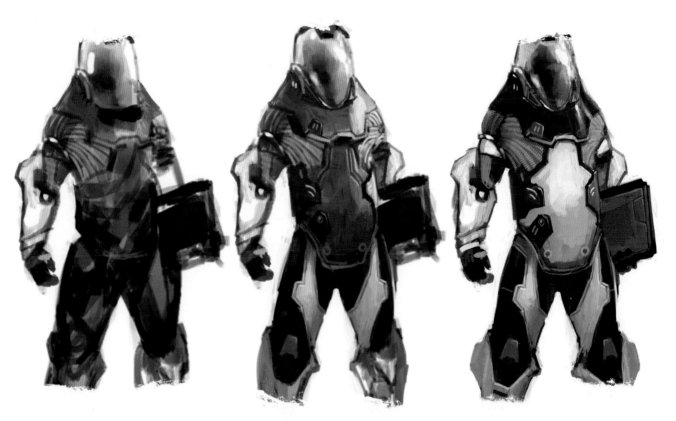

CONCEPTING USING SIMPLE BRUSHES | SQUARE

By Clint Cearley

Introduction

The process of creating the square brush is much the same as for the round brush, but the square one will behave with opacity sensitivity and be suited for creating blocks and planes.

Brush shape

Create a new file with the canvas set at 100 px in height and 30 px in width. Fill this with black and create a new brush is with Edit > Define Brush Preset. While I call this a square brush, it is actually a rectangle, which I find more useful and less clunky than an actual square.

Testing Brush

Un-customized, the brush behaves awkwardly since it always stands straight up and the angled strokes appear pixilated (**Fig.01**)(1).

Customizing Parameters

Starting in the bottom right, set the size down to 30 and Spacing to 1. Check Shape Dynamics, but leave Size Jitter alone. Instead, set Angle Jitter to

Direction. This tells the computer that the wide edge (the vertical) will always be perpendicular to the direction the stroke is going in (2).

Unlike with the round brush, turn Transfer on for the square brush. Without it, the beginning and end of the strokes tend to have twisty shapes as the computer tries to determine the direction of the pen as its being put down and lifted up.

Transfer doesn't stop this from happening, but fades it out in opacity since it is the point where little pressure is applied (3). Save the brush before continuing.

The Sketches

Where the round brush was sharp and definitive, the square brush is looser, more suggestive, and capable of building tones and establishing

masses. Starting with the head and shoulders I get a feel for the character and pose, and then continue working my way down. Keep the brush as big as possible for as long as possible to hold back on the inclination to tighten up. Once the general form is established, go back over with a smaller brush size to indicate details such as belts, swords, and armor plates. Also, set your eraser to the square brush and clean up the silhouette (**Fig.02**).

It's easy to get distracted by trying to pose a character while designing them, which is why I have about ten default poses I work from for this process. They are simple poses I've drawn many times and cover a decent range of action and attitudes.

Some of the most interesting characters come to life when the artist is open to changing the initial concept. Here I start out thinking about sketching a knight, but inadvertently make a mark that looks like a high shirt collar. Switching

gears, the character becomes an adventurer who I round out with a torch and wolf companion (third character on the bottom row).

New File

Deciding to continue with the spaceman for this exercise, I copy the figure and paste him into a new 3000 px file. Where the image in the previous tutorial was full color, this concept will be black and white only. This can be a viable and time-saving approach for conceptualizing when color isn't crucial to the design (**Fig.03 – 04**).

Modifying Shapes and Silhouette

Before painting begins, I make the decision to follow the bulkier silhouette of the science suit, instead of slimming down the suit to look more like an action/heroic figure.

On a new Normal layer, I begin painting with a focus on creating a recognizable silhouette and interesting shapes. This starts with redefining the shoulders into a large sloped piece that clearly

conveys a bulky appearance. A jut on the outside of the elbow area is also added, an element that will be mirrored throughout the concept (**Fig.05**).

Refining and Added Shapes

I continue refining by clarifying edges, mirroring the elbow shape on the opposite arm and adding shapes along the torso sides where the space is too empty (**Fig.06**).

Continuing Design and Details

I add definition to the legs, keeping them in the same design style as the top half. The elbow jut design is continued on the thighs, and I also add a new visual key in the double slashes, as seen twice on the collar piece and the stomach. Repeating visual cues is a great way to bring cohesiveness to a concept and gives you something to work with when you're approaching a new section and are unsure of what details to add (**Fig.07**).

Repeating Design Elements

The remainder of the image gets some basic refining. To save some time I copy the left leg, then paste and warp it to make the right leg.

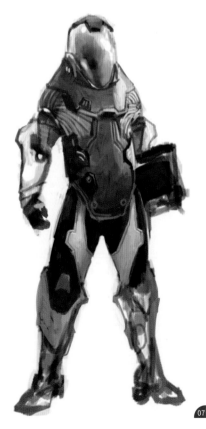

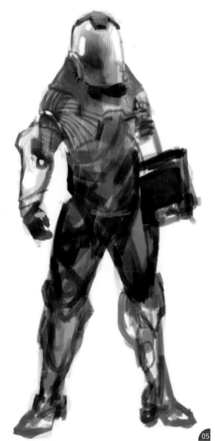

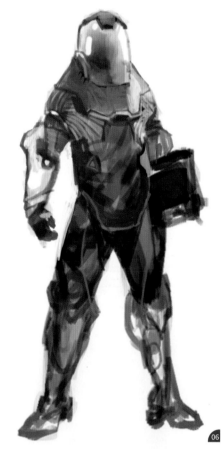

The overall shapes are working acceptably at this point, but the tones of the upper half of the body are muddled and don't really reflect a clear direction. I therefore make the decision to simplify the tones by defining areas as being clearly black, white or a light gray. This is something that is particularly noticeable in the collar piece, which has been adjusted to black (**Fig.08**).

Cleaning and Design Elements

I see the three-tone direction through by shifting the color of the stomach area and upper arms to white. The shoulder/chest ribbing is toned down to appear less striped and a fine hash pattern is painted over them to convey a textural difference. After adding a simple cast shadow to ground the figure, the proof of direction concept is finally complete.

CONCEPTING USING SIMPLE BRUSHES | TRIANGLE

By Clint Cearley

Introduction

The triangle brush is created the same as the brushes in the previous tutorials, but yields the most unique painting tool. More pattern-like than brush-like, the triangle brush is a abstract and forces a different creative approach. We will also be making two versions.

The Shape

The canvas is sized at 120 x 200 px, with the Ruler turned on (Ctrl/Cmd + R) and set to Percent by right-clicking on it (**Fig.01**). Select the Polygonal Lasso tool to draw the triangle shape (1). The percent ruler shows us exactly where halfway is, so the top of the triangle can be evenly placed. Fill the shape with black and then define the brush (Edit > Define Brush Preset) (2).

Customizing Parameters

In the Brushes window, set the default size to 65, while push Spacing to 50, unlike the other brushes. By setting it to 1, the triangular shape would be lost in a smooth stroke, so instead the

Spacing should be increased to accentuate the triangular pattern (3).

As with the square brush, set the Angle Jitter to Direction under Shape Dynamics, and turn Transfer on. Then save the brush.

This brush creates an interesting triangle ridge stroke with an important dynamic: the ridges will face right if the stroke goes down, but left if the stroke goes up. However, it is impossible to get either end to point in the direction of your stroke, hence the need to make a second version.

> **66 EVERY BRUSH HAS A CERTAIN PERSONALITY AND CARRIES ITS OWN PROS AND CONS 99**

Second Triangle Brush

There's no need to start from scratch as we've already made one brush. Select the existing triangle brush from the Brush window and turn the arrow on the angle circle to face the top. This will make the flat end of the brush face in the direction of the brush stroke. Save the brush.

The Sketches

Every brush has a certain personality and carries its own pros and cons. If you haven't used a triangle brush before, it may take some time before you feel like you know what to expect of and how to handle it.

My sketches reflect a variety of ways the brush can be used, such as where the bottom left figure shows that set to a small size, the brush can be used like a pencil. To me, this brush's sketching strength is best shown in head studies, where the graphical nature of the strokes add to the sketch rather than hinders it (**Fig.02**).

Since the other concepts cover full figures, I'll be working on the cowboy head for variety (**Fig.03**).

02

03

I copy and paste it into a new 3000 px file. The sketch layer is lightened slightly, tinted brown and set to Multiply.

Basic Tones

Under the sketch layer, I block in basic tones with large, hard and soft round brushes (**Fig.04**).

Referencing and Refining

After locating a reference for the face, I continue painting on a Normal layer over the sketch layer. I use the square brush in order to continue the angular brush work style. On the sketch, the right side of the mustache is thinner than the left, which prompts the idea that a series of scars run along that area.

> *Quick Tip:* The scars are painted lighter than the surrounding skin, which is the case for old scars, whereas new scars are darker and redder. Taking little cues from the sketch, such as in this case, can lead to more original and creative concepts (**Fig.05**).

I add variance to the skin tone by making the nose and lips redder, above and below the mouth greener and the shadow area under the brim slightly violet.

Hat Reference and Saturation

A quick Google search gives me a reference for the hat, which helps establish a proper shape. I then lighten and mute the background tones to better fit the color scheme (**Fig.06**).

Brushwork and Details

I make small additions in the form of wrinkles under the eyes and suggest gray hair in the sideburns and beard. For a start-to-finish visual consistency, I use the triangle brush once more to blend the edges and add visual interest, before calling the image finished (**Fig.07**).

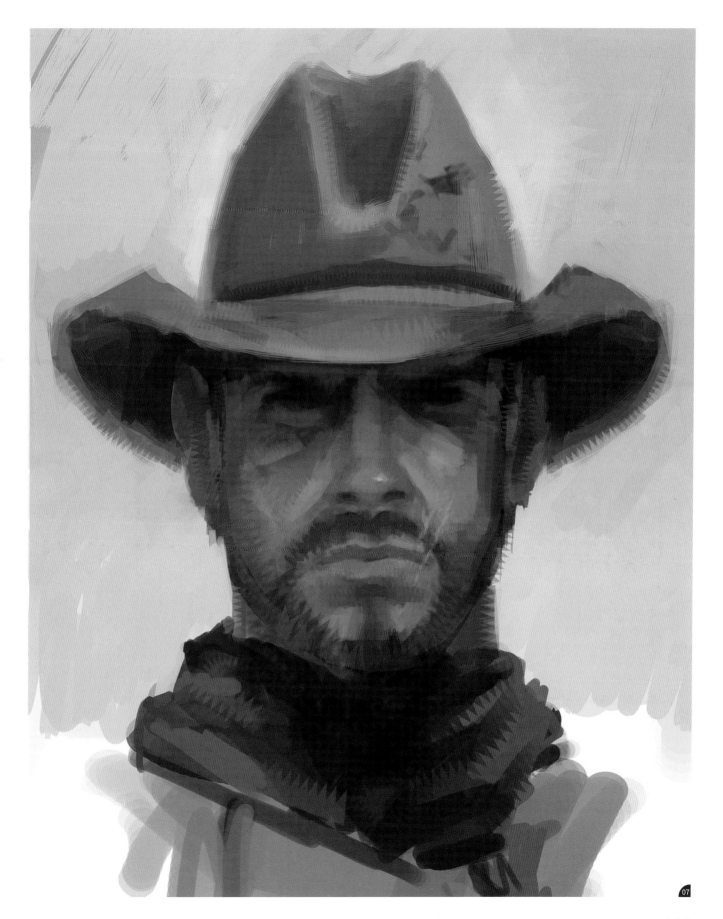

07

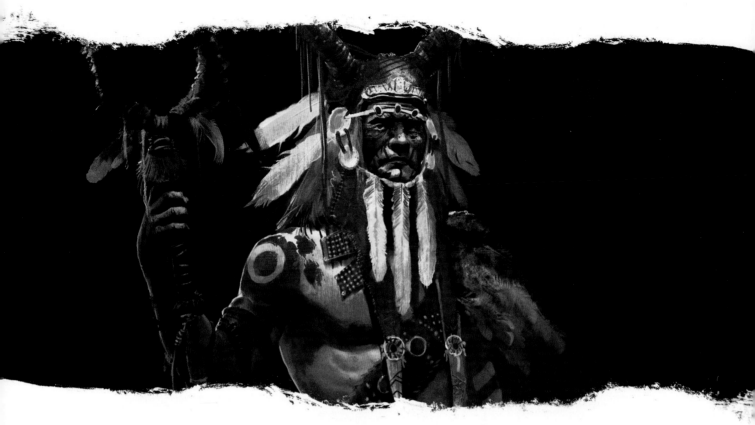

CUSTOM BRUSHES FOR CHARACTERS | RED INDIAN
By David Munoz Velazquez

Introduction

In this tutorial the goal is to create and paint using custom brushes, to build details and to enrich a character. I have made three types of brushes – shape, stamp and painting – which we're going to use in lots of different ways. I have also given an explanation and included images of how to create each type and how to use them, followed by images of the where they are used.

Creating the Brushes: The Shape Brush

The first of our brushes – the shape brush – can be seen in **Fig.01**. Here's how it can be created:

Use a photo or painting to get a black and white shape. It can have grays in it; it's not necessary to use strictly black and white. In fact, grays can be useful sometimes. It's important to know that the black is going to be the part that will become the active painting area.

Select the Rectangular Marquee tool. While dragging the selection, make sure you keep the

Shape brush

01

Shift key held down. In order to get the correct final shape, the marquee selection has to be perfectly square.

Once it's selected, go to Edit on the top row of the main options and press Define Brush Preset. It will create a brush that is instantly saved in your Brush Preset window, with the same resolution as the originally selected image (Fig.02).

In the Brush window, select Shape Dynamics. There are plenty of options to choose from. The blue sections of **Fig.03** show the settings I have used to create the result, which is painted on the side to demonstrate how it looks.

The options are not very complicated, but it's still necessary to investigate them in order to understand them and achieve the result you need. It's good to set some values and do a little painting to see if your brush is going in the right direction.

Next we have to consider rotations controlled by the attributes of your pen or the percentage of the values. Basically when we drag the brush it makes random variations, showing an accumulation of shapes created by the effect of a specific material and texture (Fig.03).

Adding Scattering will control the scatter by a percentage value, whether using the pen attributes or numeric values. Scattering is a very useful way of achieving a random look and easily covering more of the surface. This option can also be tweaked once the brush is finished, to polish the result or achieve the look that is required (**Fig.04**).

Transfer V1
Transfer V2

Transfer V1

Transfer V2

Finally we activate Transfer. A simple explanation of this setting would be that it allows the pen to change the size of the shapes and the opacity by using varying amounts of pressure. Of course, you can always set numerical values to be used instead of using the pen pressure. I separate the transfer into two types that I mostly use: V1 and V2.

V1, as you can see in **Fig.05**, is thick and works by enhancing contours; it can be used to enforce silhouettes or sometimes to fill surfaces. V2 works by just changing the settings that are on the image. It creates a feeling of depth and it's a good way to achieve textured surfaces with depth and more detail. When I use them I combine both types (**Fig.06 – 07**).

193

I've applied the shape brush to the character's staff to create the animal fur, as well as is in other parts such as on the arm, the chest, the belt and the bonnet (**Fig.08 – 10**).

Shape brushes are still repeating shapes, but in this case they aren't accumulative; they have to keep a distance between themselves. It's a brush to draw detail that's as specific as we want, like a sort of pattern that will repeat as we paint. In this case I've used a simple stitch shape, as shown in **Fig.11** (1). You can use details from a photo if necessary, but I've painted my shape.

Once you've created your shape brush and it's in the Brush window, it's time to take care of the Brush Tip Shape. There is an option to change the angle, so the shapes go in a horizontal direction.

This can change if we captured the initial shape horizontally, but it has to end up like the one on the lower part of the window in (2); this is a sample of how the stroke will look. Then we tweak Spacing until there is no overlapping of the shapes; the repeated shapes have to remain more or less the same distance apart. It's very easy to see by just moving the slider.

The settings shown in Shape Dynamics (3) will make the brush work well. Control: Pen

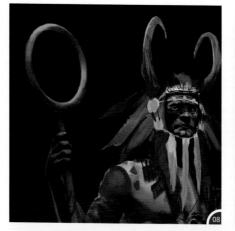

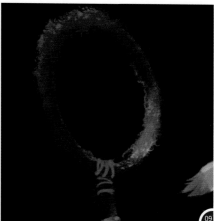

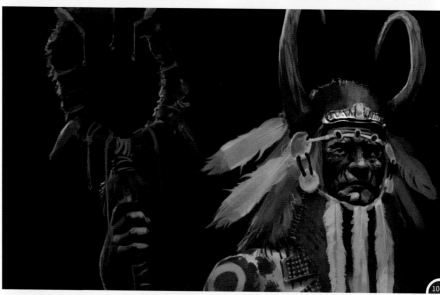

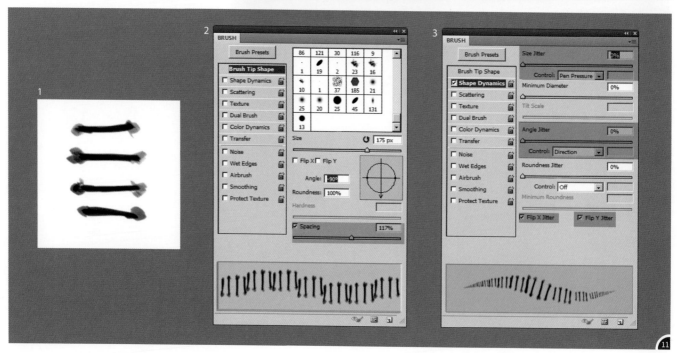

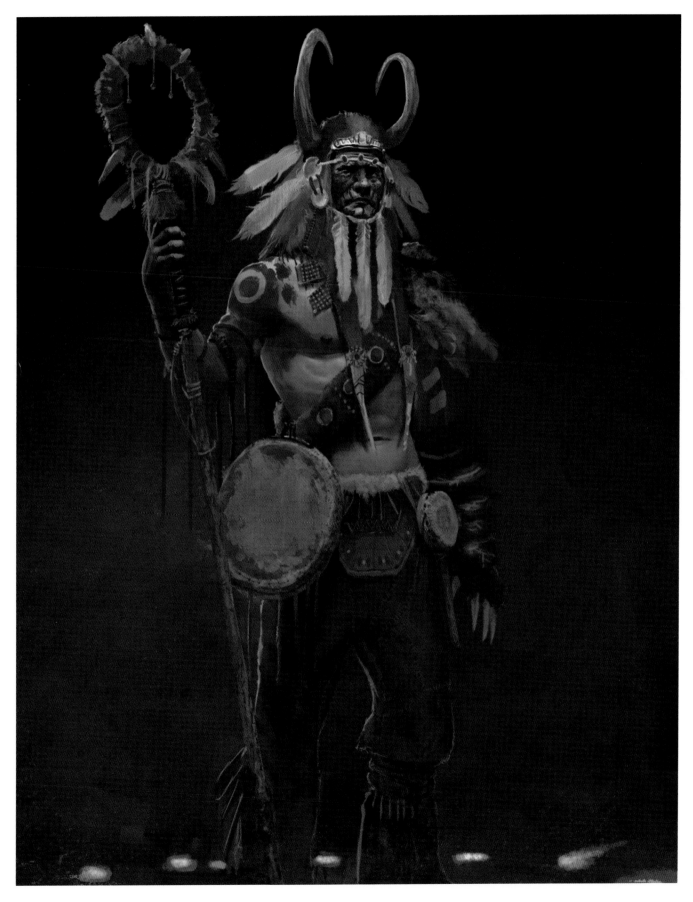

Pressure, under Size Jitter, is controlled by the pressure of the pen, so if I paint more softly then the stitches will become smaller.

The second option is the key one. Angle Jitter has to be on Control: Direction. This option will make sure that shapes are drawn in the direction of your stroke and will continue changing direction whilst you paint.

You can keep building on your own brushes and create more detailed ones, by painting a little and applying what you've done to the one that is already created. Use the same process to save it and you have a different brush (**Fig.12 – 13**).

You can see the areas of the image where I have used this technique in **Fig.14 – 15**.

The Stamp Brush

Our next brush is the stamp brush. In **Fig.16** you can see examples of some effects you can achieve with this brush.

The stamp brush is pretty self-explanatory; one single click and the brush draws what you've created. As shown in **Fig.17**, select a texture,

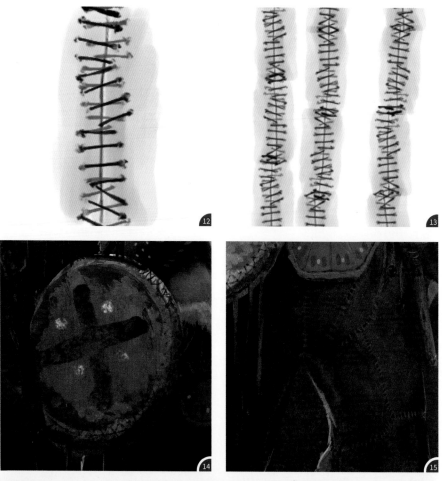

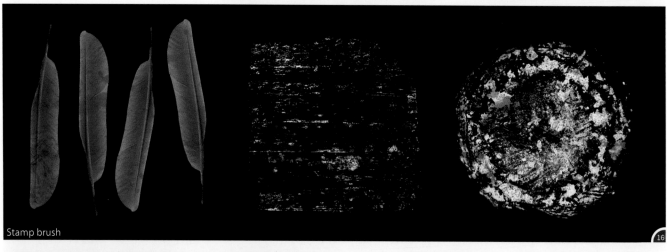

Stamp brush

Painting brush

make it black and white, use the contrast to get rid of some of the unnecessary grays, and then clean the borders or they will show on the brush.

Make sure it's on a square selection, so it keeps the same proportions when you stamp it. I like to add another texture on Overlay mode, in order to have more variation on the areas that have turned too black; it gives variation just on the places where you want it. Then use the same process that we used earlier on the shape brush to create your stamp brush and that's it!

One example of how useful it can be to have just the single stamp texture, with a light color painted and a darker one over it, is in the production of a kind of volume effect. Based on that information, if you just keep stamping bigger sizes or rotating color variations and using some layer blending modes, the result is a quick but interesting texture made with one single brush (**Fig.18 – 19**).

I've used this brush all over my canvas. In some areas it is very subtle and in others it has been used harder in order to create texture and surface variations.

The Painting Brush

The final brush I'm going to cover in this tutorial is the painting brush. In **Fig.20** you can see examples of the effects that can be achieved with this brush.

The goal of this brush is to have noise and variations, but not necessarily a recognizable shape, so that the feeling can be that of a real brush stroke. It can still be very useful to add details; I will now explain the creation and some of the ways to use it.

First select any shape you want (in my case I've gone for a non-circular one), then in the Brush Tip Shape set the Spacing low enough to look like a single stroke (**Fig.21**).

With Shape Dynamics selected, follow the settings shown in **Fig.22**; these are based more on an automatic variation than in the pen options. These options are very easy to

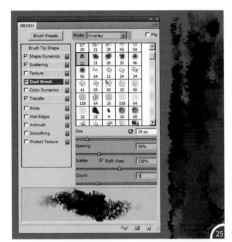

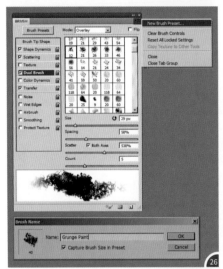

understand by just playing around a little bit. Scattering here gives the effect of a more organic brush stroke (**Fig.23**).

For this particular brush, we have to arrange the Transfer settings first. It can be done in different orders, but this way is the best because it allows us to see the results in real-time when we activate the most important option straight after (**Fig.24**).

The most interesting option for this brush is Dual Brush (**Fig.25**). Here it's about playing with the options. Normally the secondary shape you add has to be almost the same size or bigger than the principal shape; by using the Size slider it's very easy to see it. Scatter is the same as the main scatter, but applied just to the secondary shape.

It is better to have the percentage or thickness of Count low, otherwise the textures and the variations will disappear in a solid stroke.

In order to use these brushes I recommend selecting shapes that are quite different from each other, otherwise, if you are not careful, it will sometimes create a random noise without an interesting look.

Once you are happy with how the brush looks, go to the top right corner of the window (as is marked in red ink in **Fig.26**). The option New Brush Preset will appear. Click it to show a pop-up window with the basic shape and then enter a name for it – it's always good to label them. The brush will then stay in your Brush palette.

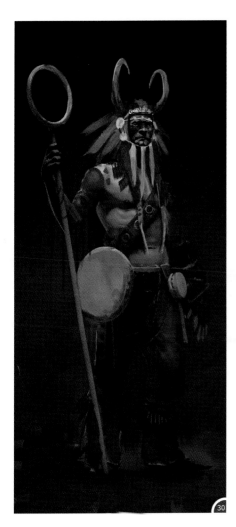

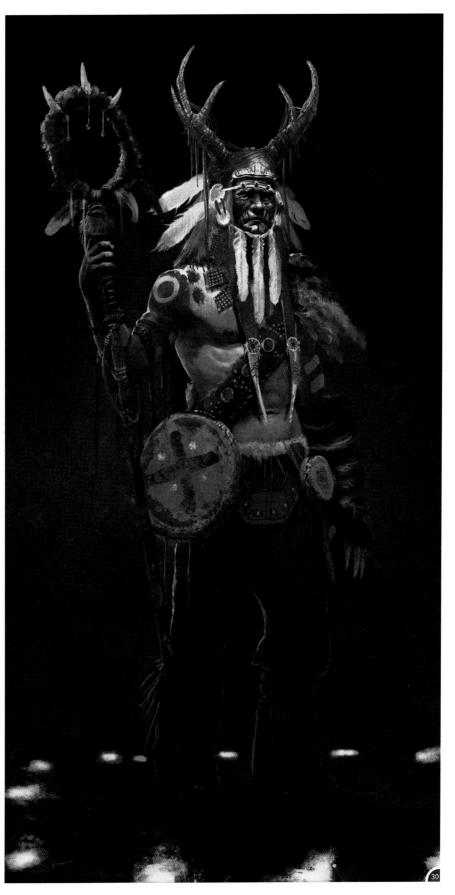

Fig.27 is an example of how this brush can be used to achieve very interesting results if used along with the Eraser tool. It can be painted with a normal brush and then some strokes can be removed, creating irregularities and interesting textures. I use this technique a lot.

You can see examples of where I have used this brush and the effect it gives in **Fig.28 – 29**. I have illustrated the base mesh of my character and my starting point in **Fig.30**.

Fig.31 shows the final character, which was created by using the different types of brushes I have explained in the tutorial.

I hope this tutorial has helped you to understand custom brushes and motivated you to use them a bit more. Thanks to 3DTotal for the chance to participate in this book and all of you that have read these words.

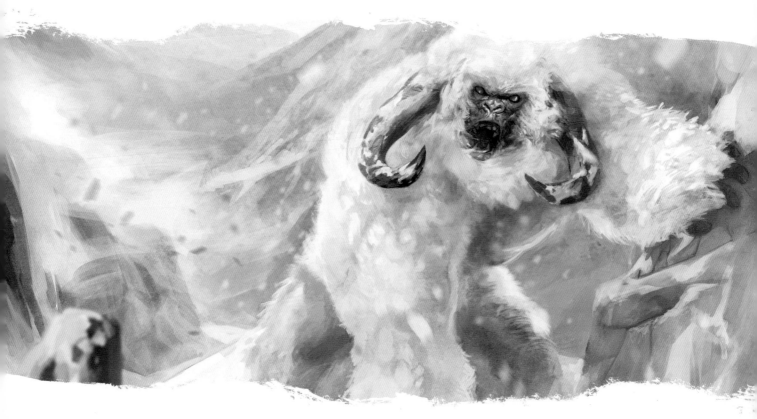

Custom Brushes for Characters | Yeti
By Bart Tiongson

Introduction

In this tutorial I am going to paint a Yeti and show how I use six brushes to get varying degrees of texture, and what I call "noise", to achieve a painted feel, along with atmosphere and realism. I sometimes use textures/photos to gain the grit and texture that I want in my images, but for this specific tutorial I'm going to rely solely on brushes and in-program techniques.

All of these brushes are set to have pressure sensitivity, because when I paint digitally I like it to feel similar to drawing with a graphite pencil. I like to control the darkness or size of my brush strokes with the amount of pressure that I apply.

You'll also see how some of the brush settings can be adjusted, so that some very cool effects are created depending on how hard or soft you are pressing on the tablet (**Fig.01**). 1 is just the default round brush that I use most of the time; I find that I have the most control with this brush. 2, 3 and 4 are noise brushes that I often

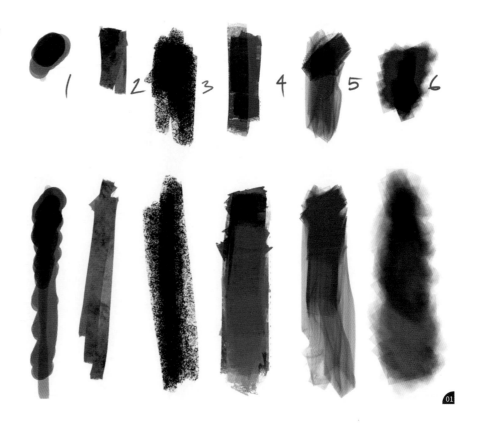

01

200

use to help with textures for rock, or dirt, or atmospheric density. 5 is a brush I found online created by the artist, Yang Xueguo. It's nice for abstract shapes that I'll talk about later in the tutorial. Finally, 6 is a soft brush that I use to create foggy or misty effects.

Thumbnails

I do some quick thumbnails to see what type of composition or design I want to go for. Any brush will work for thumbnails. Sometimes I like to use a brush with some subtle abstract shapes because it creates little, unplanned strokes, which I can later use to create specific designs. The number 5 brush is perfect for this and not only does it give abstract shapes, it also creates some variations in value that I like when I don't want to be super tight and precise.

Thumbnails are the perfect time to just relax and have fun with the image, and be very loose and gestural (**Fig.02**)!

Blocking In

After I decide on a thumbnail, I start to block in the large value areas. In this case I know that I want to eventually put the Yeti in a snow scene and, of course, he'll be white as well. I want there to be a nice amount of contrast between the character and the background, so I start blocking in some dark, rocky areas (**Fig.03**).

I try to keep the main focus on the Yeti, but I don't want him to be smack bang in the middle. While it's possible to create visually interesting imagery with symmetry, and having the subject perfectly centered, usually (unless I want to create a sense of unease, or there's a specific reason to center the image) I'll offset the focal point slightly to the left or right (**Fig.04**).

Using the Brushes

I'm starting to rough in some bushy fur, just to get an idea of how far I'm going to push the design elements. At this point I'm still really only using brush number 1 for control (**Fig.05**). Early on in the painting, try keeping your shapes big. Stay away from the details, and concentrate on the silhouettes and the compositions. I like to use big, broad brush strokes at the beginning of

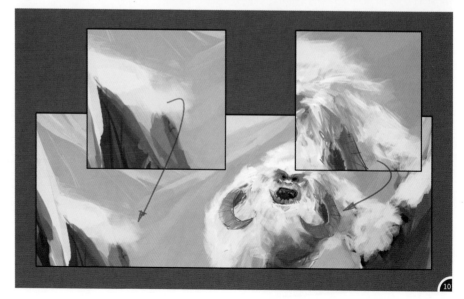

a painting – this helps me to not focus in on the tiny details, which are fun to paint, but may be smart to stay away from until later in the process.

I paint in some more background elements and established some details on the Yeti itself. At this point I'm using my primary round brush for most of the painting, along with the number 5 brush to scribble in some fur. Since that brush creates different values with each stroke, I find it's really helpful when creating the fur. I'm able to get a feeling of depth with that brush, and the very subtle illusion of strands of hair and tufts of fur (**Fig.06**).

Fig.07 uses the round brush to sketch in the fur, and **Fig.08** uses the number 5 brush for fur. It's a very subtle difference, but sometimes that subtlety is the key to getting the desired effect.

I take the brushes previously used and begin to paint in blowing snow and fur. These brushes work well both for their abstract shapes and very subtle strokes. Again, the varying values help to create depth and shadows for a more realistic texture (**Fig.09 – 10**).

I start to add color to the image here. While still very minimal at this point, the cool and warm colors allow me to see how and where I can take the painting. I also begin to paint in the details of the far-off mountain range (**Fig.11**).

Make sure to create your own unique shapes for brushes. Experiment! If you try various settings, you never know what your brushes will end up creating. Play around with all the different brush settings; it's fun to see what you can come up with, and you may just create a brush that you will use over and over again. Adjust the sliders and discover the various effects that you can achieve through experimentation!

At this point in the image the face is pretty temporary in terms of design. I always knew that I was going to develop it somewhat, so I decide to polish it up and throw in some specific details. I have the Yeti in a stage where I've roughed in the face, but in **Fig.12** I take it in a different direction somewhat. This isn't unusual in my process and I often change the direction my designs go in. It's very important though to know when to stop doodling and begin to focus, and commit to a design.

I start to picture a giant gorilla covered in white fur; after all, nature has some of the best references that an artist could ever ask for, so why not use them? I also start to move forward on the horns and fur surrounding his face. This is the area of most interest, so I want to make sure that I give it the necessary and appropriate amount of attention.

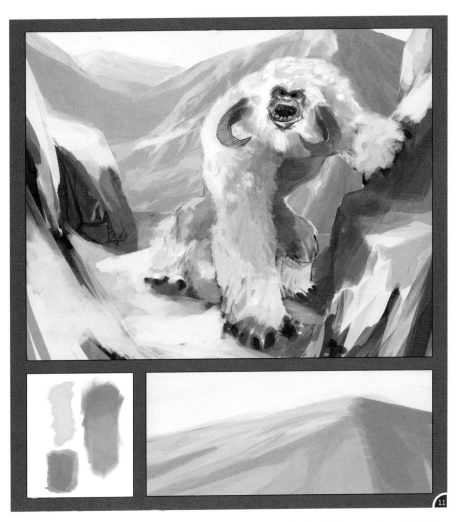

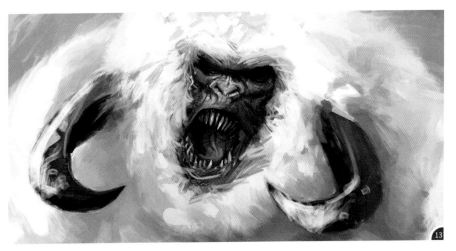

I want the dark horns to provide a nice amount of contrast to the white fur and I further accentuate the contrast by placing snow onto the horns. The use of brush number 5 is perfect for this situation because it spreads areas of thin and thick paint, allowing for some of the bony material to show through.

I decide to take the facial expressions of the Yeti even further. Rather than having a rather relaxed face, I decide to show him mid-ferocious scream (**Fig.13**).

I'm starting to take the brushes and really get specific about the details, like the stray bits of

fur. Even in the shadow you should be able to recognize the texture or material of any given object (**Fig.14**).

I often use photo references to help when painting something I'm not super-familiar with; in this instance, a gorilla. However, be careful not to over-use your photo references. The last thing that you want is for your painting to appear as though you have just copied an image that already exists. This holds especially true when creating a unique creature. Be imaginative and do your own take on an animal, don't simply copy it. After all that's what being hired as an artist is all about: creating something new that hasn't been seen before!

Here are more examples zoomed in close to show how important it is to paint in grit, noise and the various elements of texture that exist in the world around us. I like to think of this as the icing on the cake. I'm getting close to finishing the painting, but it just doesn't quite have the detailed polish that I want to achieve yet (**Fig.15**).

For the really fine, minute and subtle details I use my noise brushes and just scale them up or down to get a variety of sizes in the textures. The amount of contrast and details are being added more and more in **Fig.16**, but it's important not to overdo it. I'll add these noises on a separate layer and adjust the degree of opacity, so that it

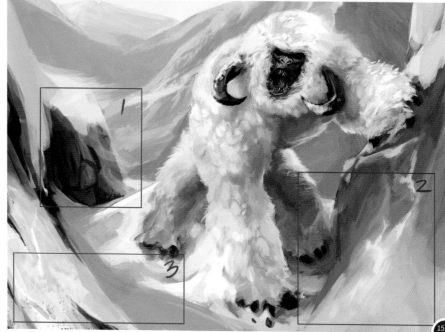

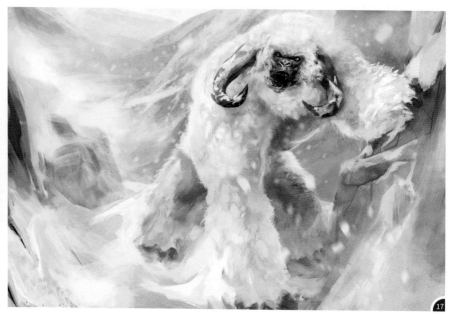

doesn't become too extreme or heavy-handed. Also, remember that as you move further into the distance, the contrast and values become more subtle. Even color begins to lose its hue the further away you go.

I start to ramp up the blowing snow effects. I want this to feel cold, so I add more blowing snow throughout. Subtle brush strokes, along with using the Blur filter in Photoshop, can go a long way to creating that blizzard effect (**Fig.17**).

Final Touches

I paint a foreground element to help create some depth, while at the same time guiding the viewer's eye to the focal point of the image. I use all my different brushes to get the rock texture I want and then I blur it slightly, so that it doesn't take attention away from the Yeti (**Fig.18**).

Finally, I adjust some of the colors in the shadows and add some debris blowing along with the snow, just to add variety. I paint in the details of his fingers, since some of it had become lost in the process. I also make sure that the levels of detail close to the Yeti aren't so subtle that they

become non-existent, specifically the area of rock underneath his hand (**Fig.19**).

Remember, use different brushes for different effects and textures, but don't rely on them to do the real work for you!

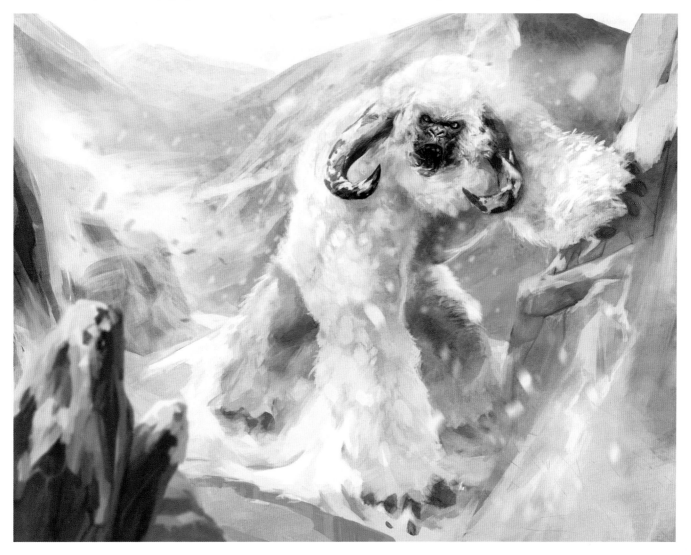

CUSTOM BRUSHES FOR CHARACTERS | ALIEN
By Richard Tilbury

Introduction
The theme of this tutorial concerned custom brushes that could be used to add detail to an alien, describing skin patterns, markings and camouflage. The objective was to create an array of brushes that could be used to provide some textural variation. The brushes could be modified and combined to create further adaptations, and become the basis for a more extensive library.

I began by designing a creature upon which I could demonstrate the brushes. Because this tutorial required a version of the alien on which you could apply these brushes yourself and create your own interpretation, I composed a line drawing before adding any color. This is not normally how I would approach a painting, but it seemed like the best way of providing a template for people to experiment with.

Thumbnails
Often the first step I take is to create a number of thumbnail sketches, and perhaps sketch

a group of silhouettes to help flesh out the general proportions and overall shape of the character. Alternatively, as in this case, I filled in a background and then started to draw on a separate layer using a hard round brush.

I had the Opacity Jitter set to Pen Pressure and then I simply started doodling until a design began to emerge. Repeatedly drawing random shapes and flowing lines will usually result in some sort of concept or idea taking form, which

1

2

can serve as a good, solid foundation on which to build a more elaborate character design.

Fig.01 shows an initial "metamorphosis" on the left, which originated from repeated doodling, and on the right, is the more refined version. I restricted myself to the brush mentioned earlier, simply because it was necessary to provide a template drawing.

This concept went through a number of transformations, involving subtle changes in the proportioning, alongside a reorientation of the muscle groups. You will also notice that the posture has changed from left to right. The initial character seemed a little whimsical and somewhat subordinate, and so I opted to give it a more domineering and assertive stance. I decided to replace the gray background with pure white in order to see the outline better.

Refining the Drawing

 Fig.02 shows two further stages during the process in which the anatomy and proportions have evolved. I decided early on to create a humanoid alien, but I felt that the hands and feet in illustration 1 resembled humans too closely and so deleted them. The other aspect that looked wrong was the articulation of the deltoid, or shoulder muscle, with the pectoral or chest muscle. Although I was trying to achieve a hunched appearance devoid of any neck, the shoulder nevertheless looked too high compared to the chest and so I lowered the deltoid, which is evident in illustration 2.

I also changed the shape of the arm, as the relationship between the biceps and triceps looked wrong. The other main modification was to the head, which although still lacking a neck, now at least seemed to articulate more realistically with the shoulders.

The drawing at this point was almost resolved, barring the hands and feet, and so these needed to be added.

In **Fig.03** you can see the completed template alongside a color overlay, which provides a decent mid-tone to begin working with.

Textures and Brushes

The next step was to start painting in some texture, but before doing so I will briefly run over some of the brush presets (**Fig.04**).

The first brush I chose to use was derived from a photo of fish scales, which can be seen in box 1. This shows the brush shape itself on the left and the corresponding "stamp" when single-clicking on the canvas.

Whenever you create a new brush, usually the first port of call will be the Spacing setting under Brush Tip Shape (2). This is where you can separate out the shape of the brush to be identifiable throughout the stroke. If Spacing is left at its default setting, then the stroke overlaps the brush shape, producing the effect of a loaded brush being dragged across a canvas, in an almost unbroken block of color (3). You can see here that the Spacing is set at 79%, which has produced a string of brush shapes throughout the stroke.

The next aspect worth changing is the X and Y Jitter settings under Shape Dynamics (4). This effectively alternates the vertical and horizontal orientation of the brush throughout the stroke, in order to create some variation and avoid obvious symmetry. Compare the stroke in the lower window to the previous one highlighting the Brush tip shape.

The last area to consider is the Opacity Jitter under Other Dynamics, which I generally set to Pen Pressure; a preset suited to graphics tablets (5). You can now see that the tonal range throughout this stroke varies.

This brush now has the ability to paint a patchwork of scales, the density of which can be determined according to the number of overlapped strokes (6).

With this brush and its modified settings now saved, it was time to start adding some details and patterns across the skin.

Fig.05 shows the first stages of using this brush, which I painted on a new layer set to Normal

mode. I changed the color of the brush to reflect the variation across the legs and torso, as well as modifying the size. The best method is to lay down some strokes without worrying too much if they are exact, and afterwards use the Eraser to refine and tidy up things.

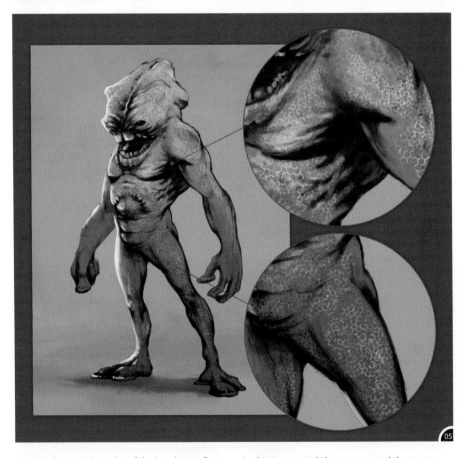

As this is a tutorial I have separated the texture brushes into layers in order, so that you may see their individual contribution.

The next was made up of a few randomly spaced dots, which can be seen in the upper left box in

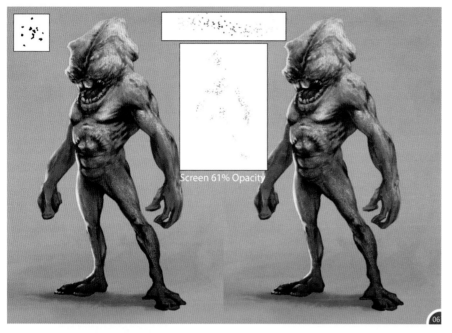

Screen 61% Opacity

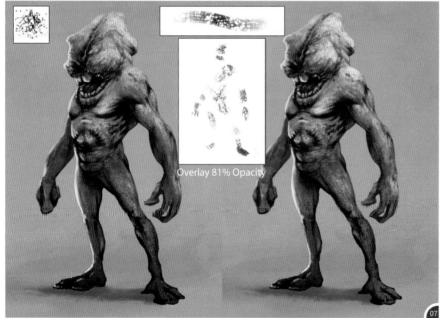

Overlay 81% Opacity

Fig.06. This brush uses a spacing of 104%, but only takes advantage of flipping the Y Jitter. You will also notice from the stroke (center, top) that the Opacity is set to Pen Pressure.

I chose a dull, reddish brown and painted in some spots across the alien, predominantly along the arms and chest. The layer was eventually set to Screen Blending mode, but the small image in the center shows it at Normal mode on a white background in order to reveal where it was used. The creature on the right shows the layer applied compared to the one on the left, which represents an earlier version.

Although subtle, each one of these texture layers will contribute a little towards the final effect and if you removed all of them you would notice a marked difference. The secret is to avoid exaggerating details such as these.

With this layer now complete it was time to move on to the third brush, which was different as it involved a Dual Brush. I will explain what this means shortly, but before that let's have a look.

Fig.07 shows the brush in the upper left and its resultant stroke to the right (centre, top). This time around I used a pale yellow set to Overlay, but have also included a detail in black and white to show where the brush has been applied (center). You can see how it has created some highlights across the head and shoulders, as well as some subtle patterns across the arms and legs.

As already mentioned, this brush incorporated a Dual Brush, which is a great way of creating variations. With the brush palette open, scroll down to Dual Brush (below Texture) and tick the small box on the left (1). **Fig.08** shows the brush on the left before Dual Brush is active, which as you can see creates a stroke resembling a paintbrush. The right window shows the same brush, but with Dual Brush now enabled (2). The sampled brush was extracted from broken glass, but more importantly you can see how this function completely transforms the brush stroke.

By experimenting with the dynamics and combining different presets it is possible to

swiftly create an array of very different qualities, all of which stem from a single brush. There are several brushes included with this tutorial, so I would encourage you to experiment with these as well as developing some of your own versions.

One other brush I developed during this tutorial is pictured in **Fig.09**, which I used to add another layer of detail. You will notice that the Shape Dynamics employ some Angle Jitter and also have the X and Y Jitter flipped. The brush tip can be seen in the upper left alongside the resultant stroke.

Fig.10 illustrates how this brush has lent another dimension to the skin and injected some delicate variation. The character on the left shows the stage before the brush was applied, with the adjacent copy showing the new texture.

Finishing Touches

As I was painting the creature and creating the brushes, I was continually revising the design and trying new variations. In this example I amended the mouth, as well as adding an eye and some gruesome detail in the form of a trophy head!

The alignment of the knees had been wrong since early on and should have been addressed at the beginning, but it is never too late to fix a problem. The other area for concern was the perspective and so to account for foreshortening, I reduced the size of the left hand and also altered the curvature of the furrow that runs up through the center of the head.

With some color corrections and a handful of small refinements, the character was finished (**Fig.11**).

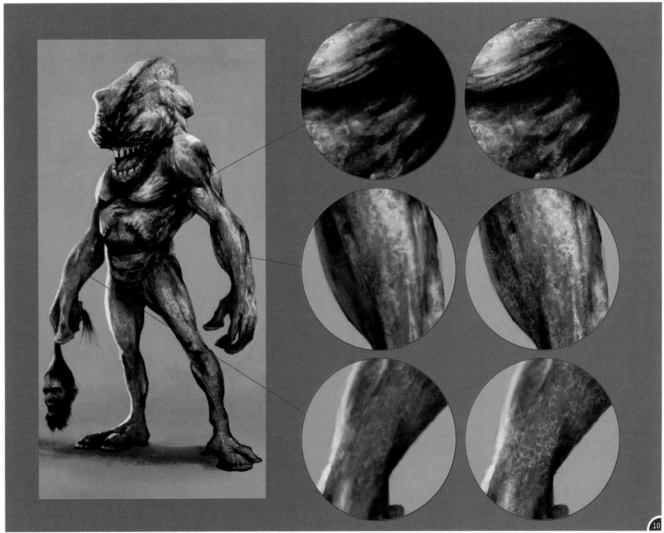

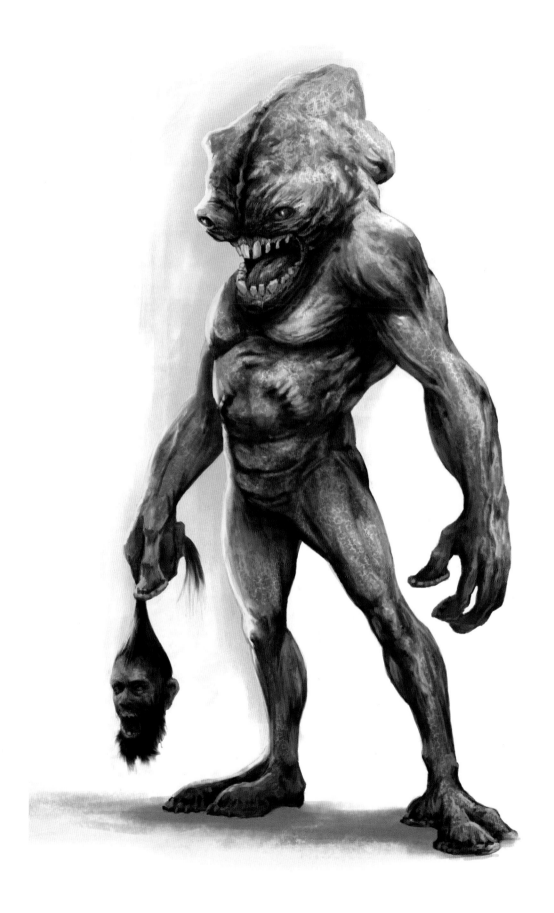

Painting Materials | Urban Environment
By Maciej Kuciara

Introduction

During my career as a concept artist and illustrator I've found myself using many techniques for producing artworks. I'm always trying to find new and better ways to do so and after 10 years in the industry, I think I could easily write an entire book about it.

This book gave me an opportunity to take some of my experiences and share them with you in the form of a tutorial. Since there was a limit to how much information could be written and presented with images on these pages, I decided to pick one of the ways I produce illustrations, both for my personal portfolio, as well as for professional production in film and video games.

This tutorial explains all the processes I go through during image creation. As a subject that provides a good variation in terms of tools and means of creation, I picked a realistic concept of a supercar parked in a derelict environment. It's a subject of contrasts: shiny vs. dirty, elegant vs. derelict, beautiful vs. hideous – giving me more than enough to talk about!

The Story

Before I sit down with any medium to convert my ideas into pictures, I always try to think about a story that would explain what's going on in the image. I always try to find something interesting, even in the most boring subject. In this case, just a supercar on the street was nothing exciting,

even if its design was thrilling. So what if the car was parked by a beautiful femme fatale? What if she was about to exit the car and we could only see her legs? What was she doing in that area anyway? Just that little addition makes us ask quite a few questions and allows us to interpret the image in many different ways. Good starting point! Let's see how it looks in pictures.

This Is Not All About Painting

During the several years I've worked on films and video games, I have often had to compromise quality to meet strict deadlines. I've found that most of the time the techniques and tools used to produce the image never matter to clients, as long as the final result meets or exceeds their

expectations. Once I realized what my clients expected, I started using and learning tools that would increase my productivity.

In this image, I went with both Adobe Photoshop and Luxology Modo 601. Using Modo, as I will be describing below, saved me hours and hours of time in the creation of this image.

Composition Sketches

I almost always start with sketches, but I stopped limiting myself to 2D media (pencils or Photoshop for example) and I often use 3D for a few reasons. There are a few pros and cons.

Starting with pros, it takes almost no effort to create nicely lit environments. You don't have to worry about perspective. You can quickly apply shaders to suggest surfaces and see if they will work together in a final concept. Lastly, with just two clicks, one scene can be rendered into several different images that would be ready to be worked on (**Fig.01 – 03**).

The only time that I've found 3D sketches aren't as fast as the traditional 2D approach, is when

you are searching for good shapes and designs. It's much easier to sketch a few lines and see if your design is cool or not. It is doable in 3D, it just takes a little more time and effort – which can result in missing the good ideas you would have achieved if you'd sketched them in Photoshop.

Luckily, with this car image, good shape and design was just part of the whole image. Not only did the vehicle have to look good, but it had to sit in a realistic environment.

We're Doing It!

To get a good sketch, I split the process into two phases: composition and design. I started with the composition, spending a few minutes creating a scene full of boxes in Modo and throwing in a few camera angles and lighting scenarios.

I started with boxes and cameras, and rendered several interesting compositions in a matter of seconds (**Fig.04 – 07**). After that I started adding different lighting information. That way, in just few minutes, I managed to get an interesting set of thumbnails out of four initial compositions.

With Global Illumination enabled, these small renders gave me a really good representation of what the final image might look like.

The next step was to replace the box car with a proper design (**Fig.08**). I could have chosen two routes to achieve this. First, used one of the sketch renders and painted over it, looking for cool car shapes and lines. Second, modeled a rough version of that car in 3D. Even though the

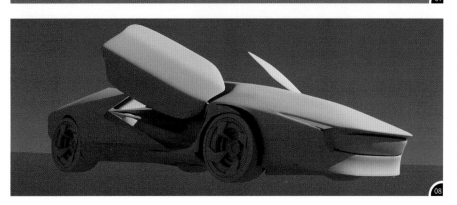

first approach would have produced quicker results here, I decided to model the car. I'd look for good shapes and lines during the modeling process, and iterate until I was happy with the result. Then I'd use a shader tree to add realistic-looking paint, reflections and light information.

Preparing the Scene and Render

Since I knew I wanted this concept to be done quickly and look realistic, I decided that I would use 3D as much as was needed and fix everything else in Photoshop. I set my main focus on getting the render of the car realistic and for that, I needed a good setup for the environment and lighting. The scene itself didn't have to be very detailed, since I planned to use textures and Photoshop to add the realism.

I took the sketch mesh and started adding a few details; just enough so that there was visible definition on the car paint reflections and shadows from the light sources. To add to the realism, I used a couple of photos I took in Los Angeles. I really liked the garage photo and used it to re-create that part of the environment in the upper right corner of my scene. I replaced the lamp with a simple box and self-illuminating shader, creating an artificial light source (**Fig.09**).

To get a good contrast of hues, I used a standard directional light that is loaded with each scene you create in Modo, and just adjusted the light material slightly to increase the warmth in the hues. I used photographs of downtown LA that I took last summer as a reference (**Fig.10 – 12**).

Building these elements and adding lighting information to the scene from the photo references allowed me to get better reflection and lighting information on the car –information that I would otherwise have had to paint in, and which would likely have taken much more time if I was to achieve the same level of realism.

The next step was to put some value and color information into the scene. Since I wanted to keep it simple, I used standard planar mapping and three textures from 3DTotal's free texture library. These can be found in the resource file that accompanies this book (**Fig.13 – 15**).

I made sure these textures sat more or less in the scene and didn't distort the way you read the scale of each element (**Fig.16**). I decided not to update the car model I'd done in sketching phase. I felt the most important part was going to be the lines and shapes I'd created, and lighting and reflection information from the render (**Fig.17**).

As soon as I felt I was happy with the results, I decided to prepare my scene to work with in Photoshop. I always assume that things might change during the creation process and the best way to prevent me from having to redo things over and over again is to prepare enough material beforehand.

The best way to avoid any re-renders was to create many render passes of the scene with and without a car. I rendered the empty scene in three standard passes: Beauty, Ambient Occlusion and Shadow. I didn't need anything else, since all other details would come from photography, textures and painting.

Since the scene was low on polygons, only had three textures and used few shaders, the render of each pass would not take much time (**Fig.18 – 19**). These renders gave me enough to work with In Photoshop.

Next, I started rendering the car. I made the same standard passes: Beauty, Occlusion and Shadow. I needed the vehicle to be fully shaded with the correct reflection and light information coming out of the scene, yet be able to have it on a separate layer. For that, I created a new Render Output layer in Modo, with a Surface ID parameter (**Fig.20**). This way I could select by color and use that selection as a mask for my car.

The last step that would involve using Modo was to render a few extra layers of the car. Because I wasn't spending the entire day modeling the environment and vehicle accurately, but rather creating a realistic-looking approximation of them, I decided to add a few extra variations of reflections and colors of the car. I could then composite them the way I wanted in Photoshop later on. I used several standard environment

materials available in Modo and re-rendered a couple of Beauty passes of the car (**Fig.21**).

With all the renders above, I felt I was done with 3D and ready for some painting action!

Brushes

Before we talk in detail about the painting process I went through with the car illustration, I wanted to discuss several technicalities that will help you to understand a little bit more about the way I work.

The first topic I would like to talk about is brushes. I tend to use customized brushes for all of the work I've been doing during my career. The biggest advantage of having a customized set of brushes is the amount of time you will save when painting.

Over my career, I have created, collected and shared dozens of customized brushes. Thanks to the awesome concept artist community, I've found a few other artist's brush sets very useful in my personal and professional work as well (these include brushes from Jaime Jones, Jan Ditlev, Shaddy Safadi and more)(**Fig.22**).

Fig.23 shows a few examples that I used for painting the car illustration. I always try to limit the amount of brushes I use per painting to a few favorites and a few that will be useful for specific artwork. The reason for limiting the brush set per painting is simple: customized brushes give specific texture and frequency of detail in the image, so the less fancy and customized brushes you use, the cleaner the image you might get. This works the other way around too: more customized textured brushes mean more detail frequency. It's important to limit the amount of that detail in order to keep the image readable, without overloading it with details.

Layer Masks and the Move Tool

As well as customized brushes, another big thing for me are layer masks and the Move tool. The layer mask technique basically refers to linking two layers together by Alt + clicking between these layers. The second layer will use the same mask as the layer that it's linked to. I will describe

this in detail with example images later in this tutorial.

The Move Tool is a super-powerful tool for stretching and deforming photo textures to make them work within your painting. I use Move Tool > Warp a lot (you can access it by clicking the bounding box of the layer and then right clicking for the dropdown menu). Later in this tutorial, I will show how to use this tool to add some extra realism when creating extra reflections on the car.

Time to Paint

With the 3D renders ready, we're finally moving to the digital painting part of this tutorial. I imported all the renders I'd done so far and composited them into one Photoshop file. This composite would be my "original plate" on top of which I'd do all the texturing and painting work. I kept some of the rendered layers separate and disabled, as I knew I might or might not use them later on (and since rendering out additional passes takes close to no time, it was better to have extra, than to get back and re-render new passes) (**Fig.24**).

Next, I divided my work process into the several stages I'd be focusing on. Because the goal of this image was to create as much photorealism as possible, almost every area of the image ended up being crisp and detailed, and in that kind

of work I've found out that the best and most efficient way to achieve that goal is to split the image into sections and work all of them up until you've got 80-90% of the desired look.

It's worthwhile noting that pursuing this technique only make sense if the majority of the image is coming out of 3D renders, where lighting, composition and some of the detail is already defined. Painting detail only in the specific areas up until it's almost finished immensely detaches your focus from other parts of the canvas, which can result in big composition and lighting errors if these two things aren't set beforehand. For example, if I went back and painted this image from scratch, using only brushes and a texturing technique,

I would probably work in details, step-by-step, evenly across the entire image. But because this illustration has a pretty well-defined composition, lighting and overall information about what elements we see and expect in the scene – and since the goal was to get realism throughout the entire canvas – I knew that focusing on specific areas and detailing it to a "finished" look wouldn't affect the final composition and lighting.

So, where to start with details? To answer this question, I analyzed my concept and looked at which elements interacted with each other (**Fig.25**). I usually find that starting from the background to the foreground works pretty well as a general rule. And while I'm keeping the most

essential layers separate, even if I change some detail in the foreground, it will be much easier to adjust the background than if I started working the other way around.

In our car image, the vehicle detail relies mostly on the light information and reflections coming from the environment that is surrounding it.

Environment

The way I usually start detailing out parts of the picture is to use any photography that can add to the image quality and fit the overall composition. Because I had already used three images I took in downtown Los Angeles as a reference for my lighting scenario, I re-used these references as photo-textures on the background.

Fig.26 shows the way I incorporated parts of the photographs, which is a very quick and dirty way to add detail immediately, yet keep all the work you've done so far intact. I painted out the trees and added several small details using parts of the photographs and one of the brushes from the examples provided before. I didn't focus on being super-accurate at this point, since I wanted to get the general placement and feel in place first. Remember the girl I wrote about while discussing the story part? This is the moment I decided she would make her appearance with a quick paint.

Environment Details

After having photo textures sitting well in the image, I started the clean-up and detailing process. Again, I focused on specific areas and continued adding more detail where I felt it was lacking.

Using the Selection tool, I made a selection on the left side of the facade and with the gradient on a separate layer, threw in lighting information coming down from the garage photo's lamps. I made the layer a Lighten blending mode, and then played around with Underlying Layer sliders to keep removing colored brightness from the black window frames and shadowed areas (**Fig.27**).

Switching from left to right, I started cleaning up the building texture where sunlight is hitting the

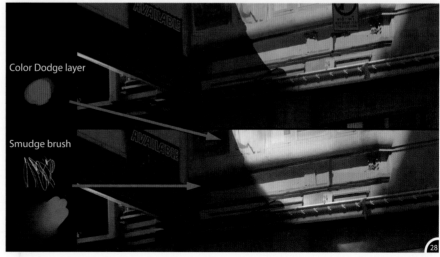

building. I used the Clone tool to paint out the traffic sign, then brush 7 from the example set to paint in some of the facade lines and clean the picture a little more (**Fig.28**).

Using brush 3 as a smudge brush, I softened the sharp shadow line and added another layer on the Color Dodge mode. Then I painted the edges of the shadows with a bright orange color to increase the hotness and bloom of the sunlight (**Fig.29**).

Moving forward, I felt the reflections of the windows didn't represent other parts of the environment as well as what could be on the other side of the camera (**Fig.30**).

Because the sun is hitting the wall the viewer is looking at, that means that any building or object on the other side of the camera, and thus visible in the reflections, will be in shadows. Again, the photography I took in Los Angeles came in handy here.

Next, I took part of the photo and blurred it out. Crisp photography in an old window with dirty glass would look unnatural. I placed the blurred photo as a new layer in Normal blending mode (**Fig.31**).

I disabled the new layer and started making a selection following the window frames. Once ready, I used the selections I'd made as a layer mask for my new blurred reflections (**Fig.32**).

The image was started to look pretty good, but it was missing any of the reflections of the overhanging structure that I had made out of a 3D render and garage photography. To make its reflection natural, without spending any unnecessary time rendering realistic reflections in Modo or painting in accurate mirroring with brushes, I just took the upper right corner of the image, copied it and pasted it in as a new layer, linking it to my previous window reflections layer, so that it would use its mask. With the Clone brush, I made a copy of the lamp on that same layer, then used blur to make this new garage-reflection layer match my original reflection layer (**Fig.33**).

Almost there! The only thing I was missing was the shadow and reflection of the window frame. I painted that with a standard round brush and blurred it slightly (**Fig.34**).

The Street Detail

Next on the list for details and touch-ups was the street. I decided to upgrade the detail with photo-textures I'd already used to create this image. I took the images from LA, as well as a road texture from the 3DTotal free textures library, and placed them on the street surface, roughly matching what I had in the render. On top of that, I used the Occlusion pass I rendered at the very beginning with the blend mode set to Overlay. I adjusted the occlusion with levels, because the original layer made the entire ground too dark. Using brushes 2, 4 and 5, I cleaned up the seams and added some extra detail to existing textures (**Fig.35 – 36**).

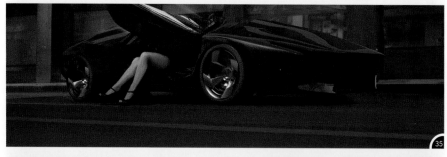

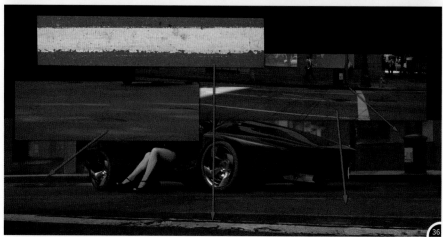

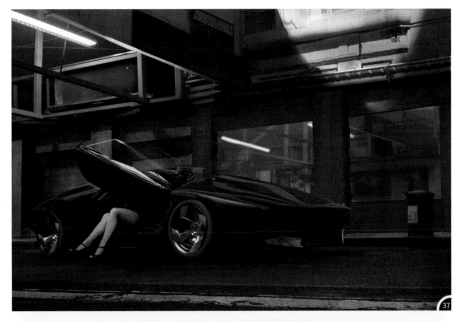

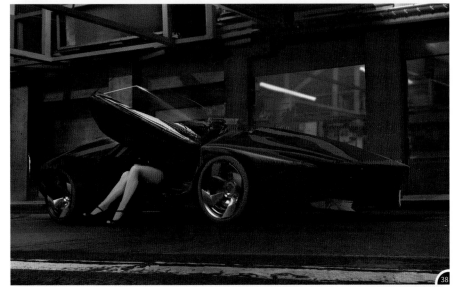

Using part of the texture and brushes, I added a trash can to fill out the empty space on the right side of the sidewalk.

After that, I added a new layer and with the Gradient tool, I added more shadows under the car and on the right-hand corner of the street (**Fig.37**).

Once I was happy with the overall detail of the street, I created a new layer in a Lighten blend mode. Using a gradient, I worked in orange and blue colors on the sides of the street, to imitate scattered light and reflections. Then using an Underlying Layer blend in the Blend Mode menu (double-click the Layer icon to access that menu), I adjusted how much of the dark colors cut through this new lighten layer – this way the ground texture was enhanced with new lights (**Fig.38**).

With all the steps I'd been through so far, I felt that the environment looked good enough for now. There was good realistic detail definition that was following the 3D structure and composition I'd built at the start. I felt it was a good time to enhance the focal parts of the image: the car and the lady (**Fig.39**).

The Car

To create all the necessary details for a realistic-looking car, I used just a few very basic tools that Photoshop has to offer: Selection tools (Polygonal Lasso mostly), Line tool, Gradient and a few brushes.

Before making use of all the aforementioned tools, I needed to adjust a few things on the composed render layers. First off, I decided to darken the tires and rims; they felt too bright and were taking away the prestige value of the car. I made the rims custom black chrome instead.

Right after I took the Polygonal lasso into action and I made sharp angular selections that I wanted to use to enhance the design of the car. Using the Gradient tool and black I created vents, a front grille, side lines and vent holes. To fix the lumpy and ugly model errors from around the tires and rims, I used selections and a black

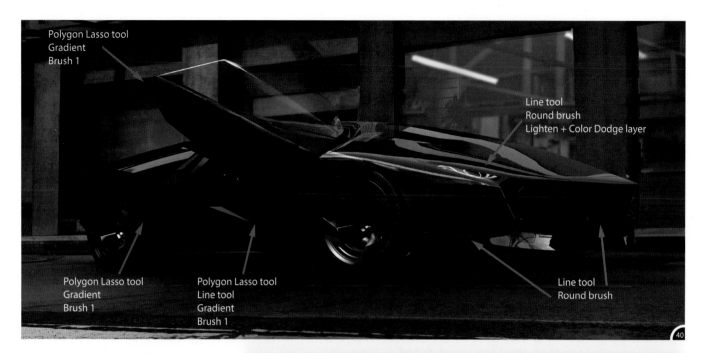

Polygon Lasso tool
Gradient
Brush 1

Line tool
Round brush
Lighten + Color Dodge layer

Polygon Lasso tool
Gradient
Brush 1

Polygon Lasso tool
Line tool
Gradient
Brush 1

Line tool
Round brush

round brush. Then I inverted that same selection to paint an outline highlight on the outer edges of the body around the tires. With the Line tool set to 2-3 px and a bright blue color, I added highlights on the body parts under and over the vents, which previously had a gradient (**Fig.40**).

To add LED headlights, I created a new layer in Lighten blend mode and, using both the Line tool and Round brush, I created blue LED light lines. After that I duplicated the layer and blurred it to create a bloom effect. I duplicated the original LED layer again, blurred it about 50% less than the bloom layer, and used it as a Color Dodge blend mode layer. This way the headlights kept the crisp lines and realistic-looking glow.

Next, I needed to add light reflection and material definition to the door windows. For that, I used the upper right part of the image with the garage photo texture and, by using Move Tool > Warp, I placed that newly deformed layer onto the door windows. I used the Color Dodge blend mode and Adjustment >Levels to adjust the look. Then with a soft round brush, I painted additional lights that I felt would contribute to the realistic look of the glass (**Fig.41**).

With all the above changes, I felt the car was looking very good already. I switched the lady legs layer back and with Adjustment > Level, a

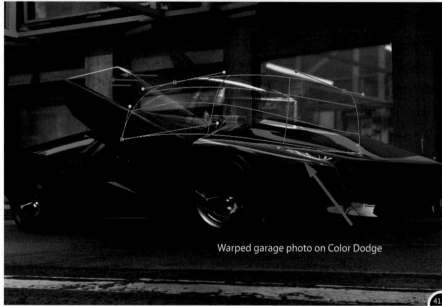

Warped garage photo on Color Dodge

43

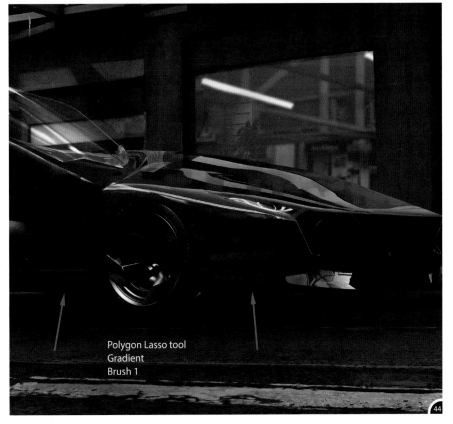

Polygon Lasso tool
Gradient
Brush 1

44

round brush and Filter > Texture > Grain filter, I
tried to achieve a realistic look, while looking at
several references of women's legs (**Fig.42**).

Right after, I decided the car would look even
better if I enhanced the reflections I already
had on it a little more. First, I took part of the
downtown LA texture, warped it and placed
it over the car front and windshield in the
Difference Layer mode. Then I erased parts of the
texture that were extending to the sides of the
car, as well as outside of the car outline. Finally,
using Levels, I adjusted the layer until it looked
good (**Fig.43 – 44**).

Next, I put the Polygonal Lasso and Gradient
tools into use once again. I made a selection
on the sides of the car and in the Lighten blend
mode, made several gradient and Brush 1 strokes
to increase the amount of street reflections on
the side of the car. I erased out the layer on the
tire and rim areas, and using the Underlying
Layer slider in the Blend Mode menu, adjusted
the layer.

Details

Finally, when I was happy with the detail and look of both the car and the environment, I started the final stage of the illustration process, which was adding all the extra bits that make good images look great! This last part was more about painting and touch-ups than anything else I'd done up to this point.

By using some of the example brushes, some of the standard brushes and by looking at some other downtown LA references I had gathered in my private folders, I painted dirt around the curb and added some randomly scattered paper etc. I also used the Line tool and round brush again to outline and give more definition to the door windows. Then by holding Ctrl and clicking on the car layer, I made a selection mask for the car and painted an extra bright, desaturated yellow rim light and reflection on the windshield of the car. Last but not least, I painted some graffiti on the wall behind the car to make the street look even cooler than it was looking so far (**Fig.45**).

Light FX and Color Correction

The very last step before I had this illustration finished was to have a go at giving the image

some extra light and color corrections, as well as some detailed light FX. For extra little details like that, I always create a new Group in the Layers tab and collect all these changes in that group to keep my PSD files organized.

I created a new layer within that group in Normal blend mode, and by color picking dark and bright spots of the picture, I tried to imitate the way the camera lens reacts to light (changing contrast, darkening dark areas of the image, glow

and bloom on bright areas). Then to suggest just a little extra contrast, I created an Overlay blend mode layer, and used black and white semi-transparent gradient strokes to achieve the contrast where I felt it was needed (especially on the car, since that was the focal point of the image) (**Fig.46**).

Because these two new layers washed out the car headlights, I duplicated the headlight layers and pushed them on top of the new gradient layers

to bring back some of that cool glow. Using the same technique I used for the front lights, I created red tail lights. After that, with a Lighten layer and gradient, I added some extra glow to the car lights, and suggested the direction and intensity of the headlights on the far right side of the street (**Fig.47**).

Finally, I decided to play around with the adjustment layers and added a Levels adjustment. In the Levels menu, I played around

with the sliders and values on all the channels, that is Red, Green and Blue and overall RGB, to crash the shadows to black (**Fig.48**).

Final Notes

Adding an adjustment layer was the last touch-up I did to this image. I was very happy with the results and decided to finish the work on the car illustration at this point. The final image answered all the questions I would want to ask myself when I looked at it for the first time.

I was happy with the way in which the techniques I used resulted in a good pace and final quality of the image created. Granted, if I had painted everything using just brushes, without the use of any 3D software or photo textures, getting a quality image like the one I achieved with this car illustration would have taken much more time.

In both film and video game production work, as well as personal artworks, I find that experimenting or even implementing new tools into the process can largely benefit both artistic skills and productivity. More than a year ago, I used to mostly paint and 3D software didn't contribute more than 10-15% to my images. The more I've learnt how fast things can get done when switching to more efficient tools and mixing them with those that you already use, the more that percentage ratio changes to very flexible numbers. There are days that 3D is 90% of my work, and those where I only use Photoshop. It doesn't matter to me what tools are used to concept or produce illustrations, as long as the final result blows me away!

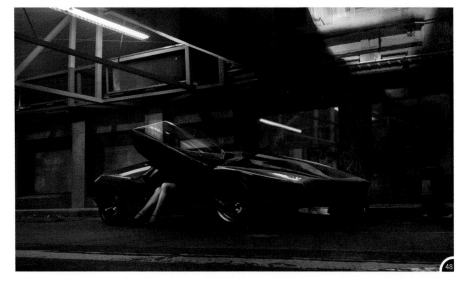

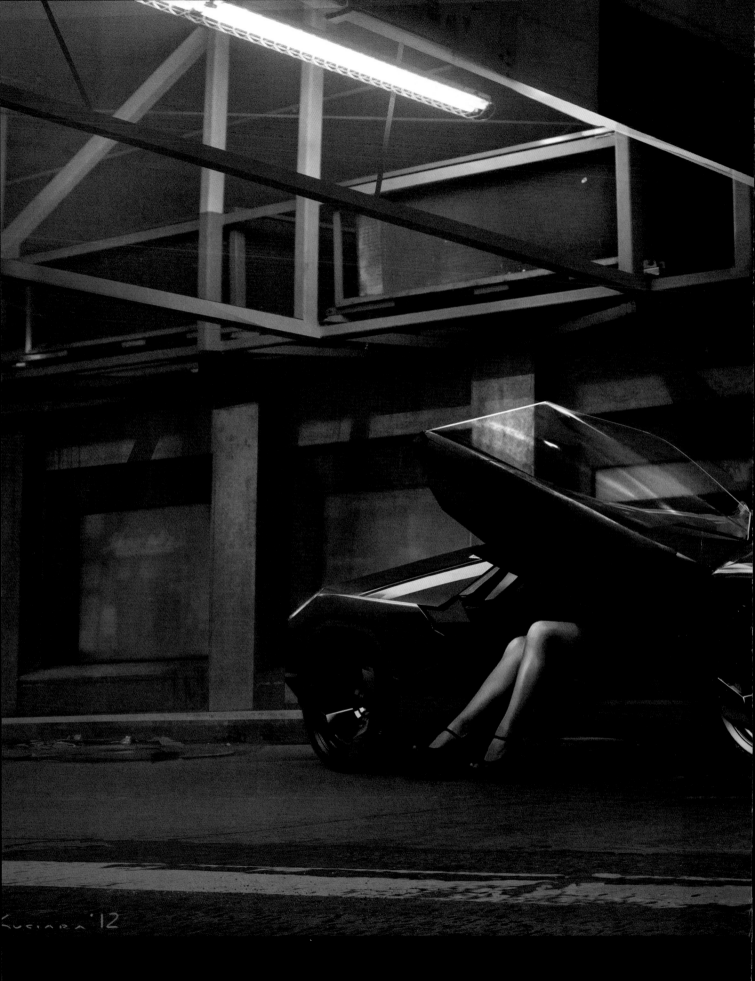

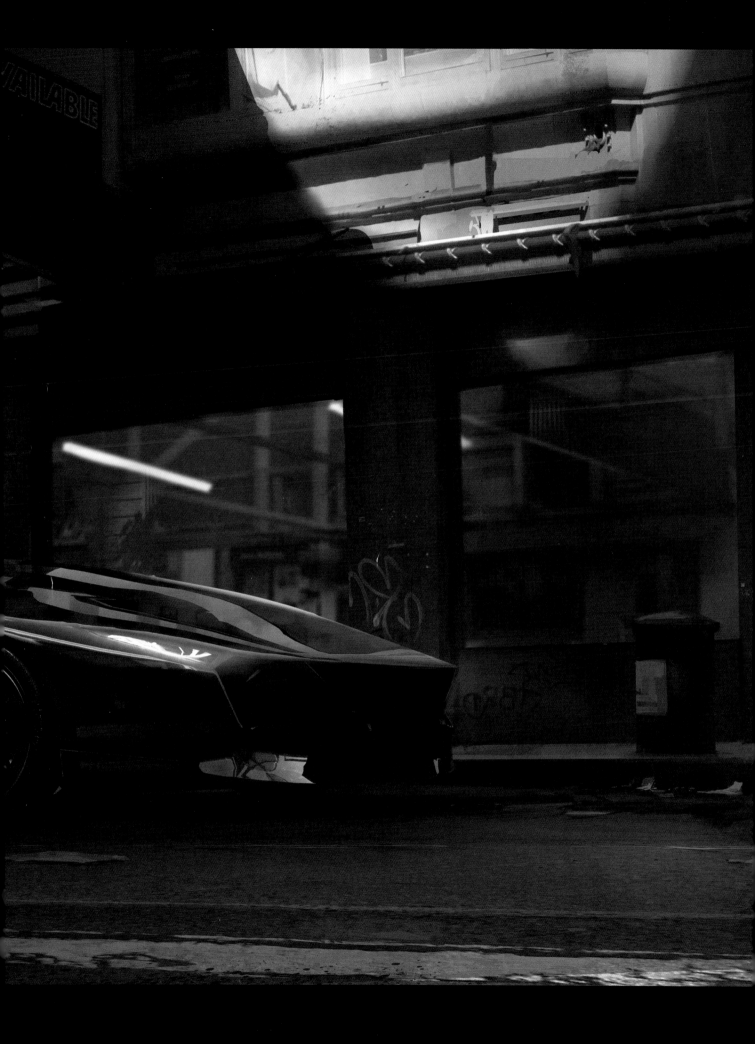

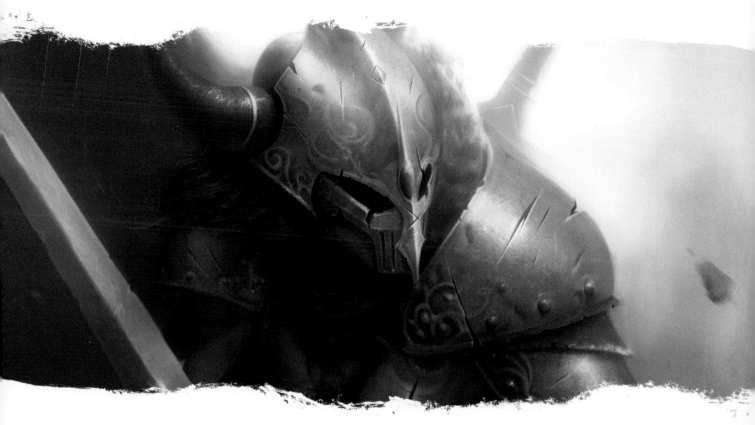

Aging Materials | Knight
By Clonerh Kimura

Introduction

In this tutorial I will be demonstrating how to age armor. The few times I've had to paint armor have usually led to painting the shiny aspects of a newer piece of armor, as if it's straight from the factory. Now not only do I find it a little boring, but almost every time it isn't consistent with the character's history or the narrative, as knights are in battles getting beaten and dirty. This is the purpose of this tutorial, to show you a way – a simple way, in my personal opinion – of making new armor look old and used. This may not be the best way to do it, but experience will help you with that, so just try to use this as a reference in case you're lost.

References

In most of my artwork, I don't usually use many textures from photographs; rather my process involves the use of references all the time. Normally I try to have as many references as possible and, of course, the use of brushes, but in this tutorial I will use a couple of textures and few

brushes. So my first recommendation is to gather these references. You can search Google or find sites with lots of textures; you don't even have to look that far as 3DTotal has a good catalog of references and textures that can be very useful.

Getting Started

Well the process begins here. As you can see in **Fig.01,** the armor is very bright, and everything is so clean and smooth. The armor doesn't show any signs of struggles, dents or dirt, and this is our main problem because we are taking away the realism from our character and the image. In fact, our knight looks totally out of context with that background.

The first thing I will do is remove all the shine on the armor; I do it as opaquely as possible, trying to not lose any volume or detail. Just for the record, the best way to do this step is to do it at the beginning of your image, to avoid having to repaint the armor, as I'm doing here, but as this is for the sake of this tutorial, it's okay.

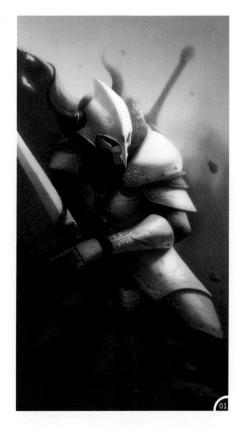

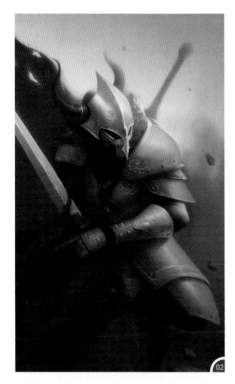

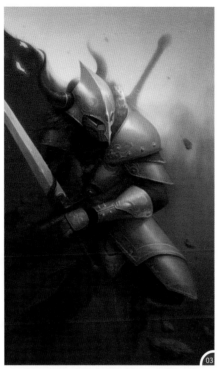

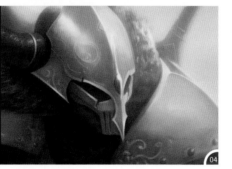

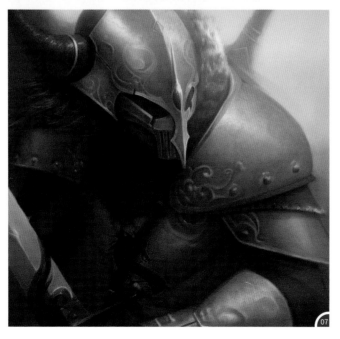

This step is actually very simple, but very important, because the level of opacity that is in this step will define how the armor will look at the end of our illustration. So, do not over-complicate it, and use a hard brush and a dark color. In this case I'm using black and mixed the color with the rest of the armor (**Fig.02**). If you are painting over clean armor, as in this case, be careful not to lose too many details, especially if you have small symbols on the armor.

The armor has lost some definition, as the process is quick and we're not focusing on the details. In **Fig.03** I'm trying to detail some things that were lost in the previous stage and also to add a bit more contrast.

You also always have to take into account the lighting, and know from the beginning where your spotlight is (**Fig.04**).

Textures

Now I'll add a couple of textures (**Fig.05 – 06**). When adding these textures, it may not seem so significant, but their purpose is, visually speaking, to generate noise on the surface of the armor, which can translate into wear and stains. At the end these little details are going to make the difference. These textures can be found in the resource file that accompanies this book.

The process is simple, but can be a little tedious, it is necessary to adapt the texture to the shape of the part of the armor that we want texturing; the texture has to wrap around the object to avoid it just being a flat image over our illustration. A quick way of doing this is to copy both textures, modify them with the Warp tool, and then try to adjust them to each part of the armor.

This tool can be used to help preserve and add more volume to armor. You do the same process with both textures, place them in layers in Multiply mode and adjust the opacity as much as you want to make the details in the armor noticeable. In my case I want to make something very subtle, because I prefer to add the rest of the details by hand. In **Fig.07** you can see the image with both the textures in place.

Adding Details

The next part is fun! It's time to add some bumps and scratches, caused by stones, swords, etc. In this case I'm going to draw these details by hand. You can always get some textures to help you in this step, but for me it's more fun to paint this kind of detail freehand. The cuts are easy to create with just two colors, black and white. The black to define the depth and the white to mark the edge of the crack. The idea here is to vary them in size and shape, and add as many as needed; in my case I've just added a few (**Fig.08**).

The armor is still looking very opaque. What I will do is add a few more highlights, because we want to keep the material looking like metal. For the shine I use the Dodge tool (O key). The range must be 20% or more exposure in the Highlights menu, and you have to merge all your layers into one. Then use a soft brush in the areas that you want to add more shine too. Basically it's all about trying to match the tones around the brighter area, like in **Fig.09**. Here the bright tone is cyan, which is matched by the tones around it to make the brightness appear more intense.

At this point the armor already looks much better. I will continue to utilize the textures by copy and pasting them into a new layer in

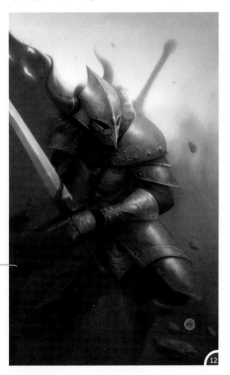

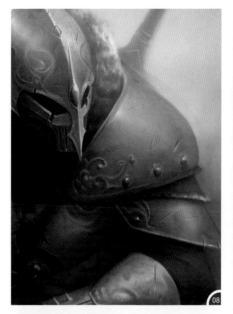

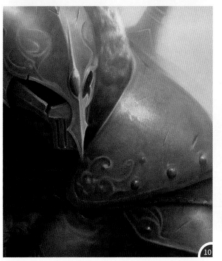

Multiply mode. I'm not going to use the Warp tool this time; instead I decrease the Opacity to 25% and with the soft brush, remove the parts that I don't need. With this, I add some brown spots with the intent of it looking like dirt and rust (**Fig.10**). A good balance of these kind of details is necessary to make the image consistent with the narrative, so too much or too little wouldn't do the armor any favors.

Finally I add some scratches and scrapes, which is very characteristic of metal. In **Fig.11** you can see how the scratches basically crowd around the brightest area of the metal, and somehow follow a circular shape, as if someone has buffed the armor in this direction, leaving those little marks only visible in bright and highlighted areas.

Finishing Touches

The armor is almost finished. I add a few final adjustments, and change one thing I don't particularly like, which is the blue tone around the armor. I'm going to remove it, but not completely. I create a new layer in Color mode and, with a gray color and a soft brush, tone down the blue, just leaving a hint of it in some areas – it's good to have tonal variation. And, so we reach the end, with an illustration more robust and engaging (**Fig.12**).

You can add as many details as you want! This part of aging materials is an interesting process and worthwhile spending more time on. Just for fun, using the same steps, I've added more details that have aged the armor further (**Fig.13**)!

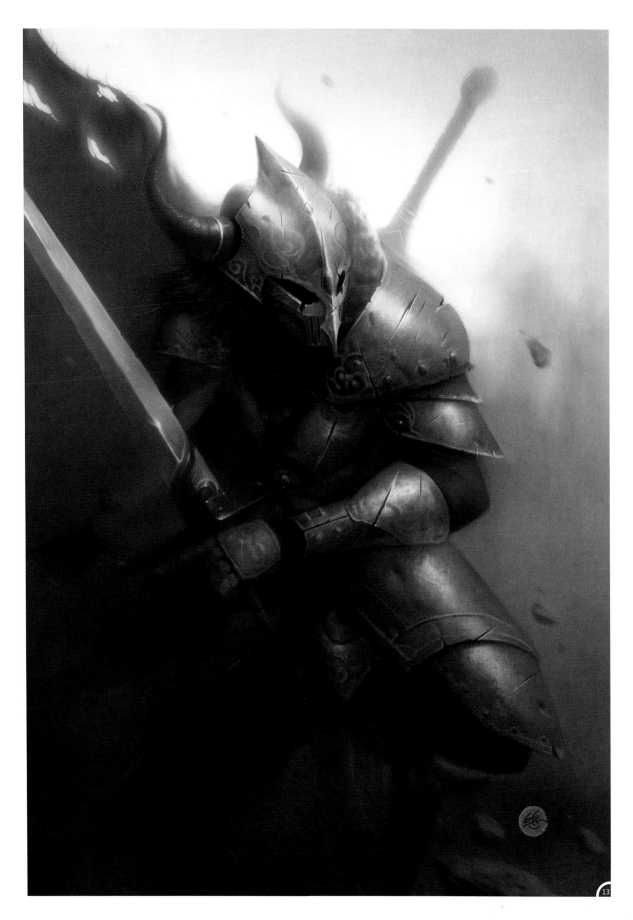

AGING MATERIALS | VEHICLE

By Matt Tkocz

Concept

For a while now I've wanted to come up with some kind of junk yard motorcycle design that looks like it was made entirely from scraps, stripped down to its essential elements – functional rather than stylish. The coolness is only a by-product of the purposeful design, but it should definitely be the name of the game.

Sketches

For the most part I prefer to sketch with old fashioned line drawings. Sometimes though, I get desperate and resort to more experimental ideation techniques, like using Photoshop custom brushes, photo-collages or something like that. It's not really my thing though. At this stage, I will usually stick to drawing flat side views because drawing in perspective is hard and in this case, the side view of a motorcycle conveniently happens to be the most descriptive angle. Another advantage is that I can use my favorite sketch as a rough orthographic drawing for when I start my 3D model.

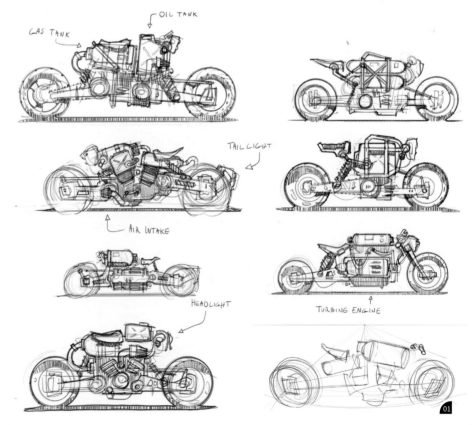

I start by looking at all kinds of motorcycle references and I find a couple of models that utilized so-called hub-center steering. It's a type of suspension where the traditional fork in the front is replaced by a swing arm that is attached at the bottom of the frame rather than directly to the handlebars.

According to Wikipedia, this system is supposed to improve handling by separating the steering from the front suspension and breaking mechanisms. I couldn't care less about that. It looks cool and futuristic, and that's good enough for a Hollywood phony like me (**Fig.01 – 02**)!

3D Model

I always make an attempt to choose my design direction very wisely, because I know I will be stuck with it throughout the entire design process. Early decisions are always more weighty than later ones and a foolish choice now would ruin my life forever.

Fortunately this type of design is literally kit bashed from existing objects. And that's exactly how I go about putting together the 3D model. I (immorally) scavenge parts from other people's 3D models I find on Google Warehouse. Engine parts, gas tanks, handlebars, foot pegs and shocks are straight up stolen. The more "styled" elements of the design like the wheels, the swing arms, taillight, cables, seat, air intake and filter I have to build myself. I keep the model very rough and basic since I know I'm going to paint the hell out of it later anyway (**Fig.03**).

Composition

Other than the good old laws of composition like the rule of thirds, the rule of odds, golden ratio and all that baloney, I first focus on the purpose of the illustration, what it's going to

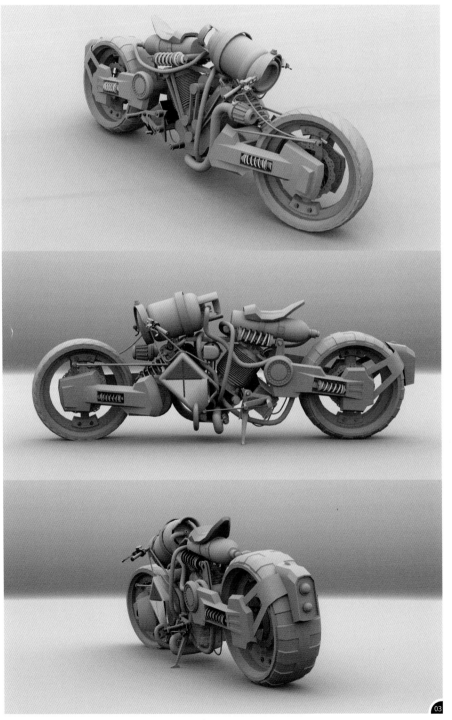

be about. Since this shot is supposed to mostly showcase the bike design, everything else in the composition should work to support that (**Fig.04**).

Quick Tip: The best way to communicate the design of almost anything would be to shoot it with a long lens in order to minimize foreshortening. However, since this tutorial already comes with a bunch of descriptive renderings from all kinds of angles, I've decided to go with a more dramatic 25mm lens (**Fig.05**). The scene itself I keep rather primitive in order to not distract from the bike too much.

Value

Before I start the painting process, I will usually paint a quick value sketch I can refer back to throughout the painting process. This is just to make sure I don't run into any bigger problems down the line. I'm not going to be painting over this value composition directly, but merely use it as a point of reference. A strong value structure can help describe many things including depth, form and local value, or it can simply be used to direct the viewer's eye.

> **LIGHTING A SCENE WITH HARSH, DIRECT LIGHT SOURCES IS TRICKIER DUE TO GENERALLY HIGHER LOCAL CONTRASTS**

Usually I use value primarily to deal with depth or atmosphere. The bike itself is only lit by ambient light, which makes its local values pretty flat and helps the darkish silhouette read easier against the brighter background. Lighting a scene with harsh, direct light sources is trickier due to generally higher local contrasts and therefore more attention is required when composing the values. Neglecting this step could possibly lead to a noisy or spotty final image that's going to be confusing to the eye (**Fig.06**).

Even after I've moved on to working on the color, I always keep a black and white adjustment

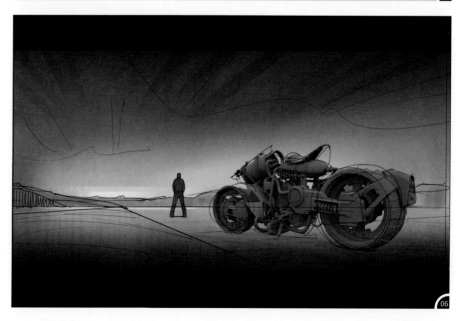

layer on the very top of my layers, so I can quickly double-check whether or not my value composition got out of hand somewhere along the way. Sometimes all those saturated, pretty colors make it difficult to judge the value composition.

Color

I usually steal the color scheme from some photographs I like. For this particular painting I don't really have a clear idea about what to do with the color. When I search the web for inspiration, I eventually stumble upon a cool fashion photograph with a nice palette. I overlay my line drawing with the photo, distorted, and paint over it to roughly match the value sketch I did earlier. When I look for these "color scheme" photos, I try to remember that it absolutely doesn't matter what the photograph is of. I'm just looking for a color scheme, nothing else. I might as well use a photograph of cotton candy. It makes no difference as long as I can dig the colors (**Fig.07**).

Painting

At this point, all important decisions have been taken care of. Now it's about editing what's already there. I keep adjusting and shifting my areas of contrast to fix my focal points. To preserve the purity of the colors, I try to be as efficient with my brush strokes as possible to make sure the colors don't get too muddy. I don't really go out of my way to paint over the life work. It's going to disappear anyway. At the same time I try to be selective where I add detail. I don't want to overwork the image, keeping in mind where I want my focal points (**Fig.08 – 09**).

95% of the time I get by with only three brushes. I only use fancier custom brushes for special occasions. All three of my primary brushes are based on the default round Photoshop brush, only with slightly modified settings. One with Pen Pressure set to Opacity only, (1) one with Pen Pressure set to Brush Size (2), and a third one with the pen pressure set to Opacity and Brush Size (3). The Mixer brush (Photoshop CS5 and later I believe) is awesome to smudge and soften unwanted hard edges, or simply to blend and lose areas of too high contrast (**Fig.10**).

Materials and Detailing

Eventually I start introducing basic material indication and local color/value information (**Fig.11**), with the help of further references.

To make my own designs look more believable, I always look at as many photos of the real deal as possible. Checking out the real-world counterparts of my designs usually gives me more than enough information to sell the realism of my own stuff. For the detailing of my motorcycle, for example, I pull up images of forklifts as they – in many ways – match the aesthetic I'm going for: purpose-driven, functional and durable.

With my newly acquired knowledge I can now slap some decals, cutlines and info graphics on my bike that seem reasonably appropriate (**Fig.12**). It absolutely doesn't matter what the graphics actually say, nobody ever bothers to read them anyway – I hope (**Fig.13**)!

Weathering

What a weathered surface looks like exactly obviously depends on the material of that surface. Generally speaking you could say that the more a material is worn, the more of its layers are revealed. Again, I look for reference imagery because these layers can vary a lot from one material to the next (**Fig.14**).

Besides wear and tear, I also try to consider oxidation. After prolonged exposure to the elements, most materials will show some kind of reaction. As always, I look up references to figure out how exactly certain materials decay over time. The dirt pass usually comes last. There isn't really much to it. I pick up a variety of splatter brushes and apply generously.

Of course, being conscious of the exact location where you apply your weathering elements will make the illustration more legit. Damage and scratches mostly appear on the more exposed surfaces; especially edges and sharper forms. Weathering and oxidation can be found where materials are worn and particularly exposed to the elements. Lastly, dirt is likely to accumulate in crevices, any number of negative form changes

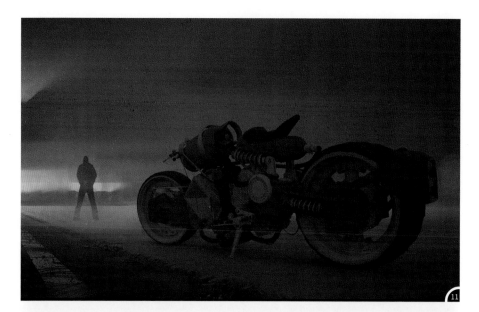

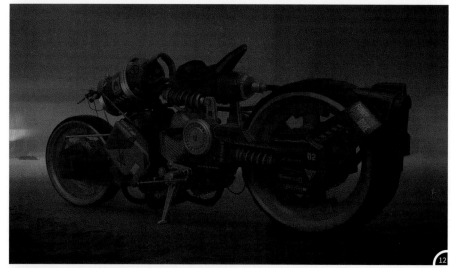

and, generally speaking, areas that are closer to the ground where debris is being kicked up (**Fig.15**).

Blending

Blending is the process of unifying everything back into the same world. When I work out details of specific areas of the illustration, sometimes I lose sight of the bigger picture. So once all the elements are in place, I usually have to reevaluate the entire image in terms of contrasts, values, edges, color and so forth. For example, sometimes I realize that some areas are too saturated. Other times the focal point is not where I want it. Maybe I have too much texture somewhere or maybe not enough. There are countless things that can (and probably will) go wrong. Like most people, I like to flip my canvas frequently, which makes it easier to spot all kinds of flaws.

In this particular case I notice I'm losing the motorcycle's silhouette against the dark background on the right-hand side. Also the local hues of the motorcycle's components are too pure, so I have to knock those back to fit the rest of the scene better. Generally the colors feel a little too monochromatic, so I shift the darks a little towards purple to increase the overall contrast in color temperature.

Although overdone a lot recently, the application of Photoshop's Chromatic Aberration filter is a cheap way to add a hint of photorealism to the image. Simulating other photographic flaws in your image like motion blur, lens flares, depth of field and so forth can also work wonders.

Logo

In a sad attempt to make the image appear more legit, I take some time to put together a pretentious logo design. That's right! No cheap trick is too low for me! I also add a signature (**Fig.16**).

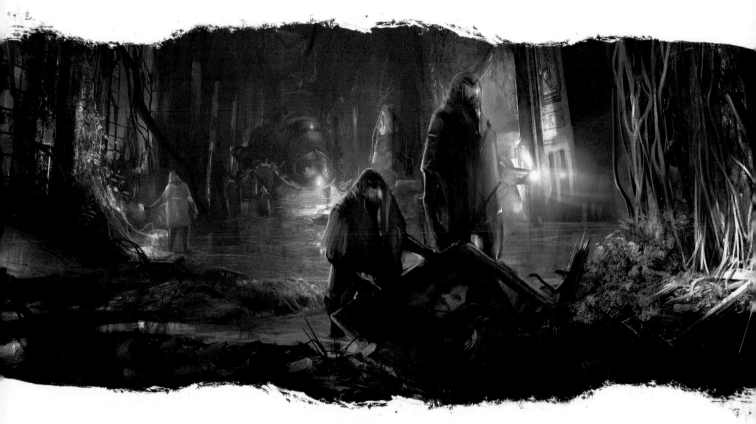

AGING MATERIALS | BUILDING
By Nacho Yague

Introduction

In this article I'm going to cover how I created a piece of concept art that showed an environment in good condition, and then subsequently aged and destroyed it. I didn't have a clear idea about what to make, but I had two clear starting points:

1: I wanted it to be an indoor environment (it's easier to focus on the texture and closer details and it means I don't waste my time working on the surroundings).

2: I wanted to have two versions of the building that were drastically different. So I would keep the source, but shift the mood, technique and historical context.

For the first part I wanted to avoid stereotypes and base it in a real context. For the second part I decided to add some sci-fi elements.

After researching and gathering references, I decided to make a corridor from a Louis XIV-style

palace. I highly recommend you make a reference image folder for any major piece you do; it helps boost your imagination and grants you a solid base from which to start.

I invented a basic plot for both parts of the illustration; this helped me to make design decisions. Each concept you make should say something and answer some basic questions like

how, when, and why (though not necessarily all of them together). It has to tell a story and you have to do that through lighting, action, angle, mood, etc.

I decided to make the palace library, where the wealthy aristocracy can meander, read and chat about social issues and the weather.

I wanted to use warm colors and natural light to express peace and coziness. Also I wanted to show the richness of the place through the construction materials and decorative elements.

Studies

Since I had so many reference images from French and Spanish palaces, I didn't make any preliminary sketches (that was a bad idea and I will explain why later). I started from scratch with these things in mind:

- Natural light
- Spaciousness
- Wooden floor
- Historic feeling

Perspective and Initial Composition

I didn't want to use a complicated perspective. I used a simple one-point perspective for two reasons:

1: It works great in hallways, increasing the sense of depth.

2: Basically, it's a tribute to classical paintings with an aggressive one-point perspective.

> **Quick Tip:** I have a vanishing point PSD; it's a simple high resolution PSD with a vanishing point on it. It saves a lot of time.

Sometimes I start an image in black and white, as it helps me focus and keep the right values. Although what I don't like about this technique is that some people add the color with Overlay layers when the image is almost finished, and it gives a washed color effect, with a poor color overlaid palette and pure blacks and whites.

❝ I WANTED TO BRING FOCUS TO THE CEILING, AND KEEP A PAINTERLY EFFECT WITH LOOSE BRUSH STROKES ❞

When I don't have a clear idea about the mood, I start in black and white, but once I feel that the values work I immediately add color (**Fig.01**).

After messing around with the composition it dawned on me that this tutorial was for a book, so I opted to shift the whole composition and make it vertical (something I would have realized if I had made preliminary sketches). This format was better for a vertical page and meant I could show my artwork without a seem in the middle.

As I've said before, I didn't use any photo textures for this first painting. I wanted to keep it simple and with a fresh painterly effect. After painting for a while, the overall scene was set. The colors varied a bit, but the mood was there, and I tried to maintain it during the process (**Fig.02**).

Painting

I wanted to bring focus to the ceiling, and keep a painterly effect with loose brush strokes. I added some golden decorative elements and a more complex color palette to the ceiling fresco. I always had in mind not to detail too much. This was going to be a picture full of decorative elements and I knew my eyes could get tired if I kept detailing every piece.

As the ceiling was catching all the attention, I added a globe with cool tones, which contrasted with the warmness of the image and helped to balance the composition.

In this early stage I kept flipping the image to see if the composition was balanced (Image> Image Rotation> Flip Canvas Horizontal).

I also added people. I knew this would probably change a bit later, but they at least help me as a reference for scale.

Rendering

Now it was time to get into the details. I created the big windows on the left by creating their flat shapes first, and then I modified them into perspective with the Transform tool: Edit > Transform > Distort (**Fig.03**).

It was very easy to place them because I followed my perspective lines. I did the same with the wall from the right side. I painted a basic marbled texture for the wall, duplicated it and placed it with the same procedure (**Fig.04**).

As the floor is a more complex element, I made a texture. First I painted a basic wooden plank that I duplicated several times, then I placed those planks in symmetric positions, duplicated them again and inverted, until I got an interesting pattern. Once the basic texture was done, I added a compass rose and merged it with the floor. When it was finished, I transformed the whole texture following the perspective lines like I did with the windows (**Fig.05**).

At this stage I hadn't lit the scene. I'd done some fast lighting tests before, and I was painting with a certain light setting in mind, but while

rendering I kept the light as neutral as possible. When all the props were placed where I wanted, I proceeded to apply the light.

This system has the advantage of allowing you to overlay a light layer and tweak it easily whenever you want.

Lighting

Here is a mini tutorial that will help you to understand the basics of lighting with adjustment masks:

Fig.06 is a sphere that has a neutral light. As you can see there is no contrast or light.

Paint Bucket fill with black

Go to the Layers window and press the black and white sphere button. An options window will pop out. Choose the Curves option.

This is going to be your shadow layer. Move the curve (RGB) until you feel your image is dark enough. It's not necessary to be accurate; you can tweak those options later (**Fig.07**).

Next create an adjustment ,ask layer. What you want is for this shadow layer to only affect the areas you want, not the whole image. You can achieve this by selecting the mask (highlighted in red) and filling it with black with the Paint Bucket tool. What happens next is that the sphere loses the tweaked darkness from the adjustment layer. This occurs because this adjustment mask is defined by a grayscale. The adjustment mask layer effect will be 0 when it's black, and 100 when it's white, so the adjustment strength depends on the amount of black and white you erase or add to the mask (**Fig.08**).

So once the mask layer is black, get a brush and start painting in grayscale. The more white you add, the darker the image will be. Just paint the areas you want. As you can see in the image, the areas painted in white in the mask are the ones that are darker in the sphere (**Fig.09**).

Now, add another adjustment mask layer for the light. Repeat the same process, but adjust the Curves to get it lighter.

This is how the sphere looks after adding the two adjustment masks. I saved mine as a PSD so you can download it and see how the layers work (**Fig.10**).

This is the technique I applied on my image. When the light was set, I polished everything and changed some elements that didn't work well, like the lamp and the sculpture.

For finishing, I added more people and light beams coming through the windows (selecting the area with the Lasso tool, painting with a soft brush and applying a Gaussian Blur filter). It made the light direction more readable and added more depth to the composition (**Fig.11**).

The Forbidden Site

Now it was time to destroy and age, which was fun! With the source image done, all that I had to do was go with the flow and do some crazy variations. As with the previous image, I invented a basic story behind the whole scene. I set the image in a future, XXVI century. A group of scientific archaeologists are on an expedition and they are looking for some old art pieces. It's nothing complicated. You don't need to invent a crazy and detailed story. It's just about thinking of some key elements.

Studies

I did some fast color tests to see which direction I should take. I didn't add any details, just focused on the mood (**Fig.12**).

Composition

I decided to go for a similar mood to that of test A. The element that was going to define the

overall light and tone was the sky, so that was the first thing I painted. I kept some parts of the ceiling and added all I wanted to show in the final image, such as the people and a spaceship; they were going to change though. I destroyed the main statue as well.

When I was happy enough with the sky tone, I adjusted the Curves of the whole image (Image > Adjust > Curves) and added a basic light (**Fig.13**).

Textures and Rendering

Video game concept art sometimes requires

tight schedules, and last minute variations and changes. It's very common to use photographs as a base to paint over, as textures or parts of the scene. Those photographs speed up the process dramatically and help the artist quickly demonstrate how those elements can look, work, and interact within the game. When you are working for a client or for your team, it is always good to give them a folder with the pictures you've used.

What I've seen sometimes is that a lot of people don't blend the textures with the painted parts and this gives off a weird result. Other people just apply the textures in Overlay mode. Sometimes it works great but in most cases, it changes the levels and makes the pure whites and blacks pop out.

Now I'm going to explain a technique that I like, which allows you total control over the parts of texture that you want to show.

Adding Texture: The Layer Mask Technique

Before working on this tutorial I made a compilation of images from the 3DTotal Texture DVD collection that I could use. I also added some pictures from my personal collection, with photographs I've been compiling through the years. For this example, I'm going to start with this debris picture (**Fig.14**).

I added the image in a new layer. In the Layer window, I pressed the Add Layer Mask (the circle in a rectangle button) that is located at the bottom of the window. This layer works like the adjustment mask I explained before, so I followed the same method.

I selected the mask panel and painted it with black, and then I used a white/gray brush to reveal the areas I wanted to show (**Fig.15 – 16**).

One of the reasons why I love this technique is that I have full control over the texture; I just paint in the areas I want to show it. With this technique, the same texture has a different opacity on the same layer (depending on the amount of white I added to the mask).

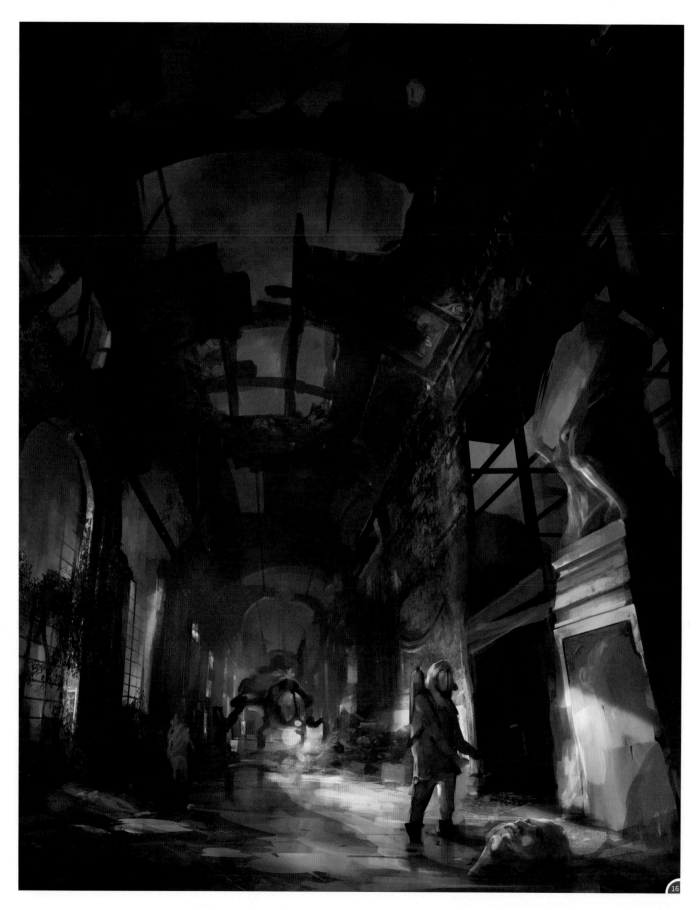

CTRL + H = Hide selection

If I think the texture is not dark enough, or the tones are not correct, I can change it. I just have to select the texture window if I want to retouch the texture (highlighted in red), and select the mask (highlighted in green) if I want to paint or hide parts of the texture (**Fig.17**).

> **Quick Tip:** When I apply photo textures, I add a filter to make it less detailed. It will blend better with the image. There are a lot of ways to apply a filter. The one I use is Filter > Other >Minimum and I set the level to 1 or 2.

Rendering

I didn't want the wooden floor showing, so I covered it up by flooding the scene. To add the water, I used the Lasso tool and applied the selection technique that I explained earlier in the tutorial. I blocked the parts that I wanted and painted it with a soft rounded brush. I later added textures and reflections (**Fig.18**).

> **❝ THE MILLION DOLLAR QUESTION IS: WHICH BRUSHES DO YOU USE? ❞**

When I'm painting on a selection, sometimes the dashed selection line is a bit annoying. By Pressing Ctrl + H, you can hide it and paint without distractions. You can turn it back on by pressing Ctrl + H again.

I also added some pictures for the vegetation. I got a photo of some leaves and applied the layer mask technique. This time, instead of painting with a rounded brush, I used a random textured

brush. To finish, I hand-painted some simple leaves using the Selection tool (**Fig.19**).

The million dollar question is: which brushes do you use? I say over and over again that the brush is 10% of an image. It doesn't matter which brushes you use; they will not make you better. Anyway, if you need some textured brushes for rocks etc, Geoffroy Thoorens at **http://djahalland.com** has some nice brush sets.

I didn't do any research for the robot. I didn't want to focus too much on it, so I started rendering the robot and the archaeologists, with basic and loose brush strokes.

Once everything was almost set, I applied the lights, as I explained earlier. At this point I wanted to bring some elements to the front and make others more diffused. So I added some atmosphere with a very soft brush (normally in a layer set to Screen) until I got the desired depth.

By general rule the highest levels of black and more saturated colors will be on the first plane, and the less saturated, with the highest level of white, will be on the distant plane (**Fig.20 – 21**).

I always have an adjustment layer (Hue/Saturation) with the Saturation set to 0. Having it on the top, and activating and deactivating it, helps to check if the levels are working well. As you can see I also keep another layer with the original image as well. It's good to come back to the original source and see if all the aged and destructed elements fit well.

Apart from that I also flipped the image several times to check that the composition was well balanced (Image > Image Rotation > Flip Canvas Horizontal).

At this point I felt that the image needed some extra details, so I added small sticking-out parts, and more debris to the ceiling. I added more

vegetation and roots as well. I added a window in a first plane, with some strong black levels, reinforcing the proximity of that element and helping to make the image more immersive. The human eye avoids those dark areas and focuses the attention on the lower part of the image.

If you just add hyper-detailed elements, without adding atmosphere and depth (with the same levels everywhere) the eye gets tired and can't focus anywhere, so it feels weird. It's better to block some areas, even if you have to hide some cool parts of your painting, to balance the image (**Fig.22**).

When I'm rendering, I never zoom into the image at 100%. This piece, for example, is about 6000 pixels wide. I usual paint at 25-50% zoom; this way I prevent myself from spending too much time detailing something that is going to be imperceptible when you see the overall image. I just zoom into 100% for very specific cases.

I paint with a limited number of brushes. Each artist has his/her own favorite set, but sometimes I use the same brush with different settings (pen pressure, less opacity, different sizes) and it's boring tweaking the settings of the same brush over and over again. What I do is create Tool Presents (Window > Tool Presets). When I want to save a brush setting that I like, I just click the icon for New on the Tool Preset window and rename it as I want. I can also save the color by just checking the Include Color box. I always keep this window open and pick my brushes from it

Now to wrap it up! The character in the front looked very static, so I added another person that allowed for a more dynamic feeling and also helped tell the story.

The previous composition worked very well in the first part, when I was showing a big portion of the ceiling. Here the action is centered at the bottom right, so for a better read, I cropped the image from the top and extended the bottom a bit. I also added in some hand-painted lens flares, by painting some lights with a soft brush over a black screen, and setting them in a layer in Screen mode. It's a good idea to create a folder with some of those lens flare effects. They are very useful for scenes with artificial or frontal light (**Fig.23**).

When I saw that everything was as I wanted, I checked the levels and tweaked the overall color slightly, then I applied a Sharpen filter to make the brush strokes pop out a bit (Filter > Sharpen > Unsharp Mask) (**Fig.24**).

Thanks for your time. I hope this tutorial was useful and inspiring!

PROJECT OVERVIEWS | WALKERS
By Donovan Valdes

Introduction

The original concept for this piece was an Elven community, whose homes were carved and "grown" from a vast forest and surrounded by towering wildlife. I typically begin pieces with a loose thumbnail, overlaying lines with basic tones to establish a quick composition (**Fig.01**).

I find that it helps to keep the image quite small on the screen to focus better on the composition and shape, rather than get caught up in details. The vertical format seemed to me an obvious choice here to highlight the tall trees and creatures.

Developing the Thumbnail

My next step was to carve out the forms and slowly eliminate the line work (**Fig.02**). I usually keep the thumbnail on a Multiply layer above everything (set down to 35% Opacity or so) to reference as I go. I wanted a relatively simple color scheme, so I laid in a couple of Color and Overlay layers – enough to add mood, but

Horizon line

" I ALSO REMEMBER THINKING OF THE *JURASSIC PARK* SCENE WHERE THE BRACHIOSAURUS IS EATING FROM A TREE NEAR THE CHILDREN "

not so much as to distract from the forms and silhouettes (**Fig.03**). I was probably an hour or so into the piece at this stage.

I wasn't trying to design much here; just explore what shapes would look good in the space. I also kept playing with contrasting values to establish depth: darker tones in the foreground and lighter tones in the background. If I can tell what's happening when the piece is just thumbnail size, then I'm heading in the right direction. I also remember thinking of the *Jurassic Park* scene where the brachiosaurus is eating from a tree near the children, and I wanted to capture that feeling of awe with the Elf spectators.

Refining the Painting

Once I was comfortable with the composition and overall feel, I started to refine the painting. My base sketch was all on one layer, so I used the Lasso tool to separate the basic elements of the painting. In **Fig.04**, I outlined the main tree trunk and platforms, and used Ctrl + Shift + J to Cut and Paste my selection onto its own layer, over a painted background. The lasso selection didn't have to be perfect, just enough to separate it from the background cleanly.

In **Fig.05**, I took the basic shapes and started carving out the forms more carefully. I prefer to use a solid-opaque, flat, square-ish brush for this stage, because it gives me nice line variation and a clean, clear outline. I've found this to be a very important part of my process, since I love to use the Preserve Transparency layer option. This one feature alone frees me up tremendously to be loose and sketchy within the confines of my shape, without risk of losing the silhouette.

You'll also notice I took perspective into account, adding curvature to the platforms (**Fig.06**) and

particularly the topmost structure. Seeing the bottom of this building helps the forms feel less flat, and lowering the horizon line below mid-point increases the sense of "looking up" here.

In **Fig.07,** I dropped in the main dinosaur using the same process as in Fig.04 – 05, cleaned him up and refined his design. I also added the figures to the platform.

> ❝ ALTHOUGH A LOT OF DETAIL IS SUGGESTED IN THE BACKGROUND AS A WHOLE, THE LOW CONTRAST AND SOFT VALUES KEEP IT FROM OVERTAKING IMPORTANT FOREGROUND ELEMENTS ❞

At this point I felt the composition was missing something on the lower left, so I added another foreground trunk (**Fig.08**). This helped to create another layer of depth, and pushed the dinosaur back further.

Fig.09 – 10 are all about adding more depth to the background. Over the years, I've accumulated a collection of foliage brushes, which I can use to fill in branches or leaf cover. Fig.09 shows one of the high-resolution brushes in my

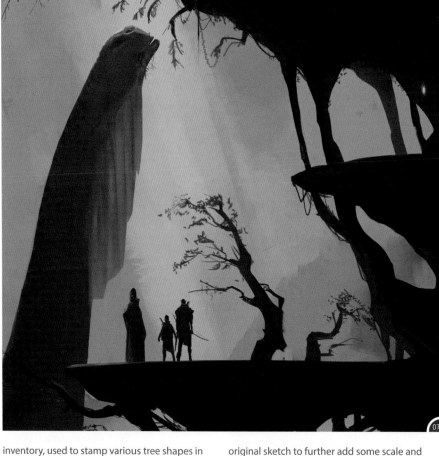

inventory, used to stamp various tree shapes in the background until I got a satisfying result. I also added the background dinosaur, and more figures on the high platform. You'll also notice I sized-down the secondary figures from the

original sketch to further add some scale and depth. Although a lot of detail is suggested in the background as a whole, the low contrast and soft values keep it from overtaking important foreground elements.

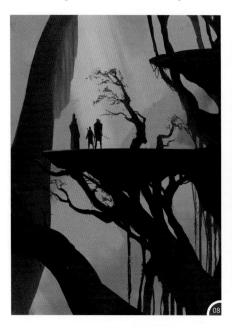

Lighting

At this point, I was comfortable enough with
the piece to start adding some lighting (**Fig.11**).
I like to keep any strong lighting on a separate
layer, using the Vivid Light blending mode. As
long as I keep my light's saturation levels low
(2-15% often works well) and the brightness
in the 60-80 range, I find it adds some great,
unexpected vibrancy and punch to colors
beneath. For example, the pink/orange glow on
the main dinosaur's neck flap hovers around 10%
Saturation and 75% Brightness.

Keeping my overhead light source in mind,
I created a dappled effect on the dinosaur's
neck and the branches with a textured brush,
highlighting the surfaces facing the source (A).
Placing a broad stroke of light, then going back
and erasing sections can produce some nice
random, organic patches. I also introduced a
warmer, reflected light on the downward-facing
planes (B), to illuminate some of the shadows.

That about wraps it up; I call an image done
when I can't think of anything else to fix (**Fig.12**).

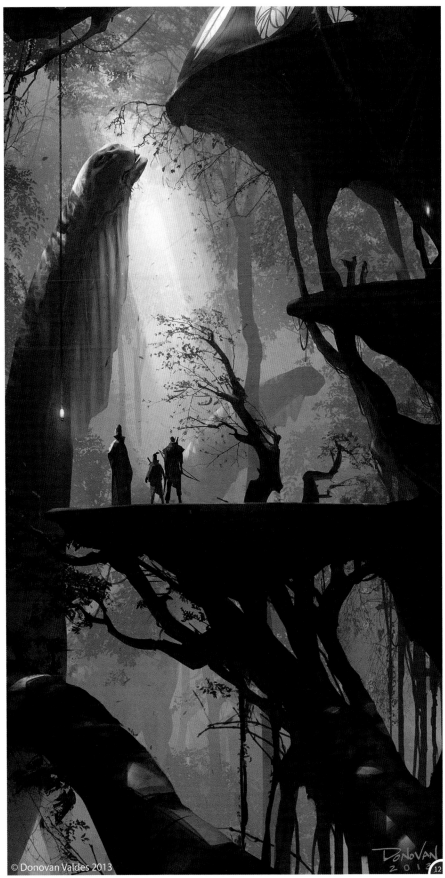

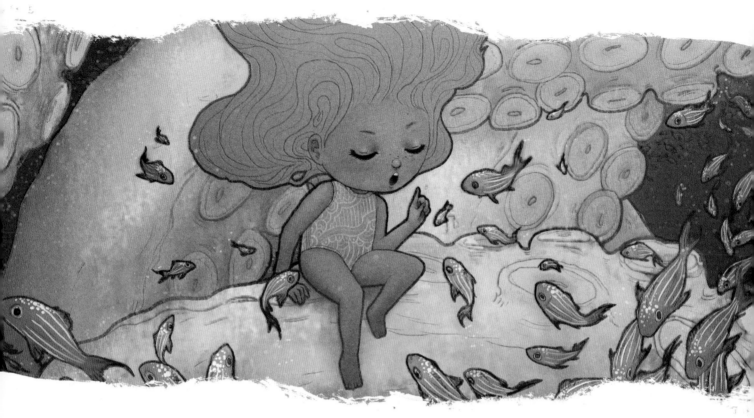

PROJECT OVERVIEW | LISTEN TO ME AND I'LL TELL YOU A STORY

By Ejiwa Ebenebe

Introduction

Hello there, today I will be talking about how this illustration came to be. I will be explaining my process from conception to finished piece, and I hope you will enjoy seeing how this all came about!

The Concept

It all started off as a rough scribble, which had been sitting on my hard drive for a few months (**Fig.01**). It is quite a bit different from what turned out as the final product, and I do hope to revisit the original concept someday, but I digress!

To start off, I wasn't happy with the closed-off composition at this point; it felt so limited and typical of me, and I really wanted to break out of that habit. I also wanted to incorporate some sort of story as it all seemed rather lacking at this point, so I set about redrawing the sketch and trying to figure out just what this little girl was doing! Was she floating? Swimming?

Sitting? Why was she sitting here? Maybe she was lost? Storytelling is a skill that I am working on improving, so this was quite a good exercise. Eventually I decided on the setting you see now: a curious little girl getting ready to tell some fish a story.

The Drawing

My illustrations often begin with small, colored sketches in Photoshop, such as Fig.01. I color my rough concepts because I like to visualize what the overall end product will be like (and, let's face it, I just can't resist adding color in when I can).

254

After my general idea has been roughed out, I then do a slightly more refined and deliberate drawing over the scribble (I simulate a light box in Photoshop by changing the opacity of the sketch layer to a low value, and then creating a new layer above it to draw on) to start figuring out the placement and form of the elements involved (**Fig.02**).

Nothing is beautiful at this stage; a lot of things are still vague and rough, and things are still being moved around and deleted. The refinement/figuring out of details will come in later as I develop the image (for example, I decided to make the girl much smaller in the scene as the image progressed). I also still work at quite a small canvas size because I don't like working out my sketches on large documents. I find that working small at this point allows me to focus more on the overall idea and feeling of the image. It also allows me to avoid needlessly slowing down my computer at this stage of my work.

In the past I would flesh out everything from the sketch to the final image on my computer, but lately I have been returning to pencil and paper to figure out my base drawings. I find this stage to be far more enjoyable when working on paper and I seem to draw with more ease too! I find I enjoy working out my initial concepts and color sketches in Photoshop, and then moving to pencil and paper to work out things like the separate elements and anatomy (using my light box to overlay paper sheets as "layers" really works for me) and then returning to Photoshop to take the image to completion. While I am not bound to this exact process (I like to experiment with doing things in many different ways), this method seems to be very effective for me (**Fig.03**).

References and Critique

I wanted to make sure I wasn't guessing my way through this piece, so I did a lot of research with regards to the tentacles and fish, trying to understand how they worked and how they were put together. I collected quite a few references from Google, which I then used to figure out the anatomy of the elements in my compositional

sketch (**Fig.04**). I like to sketch out my concepts and ideas first, and then use references to resolve the anatomy and details, rather than start by building my work directly from references. I find that this helps me in terms of creativity earlier on and not having to worry about copying and being too reliant on the reference, which I find can be the tendency if an idea has not already been established.

Another thing that really helped me out as I was figuring out the drawing was getting critique. I had sketched out the little girl on paper (**Fig.05**),

but after scanning the sketch in and placing her in the scene I realized something was really bothering me. I then showed the sketch to a friend who pointed out the issues with her anatomy (her eyes weren't sitting correctly etc). Sometimes it becomes difficult to see the problems in our own work, especially when we have been staring at the piece for a long time. It can be extremely helpful to get an outside view.

Lines

After I had worked out my composition, scanned in the pencil drawings I had done, and arranged

all the elements in place in Photoshop, I then resized the canvas to the size I wanted my final image to be and began the line work. I usually do my lines in groups, placing each main element on its own layer (e.g the girl, the different layers of tentacles, groupings of fish, etc). This gives me the flexibility to:

• Turn the visibility of major elements on or off as I wish
• Draw through and erase different parts of the image without difficulty
• Colorize my lines easily during the later stages.

Also, while the accompanying images show my lines on white backgrounds, I rarely do line work this way. I prefer by far to do my lines over a colored background. Perhaps it's due to my inclination towards color, but working on white really bores me and I also find it strains my eyes (**Fig.06 – 07**)!

❝ Embrace trial and error. You'll be doing a lot of it! ❞

Flats
After I'm done with my lines I move on to flatting. This is something I started doing recently and I find it helps me a lot in the later stages. I don't do extremely detailed flats as I find that I don't need them, but I do just enough to separate the important elements (**Fig.08**). It really helped me with this complicated composition, as I didn't need to overload my file with numerous layers for each object. I could simply use the Magic Wand tool to select the area I wanted to work on from my flats layer, and work on my color layer without worrying about messing up the surrounding areas.

Color
After flatting, I then rearrange my layers (things can get very messy during the earlier stages) and now I can finally start on the colors! Colors have got to be one of my favorite things to work on, but I must admit that this image nearly drove me crazy at one point. I went through a few different

color schemes: I started with the original idea I had roughed up in my first sketch, but it just didn't work with the new, more open scenario I had set up. So I then started experimenting with different options, but it just wasn't working. Eventually I decided to save out a small copy of my lines (I had been trying out these different ideas in my large file and it was getting very tedious and slow) and scribbled out a few different color ideas until I ended up with a color rough I was pleased with (**Fig.09**).

I then applied these new colors to my working document and I was happy with them for a short while. But then I realized it still wasn't giving me the feeling I wanted! A lot of tweaks, seesawing and adjustments later, and I ended up with the final direction for my color scheme (**Fig.10**). Embrace trial and error. You'll be doing a lot of it!

Lighting
I love using layer modes (such as Soft Light and Overlay) in my work; I like the effects I can

achieve with them. I like to pump up the lighting and color intensity in my work using multiples of these layers, with various colors at varying values depending on the effect I am aiming for.

Another tool I have found to be useful at times are the Gradient Map adjustment layers. Applying them on top of an image can yield very interesting results depending on the opacity used, blending modes and the combination of gradient map layers. I like to play around and see what I end up with.

In this case, one of the things I wanted to do was intensify the light coming from the top of the image, and darken the bottom. While my process may seem linear, this is usually not the case. I go back and forth between a lot of the phases in my process and sometimes elements and layers last throughout my process from beginning to end. More often than not my layers will appear randomly throughout my process as ideas jump into my head.

The lighting layers in this illustration came at different points; some of them I had active as I was playing around with rough color ideas, others were deleted completely or redone later. For example, I played around with the idea of light rays at one point (**Fig.11**). At the end of the

day, I just experiment and see what I end up with. This is a lot of the fun of the process, I think!

Final Touches

To finish up my images I usually save the working document under a new name, and flatten it (I like to retain my layered files as I never know when I'll need/want to return to it). Now I can start adding in my final touches: I create a new layer, fill it with 50% grey and apply Noise. I then apply Spatter (**Fig.12**) to that noise layer and then blur the whole layer slightly. Finally I set the layer to Overlay and reduce the opacity until I'm happy with the look. I learned this technique a while back and I really love it! It adds a dimension to my work that I enjoy.

Another thing I love to do is apply very slight chromatic aberration. I do this by completely flattening the document, then copying and pasting the illustration to a second layer. I then

right-click on the layer tab and select Blending Options from the menu box. In the default blending options tab, I access the Advanced Blending section and this is where I control my chromatic aberration (**Fig.13 – 14**). It's as easy as deselecting one (or two) of the R, B or G tabs, then hitting OK.

You won't notice any changes yet, but all you need to do now is select the Move tool, and nudge that duplicate layer as much as you like in any direction. You should now see the shift appear (**Fig.15**). You can play around with the combinations of selected RBG channels until you get something you like. I like applying this to my work; it adds yet another layer.

After all this, all that was left was to add my watermark and it was done! I hope you enjoyed learning about my process and that you gained something from it!

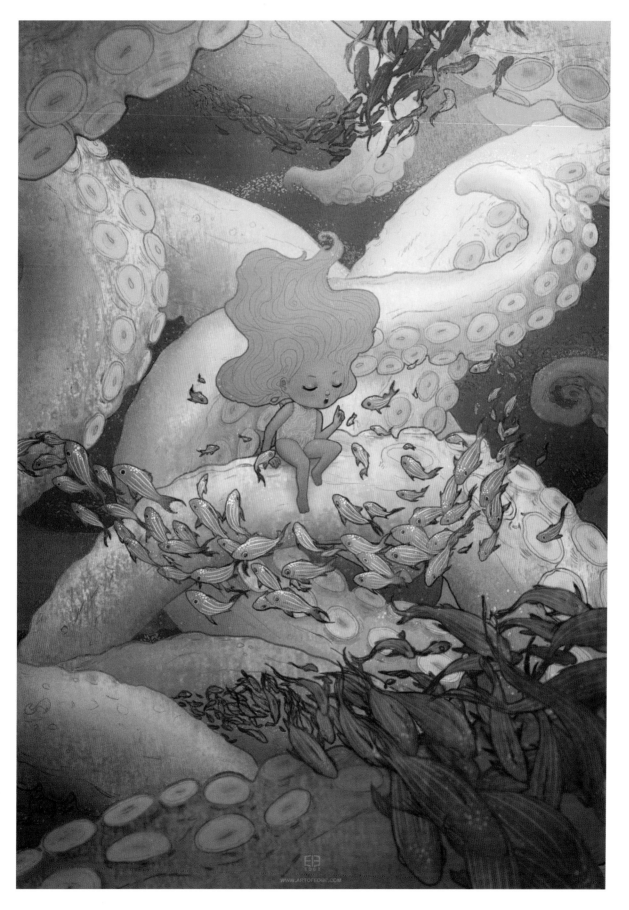

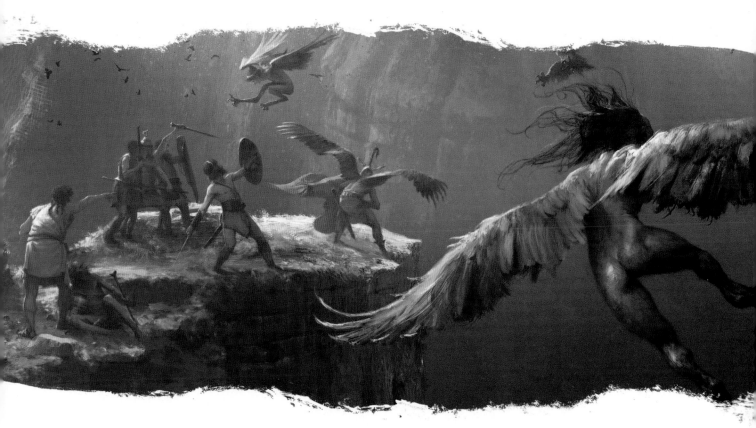

PROJECT OVERVIEW | THE HUNT FOR THE HARPIES

By Jose Daniel Cabrera Peña

Introduction

The illustration was commissioned by Osprey Publishing as part of the art contents of the first book in their new Osprey Adventures *Myths and Legends* series. As part of the Osprey Publishing editorial line, our recreation of Jason and the Argonauts had to try to match the historical accuracy of their traditional book series, while still keeping a sense of myth and fantasy.

So we went back to the Bronze Age, around 1200 BC where the myth was born, to design armor and weapons. The strongest reference about this may be the well known Dendra Armor.

Initial Ideas

Keeping this in mind, I began with a loose idea of the whole plate, based on lone character poses, and related by pairs or groups. I wanted to add a strong narrative and a sense of movement to it, so poses had to show stress and violence. I paid special attention to the wing dynamics and tried to find an adequate photo reference (**Fig.01**).

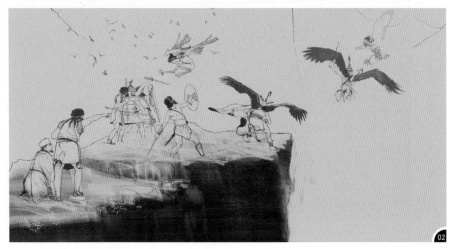

I had in mind the image of the Argonauts having set the trap to catch the harpies at the top of a prominent rock, where Phineas (the blind) would be; from there, the Boreads Zetes and Calais, two winged brothers who were also Argonauts, would chase the harpies. So I started with a first rough of the composition, searching for the feeling of height, and a strong feeling of atmosphere (**Fig.02**).

Atmosphere

Having placed a rough background color that would more or less act as the working palette, I moved on to trying to achieve the atmosphere gradient I wanted to show. Placing this gradient in a layer between the background, the foreground and the characters, I was able to hide shadows, highlights and/or general background detail by using the layer blending sliders. It could be accessed by double-clicking the layer where the gradient was. This gave me the needed smoothness I'd need to level the atmosphere properly later on (**Fig.03**).

Here, I received some advice off the editors who wanted to see Phineas dressed in rags to fit the story better and my beloved Rocío Espín's role in the composition should be to bring the readers closer into the action by placing him and other elements closer to the point of view. Also by making the atmosphere more graded, I was creating a third level of distance to the reader. The final composition was now ready (**Fig.04**).

Painting

Being a complex composition, I needed the lines to be there when I started the paint work. So I painted with simple brush strokes in another layer under the drawing layer. Many would find this to be a bad method of making the paint flow – creating hard edges and a general sense of static – but this can be necessary when depicting small elements, such as those found in armors and weapons. When working for history publications this can be an easy way to accomplish accuracy, but of course this is not the only way.

Until now, only basic colors had been used on the characters and the background. Because of this, I can talk about a simple way I figured out to bring color variations and unfiltered light sprays to a scene at anytime. I hid the drawing layer and

applied Noise at a low resolution to a copy of the image. This gave me color variation samples all over the image to be used wisely in the same areas. This would not be very useful with strongly filtered or near to grayscale palettes, but it was useful to add slight color changes to anything within the image (**Fig.05**)

It was now time to paint over all that, picking color and mixing freely. At the end of doing this, I was left with the painting ready for finalizing (**Fig.06**).

Making corrections is a complex process unique to each image, so general hints here will be

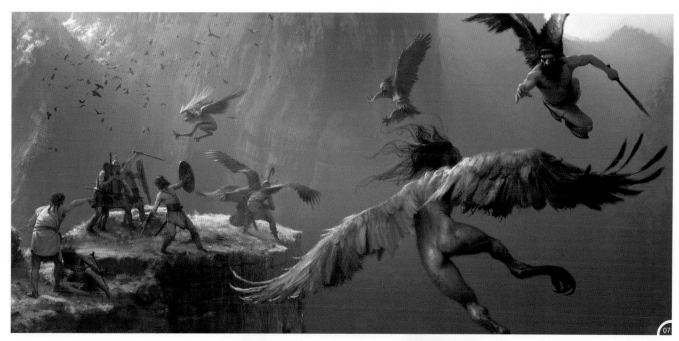

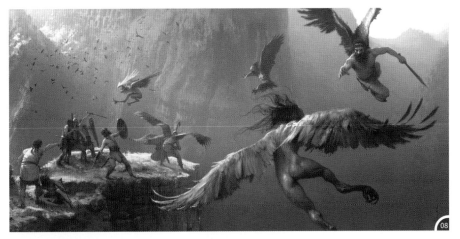

useless. In this painting I wanted to place a dramatic backlight without killing most of the color in the characters, so a lateral light had to be built and warm filters had to be used without turning the general bluish tones in the background green. Blue tones were needed to keep the atmosphere. It is possible that truly green tones keep looking as bluish in relation to the rest of the scene, so I could push the limits a bit (**Fig.07 – 08**). A warmer mood looked more dramatic to me.

Finishing Touches

As a final step before finishing it all, I made sure that there weren't any areas in the image that were too bright or too dark, breaking the general mood, raising the blacks and painting over the lights. A general airbrush stroke was applied over the mid-ground elements to refine the atmosphere, and I also took care of other minor and final elements by painting directly over it all (**Fig.09 – 10**).

The initial palette was only a working palette; it did not reflect the final look, as opposed to setting the initial palette from the start, which I find more genuinely pictorial.

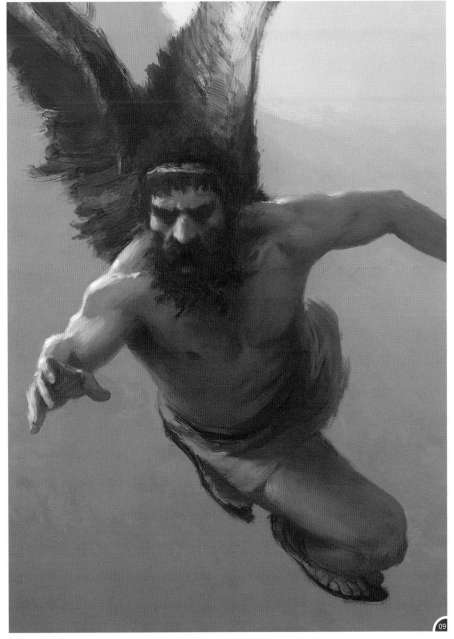

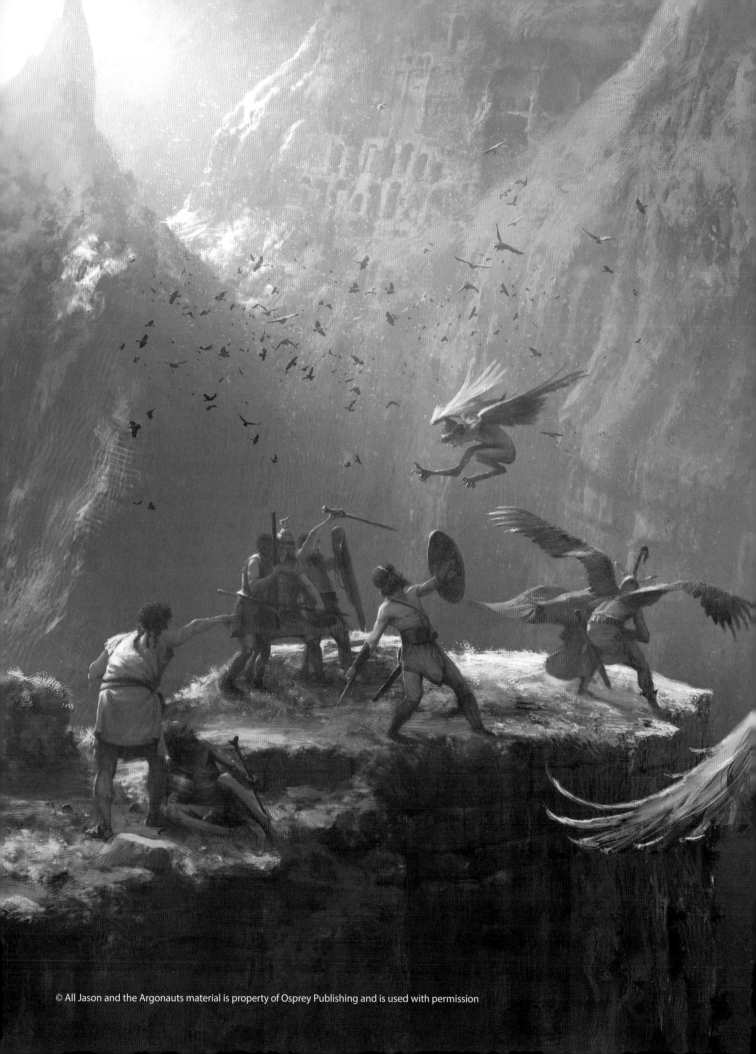

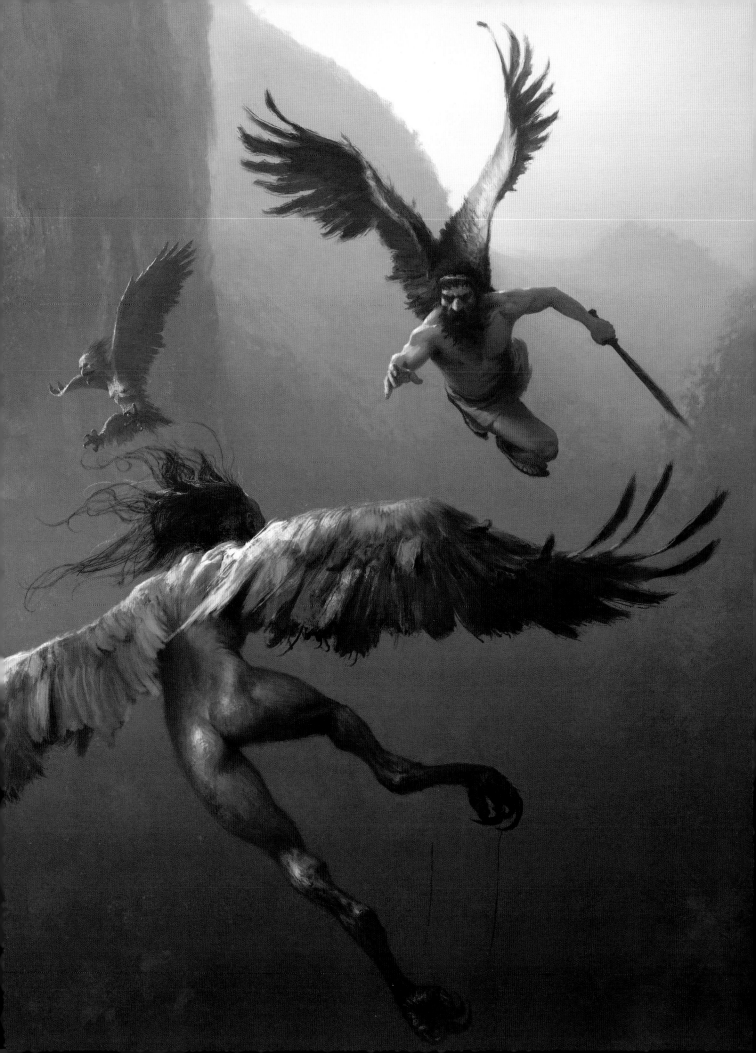

CHAPTER 04 | THE GALLERY

A great way to be inspired to create your own images and jump-start your imagination is to look at the work of other artists. In the following pages you will find a collection of inspiring images from some extremely talented digital painters in the industry, which will hopefully awaken the creative inside you and lead you to putting the techniques and methods displayed in this book into action, to create your own gallery pieces.

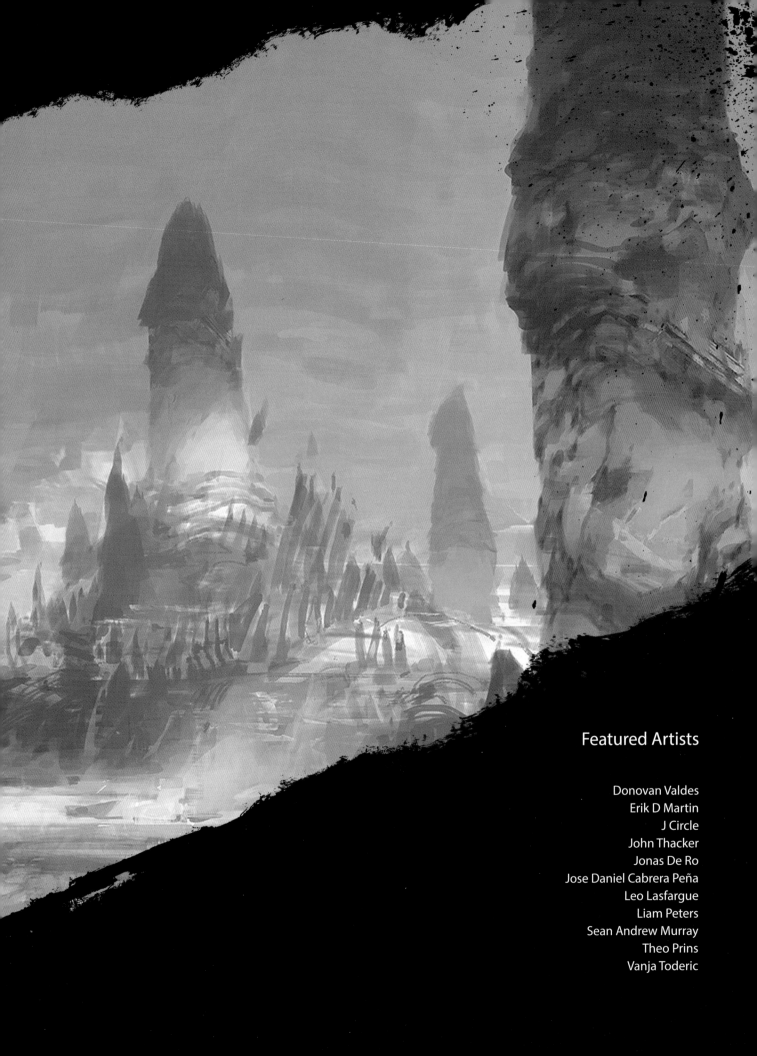

Featured Artists

Donovan Valdes
Erik D Martin
J Circle
John Thacker
Jonas De Ro
Jose Daniel Cabrera Peña
Leo Lasfargue
Liam Peters
Sean Andrew Murray
Theo Prins
Vanja Toderic

Medieval Market
Donovan Valdes
www.donovanvaldes.com
donovanvaldes@yahoo.com
Art by Donovan Valdes. © Ubisoft
[Top]

The Site
Jose Daniel Cabrera Peña
joscabrera.blogspot.com.es
llowee@hotmail.com
© Jose Daniel Cabrera Peña
[Above]

Secret Castle
J Circle
www.j-circle.net
pjwphn@naver.com
© 2013 All Right Reserved by J.CIRCLE
[Right]

Secret Castle

J Circle

[Top Left]

Tokyo Ruins

Jonas De Ro

[Bottom Left]

Southsun Cove (01)

Theo Prins

[Top]

Under the Arches

John Thacker

[Above]

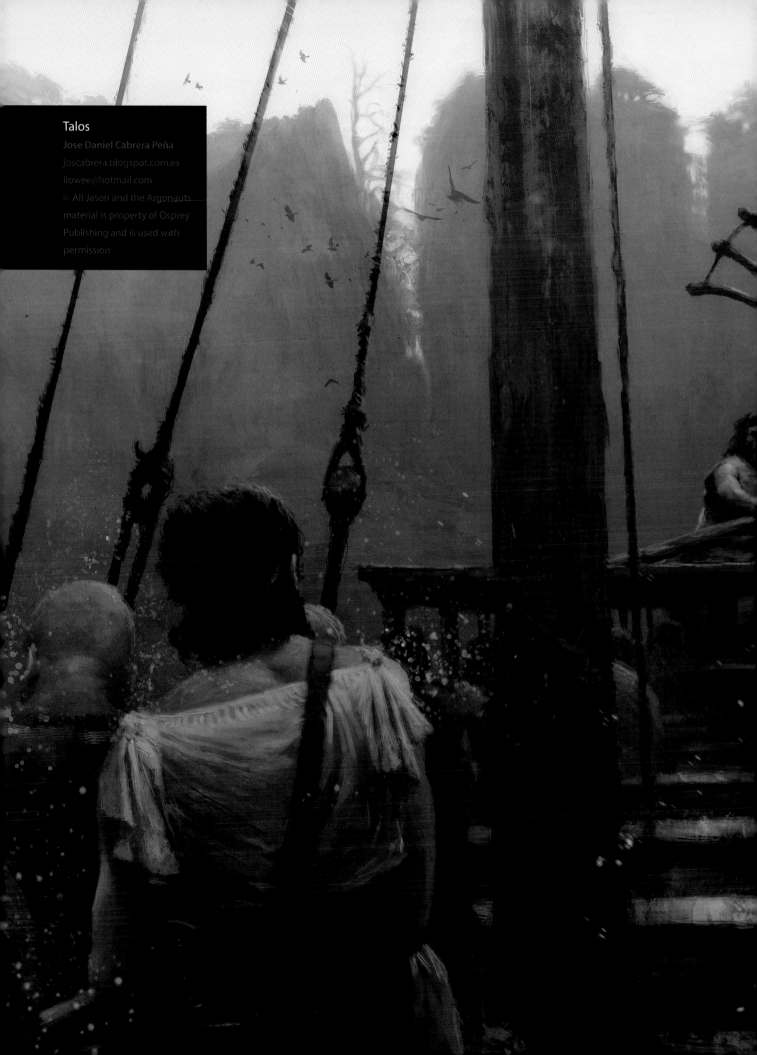

Talos

Jose Daniel Cabrera Peña

joscabrera.blogspot.com.es

ilowee@hotmail.com

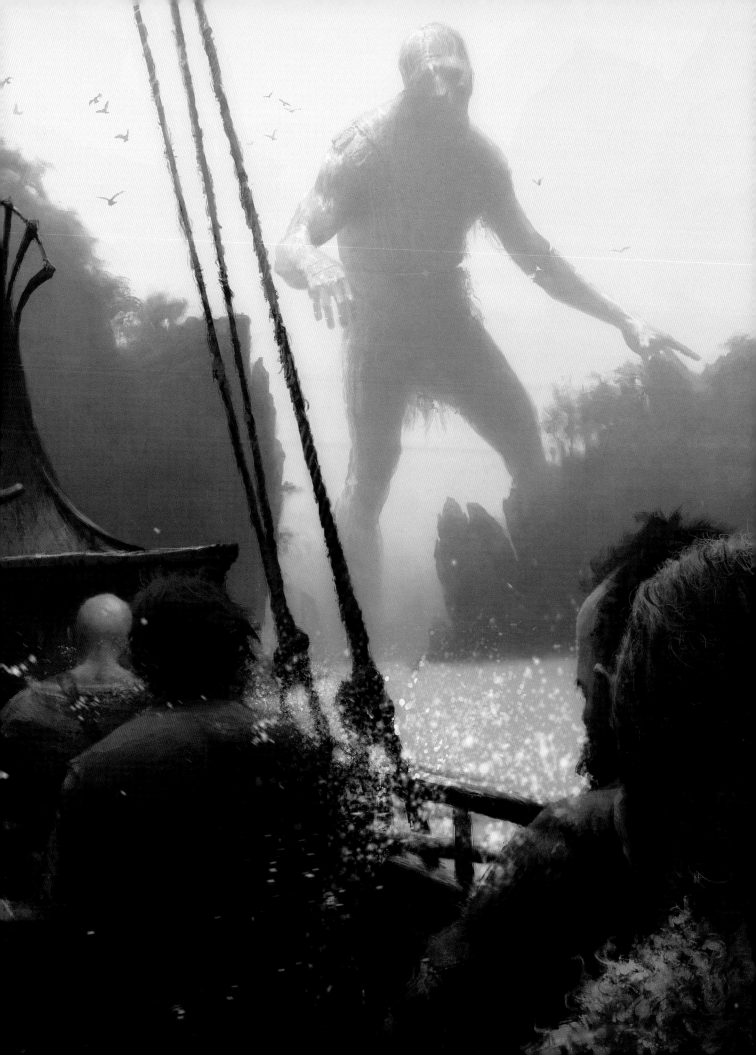

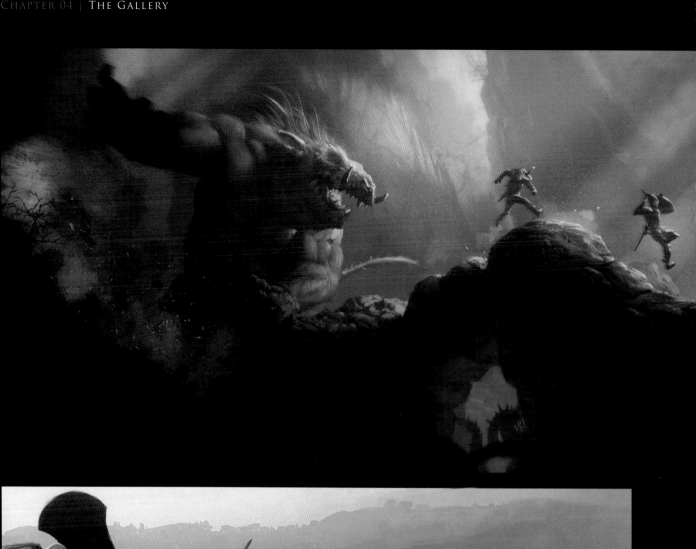

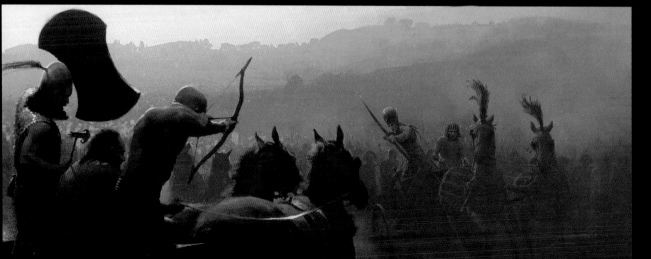

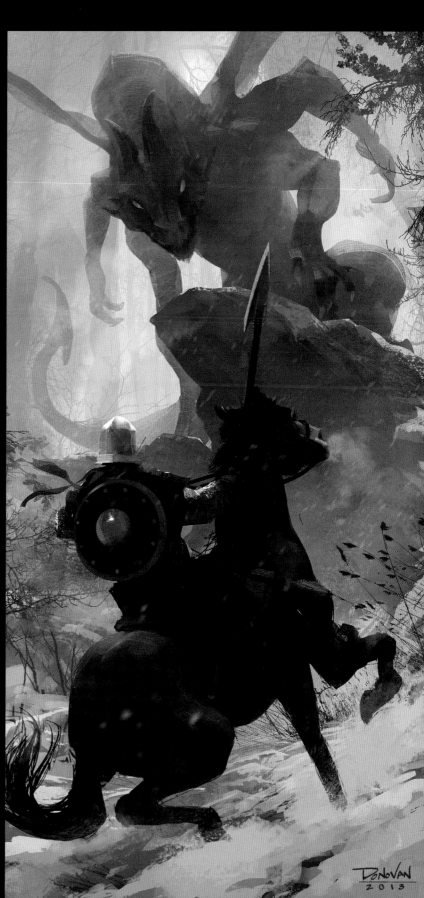

Badagro

Leo Lasfargue

www.leolasfargue.com

leolasfargue@gmail.com

© Leo Lasfargue

[Above]

Kadesh Battle

Jose Daniel Cabrera Peña

joscabrera.blogspot.com.es

llowee@hotmail.com

© Jose Daniel Cabrera Peña

[Left]

Confrontation

Donovan Valdes

www.donovanvaldes.com

donovanvaldes@yahoo.com

© Donovan Valdes 2013

[Right]

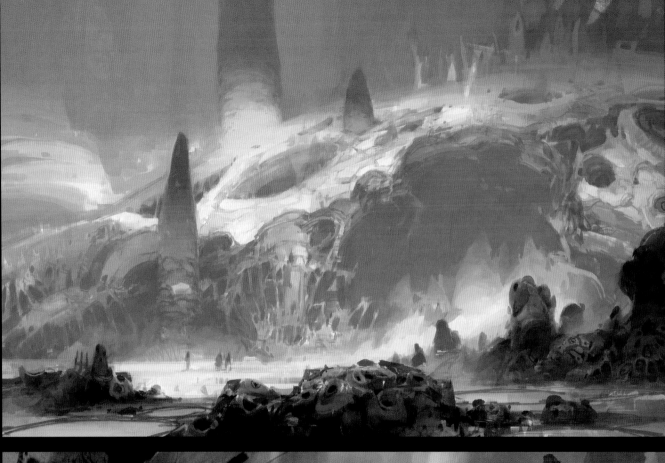

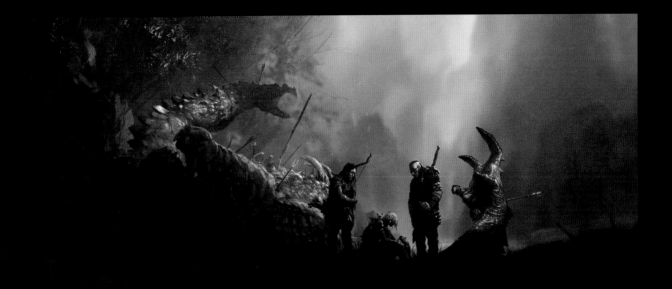

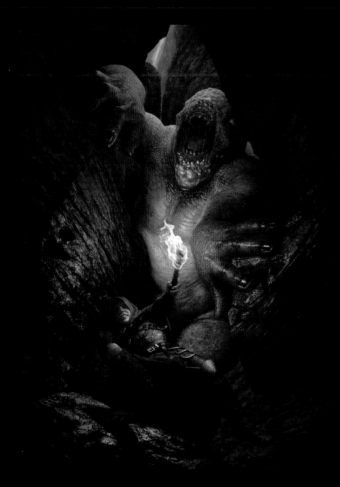

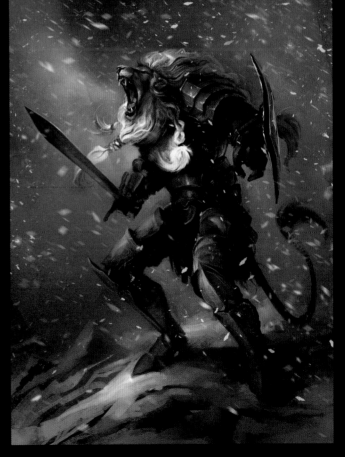

Garuk the Creeping Death

Leo Lasfargue

www.leolasfargue.com

leolasfargue@gmail.com

Cave Monster

Liam Peters

lpeters.deviantart.com

petersliam@hotmail.com

Lion Knight

John Thacker

johnthacker.cghub.com

johnrthacker@yahoo.com

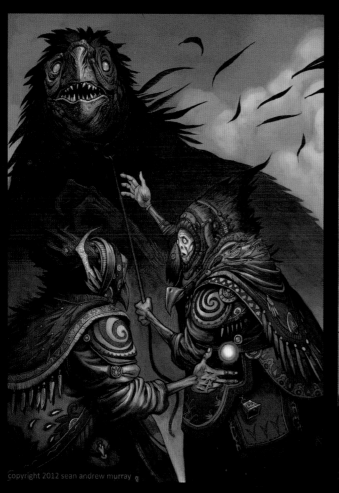

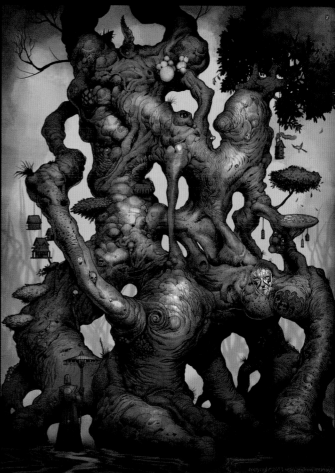

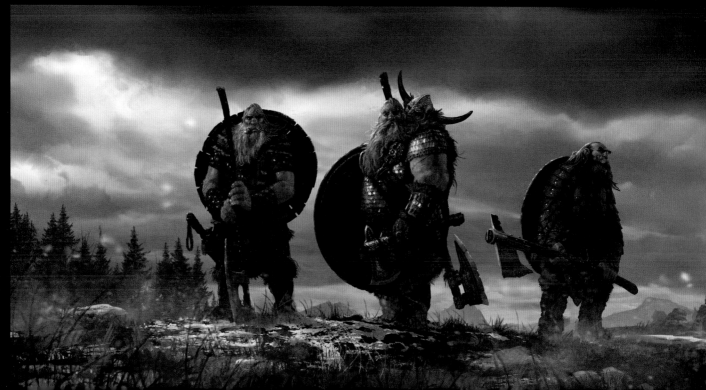

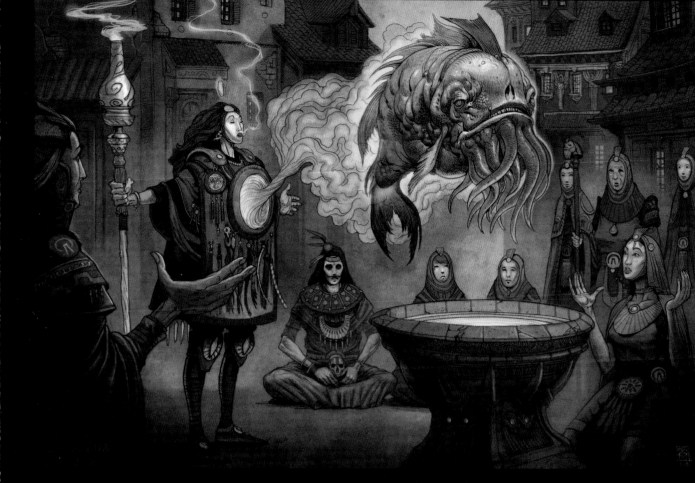

Gone Full Bird

Sean Andrew Murray
www.seanandrewmurray.com
sean@seanandrewmurray.com
© 2013 Sean Andrew Murray
[Far Top Left]

Illiandar Mage Tree

Sean Andrew Murray
www.seanandrewmurray.com
sean@seanandrewmurray.com
© 2013 Sean Andrew Murray
[Far Top Right]

Peuple du Nord

Leo Lasfargue
www.leolasfargue.com
leolasfargue@gmail.com
© Leo Lasfargue
[Left]

Mistress Ocheka Summoner of Ashes

Sean Andrew Murray
www.seanandrewmurray.com
sean@seanandrewmurray.com
© 2013 Sean Andrew Murray
[Above]

The Groom Snake

Vanja Todoric

vanjatodoric.blogspot.co.uk

vanja3d@gmail.com

© Vanja Toderic 2013

[Above]

The Golden Fleece Ram

Vanja Todoric

vanjatodoric.blogspot.co.uk

vanja3d@gmail.com

© Vanja Toderic 2013

[Right]

Father Study

Erik D Martin

www.erikdmartin.com

erikdmartin@gmail.com

© Erik D Martin 2013

[Far Top Right]

Mechanical Menace

Erik D Martin

www.erikdmartin.com

erikdmartin@gmail.com

© Erik D Martin 2013

[Far Bottom Right]

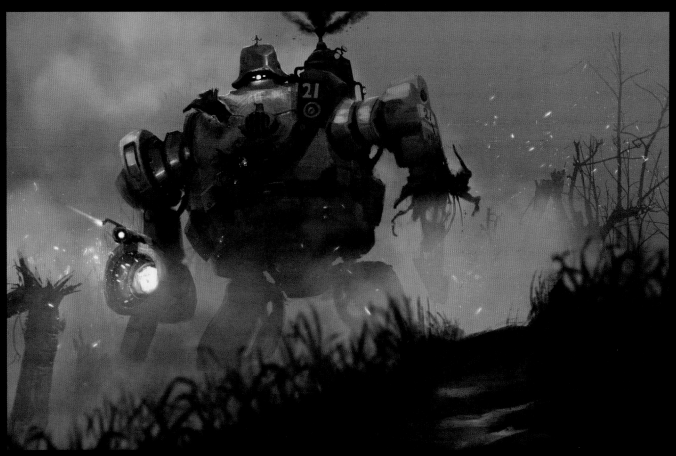

FEATURED ARTISTS

Brian Sum
brian@briansum.com
briansum.com

Bart Tiongson
BTiongson@RobotEntertainment.com
riceandeggs.blogspot.com

Brett Bean
brettbean@yahoo.com
2dbean.blogspot.co.uk

Carlos Cabrera
carloscabrera@gmail.com
www.artbycarloscabrera.com

Clint Cearley
poetconcepts@hotmail.com
www.clintcearley.com

Clonerh Kimura
clonerh@ymail.com
clonerh.blogspot.co.uk

Daniel Baker
thatdanielbaker@hotmail.co.uk
dan-baker-art.blogspot.co.uk

David Munoz Velazquez
munozvelazquez@gmail.com
www.munozvelazquez.com

Denis Zilber
deniszilber@gmail.com
www.deniszilber.com

Donglu Yu
donglu0419@gmail.com
donglu.cghub.com

Donovan Valdes
donovanvaldes@yahoo.com
www.donovanvaldes.com

Ejiwa Ebenebe
ejiwa_ebenebe@yahoo.com
www.artofedge.com

Erik D Martin
erikdmartin@gmail.com
www.erikdmartin.com

Fenghua Zhong
630598615zhf@gmail.com
zhongfenghua.cghub.com

Gabriel Gomez
gabrielgomez@neuf.fr
new-territories.blogspot.co.uk

Ignacio Bazán Lazcano
i.bazanlazcano@gmail.com
http://neisbeis.deviantart.com

Ivan Smirnov
sonkes@yandex.ru
real-sonkes.daportfolio.com

Jason Seiler
seilerillustration@gmail.com
www.jasonseiler.com

Jason Wei Che Juan
jasonjuan05@gmail.com
www.jasonjuan.com

J Circle
pjwphn@naver.com
www.j-circle.net

Johannes Helgeson
helgesonart@gmail.com
helgesonart.blogspot.co.uk

John Thacker
johnrthacker@yahoo.com
johnthacker.cghub.com

Jonas De Ro
jenovah-@hotmail.com
www.jonasdero.be

Jose Daniel Cabrera Peña
llowee@hotmail.com
http://joscabrera.blogspot.com.es

JP Räsänen
juhis_r@hotmail.com
www.jprasanen.com

Kris Thaler
Kris@rmory.net
kristhaler.cghub.com

Leo Lasfargue
leolasfargue@gmail.com
www.leolasfargue.com

Levi Hopkins
levimhopkins@hotmail.com
levihopkinsart.blogspot.co.uk

Liam Peters
petersliam@hotmail.com
lpeters.deviantart.com

Maciej Kuciara
kuciaramaciej@gmail.com
www.maciejkuciara.com

Markus Lovadina
malo74@gmx.de
malosart.blogspot.co.uk

Matt Tkocz
matt@mattmatters.com
www.mattmatters.com

Max Kostenko
hypnoticw@gmail.com
max-kostenko.com

Michal Lisowski
ml@michallisowski.com
www.michallisowski.com

Nacho Yague
nachoyague@gmail.com
nachoyague.net

Richard Tilbury
ibex80@hotmail.com
www.richardtilburyart.com

Sean Andrew Murray
sean@seanandrewmurray.com
www.seanandrewmurray.com

Shaddy Safadi
shaddysafadi@yahoo.com
www.shaddyconceptart.com

Simon Dominic
si@painterly.co.uk
www.painterly.co.uk

Simon Kopp
simonkopp@web.de
simonkopp.de

Theo Prins
theo.w.prins@gmail.com
www.theoprins.com

Vadim Sverdlov
haidak@gmail.com
tipagraphic.blogspot.ro

Vanja Toderic
vanja3d@gmail.com
vanjatodoric.blogspot.co.uk